The DSLR Filmmaker's Handbook

Second Edition

Photos courtesy of Carrie Vines Photography

The DSLR Filmmaker's Handbook

Real-World Production Techniques

Second Edition

Barry Andersson

SYBEX®
A Wiley Brand

Acquisitions Editor: Mariann Barsolo
Development Editor: Kim Wimpsett
Technical Editor: Robert Corell
Production Editor: Dassi Zeidel
Copy Editor: Linda Recktenwald
Editorial Manager: Pete Gaughan
Production Manager: Kathleen Wisor
Associate Publisher: Jim Minatel
Book Designer: Mark Ong, Side by Side Studios
Compositor: Maureen Forys, Happenstance Type-O-Rama
Proofreader: Amy J. Schneider
Indexer: Ted Laux
Project Coordinator, Cover: Patrick Redmond
Cover Designer: Wiley
Cover Image: Courtesy of Barry Andersson

Copyright © 2015 by John Wiley & Sons, Inc., Indianapolis, Indiana

Published simultaneously in Canada

ISBN: 978-1-118-98349-2
ISBN: 978-1-118-98350-8 (ebk.)
ISBN: 978-1-118-98351-5 (ebk.)

For general information on our other products and services or to obtain technical support, please contact
our Customer Care Department within the U.S. at (877) 762-2974, outside the U.S. at (317) 572-3993 or
fax (317) 572-4002.

Wiley publishes in a variety of print and electronic formats and by print-on-demand. Some material included
with standard print versions of this book may not be included in e-books or in print-on-demand. If this book
refers to media such as a CD or DVD that is not included in the version you purchased, you may download this
material at http://booksupport.wiley.com. For more information about Wiley products, visit www.wiley.com.

Library of Congress Control Number: 2015930540

10 9 8 7 6 5 4 3 2 1

To my kids, who put up with me, inspire me,
challenge me, and make me laugh every day.
I love you both more than you will ever know.

Acknowledgments

I could not have written this book without the help and support of many people. First, I need to thank Janie L. Geyen, who coauthored the first edition of this book. Without her tireless dedication, patience, passion, and support, this book would have never made it off the ground.

I also want thank my kids, Trinity and Stonewall, for being so patient with me during the whole writing experience as well as being good subjects in so many of the examples and testing over the past couple of years.

I must also thank the contributors, Michael Heagle and Daniel Brown. Michael wrote the chapter on fixing it in post and did a superb job of making the subject matter of post-production seem to be no problem at all. Daniel wrote the entire section about shooting underwater photos and video. His many years of experience were invaluable and distilled to a point where we believe anyone reading his tips will be well on their way to top-quality underwater images.

I also want to thank some of my close friends who allowed me to share some of their invaluable knowledge with their permission. Shane and Lydia Hurlbut and their top-of-the-line Hurlbut Visuals Elite team were awesome. They are leaders in the field and helped us tremendously in better learning the DSLR video cameras and workflows; I also gleaned information from their blog at www.hurlbutvisuals.com. Additionally, Chris Fenwick, editor extraordinaire, was invaluable in helping with a simplified workflow for compressing final images and getting them ready for multiple devices. Thanks to Scott Sheppard for the many hours of assistance in helping set up test after test and being a sounding board for everything from lenses to editing to compression to color and more, to Milo Durben for his invaluable knowledge of gripping and rigging and the patience for all the images we had to take during the course of writing the book, and to Jack Boniface for being a great sounding board and a great help with consulting on the audio portions of the book.

I also cannot thank enough our cast and crew of *The Shamus* for their outstanding performances and their patience in working with a young technology so early in the DSLR game: to our actors, Charles Hubble, Greg Hain, Emily Tyra, Sarah Richardson, Sam Landman, Sasha Andreev, and the many other outstanding actors; and to our crew, Michael Dvork, Ryan Dodge, Tammy Hollingsworth, Deena Graf, Thomas Popp, and the rest of the gang who helped make the film such a joy to work on.

Additional thanks to Julien Lasseur, Anne Gaither, Jeff Lalier, Antonio Aguirre, Rachel Weber, Michael Patrick McCaffrey, David Svenson, Scott Citron, Richard Schleuning, and Nocole Balle from Carl Zeiss, Brian Valente from Redrock Micro, Rick Booth and Dan Ikeda from Tiffen/Steadicam, Garrett Brown for his lifetime dedication to the perfection of movement in film, John Peters, Matthew Duclos from Duclos Lenses, Joel Svendsen from Rosco, Steve Holmes, and Lee Varis.

Lastly, I have to thank my great friend and DSLR video champion Mitch Aunger and his website Planet5D.com. It is the must-read blog and information resource on the Web. Bookmark the site and visit it often.

Of course, the book wouldn't have been possible at all without the Sybex team: Mariann Barsolo, acquisitions editor; Kim Wimpsett, developmental editor; Dassi Zeidel, production editor; Linda Recktenwald, copy editor; Amy Schneider, proofreader; and the compositors at Happenstance Type-O-Rama. I also want to thank the technical editor on this edition, Robert Correll.

About the Author

Barry Andersson is an award-winning independent filmmaker and trainer. His career started with live television video production, ranging from international live interactive broadcasts to live sporting event production. About the same time Andersson started in video production, he also started to produce and direct 35 mm motion-picture short films. Working with everything from ½″, ¾″, Beta, and high-definition video to 8 mm, 16 mm, and 35 mm motion-picture film, he has knowledge of both the video and traditional film workflows. Early in his career he shot over 100 weddings and since then has directed several award-winning short films, several television pilots, episodic television, numerous commercials, and one of the first DSLR feature films. Mr. Andersson's client list includes ESPN, PBS, Discovery Channel, NBA, Disney, Skype, and Samsung Electronics, to name a few.

Follow Barry Andersson:

Instagram: @barryandersson
Twitter: @mopho_barry
Facebook: www.facebook.com/barryanderssonpro

Contents

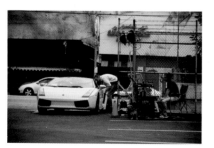

Introduction

This book is a culmination of untold long hours fiddling with cameras and trying to get a shot to work on a variety of DSLR cameras. Since the first edition, these methods have been honed and battle tested over the course of close to 100 productions ranging from low-budget to Fortune 100 companies.

The transition from shooting with film or standard video to working with a DSLR is an exciting and daunting prospect. It is a combination of technological knowledge and a lot of trial and error. This arena is constantly changing as innovations are added or new cameras enter the market. However, we are at a point where there is a DSLR core knowledge base that will provide a foundation for any project. Currently, most DSLR knowledge comes from word of mouth or from "some blog or forum that I once read." Tips and disinformation are given equal footing, and ultimately everyone is stuck holding a camera on the first day of shooting wondering whether the information that they have been gleaning in bits and pieces is actually going to work. This book cuts to the chase; if it's in here, it's going to work. This book attempts to cram that core knowledge of DSLR video into one volume.

It offers information on every subject that you need to be aware of to shoot a DSLR project. This book addresses the practicalities that a filmmaker needs to know to actually be able to complete a DSLR project or that a videographer needs for a shoot. You will find out how to pick gear, set up the gear, and choose and manipulate lenses and various tools to improve your shooting. As you plan all aspects of your shoot, the book will give you direction to ensure that you have your bases covered. Whether you have never worked with DSLR video or you have DSLR video experience, we cover how to create a professional, high-quality project from start to finish and help you avoid pitfalls that might hurt your final project.

Obviously, at times, further knowledge or proficiency is necessary. For example, we can tell you about a Steadicam rig, but you will need to practice using a rig or test your motion needs with an operator in order for it to function correctly. We can highlight various editing workflows, but when you get your footage, you will need to have a working knowledge of editing in order to edit it.

This book is for anyone who wants to shoot a DSLR project whether it be a feature film, a wedding, or any other production. This book does not cover film theory, ways to break into Hollywood, or how to start your own wedding videography business. What we do cover are ways you can best use DSLR cameras, lenses, and other accessories to help you create a professional-looking project.

Who Should Read This Book

As the title implies, this book is intended for people who own or want to shoot video with DSLR cameras. However, we strive as much as possible to make most of the information as camera platform neutral as we can. Much of this book can be used regardless of the camera

platform you end up shooting with. However, people who want to shoot with DLSR video probably fall into two basic groups:

- Independent filmmakers trying to get the "film" look on an affordable budget
- Photographers who are looking to start shooting DSLR video but have never worked in the video world or the motion-picture film world

We are making certain assumptions regarding the reader here:

- You are familiar with using a video, film, or still camera.
- You are interested in diving deeper than the factory settings on the camera to achieve a certain look for your video.
- You have a rudimentary understanding of movies and the visual language of movies.

For the purposes of this book, an independent filmmaker is not only a filmmaker as in Hollywood movies but also a videographer who creates or wants to film documentaries, music videos, weddings, commercials, or corporate videos. As for still photographers, we assume many will have little to no knowledge of video, editing, and the effects that motion will have on the lens choice in the final image. If you are a photographer with more exposure in this arena, then you are ahead of the game, but there is still plenty of practical advice, tips, and tricks you can benefit from before you head out on your shoot. If you are an aspiring filmmaker, then you will find out what you need to successfully prepare and shoot, as well as what problems to watch out for before you start your next film.

With *The DSLR Filmmaker's Handbook*, we aim to provide a clear overview and pitfalls of the DSLR video workflow. We will touch on various camera types, lenses, and more, but on the whole there are practical advice and tips regardless of what camera and/or equipment you use. We hope this encourages people to dive in and test the DSLR video capabilities and not be discouraged with any limitations of the technology. Use the new technology as a challenge to create the very best video possible, and feel free to learn from our mistakes and successes.

As with any technology, DSLR cameras will continue to evolve and change. You can contact me directly with your questions via Twitter or my website at www.MophoRentals.com. Additionally, I am a guest blogger on my friend Mitch Aunger's website at www.Planet5D.com. Make sure to stop by to keep up to date on any new cameras, equipment, or workflows that evolve after the printing of this book.

What Is Covered in This Book

Here is a glance at what is in each chapter:

Chapter 1, "Fundamentals of DSLR Filmmaking," is key. Whether you are a person familiar shooting with standard video cameras, a still photographer, or a filmmaker, there will be overlap in equipment and vernacular. However, there are some unique processes, gear, and workflows that apply specifically to shooting video on DSLR cameras.

Chapter 2, "Gear and Recommendations," helps you decide what camera is the best fit for you, tells what gear is available to help shoot your next film, and offers our recommendations for what you should use for your next project.

Chapter 3, "Testing and Custom Settings," helps you control the look of the image, which is a first-order goal of the filmmaker. Accurate color, the ability to create a "look," and the proper way to set up the cameras are all part of the DSLR workflow.

Chapter 4, "Cameras and Lenses on Location," covers cameras and lenses since the DSLR platform has exponentially expanded the number of available cameras, lenses, and formats that a filmmaker can work with. It is now more important than ever to understand the tools and be aware of the available choices and the reasons to choose your camera and lenses.

Chapter 5, "Camera Motion and Support," covers not just equipment but also a method for adding movement and motion to your shots. See what type of equipment is available, explore best practices for creating the motion, and learn how to plan for the equipment you will need in order to get the shot you want.

Chapter 6, "Lighting on Location," covers lighting, from available natural light to full-on professional lights and lighting setups. Check out best practices and things that will help you achieve a better image.

Chapter 7, "Sound on Location," provides suggestions for working with DSLR cameras, which is totally different from working with traditional video cameras. DSLR cameras should be treated much more like film cameras, where the best option is to record audio on a separate device for maximum quality.

Chapter 8, "Organizing and Storing Data in the Field," covers how to handle your data. With a little forethought and planning, you will save tons of time and headaches later in post-production. Don't skip what might seem like a boring chapter.

Chapter 9, "Troubleshooting," helps you be aware of the common issues when shooting DSLR video and that there are problems and limitations (but nothing that you can't work around). Knowledge is power in this sense, and the more you know, the easier it will be to craft the way you shoot your film so you can be successful.

Chapter 10, "Converting and Editing Your Footage," shows you how (and when) you need to convert your original footage, best practices for backing up your footage, and how to get organized for the edit. If you are unfamiliar with editing, this will get you started (but is not a comprehensive how-to on editing).

Chapter 11, "Audio Crash Course," covers everything from syncing audio and video all the way to how to ADR lines that you didn't get or didn't turn out in post.

Chapter 12, "Color Correction and Grading," covers not just the look of the movie but also correcting color problems and creating a seamless image that is technically satisfactory and ready for you to show to an audience.

Chapter 13, "Compressing Your Film," looks at how you can compress your film so it looks as close as possible to the uncompressed version you edited and so it can be viewed in the best-quality compressed version no matter whether you show it online, on a DVD, or in a theater.

Chapter 14, "Post-Production Looks," covers many common problems that come up during shooting that need to be fixed in post. We look at the top issues both for DSLR video shooters and for video in general.

Chapter 15, "Workshops," covers some tips and tricks for shooting underwater, for shooting in or at a moving vehicle, and for changing your video speed to achieve the cinematic look you want.

How to Contact the Author

I welcome feedback from you about this book or for suggestions about books you'd like to see from me in the future. You can reach me by writing to barry@barryandersson.com. For more information about our equipment rentals, for consulting inquiries, or for questions regarding hiring me for work, please visit www.MophoRentals.com and/or www.barryandersson.com.

Sybex strives to keep you supplied with the latest tools and information you need for your work. Please check the book's web page at www.sybex.com/go/dslrfilmmaker, where we will post updates to the book's content should the need arise.

one

Fundamentals of DSLR Filmmaking

When choosing to shoot with DSLR

cameras, you need to know some of the basics. Whether your background is with a traditional video camera, as a still photographer, or as a filmmaker, you'll see some overlap in equipment and terms you are familiar with. However, some unique processes, gear, and workflows apply specifically to shooting video on DSLR cameras, so don't just skip ahead and assume you know everything.

Features of DSLR Cameras

Until Nikon released the D90 in 2008, buyers had to choose between a digital still camera and a digital video camera. Filmmakers were using film or traditional video cameras for production. When the D90 and, quickly afterward, the Canon 5D Mark II were released, you finally had the ability to shoot digital stills and HD video on the same device. Since then, every major camera manufacturer has added DSLR cameras that can shoot video.

At the time, HD video on a still camera was controversial. A lot of photographers worried that improvements to the still camera would be limited because it seemed all the attention was being placed on the video side of the camera. Independent filmmakers took one look at the early footage and realized the vast potential of this new technology. HD video has been around since the 1990s but was practically available only on traditional video cameras. The design and function of traditional video cameras prevented a lot of the cinematic qualities that traditional film cameras provided.

DSLR cameras allowed filmmakers to easily and inexpensively use interchangeable lenses to craft the look of their film more like traditional filmmaking. These factors, along with an available shallow depth of field and low-light capabilities, were not available on most traditional video cameras. These issues, coupled with the price and quality of the video image, helped supersize the growth of the DSLR market.

As stated previously, since the launch of the Nikon D90 and the Canon 5D Mark II, manufacturers have released an endless string of DSLR cameras that shoot video. The still/HD video hybrid has become the norm for capturing video. You can now just compare models and find the right functions and price point for your project and start shooting.

Sensor Size

If you are not a photographer and not accustomed to dealing with sensor sizes, let's put it in motion-picture film terms. Sensor size is a bit like choosing whether to shoot on 8 mm, 16 mm, Super 16 mm, 35 mm, Super 35 mm, or 70 mm film. Just as you would with motion-picture film stock, you choose your sensor size based on your budget, the depth of field, and the aesthetic look for your film. In general, the bigger the sensor, the more expensive the camera (just like 35 mm or 70 mm film); the smaller the sensor, the cheaper the camera. This is a generalization, because some higher-end cameras have smaller than full-frame sensors.

A *full-frame sensor* is approximately the same size as a single frame of 35 mm film from a traditional still film camera (Figure 1.1).

Any *non*-full-frame sensor is referred to as a *crop sensor* (Figure 1.2). These sensors vary in size but are smaller than a single frame of 35 mm film from a traditional still film camera.

Figure 1.1: A full-frame sensor and 35 mm still film are the same size; the sensor area is 36×24 mm, or 864 mm².

Figure 1.2: A crop sensor is smaller than 35 mm film. The Canon APS-C sensor area is 22.2×14.8 mm, or 329 mm².

The sensor size affects the "grain" in your image, the light sensitivity, and the depth of field aesthetic for that camera. At the time of this writing, there are two dominant sensor sizes: full-frame sensors and APS-C crop sensors.

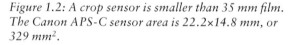

APS-C is currently in all non-full-frame Nikon cameras and the Canon 7D Mark II, EOS 70D, and Rebel T5i. To make things slightly more confusing, there is a slight difference between the Canon APS-C and Nikon APS-C sensors (Figure 1.3): specifically, the Nikon APS-C sensor (22.2×14.8 mm, or 329 mm²) is slightly larger than the Canon version (~23.6×15.7 mm, or about 370 mm²).

Figure 1.3: Nikon APS-C (left) vs. Canon APS-C sensor (right). The Nikon sensor is also used by Pentax and Sony. Notice that the Canon APS-C sensor is slightly smaller than the Nikon APS-C sensor.

If you are using a crop sensor, be aware of how this affects your lenses. When you're shooting with lenses from traditional 35 mm film cameras, the field of view will not match up with the given focal length on the lens. This is due to the fact that the sensor is smaller than the area the lens would normally be filling when shooting with 35mm film or a full-frame sensor camera.

Some people say that the focal length will be changed when used on a crop-sensor camera, but that is not accurate. Standard still lenses were designed so that the field of view would cover the full frame of the 35 mm film (Figure 1.4). A crop sensor is smaller than a standard 35 mm film frame, and when a standard lens is used, the field of view is greater than what is captured on the sensor (Figure 1.5). This creates a magnification effect. For example, your 50 mm lens will have a narrower field of view. This does not in any way change the actual focal length of the lens, just how much of the area of view is captured (Figure 1.6).

Figure 1.4: Field of view comparison between full-frame sensor (blue) and crop sensor (red)

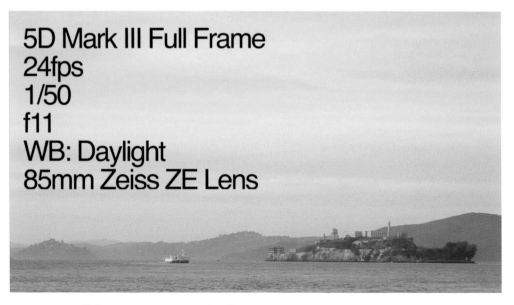

Figure 1.5: Full-frame sensor captured with an 85 mm Zeiss lens

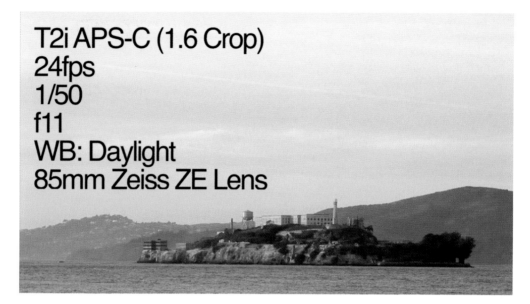

T2i APS-C (1.6 Crop)
24fps
1/50
f11
WB: Daylight
85mm Zeiss ZE Lens

Figure 1.6: APS-C sensor in the same camera position with the same lens. Notice the magnification effect as compared to the full-frame image in the previous figure.

The various sizes of crop sensors have their own multiplication factor specific to that size of sensor; these are referred to as either the *crop factor* or the *focal length multiplier*. Specific crop factors range between 1.3 and 2 depending on the size of the sensor. The way the crop factor is determined is a simple division of the size of the sensor by a full frame. For example, a full-frame sensor is 36×24 mm, and a Canon APS-C sensor is 22.3×14.9 mm. Dividing 36 by 22.3, we get 1.614, which we round to 1.6. If you are using a standard 24 mm wide-angle lens on a 1.6 crop sensor, your field of view is more like what you get with a 38 mm lens than with a 24 mm lens. This can hurt you if you are shooting in a really tight location, because you may not be able to achieve a wide enough angle.

The APS-C crop sensor is almost identical in size to the standard 35 mm film that Hollywood uses. So, don't get worried if you have a crop-sensor camera. Before you decide which camera you should buy, look at some footage from the cameras you are looking to shoot with and choose the one that best aesthetically matches the movie you want to make. Decide the speed of film (ISO on your camera) and the grain tolerance (sensor size), and choose as you would between standard film stock, Kodak Vision stock, and so on.

Full-frame sensors are, for a variety of reasons, the most desirable, and the Canon 5D Mark III and the Sony A7s are the two leading cameras in the DSLR space with full-frame sensors. The great part of the full-frame sensor is that traditional 35 mm film lenses retain their true focal length. If you have your trusty 35 mm or 50 mm lens (or any lens, for that matter), then there is no learning curve for what image you will get. It will look the same as when shooting still images.

A good thing to note when comparing a full-frame digital sensor to 35 mm still or motion-picture film is that a full-frame digital sensor is in fact *larger* than 35 mm film. In reality, a full-frame sensor is almost equivalent to a VistaVision frame (Figure 1.7).

Figure 1.7: VistaVision film frame (left) vs. 35 mm film frame (right)

VistaVision

VistaVision was created in 1954 at Paramount Pictures; 35 mm motion film stock is 24×36 mm, whereas the full-frame digital sensor is 36×24 mm.

In VistaVision, instead of recording an image horizontally from edge to edge of 35 mm motion-picture film, the image is recorded vertically, allowing a much larger area of the film stock to be used for each frame. The main benefit is a much higher-resolution image and the possibility of a much greater depth of field.

Because of the lack of speed of the film stock circa 1954, usually productions blasted the scenes with light to create a large depth of field and usually didn't take advantage of the ability to have a narrow or shallow depth of field. Thus, if you watch VistaVision movies like Alfred Hitchcock's *North by Northwest*, you won't see a shallow depth of field because they lit everything with mega Hollywood lights. Because DSLR cameras are so sensitive, now for the first time filmmakers are able to shoot at narrow depths of field previously not seen on a mass scale.

Table 1.1 lists the dimensions of the most common DSLR sensors; Figure 1.8 compares those dimensions visually. Figure 1.9 compares various physical film sizes.

Table 1.1: Sensor dimensions

Sensor	Dimensions	Area
35 mm full frame	36×24 mm	864 mm^2
APS-H: Canon	28.7×19 mm	~545 mm^2
APS-C: Nikon DS, Pentax, Sony	~23.6×15.7 mm	~370 mm^2
APS-C: Canon	22.2×14.8 mm	329 mm^2
Foveon (Sigma)	20.7×13.8 mm	286 mm^2
Four-Thirds system	17.3×13 mm	225 mm^2

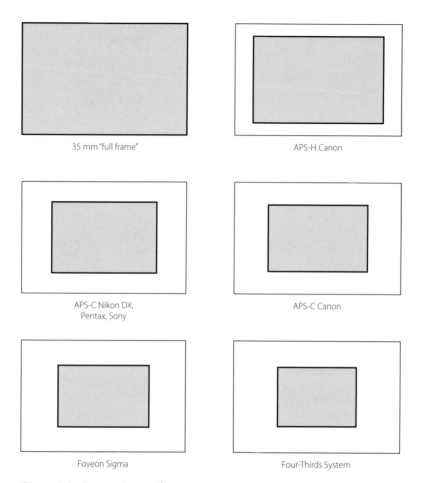

Figure 1.8: Comparisons of sensor size

The major benefits of using a camera with a full-frame sensor are that it is more light-sensitive, creates less noise in your image, and offers the ability for a narrow depth of field.

More Light Sensitivity The reason that a camera with a full-frame sensor has more light sensitivity is simple—there's more space for light to hit the sensor and bigger pixels collect more light (photons). The full-frame sensor has more than double the area of the APS-C crop sensor. The bigger (fatter) pixels catch more of the light than the smaller sensors.

Less Noise By having the larger pixels to catch the light, the camera doesn't have to amplify them in order to match the same ISO from a smaller sensor. Think of it as blowing up your image. The larger the image you begin with, the less noise in your final print. The larger the sensor you start with, the less noise in your final footage.

Depth of Field Most filmmakers were never happy with the look of video. When HD came into existence, it was touted for its clear and sharp image. Many filmmakers didn't like the look because it didn't look cinematic. That all changed with the release of the first DSLR cameras. The ability to have a shallow depth of field and the more natural color rendering of flesh tones made HD video desirable to many filmmakers who previously disliked the look of HD video.

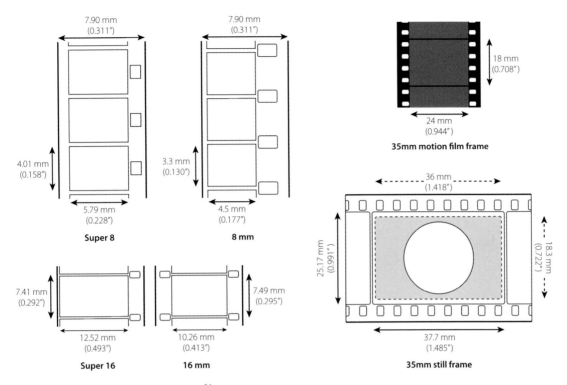

Figure 1.9: Various motion-picture film sizes

Depth of field is what we unconsciously think of when we want something to look cinematic. Look at your favorite movies to see how much you see of the background in any given shot. You will see that many scenes have a shallow depth of field where the background is more or less out of focus. With a traditional home video camera, you always have a deep depth of field, and when you view your footage, you will find that most things are in focus almost as far back as you can see. This is because sensors in home camcorders are small and the lenses are not fast so they have a bigger aperture than a DSLR camera.

The larger the sensor, the more shallow the possible depth of field; the smaller the sensor, the deeper the depth of field will be. Also, shooting at lower f-stops will cause a shallow depth of field vs. a higher f-stop on any sensor size.

With DSLR cameras, you can now create films just like Hollywood does. As a matter of fact, DSLR cameras have now been used to shoot major Hollywood film theatrical releases, many leading TV shows, and even many images you see when watching sports. You can choose a lens and paint with light just as filmmakers have since the dawn of the movie industry. And that is why shooting on a DSLR camera is revolutionary. We are making movies that look just those we have been watching for as long as the medium has existed.

Frame Rates

Current DSLR cameras offer a range of frame rates depending on which camera you buy or rent. Let's talk for a moment about the standard frame rates in both film and video production. We call these *frames per second* (fps). These are the most common, or standard, frame rates:

24 fps is the standard rate at which motion-picture film gets run through the camera. So, any movie that is shot on film that you see in the movie theater was shot at 24 fps and is the holy grail of the "film feel" of your footage.

25 fps is the standard in most of the world (outside the United States and Japan) for video broadcast. This is close to the "film look" and was widely sought after in video cameras in the United States for filmmakers looking to get away from the 30 fps look of U.S. video cameras.

29.97 fps is the standard for broadcast in the United States. Most people refer to this as 30 fps, but there is a huge difference between 30 fps and 29.97 fps when it comes to broadcasting or viewing your footage in traditional formats (that is, TV, DVD, VHS, and so on).

30 fps is the standard more or less for web video. On the Web, there are no rules for frame rate. The Canon 5D Mark II originally was able to shoot only 30 fps and was limited to web-only video or complicated transcoding that doesn't always work without problems.

Slow motion would be any frame rate greater than 30 fps. The two most common frame rates on DSLR cameras are 50 fps and 60 fps. This means you are recording double the number of frames as you would at 25 fps or 30 fps, and you can (in post) play these shots back at half speed smoothly, giving you slow motion.

fps and *p* vs. *i*

Many times *fps* is not listed next to your frame rate. Instead, you will see the frame rate of 24, 30, and so on, and either the letter *i* or the letter *p* will follow it. For example, if you want to shoot at 24 fps, you can select 24p, which stands for "24 frames per second progressive."

When you see 60p vs. 60i, the *p* stands for "progressive," and *i* stands for "interlaced." Interlaced video records every other line, whereas progressive records a full-frame image. For example, 60p means you are recording 60 full-frame images each second, whereas 60i means you record half an image each second, so you end with a total of 30 full frames.

You might hear a few other terms related to frame rates. For example, NTSC stands for "National Television System Committee" and is the analog television system used in North America, South America, South Korea, Taiwan, Japan, Burma, the Philippines, and some other Pacific islands. NTSC has been the standard for more than 50 years in broadcast media in the United States and represents a 4:3 aspect ratio (think of the standard TV image, that is, non-wide-screen models) and a frame rate of 30 fps (also 29.97 fps). Both 30 fps and 29.97 fps are referred to when talking about NTSC. Although 30 fps was the initial standard for NTSC in 1941, in 1953 with the introduction of color television, the committee required a slight reduction in frame rate down to 29.97 fps. This reduction was needed because of visible interference with the chrominance signal and the sound signals over the airwaves. (In June 2009, the United States transitioned from analog to digital

transmissions, and the new standard is called ATSC, which includes the digital formats 16:9 and 1920×1200 resolutions.)

ISO Settings

What is ISO? ISO represents how sensitive the image sensor is to the amount of light available. The higher your ISO, the more sensitive the image sensor is, thus increasing your ability to get shots in low-light situations. By raising your ISO rating to shoot with less light, you will be adding more noise or video grain into your image. Just note that often when you change one setting you are not changing just one thing—likely you are affecting something else by your choice. This is why it is critical to know all the basics and how they all interact so you can make sure you understand and predict what the end result will look like in the video image.

ISO is mostly an issue when you are shooting in low-light situations. If you are outside on a bright, sunny day or if you light your scene, you will be able to stay with a lower ISO. Think of ISO as a tool to help you capture an image if you aren't in ideal conditions or if you don't have enough lights to illuminate the scene.

Which ISO settings are available will differ from camera to camera.

If you have a still-film background, you may be more familiar with this being referred to as the ASA rating. ISO is the digital-photo equivalent of a film stock ASA rating.

As the famous quote states, "You can't have your cake and eat it too." There is a trade-off to high ISO settings: *noise*. When you boost your sensor's sensitivity by selecting a higher ISO, you are enabling the camera to record a fainter light signal. By enabling the camera to record a fainter light signal, you, at the same time, are allowing the camera to record the fainter noise signal. Noise is defined as any signal that is not attributed to the light from the subject you are shooting. Noise appears as colored pixels usually most visible in the shadows and dark areas of your footage.

The sensor in your camera is an analog device and as such will create some noise itself in capturing your footage. This, coupled with the increased ability of the sensor to capture the light signal and noise signal, creates the visible noise in your captured footage. If you ever shoot high ASA film stock, then you have *grain* instead of noise; in general, film grain is acceptable, whereas digital noise is considered bad.

Your sensor size and camera manufacturer determine the range of ISO settings available on any given camera without being affected by noise (at least noticeable noise). The *signal-to-noise ratio* (or the S/N ratio) is the amount of light (signal) captured in relation to the amount of noise captured. This is why, in general, the larger the sensor, the less noise present in your footage. The reason for this is the number of pixels and their density on the actual sensor. Look at various camera models, and you will see that the manufacturer has placed a rating of 8 megapixels (MP), 10 megapixels, 12.1 megapixels, and so on for the sensor of those cameras (a megapixel is 1 million pixels).

This can be a bit deceiving, though, because it's possible for two cameras—one that has a crop sensor and the other a full-frame sensor—to have the same megapixel count. In this case, the manufacturer has crammed the same number of pixels on the smaller sensor as on the larger sensors. This causes the pixels to be much closer together and affects how much signal (light) can be captured through each pixel. For instance, consider an 18 MP

Canon 7D (Canon APS-C sensor) and a 16 MP Canon 1D Mark IV APS-H. You might think that because the 7D has more megapixels, it would yield a better image. Actually, the 1D Mark IV, with only a 16 MP count, will yield a better (less noisy) image because the pixels are less densely packed on the larger sensor.

So, you cannot look just at the megapixel count; you also need to look at the sensor size and the density of the pixels in the camera you want to use. The best possible situation is a full-frame sensor with a high megapixel count. If you are looking at cameras that share the same sensor size but have different megapixel counts, you may want to rent both cameras and shoot some footage to test the noise signals and see which one gives you the better image for your project.

Features of SLR Lenses

The lens is the "eye" of your camera; what is captured in the lens is what will end up on the screen. Shooting with a DSLR opens up the world for most videographers who were limited by a single lens or complicated adaptations, and filmmakers are curious to see how a familiar lens interacts with the new system.

Because the choice of lens is the single most important decision you will have to make for every single shot, it is important to start with the relevant basics. Here we will talk about the lens choices and how they affect your final footage.

Aperture, f-stops, and t-stops

Aperture (the measure of the space that light passes through in the lens) is measured in f-stops. An *f-stop* is a ratio or fraction, so smaller numbers mean more light. Often lenses are considered fast or slow: a lens with a low-numbered minimum f-stop is considered a fast lens because it allows in more light (or, put another way, you can use a faster shutter speed). A lens with a large minimum f-stop number is considered a slow lens.

The sequence of f-stops follows an unusual pattern; this is a typical sequence:

f/1.0, f/1.4, f/2, f/2.8, f/4, f/5.6, f/8, f/11, f/16, f/22, f/32, f/45, f/64

Each stop represents a change of half the size greater or lesser than the adjacent aperture; so, f/2.8 lets in twice as much light as f/4.

The reason for these apparently strange numbers is that the aperture opening is essentially a circle, so each successive f-stop is calculated by dividing by the square root of 2.

There are also half-stop and third-stop calculations, which allow for even greater control of the amount of light passing through the aperture opening and the exposure. If you see other numbers between the standard full stops, these represent half or third stops.

An f-stop is a geometric calculation between focal length and aperture, but light can be lost within the lens or optics. This loss will usually be more apparent with zoom lenses or when shooting with multiple lenses. The determination of a *t-stop* is used to handle this loss of light within a camera system. A t-stop is a "true" stop or "transmission" stop and measures exactly how much light is making it through the lens to the sensor. A t-stop is a simple measurement of actual light and deals only with exposure, not depth of field. In general, t-stops will not be an issue, but certain lenses are calibrated in both f-stops and t-stops.

Cine-Style Lenses vs. Photo Lenses

Cine lenses were lenses originally designed with the goal of the recorded image being projected in a theater. A good cine lens is designed to be incredibly sharp and has amazing glass that transmits light nearly flawlessly with high resolution and often low contrast. Cine lenses were also designed to fit a 35 mm movie film print, so if these lenses are used on a DLSR camera (Figure 1.10)—where the sensor is larger than 35 mm motion-picture film—vignetting will occur. Also, cine lenses may be marked with t-stops instead of f-stops.

One of the main differences of cine lenses from traditional still photography lenses is that cine lenses are matched sets optically: they have matching t-stops, barrel size, focal length, and back focus throughout the set of lenses. This means there is no change from lens to lens when switching from one cine prime lens to the next. Still lenses are not always matched, and the f-stops, barrel sizes, focal lengths, and so on can change from lens to lens. Another feature of a cine lens is properly calibrated marks for distance, and on cine lenses there are usually more than on a still lens.

A cine lens is designed with focus in mind and has focus gearing. The lens has a wider and smoother range of movement from one focus point to another than a still lens. This increased turning distance is necessary for various focus changes within a shot. A cine lens is designed so that it can be manipulated by a second person and can be done with extreme accuracy because focus is even more crucial when the image is going to be projected in a theater.

A cine lens also has internal focus. As you obtain focus, the lens front does not move forward because cine lenses utilize internal focusing. Cine lenses do not "breathe" much, or at all, as you focus.

Figure 1.10: A cinema-style lens on a DSLR camera

"Breathing" Lenses

This phenomenon happens in some lenses (both prime and zoom lenses): when you focus the image, it temporarily appears to expand and reduce. If you are doing a rack focus from a foreground image to an image in the background and you have a lens that breathes, you will not get a smooth rack focus from the foreground to the background. The only way to find out whether your lens breathes is to do a rack focus and see if it does it.

Some cine lenses may still have slight breathing problems, and some photo lenses won't breathe. Testing is always critical because breathing is more apparent when the image is projected.

Cine lenses also do not have "hard clicks" and have a step-less aperture for f-stops. This feature means that you can set the f-stop exactly at the level where it needs to be with no need to move to the next level in order to get close.

"Hard Click" for f-stop

Most still-camera lenses have spring-type mechanisms that click as the aperture setting of the lens is turned. The click indicates that the next f-stop setting or step has been reached, and the f-stops are generally accurately set. Importantly for moviemakers, this also means that only the preset f-stops can be used.

In Chapter 4, "Cameras and Lenses on Location," we'll tell you how to "de-click" a lens.

Figure 1.11: Zeiss CP.2 lenses are modified still lenses that are housed in a cinema-style body that allows for measurements on both sides of the lens and a longer focus throw for better focus pulling.

Lenses can be put into cine-style casings (Figure 1.11), or you can get a cine-style lens that is easier to use when shooting video. A real cine lens is more expensive than a comparable still lens. Cine lenses are also quite heavy and can feel cumbersome to use, especially if used with added matte boxes or other accessories.

Photo or still lenses are and should be used for DSLR video because they give you great results. The advent of high-quality DSLR cameras and options for the filmmaker has opened the floodgates on lenses that can be used. Traditional still lenses are now being used to shoot movies. There are some noteworthy differences between a cine-style lens and a still lens.

In general, the focus and zoom on photo lenses are designed for quick adjustments for stills. The movement is not going to be incorporated into the shot either with a zoom or with a focus change, so the focus and zoom on a still camera can sometimes be too sensitive for easy motion on video. This means the focus on a still lens may change drastically by moving the focus ring only a small amount. This small amount of movement can make pulling focus and smooth zooming difficult but not impossible. Some photo lenses also have the focus, zoom, and aperture ring set in the opposite direction of a cine lens and so shifting between lenses forces you to shift more gear around or mentally take note of the shift. Some still lenses rely on the camera settings to make aperture changes, which limits the aperture range that can used for the shot. So just like with cameras you need to use trial and error to find the exact lens or lenses you want to use for the long run.

"Hard Stop" for Focus

A *hard stop* occurs when the lens will not spin any further. Cinema lenses or high-quality still lenses like Zeiss ZE or ZF lenses will not spin around forever. They have a hard stop at infinity and the other end of their focus ring. This provides the ability to accurately predict your lens when pulling focus.

Types of Lenses

Most films are shot using a combination of lenses. The combination of lenses you choose will depend on a number of factors. These include availability, desired look and effect, budget, and location parameters. Some combination of primes and zooms will be used on most DSLR shoots.

Prime Lenses

Prime lenses are lenses with a fixed focal length; this means each lens has a single angle of view. It is this angle of view that categorizes what type of prime lens it is.

You will often hear the phrase "a set of primes," and that just means a multitude of prime lenses. There is no standardized set of prime lenses; rather, a set of primes is a

collection of lenses of various highly used and versatile focal lengths (Figure 1.12). The goal in choosing a set of primes is to allow for desired shots in a variety of locations and situations.

If you have no prime lenses and you want to start with three lenses, it would behoove you to grab a wide-angle lens, a "normal" lens, and a portrait or telephoto lens. This gives you a range to work with. With this said, you should move your focal lengths farther away from each other. For instance, don't buy a 35 mm for your wide, a 50 mm for your normal, and an 85 mm for your portrait lens. These focal lengths are so close together you don't get much variety. You would be better off with something like a 24 mm for your wide, a 50 mm for your normal, and a 100 or 135 for your portrait/telephoto lens. Again, these are guidelines and not hard and fast focal lengths you should buy. Some of what you need is dependent on what you are shooting.

Zoom Lenses

Zoom lenses (Figure 1.13) are lenses that have a range of focal lengths and angles of view available in a single lens. The zoom range refers to these lengths; for example, an 18–70 mm lens will cover the focal lengths between 18 mm and 70 mm. Zoom lenses are named based on the ratio of their longest to shortest focal lengths or their magnification factor.

Figure 1.12: A set of Leica R prime lenses

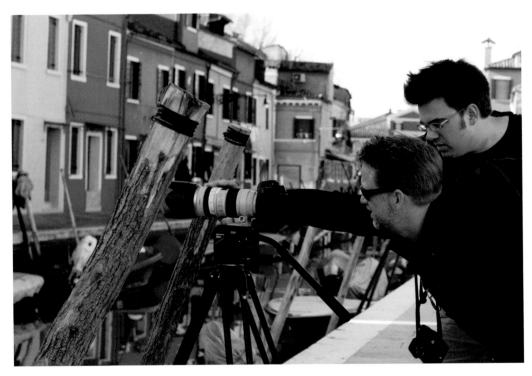

Figure 1.13: Canon 70-200 2.8 IS zoom lens on the set of The Shamus in Burano, Italy

The other major factor on a zoom lens is aperture and whether the lens has a variable aperture or a fixed aperture. A variable-aperture lens means that the f-stop will change depending on the focal length the lens is set at or zoomed to. If you have a lens that is a 28–135 mm f/3.5–5.6, the range of f-stops indicates that it is a variable-aperture lens: at 28 mm wide, the f-stop can be 3.5, but when the lens is zoomed to 135 mm, it can be opened up only to f/5.6.

A fixed-aperture lens allows you to set the aperture or shoot at the lowest f-stop the lens will allow at any focal length.

One drawback of zoom lenses is that they can be large and heavy. If size and weight are of the utmost importance to you, then you might want to not use or at least minimize the use of zoom lenses on your shoot.

Categorizing Lenses Based on Angle of View

Lenses are often broken down into categories based on the focal length's interaction with the angle of view. The angle of view, or field of view, is determined by the focal length and the dimension of the image format, which in a 35 mm film shoot is the size of a frame; for a DSLR, this correlates with the sensor size.

Extreme wide-angle lenses are typically in the 8 mm to 16 mm range.
Wide-angle lenses are typically in the 16 mm to 35 mm range.
Normal lenses are typically in the 35 mm to 80 mm range.
Telephoto lenses are typically in the 80 mm to 200 mm range.
Super telephoto lenses are typically in the 200 mm to 800 mm range.

Specialty Lenses

Specialty lenses are increasingly being used in DSLR productions. Often they were limited to big-budget feature films that had the luxury of time and budget to include elaborate shots. Now DSLR filmmakers can easily rent, buy, or borrow these lenses to achieve unique looks in their productions.

Macro Lenses These are lenses designed for close focusing and for getting close to the subjects they are recording. They are typically used for small items or items where tiny details are crucial. The depth of field is limited, which allows the subject that is the focus of the shot to be prominent.

Fish-Eye Lenses These are ultra-wide-angle lenses that result in an extremely wide hemispherical image. They are deliberately distorted and have a view up to 180 degrees.

Tilt/Shift Lenses These are distinctive because they move side to side (laterally) and up and down (vertically) while allowing for a coherent image to be captured with the sensor.

The Tilt

With a normal lens, the sensor plane and the plane of focus are parallel to each other (Figure 1.14).

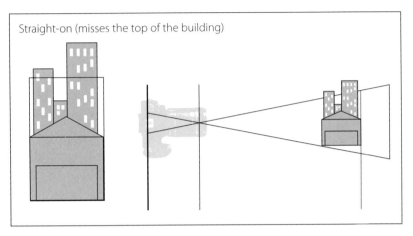

Straight-on (misses the top of the building)

Figure 1.14: Angle of standard lens to a building that cannot fit entirely in the frame

Tilting the lens and moving it to the side allows the plane of focus to be at an angle to the camera instead of perpendicular to it. This means you can change the plane of focus in relation to the sensor and you can have more control of what is in focus in a given shot (Figure 1.15).

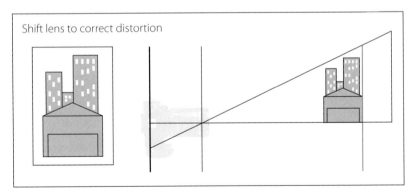

Shift lens to correct distortion

Figure 1.15: The angle of a tilted lens to the same building; notice how the entire building is in the frame with the lens correction.

The Shift

By shifting, or moving laterally, the lens, you have control of the relationship between the image plane and the subject plane. Shift lenses allow you to move the centerline without

moving the camera or changing the angle of the camera or perspective of the image (Figure 1.16).

The lens elements are still parallel to the sensor/film, but they are no longer directly in front of the sensor/film (Figure 1.17).

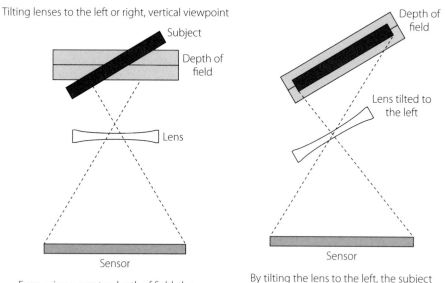

Tilting lenses to the left or right, vertical viewpoint

Subject

Depth of field

Lens

Sensor

Even using a greater depth of field, the subject cannot be brought into focus even when the lens is stopped down.

Depth of field

Lens tilted to the left

Sensor

By tilting the lens to the left, the subject can be brought into focus without stopping down at all.

Figure 1.16: The plane in relation to the camera and the shifted lens

Figure 1.17: The lens is to the side of the center of the camera.

In addition to allowing for special-effect shots such as miniaturization, tilt shift lenses have a utilitarian purpose. Tilt movements allow you to obtain a wide depth of field even at the maximum aperture and still keep the entire subject in focus. Shift movements correct the trapezoidal effect seen in pictures taken of tall objects so as not to distort the subject. This can be helpful when using your DSLR camera in low-light situations.

Lensbaby, Subjectiv, and Loreo Lenses

These kinds of lenses are used for various special effects. The effects include pinhole, multi-element anachromatic, some unique tilt functions, and selective focus. These special-effect lenses are used for shots where a distinctive look is the goal, and they have specialized components and construction.

Anamorphic Lenses

Anamorphic lenses are often used with DSLR filmmaking to achieve unique lens flare and bokeh. An anamorphic lens is designed to "squeeze" a widescreen image onto the sensor and must be "unsqueezed" in post to be viewed correctly. When you use an anamorphic lens, your horizontal image will be up to two times wider than a standard 16×9 frame so you will have letterboxing on the top and bottom of your image. This process creates an interesting look and effect on the footage.

How Sensor Size and Lenses Interact

One of the major options for DSLR cameras is sensor size, and one of the factors to take note of is how sensor size affects lens choice or usage. Here we will split the sensors into two rough categories: full-frame sensors and crop sensors. The format—that is, the sensor—changes either in relation to 35 mm or because various cameras have different size sensors. The sensor size affects how a lens will work with that particular format, so lenses that you are accustomed to working with in a different format may behave differently than you think. The change can be compared to moving from a standard 35 mm still camera to a medium-format camera or moving from 35 mm film to 16 mm but still using the same lenses on each camera body.

Film movie cameras have always had lenses designed specifically for their format, but with DSLRs, the lenses can be used on different formats and in many cases interchangeably. Additionally, a 35 mm movie frame is a different size than the DSLR formats, most dramatically with a full-frame sensor camera, so the lenses may not behave as you envision. When comparing the size of a DSLR sensor to 35 mm, most people mean in the context of the 35 mm being the size of a 35 mm film frame taken with a still camera, not a movie camera, because that is where most of the lenses for these cameras originated; ultimately, the cameras are both still cameras and video cameras. The great news is that camera manufacturers are meeting the demand for lenses, and lenses are manufactured with sensor size/format type in mind.

Canon makes an EF-S series of lenses specifically for the APS-C sensor size. EF-S lenses are designed to provide a narrower field of view (sometimes referred to as a *light cone*) to match the smaller sensor, allowing the actual focal length to be achieved on crop-sensor cameras. The main benefit is that wide-angle lenses actually stay wide angle instead of the 1.6× that a regular lens would have. EF-S lenses are a bit more expensive, and you might have a hard time finding used lenses of the EF-S series. Nikon makes a DX lens for its APS-C sensor; however, they make only a limited number and are mostly consumer zoom lenses.

Focal Length Multiplication Factors

In an effort to figure out how the different lenses work with different size sensors, you can look to *focal length multiplication factors*. The focal length multiplier (FLM), or sometimes *format factor*, is stated as a ratio between the size of the sensor and the size of 35 mm still film.

A full-frame sensor is the same size as a 35 mm film still, so its FLM is 1. A larger FLM indicates a smaller sensor and vice versa. Table 1.2 shows some of the most common FLMs.

Lenses are designed with a minimum FLM. A full-frame lens is designed for an FLM of 1 but can be used with smaller sensors, such as those with an FLM of 1.5. However, a lens with an FLM of 1.5 cannot be used on a full-frame camera.

Table 1.2: Common focal length multiplication factors

Model	Factor
Nikon DX	1.5 FLM
Canon APS-C	1.6 FLM
Olympus Four-Thirds chip	2 FLM
Panasonic Four-Thirds chip	2 FLM
Canon APS-H	1.3 FLM
Olympus micro 4/3	2.0 FLM
Panasonic micro 4/3	2.0 FLM

Focal Length and Field of View

What do you do with these multiplication factors? You multiply them by the given *focal length* of the lens to determine the *field of view* (see Figure 1.18).

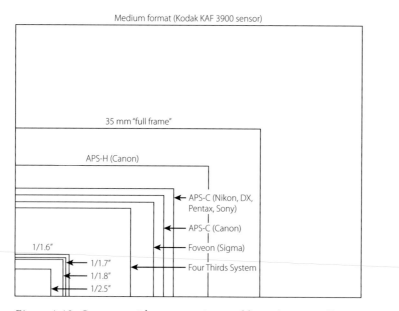
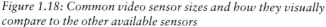

Figure 1.18: Common video sensor sizes and how they visually compare to the other available sensors

Focal length is a measurement of the distance from the lens, specifically a point of the lens called the *nodal point*, to the focal plane when the lens is focused on an object set at infinity. The focal plane is inside the camera at the point where the light rays are brought back into the lens to form a point. Practically speaking, this measurement is gauging the capacity of the lens to bend the light back to a point where it will hit the sensor. This measurement is made inside the lens casing, and lenses are labeled by their focal length measurements (Figure 1.19).

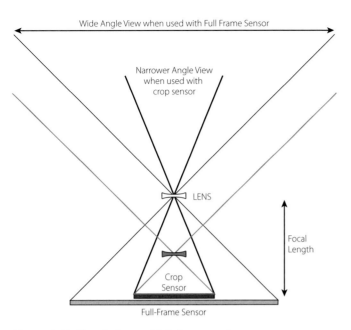

Figure 1.19: Focal plane of full-frame and crop-sensor camera

The focal length is an indicator of the angle of view of the lens and the perspective of the shot. In simple terms, it measures how much the lens can see in a given area or how much of the scene will be in the shot. For a given sensor size, a longer focal length will generally provide a narrower field of view.

For instance, looking through a 50 mm lens on a 1.6 crop-sensor camera yields a field of view that is equivalent to 80 mm on a full-frame body or on 35 mm film (50 × 1.6 = 80). With a 1.6 FLM, in order to achieve the "normal" field of view traditionally seen through a 50 mm lens on a full-frame/35 mm film, you must use a 30 mm lens. Multiply the 1.6 crop factor by the focal length 30 mm, and you get the equivalent 48 mm field of view . . . close enough.

Because of the explosion of digital photography and the popularity of smaller camera sensors, manufacturers have begun to develop lenses that are exclusively designed for specific sensor sizes of digital SLRs. In general, a DSLR with a smaller sensor size can use a lens that was designed for a larger sensor size but not vice versa.

The size of the camera's sensor determines the field of view in the recorded image. Most lenses used on DSLR cameras cast a light circle that is intended to cover a full-frame sensor/35 mm negative. Since crop sensors are actually smaller than a 35 mm negative, the sensor captures a smaller portion of the light circle that is covered by a full-frame sensor. Figure 1.20 is a rough illustration. By capturing a smaller area of light, the field of view that is recorded in the picture has the appearance of having been cropped from the center of a 35 mm photograph.

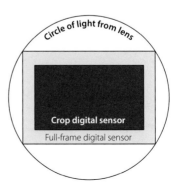

Figure 1.20: Field of view circle with sensor sizes

It is important to note that sensor sizes *do not* change the actual focal length of a lens. A 50 mm lens will always be 50 mm no matter what the sensor size is of the camera being used. A crop sensor simply changes the field of view in an image taken at a given focal length.

Angle of View and Magnification Factor

Angle of view is defined as the angle that fills the frame (of any format) of a still or motion-picture camera. The actual angle of view is determined by the film format (35 mm, 16 mm, full-frame sensor, crop sensor, and so on) in relation to the focal length of the lens (50 mm, 28 mm, 200 mm, and so on), not the focal length on its own.

As previously stated, the size of a DSLR's sensor affects the viewing angle of any given lens. The angle of view is thus magnified on most DSLR cameras since the majority of DSLR cameras use sensors that are smaller than the 35 mm format.

Compare a standard 35 mm film camera equipped with a 35 mm lens to a digital SLR with a sensor size of 22.5×15.0 mm. The DSLR's image sensor is smaller than the full-frame 35 mm camera's film area by a focal length multiplier of 1.6. This means the 35 mm lens translates essentially to a lens of 50 mm (35 mm × 1.6 = 56 mm) when used on this particular DSLR.

The angle of view of a lens is proportional to the sensor size. The smaller the format, the shorter the focal length needs to be for any given angle of view.

The magnification factor affects wide-angle lenses as well; thus, it's challenging for a digital photographer or cinematographer to find a wide-angle lens that is truly a wide angle when dealing with a smaller sensor size. When translated by the multiplier, most wide-angle lenses offer only a standard angle of view. For example, an 18 mm lens would be extremely wide on a full-frame camera but has an effective focal length of 28 mm, or moderate wide angle, on a DSLR.

The term *crop* is commonly used to describe the alteration of angle of view: the imaging area is physically smaller. If you look at the image circle projected by the lens, less of the total area is used. However, crop is more than a simple angle-of-view change.

The image remains the same size at the film plane for a given lens and subject distance; it is not magnified. However, it does take up a larger proportion of the (smaller) frame. It is easy to see why some people refer to it as a magnifying effect.

Small sensor sizes have other big advantages when it comes to telephoto lenses. You can achieve a 300 mm telephoto angle of view, using a camera with a 1.5 FLM, by using a smaller-focal-length lens. You can use a 200 mm telephoto lens and get in effect a 300 mm image. Therefore, you can buy telephoto lenses that are less expensive and lighter weight.

Tele-extenders

You can use a tele-extender to increase the focal length of your lens. To use a tele-extender, you must have a lot of light available because you lose from one stop to two stops of light when using one. By using a crop sensor and lens, you don't lose any stops to achieve the same focal length image.

two

CHAPTER

Gear and Recommendations

Now that you know what makes *one camera different from another, let's dig into what camera is the best fit for you, what gear is available to help shoot your next film, and our recommendations for the equipment you need for your next project.*

What Camera Is Right for You?

Choosing a camera is a bit overwhelming. Several manufacturers make DSLR cameras, and the prices for cameras vary from $700 to $800 all the way north of $5,000 just for the body. Of course, features vary from camera to camera, even from the same manufacturer.

As you begin the decision-making process, it would be beneficial for you to physically handle as many different cameras as you can after you narrow down what cameras might work best for you. It is also beneficial to look at examples of footage produced by a variety of DSLR cameras. Video from DSLR cameras is often referred to in vague terms like "the cinematic look" or the "incredible ability to handle light." These descriptions are compelling, but in the end picking the camera that is able to produce footage that *you* appreciate is the goal, so go look at footage!

As you choose your camera, you'll have other considerations, too, such as the particular parameters that are imperative to a shoot's success. Budget (either the overall budget or the camera-specific budget) for a lens mount that is compatible with lenses you already own. If you are coming from a still photography background, being able to use your available still lenses should not be taken lightly. This may steer you to a camera model that matches your lenses or, if your lenses can be used with an adapter, that frees you to choose any DSLR camera that will accept an adapter with your brand of lenses.

The Canon EOS mount and the Sony E Mount are the two most flexible lens mounts currently available. They allow more adapters and lenses to be mounted to cameras than any others on the market today. Just a few key features will help you focus on what cameras to choose: sensor size, resolution, frame rates, lens mount, and ISO sensitivity. These key features will determine how you pick your camera and help you know exactly how your camera will handle various shooting scenarios.

It is impossible for us to cover every possible use for each camera and recommend just one type of camera. So, the best way to decide is to look at what options you need or want on your camera and find a model with those options that is closest to your budget. Refer to our chart in Chapter 1, "Fundamentals of DSLR Filmmaking," for a list of features available on many of the DSLR cameras.

Decisions in Choosing a Camera

In terms of camera choice, you have a few major decisions to make:

- What sensor size do you want?
- What frame rates do you want to shoot at, and can your camera handle those frame rates?
- What ISO do you need to be able to work with?
- What resolution do you need to shoot? Is 1080p footage OK or do you need 2K or 4K video?
- What lens mount do you want on your camera? This impacts what lenses you can use—either older vintage lenses or new lenses.

Sensor Size

Which sensor is best for you? As we described in Chapter 1, there are about five different major sensor sizes for most DSLR cameras. They range from full-frame sensors all the way down to micro 4/3 sensors. Each different sensor size has pros and cons of working with it. APS-C sensors are close in size to the 35 mm film used in movies and TV shows. A full-frame sensor is more like a VistaVision film frame and has a much shallower depth of field and better light sensitivity (in other words, you need less light and will get a less-noisy image). In general, the smaller the sensor size, the cheaper the camera. If you are on a tight budget, then paying attention to sensor size may lead to a price point that is perfect for you.

Large, full-frame sensors have several benefits. The potential shallow depth of field allows for a varied range of cinematic shots. One key element of cinematic shots is that they feel like shots you would see in a movie theater. In most movies, there is a very directed focus that helps lead your eyes to something in the frame. Out-of-focus areas of a given shot can be part of the deliberate artistic look for a given scene. Cinematic shots are not just shots that have a shallow depth of field, but they also selectively focus on what the filmmaker wants the audience to see in the frame and allowing for greater creativity in the filming process. The large, full-frame sensor allows for beautiful selective-focus shots that have a shallow depth of field in close-ups under low-light conditions. Obviously, the full-frame sensor is not limited to just the shallow depth of field and will allow for wide depth of field in medium and wide shots, but this depth-of-field capability makes it unique in the DSLR video world.

Additionally, large, full-frame sensors often have pixels that are larger than pixels on smaller sensors. A larger sensor size allows for larger pixels, but it still maintains a tight pixel density. Pixels that are tightly spaced can actually increase the noise of an image; however, these larger pixels are better able to gather light and often handle contrast better.

For the most desirable video image, our recommendation is a full-frame sensor. More full-frame sensor cameras are becoming available all the time. A general rule is that the bigger the sensor, the better the image quality overall. Another benefit of full-frame sensors is that you can use standard 35 mm still lenses and there is no crop factor. So, if you have a choice when buying your camera, we recommend that you buy a full-frame sensor.

Still, there are advantages to cameras with smaller sensors in many situations. In general, they are cheaper and sometimes can be adapted to other lenses more easily. Some lenses have a large rear element or an area at the rear of the lens that sticks out a bit; this can run into the mirror on the Canon 5D Mark III but might not hit the mirror on a Canon 70D or Canon T5i due to the smaller sensor size. In addition, some older Nikkor lenses have a metal tab that sticks out and will cause problems on the 5D Mark III if not removed. Do some research if your lens has any elements that look like they may come close to hitting the mirror. Another advantage to smaller sensors, such as the APS-C, is that they are closer in size to a 35 mm motion-film frame. If you want to shoot with cinema film lenses, some old cinema lenses can be inexpensive when compared to cinema lenses designed for a full-frame sensor. Also, if you really want to use standard cinema lenses, you will be dealing with PL mount lenses. To use PL mount lenses on a DSLR camera, you need to convert the camera to have a PL mount (which is not inexpensive). However, a converted PL mount 7D or T5i has major advantages over a converted 5D Mark III. Since PL mount lenses were designed to have a field of view to fill a 35 mm motion-picture film frame, this means the full range of PL lenses will work on a converted 7D or T5i. If you use some of the wider-angle PL mount lenses on a converted 5D Mark III, you will get major vignetting because the lens was not designed to fill a frame that large.

If budget considerations make expensive rigs out of the question for you, the size and weight of the camera are important factors, and the smaller sensor cameras may be a good choice.

Frame Rates

What frame rates do you want to work with? This is somewhat easy to answer. If you plan on shooting a lot of slow motion, only a few DSLR cameras have that option.

You can use software programs to convert your footage into slow motion. We cover this more in Chapter 10, "Converting and Editing Your Footage."

If you are shooting a movie or shooting for television and don't require slow motion, then you can choose from almost any DSLR camera because they now support the major standard frame rates (24, 25, 29.97, and 30 fps).

The golden standard for what is known in the video world as the "film look" is 24 fps, because motion-picture film uses this rate. The look of a movie at the movie theater or on DVD is shaped by the 24 fps frame rate of the image; therefore we perceive 24 fps to be more "cinematic." Most DSLR cameras now natively shoot in 24 fps, so your choice in cameras has grown since they first launched. However, not all cameras have the 24 fps option, so if you want a look that is closest to film, this is something you need to double-check.

If you are doing production in Europe or somewhere that your final output is PAL format, then you must buy a camera that shoots in 25p because frame rate conversion is not reliable; it is a tricky process that involves a lot of planning to effectively do in post.

PAL and NTSC

Phase Alternating Line (PAL) is a system for broadcasting color television in many countries around the world, including most of Europe. All of these countries broadcast video at 25 fps and require final output to be played to be at 25 fps. In contrast, the National Television System Committee (NTSC) format used in North and Central America and parts of South America plays at 30 fps.

Table 2.1 lists what we consider to be the best camera for each frame rate (based *only* on frame rate). All of these recommendations are Canon bodies; note that we make different recommendations later in the chapter when we divide the products by purpose instead of frame rate.

Table 2.1: Best camera at each frame rate

Rate	Uses	Recommendation
24 fps	Same frame rate at which motion-picture films are shot	5D Mark III, 7D Mark II
25 fps	European video standard (PAL)	5D Mark III, 7D Mark II
29.97 fps	U.S. television broadcast standard (NTSC)	5D Mark III, Panasonic GH4
30 fps	More or less a standard for web video	Any
> 30 fps	Slow motion	Sony a7S, 7D Mark II

ISO Settings

Choosing the range of ISOs that you will use on your camera is a bit of trial and error. It is somewhat subjective based on the amount of noise you consider acceptable as well as whether you think the image helps the visual look of your film. When choosing DSLR video, your focus should be on high ISOs, because all DSLR cameras perform well at low ISO ranges. Therefore, if you will not have extreme ISO requirements, then ISO will not be a huge area of consideration in camera choice. However, not all ISOs will provide the same quality image, and some ISOs, especially at the top end, may give a video image that is noisier than desired. At high ISOs, camera models with smaller sensors often do not perform as well as larger-sensor cameras at the same ISO. Some cameras provide extremely high-ISO options designed for exceptionally low-light conditions. The best high-ISO cameras are the Sony a7S, the Nikon D4S, and the Canon 5D Mark III, in that order. In general, if you must shoot in low light or "run-and-gun" conditions most of the time, then looking at how the camera operates at a high ISO will save time and gear expenses in lighting in the long run.

If you buy a camera that does not operate well in high ISOs and you find that you need to use them, many post-production options can help reduce the noise in your footage so you can shoot at a higher ISO and still have little to no noise in your finished film.

Here are some general suggested ISO ranges for shooting video on some of the most common DSLR cameras that will leave you with the least noisy image to use in post:

- Canon 5D Mark III: ISO 100 to 1600
- Canon 7D Mark II: ISO 100 to 800
- Panasonic GH4: Up to ISO 1600
- Nikon D800: Up to ISO 3200
- Canon T5i: Up to ISO 800

For more information, see Chapter 3, "Testing and Custom Settings," for how to test and determine the best ISO settings for your camera. Remember, each person will have a different opinion on how much noise is acceptable, and each project may require more or less noise for the look you are trying to create. There is more room to move to higher ISOs on all these cameras, so these are the ranges that will give you the best image quality with the least amount of noise.

Best Camera For...

Here are our recommendations for the top cameras in various categories:

Best All-Around Camera: Canon 5D Mark III The Canon 5D Mark III (Figure 2.1), in our opinion, is the top camera if you want to shoot a film on a DSLR camera. The full-frame sensor absorbs light in a way that all the other DSLR cameras don't. Having no crop factor when using old or new still lenses is a huge plus, so you can actually find and get wide-angle shots with little to no distortion.

Figure 2.1: Canon 5D Mark III DSLR camera

Best Camera for Low Light: Sony a7S The Sony a7S (Figure 2.2) is a full-frame mirrorless camera that has amazing low-light capabilities. You can shoot this camera up to over 400,000 ISO so it takes the meaning of shooting in the dark to a new level. Sony's S-Log2 allows you great range and the ability to shape your video in post.

Best Micro Four-Thirds/Mirrorless Camera: Panasonic GH4 The Panasonic GH4 (Figure 2.3) is a huge step up from the GH3. It has much better performance in low-light situations than the original. It has audio metering built into the camera but not yet professional-quality audio; still, it's better than the Canon audio options. It comes with a built-in electric viewfinder (EVF), which is a huge help in stabilizing the camera while shooting. Usable ISO range is north of 3200, so it performs well in low-light situations. Add shooting in 4K and this is a great little camera.

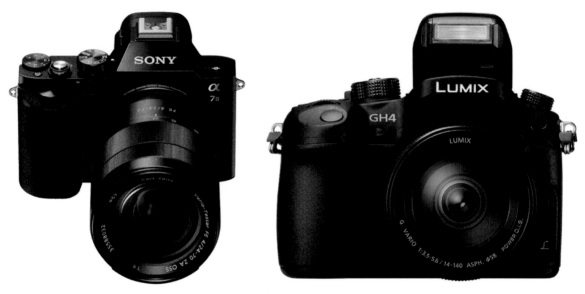

Figure 2.2: Sony a7S camera *Figure 2.3: Panasonic GH4 DSLR camera*

Best Camera for Stills and Video Usage: Canon 7D If you are equally shooting video and taking stills with your camera, then the Canon 7D is probably your best choice for all-around camera. The 5D Mark II comes close, but if you are not primarily shooting video with your camera, then the 7D narrowly wins this category.

Best Camera on a Budget: Canon T3i This camera is the best value for your money if you are on a limited budget. If you can still find the T3i, it will be way cheaper than the T5i. The feature set isn't greatly improved, but anything in the TXi line is a great starter camera.

Best Camera for Firmware Modifications: Canon Cameras with Magic Lantern Almost all Canon DSLR cameras have firmware hacks that provide added functionality. The modifications range from increasing the data rate to adding on-screen audio monitors, adding custom crop marks, and creating video peaking. Do an online search to find out the latest cameras with these hacks, and see whether you are interested in trying the firmware modifications.

Mirrorless Cameras

A DSLR camera that has no mirror between the lens and the sensors is called a *mirrorless camera*. Eliminating the mirror, and in some cases the viewfinder, so you look only at an LCD screen, makes a mirrorless camera much lighter and more compact than a standard DLSR camera. Aside from the lack of a mirror and perhaps a viewfinder, the cameras work in very similar if not identical ways to ones with mirrors.

Manual Controls

One question you must ask yourself when deciding what DSLR camera to use is "What does this camera allow me to control?" DSLR cameras range from no manual controls to full manual controls. The optimal is full manual control. If you are not sure whether your particular camera has full manual controls, do some searching on the Web or get your hands on one and test it. You want to be able to control the following:

- Shutter speed
- F-stop
- Aperture
- ISO
- Frame rate
- Kelvin white balance

Lenses and Accessories

When choosing your camera, you need to decide how to complete your camera package by picking the lenses and accessories to buy or rent. Your camera choice will influence the kind of lenses that you will be using, so the camera and lens decisions should be made concurrently. As you choose your lenses, keep in mind what kind of lens mount you are using and whether your camera will need to be adapted to fit the lens choice.

Trying to pick the best lens or the right lens for a shot is almost impossible. The sheer number of lenses available, the creative reasons for using one lens vs. another, and the subtleties that vary from lens to lens all make choosing a lens almost an endless process with no definitive answer.

50 mm Lens

The most common and widely used camera lens is a 50 mm. This lens is widely described as having the view of the normal human eye. This means that using a 50 mm (Figure 2.4) lens closely mirrors what you see as your field of view on a day-to-day basis. When in doubt, this is a great lens to default to or use if you are limited in the number of lenses you have available. Make sure to have a 50 mm lens in your kit and readily available.

Figure 2.4: Sony A-mount Zeiss 50 mm

Set of Prime Lenses

As mentioned in Chapter 1, a *set of primes* (Figure 2.5) refers to your chosen inventory of fixed focal lengths. If you have three or more prime lenses, you have a set of primes. However, a set of primes is as varied as the number of angles you can shoot from. How do you narrow your choices?

Figure 2.5: Zeiss CP.2 Super Speed lens set

First, choose a lens for any specialty shot or unique look you are trying to create. For instance, if you are shooting a scene from the top of a building and you need to turn the cars and people on the ground into miniature versions, you would need to use a tilt-shift lens. On most shoots you will not need a specialty lens, but if you do, it is easy to identify and rent or buy that lens.

Second, decide whether you will be shooting in close quarters or shooting from longer distances in more open areas. In general, you are trying to get a range of focal lengths that allow you to get coverage in the locations where you are shooting.

The more lenses you have and the better understanding you have of how lenses change the compression of the image, the framing of the image, or the action in the shot, the better you will be able to narrow your choices. Here are three sample prime lens "kits" that you could use as a guideline for building your prime lens set if you are using a full-frame sensor camera. You will need to do your crop factor conversion if your camera is not full frame.

Three prime lenses	Five prime lenses	Nine prime lenses
24 mm or 28 mm	24 mm	15 mm
50 mm	35 mm	21 mm
135 mm	50 mm	28 mm
	80 mm or 100 mm	35 mm
	180 mm or 200 mm	50 mm
		60 mm
		80 mm
		100 mm
		180 mm or 200 mm

Trade-offs

Since so many lenses are available, there are trade-offs between the common types of lenses.

First, let's look at older lenses vs. newer glass. The glass in a newer lens has a multi-coating that improves the quality of the image and reduces the flaring of the lens. Also, since the lenses are new or nearly new, there are few to no problems with the aging of the lens. Scratches, fungus, hazing, and overall high use of a lens can be issues on older lenses and glass. One drawback to using newer glass, though, is most everyone has the same lenses and glass. If you want to stand out with a unique look created in camera, then it is much harder to achieve that using only the latest lenses.

One benefit of new lenses is the ability of the lenses to be controlled by the camera. Older lenses have no way to communicate with your camera, so you have to manually focus

the lens at all times, including when taking stills. Since there is no communication between camera and lens, the metadata of your f-stop, the shutter speed, and so on is not stored with your footage or images. Also, they may not have multi-coating on the glass, so the lenses themselves may not be in pristine condition. On the flip side, in general used glass is cheaper than new glass. In some cases, you can get amazing-quality lenses with top-quality glass at a fraction of the cost of new lenses. Additionally, the lack of (or reduced) multi-coating can actually give you beautiful flares and help create the "look" of your film in camera. Don't rule out using older lenses with great glass. Just because it was made in the 1960s doesn't mean it doesn't still take world-class images.

Buying Lenses on a Budget

Don't confuse a lens kit with a kit lens. Kit lenses are those sold with a camera body when purchased new. Many people buy a camera with a kit lens so they have a lens to start with, but kit lenses in general are not very good. They typically are zooms that do not have a fixed aperture. (Fixed aperture means the fastest f-stop of the lens can be achieved at any focal length. Kit lenses usually become slower the more telephoto you shoot.)

To save money, skip the kit lens. Instead, buy old prime lenses and use lens adapters or have them converted, or put the savings toward a zoom lens with a fixed aperture. Older, good-quality prime lenses are more likely to give you a superior image than standard kit lenses. If you are willing to hunt eBay and other websites, you can buy three or four fast, older prime lenses for the price of an average kit lens.

Here are some recommendations for basic lens kits that would be good to have on a shot. These are suggestions for getting started, and if you can add more lenses to the mix, then you should add them as you need them. Again, these recommendations are for a full-frame sensor camera, and you need to convert if you are using a crop sensor camera.

Versatile Kit This kit would consist of two zoom lenses and a prime lens: 24–70 mm, 70-200 mm, and 50 mm. If you are shooting a documentary or have little to no time to set up for a shot, then this kit will get you the coverage you need and allow for some flexibility in the speed of setting up your shots. Get yourself a wide-angle zoom, such as a 24–70 mm, and a telephoto zoom, such as a 70–200 mm, to cover the likely range you will need during your shoot. In addition, get yourself a trusty 50 mm prime in case you can shoot interviews or some of your setups without having to use one of the zoom lenses.

Movie Kit This consists of one zoom lens (either a 24–70 or a 70–200) and a set of three prime lenses from among 24, 35, 50, 80, and 100 mm. A set of prime lenses can help you create the visual look you want and affect the way you tell your story. The biggest factor in your lens choice for this kit will be where you are shooting. If you are inside a house or in very tight space, then wider-angle lenses are a better choice than long lenses. However, if you are doing mostly exteriors or you're in a location with a lot of space, a mix of standard primes and some longer lenses would be a better fit.

One Lens If you have a limited budget or if you are going for a particular look or style, you should narrow your lens choice to only one lens, either a 50 mm or a zoom. Lenses are expensive and in some cases can paralyze you with the number of available choices for any given scene. Try shooting on just one lens and see what your creativity can bring to the screen. Sometimes less is more.

Giving a recommendation for a lens is like picking your favorite child. There is no way that everyone will agree with your recommendation. We are giving our opinion on what we have found using the various lenses available, and that is what it is—our opinion. If you are heavily invested in one brand of lens, then use that lens. Just get out to shoot something and test what you have. If it turns out that later you want to try some other lenses, then take a look at the following material and pick some off our recommendation list.

Lens Rentals

There is no definitive answer as to what is the best lens to use for filming on a DSLR camera. How one person feels about a lens can vary widely from the opinion of another person. Good lenses are not cheap, and there are a few reasons to rent a lens.

Lens rentals provide a relatively cheap training ground. If you don't have a lot of experience with still (or cinema) lenses, then choosing the correct one to buy is like taking a shot in the dark.

If you are going to be using a specialty lens for only part of a shoot or for a limited time, it may make sense to rent a high-quality lens as opposed to buying a cheap lens that you will rarely if ever use again.

Many companies rent lenses, and we recommend renting a few lenses that you are considering buying and testing them. Check out LensProtoGo.com, LensRentals.com, or Mophorentals.com for some great options.

Lens Brands

There are many lens manufacturers both past and present, and most if not all are valid choices for you to use. The main brands we will talk about in this book are Canon, Nikon, Panavision, and Zeiss.

When recommending lenses, there is no official best lens. Lens choice is personal and more based on your aesthetics and the look of the piece you are trying to achieve.

We have worked with most of the major lenses. Here is a list from our favorite lenses based solely on image quality:

- Zeiss ZE/ZF
- Zeiss CP.2
- Canon L series
- Nikkor Nikon lenses
- Sigma
- Rokinon
- Leica R
- Nikon AIS

We started with several Canon L series lenses as our main lens choice. When shooting our feature film, we mixed and matched Canon L series and Nikon glass and got good results with both. Most recently, we purchased a set of super-speed Zeiss CP.2 primes as our main lenses. In our opinion, these are the very best lenses for the image quality, sharpness, and visual look they render on the DSLR platform and also the most versatile for the ever-changing camera landscape.

- Zeiss lenses are premier-quality lenses that are very affordable and accessible. You can easily find lens mounts to fit your camera of choice. If you want the best long-term value in your lenses, then Zeiss should be your choice.

- Canon lenses are good, high-quality lenses that work for a lot of projects and have autofocus if you are jumping between stills and video.
- Nikon lenses in general produce some of the clearest and crispest images on the market.
- Leica lenses are some of the most desired in the world. They are highly coveted still lenses, and the majority of top cinema lenses are made with Leica glass.

Panavision Lenses

Panavision lenses are the top "cine" lenses in the world. The problem is that you cannot buy Panavision lenses; they must be rented with a Panavision film camera. So, unless you are working with a big budget, it may not be an option to rent a camera that you will never take out of its case. Also, you need a special lens mount that is custom made and very hard to get your hands on. With that said, the image results are incredible and well worth the cost and hassle in a lot of situations.

Lens Mounts and Adapters

The first thing you need to know prior to deciding on brands or types of lenses is the type of mount a lens uses to attach to the camera. In general, camera manufacturers engineer their cameras to fit their own lenses (for example, Nikon cameras mount only Nikon lenses). This is where lens mounts come in.

A lens mount is the configuration that allows interchangeable lenses to be attached to the camera body. The lens mount interface has the mechanical means to physically attach the lens to the camera body and has electronic components to allow the lens and the camera body to communicate with each other. The camera body has a specific lens mount system, and all lenses with that configuration can easily be attached to the camera body.

Lenses with nonconforming mounts usually can be mounted by using lens adapters. Many manufacturers make lens mounts so that you can use one manufacturer's lens with a different manufacturer's camera (for example, you can use a Nikon lens on a Canon camera). In some cases, certain lenses might damage the mirror or sensor on your camera, so you need to do some research to make sure others have successfully mounted the lens you want to use on your camera.

Canon to Nikon Adapters?

It is possible to use adapters to mount Nikon lenses to Canon cameras, but it does not work the opposite way. There is no way to use an adapter to mount a Canon lens onto a Nikon camera body.

PL is a lens mount developed by ARRI for use with both 16 mm and 35 mm movie cameras. The *PL* stands for *positive lock*. PL mounts are the standard mounts for most cinema lenses. If you choose to use standard cinema lenses on a DSLR camera, then you need to have your camera outfitted with a PL mount (Figure 2.6).

Figure 2.6: PL mounts on two 7Ds and a 5D Mark II camera

When you mount a nonconforming lens, the electronic interface may not function, or older lenses may not have an electronic component; in these cases, the lens may have to be used partially or entirely manually. Most DSLR cameras can be fitted with adapters (Figure 2.7) to allow the camera body to accept cinema lenses, and as a result, the flexibility on lens choice is nearly limitless.

Figure 2.7: Various lens adapters

Matte Boxes

A matte box (Figure 2.8) is one of the pieces of equipment that makes independent filmmakers feel more like Hollywood directors. As much as the matte box is iconic for movies, the matte box actually predates the invention of motion pictures. Their original use was for still photographers to easily "matte" out part of the frame of film they were exposing so they could re-expose the other part of the film for an effect or some sort of creative choice.

A matte box is a camera accessory that mounts in front of the lens. Its purpose is to block stray light and reduce lens flare. Typically a matte box will have moveable wings to aid in this purpose, and the wings are usually adjustable and allow for better control of the light reaching the lens surface. Often a French flag—a moveable and adjustable hard leaf usually mounted along the top—is added to increase shade capabilities. The front of the matte box acts as a hood (not unlike you cupping your hands around your LCD screen to block light) and helps keep light from hitting the front of your lens. If a light source hits the front of your lens, you can get lens flares or light spill, which you can't always see from your LCD monitor; this will wash out your image and can cause you headaches in post.

Another crucial function of the matte box is to hold filters such as a polarizer, a graduated neutral-density filter, or a Pro-Mist filter. Matte boxes have slots that hold filters in place in front of the lens. This means that you don't have to purchase separate filters for every lens, and you can use one set of filters for several lenses. Depending on the price and

quality of the matte box, they are engineered for specific size filters (4×5.6 inches being a common type) or may accommodate a variety of filter sizes.

The slots can hold one or several filters and are fixed or adjustable to allow the filter to be rotated for the desired effect. With the various numbers of slots that can hold filters, you can stack filters to create the effect you want right in the camera. Additionally, the matte box allows you to rotate your filters. This is handy when you need to use a graduated neutral-density filter and want to position it at an angle. For example, if you are shooting and you need the sky in just the corner to have some filter on it, you can rotate the filter in the matte box and position it exactly as needed.

The matte box is usually mounted with two rods that extend along the camera body to support the lens, the matte box, and potentially other accessories. Sometimes the matte box is mounted directly on the lens. In the case where it is attached to the lens, you must remove it and attach it to a new lens each time you switch lenses for a shot.

Figure 2.8: Redrock microMattebox

Filters

Filters are transparent pieces of glass, plastic, or gelatin that go in front of a camera lens to create an effect on the recorded image. Filters are used for a variety of reasons such as artistic factors, for special effects, or to make a scene look normal on the recorded image.

Filters come in all shapes and sizes. They can fit all shapes and sizes of matte boxes; you can also purchase screw-on filters that fit your lens.

Why use a screw-on filter vs. a matte box? Screw-on filters are small and portable. They attach directly to your lens, and you can forget about them until you change lenses or need a different filter. They too can be stacked; you just screw a filter onto another filter. They have threads on both sides, so in theory you can go nuts stacking all day long. But the more you stack, the more you can get dust in between the filters and the heavier your lens becomes. If you are trying to shoot as small, as quickly, and as unnoticed as possible, then a screw-on filter is better than a matte box. You won't look as obvious as with a giant matte box sticking off the front of your camera.

Neutral-Density Filters

A neutral-density filter, also called an ND filter (Figure 2.9), reduces the amount or intensity of light coming into the camera lens. A good ND filter simply reduces the intensity of all wavelengths of light and doesn't change the overall hue. They are usually gray or colorless. ND filters can be used either to provide a proper exposure or to reduce light without adjusting the aperture, thereby maintaining the depth of field.

Figure 2.9: Tiffen WW ND filter set

A *graduated* ND filter (Figure 2.10) has a subtle effect across the surface of the filter where the filter transitions from neutral density to clear. A *variable* ND filter essentially is two ND filters fused together, and as they are turned, the filter factor can change stops along a range.

ND filters are numbered according to their f-stop reduction or optical density. If a higher-numbered filter is required, you can stack the filters.

Figure 2.10: Tiffen color-graduated ND filter

Figure 2.11: Tiffen circular polarizer

Polarizing Filters

Light can become polarized in many different ways: passing through air filled with dust, striking water, passing through water or other surfaces, or bouncing off shiny surfaces. Polarization happens when the light waves start vibrating in different directions or angles and a higher number of them are vibrating horizontally. When a higher than normal percentage of light waves in a beam of light vibrate horizontally, our eyes perceive this as glare, and the shot will also be influenced by the glare.

A polarizing filter (Figure 2.11) changes the light waves or restricts the horizontally vibrating waves so that more waves are vibrating in the same direction; this reduces overall glare both to the eye and in the final image. Polarizing filters work best when positioned at a 90-degree angle to the object being filmed. For instance, a reflection in a window or off a lake or water surface can be reduced or eliminated with a polarizing filter.

To achieve the proper effect, the polarizer's outer ring rotates to change the angle and filter the light waves. A polarizing filter will have a one-stop to two-stop effect on exposure; the stop variance depends on how the filter is oriented and the kind of light in the shot. The filter can be used to reduce or eliminate glare or reflections from windows or nonmetallic surfaces, can darken the sky, and can provide a richer-color final image.

Ultraviolet, Skylight 1A or 1B, and Clear Glass Filters

These filters are generally used as lens-protection filters. It is a personal preference to use a lens-protection filter in a given situation. Some of the filters commonly used for protection can also be used to combat chromatic aberration, but they also have the potential to increase flare or soften the image.

Never put anything in front of your lens unless it is absolutely necessary. A UV filter, which simply absorbs UV light, is primarily used as a lens protector. Buy any cheap UV filters you can get and put them on all your lenses for storage and transport. As soon as you are on set, *take them off the lenses*. You are spending top dollar buying good lenses or renting the best lenses; don't ruin the image by needlessly shooting through a UV filter.

Often, colored filters are referred to by numbers. These numbers are based on a numbering system designed by Frederick Wratten. Several companies produce filters with Wratten numbers that may not exactly match but are designed to be aesthetically similar.

Diffusion Filters

Diffusion filters (Figure 2.12) soften the image without affecting the sharpness. A diffused image is not out of focus but rather is considered a soft focus; a diffusion filter keeps the focus but lessens the harshness of the image. For example, diffusion filters work to soften the skin and reduce the appearance of imperfections in close-ups or to provide a glowing look to a shot. The filter spreads out a strong light, creating an image that is often described as dreamy or hazy. Diffusion filters work by having an irregular, uneven surface or pattern that fans out the light.

Methods that have been used to create a diffused image without a filter include putting a nylon stocking over the lens or coating a UV filter with petroleum jelly or a layer of hairspray.

Figure 2.12: Tiffen pearlescent 4 × 5.6 diffusion filter

Contrast Filters

These filters work by adjusting the overall contrast of the scene, in other words, adjusting the ratio between highlights and shadow. If the scene needs the shadow darkened or lightened, ambient light spread, detail in the dark areas, or similar contrast issues, a contrast filter (Figure 2.13) is a useful tool.

Color Filters

Color filters (Figure 2.14) are used to add an overall color change to the entire shot. They can be used to add a warmer effect to a shot that happens in a sunset (or needs to match a sunset shot), to add an unrealistic color cast, or simply to add a hint of color. Many color filters exist, and they allow a degree of artistic color control in-camera.

Figure 2.13: Tiffen low-contrast filter

Color-Compensating or Light-Balancing Filters

These filters subtly warm up or cool down a scene. They can also be used to alter the color balance of the light.

Figure 2.14: Tiffen 812 warming filter

Your camera will have a sophisticated approach to setting white balance, either automatically or manually. However, you can also use these filters for a distinctive effect or in cases where the white balance settings are not achieving a desired look.

Graduated and Split-Density Filters

Graduated and split-density filters (Figure 2.15) have different filtration on each side of the filter. In a split-density filter, one side of the filter can simply be clear glass so that only half of the image is affected by the filter. If the transition between filtration is gradual, it is a graduated filter.

Filter Recommendations

Here's what we routinely use:

Figure 2.15: 4 × 4 split-density filters

- Neutral density: A set of Tiffen Water Whites (WW) (77 mm: 0.3, 0.6, 0.9, and 1.2) and a Fader ND, which is a screw-on filter that you can twist and change from a light ND to a super-high ND within the same filter
- Polarizing: Tiffen circular polarizer
- Diffusion: Tiffen 1/8 Black Pro-Mist
- Contrast: Tiffen Low Contrast, Soft Contrast, and Ultra Contrast
- Graduated: Again, Tiffen

We have also used and liked Schneider filters.

Lens Accessories

You might need accessories of several types:

- Close-up or split-field diopters
- Extension tubes, extenders, or teleconverters
- Reversing rings or bellows
- Lens-cleaning materials

A close-up diopter (Figure 2.16) is a lens that mounts like a filter to the front of the original lens. It permits closer focusing with no exposure compensation but does affect the focus, so all focusing must be done manually.

Figure 2.16: Neewer close-up diopter filter set

A split-field diopter (Figure 2.17) is like a filter that mounts to the lens but is designed to affect focus. It is half plain glass and half close-up diopter. This design means that two subjects, one at a far distance and one near, can be in sharp focus in the same shot. The frame essentially is split in half with two focus points.

Extension tubes (Figure 2.18) are simple black tubes that are mounted between the lens and the camera body. They move the lens farther away from the image plane or sensor. The purpose of using an

Figure 2.17: Schneider split-field diopter

extension tube is to increase the size of the image on the sensor to allow for macro shots or extreme close-ups.

Teleconverters (or, as Canon chooses to call them, *extenders*, and additionally sometimes referred to as *multipliers*) are used to increase the effective focal length of the lens. They mount between the lens and the camera body and enlarge the central part of the captured image. They are used in situations where you want to zoom in a little more but don't want to pack or buy an additional lens.

Reversing rings allow the camera lens to be mounted backward to get a macro shot. Often the image can have an interesting focus with a specific spot very sharp and gradually softening.

Figure 2.18: Canon EOS extension tubes

Bellows (Figure 2.19) are moveable accordion-style tubes that allow extreme macro-photography shots. They increase magnification and provide a very shallow depth of field. There are also bellows systems that allow for tilt/shift and swing and provide the benefits of perspective change or correction.

It never hurts to throw a cleaning kit (Figure 2.20) into your bag. At the least, a lens cloth will come in handy on nearly every shoot.

Viewing While Shooting

Since DSLR cameras were never designed to operate like video cameras, the viewfinder (or lack thereof) is a huge issue to address. Unlike traditional movie cameras, there is no eyepiece or moveable viewfinder to look through while filming. This is a real problem when shooting, especially when moving the camera during the shot. The lack of a viewfinder makes focus difficult, especially because DSLR cameras are often used heavily in low-light situations where depth of field is very unforgiving.

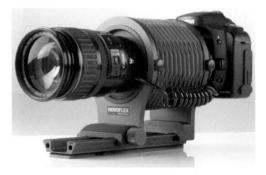

Figure 2.19: Novoflex bellows for Canon cameras and lenses

LCD Screen

The standard LCD display on the back of the camera (Figure 2.21) varies in size, resolution, and brightness. Since you will not be selecting a camera based on the LCD, you will be stuck with what comes on the camera you want to use. If you are mostly shooting on a tripod in controlled environments, then the available LCD screen should be fine and won't require an external monitor.

Figure 2.20: Basic camera and lens-cleaning kit

Figure 2.21: An LCD screen on the back of a camera

The real problem isn't the size, resolution, or brightness of the LCD screen but rather that it is not in an ideal position to look at the image while shooting video. Some more recent models such as the Canon T5i have introduced articulating LCD screens that move the screen out to the side of the camera; this allows you to tilt the screen up or down depending on the angle at which you are shooting. The biggest enemy to using the LCD monitor is ambient light. If it is bright where you are shooting, then we recommend using some black cloth over the camera and operator's head or using a viewfinder.

Viewfinder

If you intend to hand hold your camera or have mobile camera support rigs, then you need to buy a third-party viewfinder. The most popular viewfinders are the Hoodman HoodLoupe (with the Redrock Micro microFinder loupe accessory) and the Zacuto Z-Finder.

Hoodman HoodLoupe This is a very affordable option for most DSLR users. The glass used in the Hoodman (Figure 2.22) is manufactured in Germany by Leica. They are not able to advertise this, but the quality of the glass is second to none. The biggest drawback is the discomfort of using the stand-alone HoodLoupe (there is no eye cup, and there is no actual magnification). Hoodman now offers a separate eye cup and a 3X magnifier with eye cup adapter for the HoodLoupe.

Zacuto Z-Finder This is the Cadillac of viewfinders. It is much more expensive than the HoodLoupe but has a super-comfortable eye cup and comes with a 2.5X or 3 X magnifying glass standard. Using the

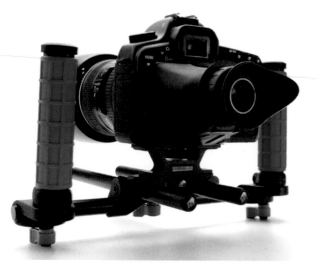

Figure 2.22: HoodLoupe with a Redrock adapter

Z-Finder (Figure 2.23) makes getting critical focus much easier and helps stabilize the camera.

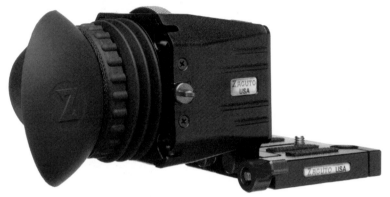

Figure 2.23: Zacuto Z-Finder

Electronic Viewfinder

An EVF is a viewfinder that is more like a traditional viewfinder on a video camera. You look through the viewfinder, and you can see your image. Some have zebras for judging overexposure and flexible positioning, and they don't have to be attached directly to your camera, so you have a lot of flexibility in monitoring. There is also a loop-through for your video image so that not only do you get an image in the viewfinder but you have another HDMI port where you can output the signal to another monitor or device. Currently Cineroid (`www.cineroid.com`) has a unit on the market, and Redrock Micro (`www.redrockmicro.com`) has announced that its version is coming soon; we are sure there will be many more to follow.

Monitors

You should be aware of the three main categories of monitors. Each offers different advantages and may be more appropriate for certain shooting styles and locations than others.

External monitors can be extremely helpful during a shoot. They can provide easier viewing for tight or odd camera angles. A monitor is also very useful for focus pulling, checking exposure, and allowing everyone on-set to see a more accurate view of how the shot will look onscreen.

Onboard Monitors

A great way to better see what you are shooting and to check focus is to use a field monitor. Onboard monitors are exactly that—monitors that are attached to the camera or the camera rig you are using. Onboard monitors replace using the LCD screen as your monitor while shooting. Since DSLR cameras lose the image on the LCD screen when connected to another monitor, you are choosing an onboard monitor over using the LCD screen on the back of the camera. There are a variety of small monitors, usually ranging from 5 to 7 inches, to choose from.

HDMI Output

A key thing to be aware of is the connection for the monitor. If you are familiar with only profes-sional film and video equipment, you probably haven't worked with HDMI cables. The video output from most DSLR cameras is High-Definition Multimedia Interface (HDMI), which is a consumer protocol for most TVs and home audio/visual entertainment systems. HDMI is not robust or easy to work with in real-world production environments, so be prepared for losing the signal on the monitor and having cables go bad.

The output of some DSLR cameras is not a true HD out (in this case the image is dropped to a standard definition signal while recording). Also, on some cameras when you are in live view and connect to an external monitor, you will lose the image on the camera's LCD screen. The lack of having an image on the camera's LCD and the external monitor makes it very difficult for the camera operator, director, and/or client to see what is being filmed at the time. To further compound the situation, when you start recording on your camera, the signal out of the camera drops from HD to standard definition. The actual image will shrink in your external monitor while the camera is recording.

Our recommendation for an onboard monitor is the SmallHD DP7 7-inch (Figure 2.24).

Studio Monitors

If you are shooting in a studio or in a situation where the camera is stationary and you can operate from a larger monitor, then working with a studio monitor is a better option. Where available, get the largest, highest-resolution, and brightest monitor you can afford. Use that

monitor to judge your exposure, color, and lighting, and then it will be easier to use the LCD or viewfinder when you are ready to shoot.

Using a larger studio monitor is great when setting up a video village or when you are able to shoot non-handheld, like on a tripod or dolly. We find the extra real estate we get in the larger monitor priceless and use it whenever we can on the set. If you are doing handheld or certain other motion shots, you have to use an onboard monitor. We carry both in our package and use both regularly.

We use the HP DreamColor 24-inch LP2480zx as our studio monitor. We chose this monitor because HP originally developed it for DreamWorks Animation and it supports many times more colors than traditional LCDs.

There are three types of monitor screens: TN, VA (usually PVA or MVA), and IPS. TN is the cheapest and most common and displays 6-bit color. VA displays 8-bit color but is expensive to make and has mostly been phased out with the advent of IPS monitors. IPS is the standard for all professional monitors. They can display 8- or 10-bit color (depending on the model you choose) but are not sold in traditional electronics stores.

Figure 2.24: DP7 HD onboard monitor

Another key element in the performance of a monitor is the color gamut. The color gamut is the range of colors a monitor is capable of displaying. The three color spaces are sRGB, Adobe RGB, and ProPhoto RGB, which are in ranking order from lowest to highest quality.

To make things a little more confusing, the LCD panel in a given monitor can have one of three different types of backlighting: LED, CCFL, and RGB LED. LED backlighting is rated at 72 percent of Adobe RGB, CCFL is rated at 96 percent, and RGB LED is rated at 125 percent.

So, to achieve the highest-quality image and color, a monitor would need to have an IPS LCD screen, 10-bit color, and RGB LED backlighting, and the only such monitor currently on the market is the DreamColor 24-inch (Figure 2.25). As a bonus, HP claims you can use the monitor for more than 2,000 hours before you have to color calibrate it.

Figure 2.25: 24-inch HP DreamColor monitor on the set of Remus

Wireless Monitors: Teradek's Bolt

In some cases, having remote monitoring is a necessity on-set. Recently Teradek (www.teradek.com) released a product called the Bolt. The Bolt can be connected to your camera to encode your video signal and send it out to other devices wirelessly. The unit creates its own wireless network and the network can easily be connected to by laptop or a tablet of your choice. You can now easily have director monitors, client monitors, and so on for many people without running cables and splitters all over the set.

Lights

A big attraction for shooting with DSLR cameras is their ability to shoot in very low light and, some would say, no light. One of the top reasons to use these cameras is they perform great in low-light situations where traditional film and video cameras cannot operate. However, that doesn't mean you shouldn't use lights or light your scenes.

Studio Lighting

If you have control of your set and can use traditional studio lights, you have many options available. You can use standard film lights from Kino Flo, Mole-Richardson, and Lowel.

A good Lowel lighting kit (Figure 2.26), when used in conjunction with other household lights, can light almost any scene. Get a three- or five-light kit, and you have your lighting "truck."

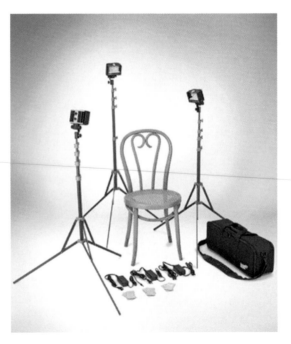

Figure 2.26: Lowel Blender LED kit

LED Lighting

Many lighting manufacturers are releasing LED lights. The huge benefit is they use very little power, so you can use more lights on a smaller circuit, and they give off basically no heat. Just ask your actors how great that is. Additionally, there are more LED lights that are battery powered and can be moved to remote areas, such as a field or side of a road, without available power.

We have been using Litepanels LED lights (Figure 2.27). We have the 4-inch model in our kit and frequently rent the 12×12 light for larger shoots. These are versatile, fast, and easy to use. They last a long time even on battery power and are great for tight spaces or locations with little access to power. Another feature of LED lights is they offer adjustable power with no change in color temperature.

Hardware-Store Lighting

As any good independent filmmaker knows, sometimes you need to use what you have available. Since DSLR cameras are so light sensitive, you don't need a huge 4K (4000 watt) light as you would on a traditional film set. There is plenty of great work being done today with lights or lighting setups created from the local hardware store.

In reality, the best tools in the DSLR toolkit are the actual light bulbs and dimmers from your local hardware/home improvement center. For less than $50, you can get a couple dimmers and a ton of various-watt light bulbs that will help you turn almost any room into a studio light room. Because most DSLR cameras are great in low-light situations, many times a simple home lamp with a 60w incandescent bulb (for those using compact fluorescent, a 13w bulb) will blow out completely in your shot. With a dimmer like the one shown in Figure 2.28 and a 25w bulb, you can adjust the light quickly so it doesn't blow out and take away from the actor in the scene.

We cover lighting in more detail in Chapter 6, "Lighting on Location."

Figure 2.27: 4-inch Litepanels Chroma LED light

Figure 2.28: $10 dimmer from local hardware store

Audio

When approaching audio with DSLR cameras, you really have two ways to go. You can use the audio port on the camera (Figure 2.29), or you can record audio on a separate recording device and sync the audio in post. Let's take a look at both methods so you can decide which is the better choice for your project.

Figure 2.29: Audio input on a 5D Mark III

If you tell people you are shooting video on a still camera, you will hear a lot of people telling you to use a real tool like a "proper" video camera because it will have an easier on-set workflow. They are right that you will occasionally run into troubles when shooting on DSLR cameras because they were not designed to be traditional movie cameras. The audio inputs are just not as good as they would be if they were "proper" video cameras.

You can consider a variety of audio recorders. You can use portable digital audio recorders, record audio directly to a laptop, or use a more professional digital multichannel audio mixer/recorder.

The biggest advantages for the external recorders (Figure 2.30) are better audio quality, extra cables kept away from the camera, and the ability to mix to separate tracks and not have the audio mixed down into the camera. The drawbacks are there is more file management with the digital audio files and there will be a lot more work in post to get everything synced up.

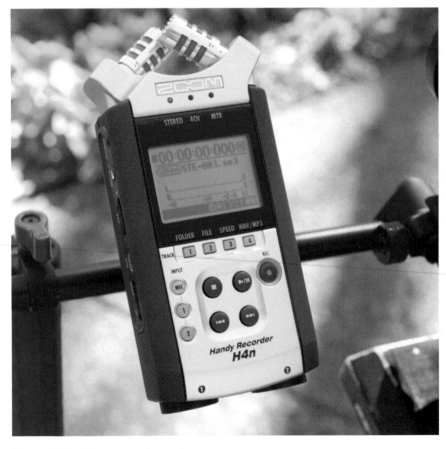

Figure 2.30: H4n external recorder

If you are shooting with one or two actors, then a small portable digital recorder will work fine. If you have more microphones than your recorder has inputs, you will need to mix your audio in the field and have no flexibility in post. If this is a concern, you may have to move out of the smaller digital recorders and look into renting a digital recorder from a rental house that deals with more complex audio issues. Your local movie rental house is a great place to start.

Mixers

If you are shooting a movie that has more than one actor, then you should use some sort of mixer. Even with a single actor, a mixer will give improved flexibility and ease in post. You will want to mic up each actor who has a speaking role and have a boom mic for covering the whole scene. All of these inputs should be recorded onto separate tracks that you can adjust in post.

Some mixers will have a built-in hard drive so you can more or less kill two birds with one stone. Have your mixer and recorder in one device (Figure 2.31). Regardless, you will use the mixer to adjust the levels of each actor and the ambient noise so you have the most latitude in post to work with. Without a mixer, you could have a soft talker and a loud talker in the same scene, and you would struggle to balance those in post if you recorded without a mixer on the set.

Figure 2.31: 744T digital mixer and recorder

Microphones

Regarding which microphones to use, there are many options that range widely in cost. If you can afford it, hire a professional sound person with their own gear so you are covered.

If you are handling sound yourself or with a small crew, then here are options for reliable microphones:

- Boom mic
- Onboard mic
- Wireless lavaliere mic

A boom microphone (Figure 2.32) is simply a microphone on a long stick/handle. The type of microphone that is attached to the boom is up to you or your audio person. Most commonly you will use a shotgun microphone on a boom pole so you can get clean audio from your actor without all the ambient background noise. We like to use RØDE NTG3, but there are many good shotgun microphones you can use.

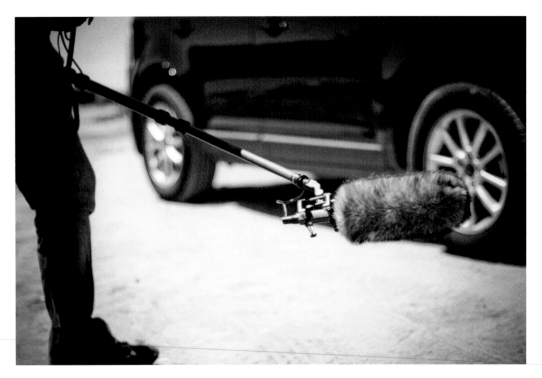

Figure 2.32: Boom microphone in use on-set

For our onboard microphone, we use a RØDE VideoMic (Figure 2.33) for recording reference audio (when we can't get a feed from the audio guy). It is not good to actually record your audio for your film directly to the camera as your main audio source. (As previously discussed, there are audio limitations on most DSLR cameras.) Use the onboard audio feed for reference audio only. You will record the audio directly into the camera, and when you sync your audio from your external recorder, it will be easier to sync and match the audio.

Figure 2.33: RØDE VideoMic Pro

In some situations, you will need to use wireless microphones. The first question you need to ask is, will you have power where you are shooting? If you do, then there are many good-quality microphones you can use. The Audio-Technica 3000 Series Wireless Lavaliere System is available for a reasonable price.

If you don't have available power, then you need to get a wireless microphone that has a battery-powered receiver (unlike the Audio-Technica that must be plugged in). For the money, the Shure FP Wireless system is the way to go (`www.shure.com`; Figure 2.34). When you purchase it, the microphone will come in a kit with everything you'll need to get started right out of the box. You will need a ton of batteries because you will have to change the batteries up to three or four times throughout the day depending on how much you are shooting and for how long. We own this system in our production kit.

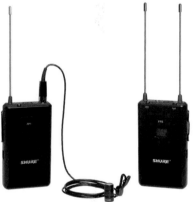

If you have a production that has four or more actors, then you will need a mixer and/or a digital recorder that has the same number of inputs as you have microphones. In general, the more inputs you want to use, the more expensive and complex your audio recording needs will be.

Figure 2.34: Shure FP Wireless lavaliere microphone

Check out the Lectrosonics SM (`www.lectrosonics.com`) series of wireless lavalieres. They are very high end and expensive, so renting is your best option. The benefit is they are small and can be hidden almost anywhere. A lot of the reality TV shows use these microphones because they are durable, are easy to hide, and provide excellent audio quality.

We'll talk more about audio equipment in Chapter 7, "Sound on Location."

Slate (Clapboard)

You need to consider how you will sync your sound if you are not running audio directly into your camera. The tried-and-true way is to use a slate (in other words, a *clapboard*; see Figure 2.35). You can order them online starting at just a couple bucks; you write your scene number and take right on the board. This helps you in post because you can look at the front of your scene and visually see what scene/take you are viewing and find the audio

clip you need to sync to that scene. Another option is to have someone clap their hands (like an alligator clap) and be the human version of a slate. As long as the person is in clear view and claps fast, this can be a good trick if you are in a bind.

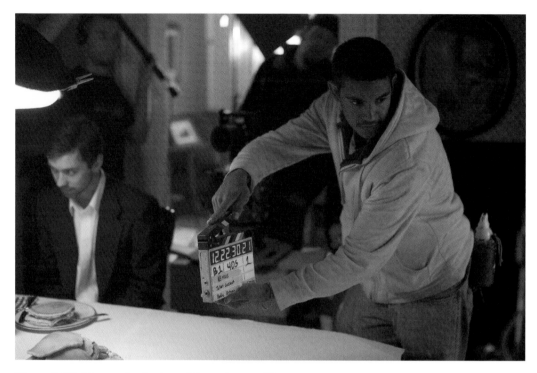

Figure 2.35: Time code clapboard from the set of Remus

Another great option is a software plug-in called PluralEyes (www.pluraleyes.com). We will walk you step by step through using PluralEyes in Chapter 11, "Audio Crash Course."

Tripod and Dollies

On any shoot, stabilizing the camera is key. The most common, and in a lot of cases the best, weapon of choice is a good old-fashioned tripod. Even though DSLR cameras are small and light, that doesn't mean you should buy a smaller, lighter tripod. You absolutely need to get a great fluid head and a heavy, sturdy tripod for your shoot. As with traditional video or film cameras, a good fluid tripod head allows for smooth camera movements that look very cinematic. DSLR cameras in general are a bit more temperamental about quick camera movements or handholding, so make sure your fluid head has drag and can be set so you can finish panning and let go of the tripod.

The importance of a good tripod cannot be overstated. You can choose from many good brands and models. When choosing, make sure you get a fluid-head tripod and preferably a big, heavy-duty one. We use a Sachtler Video 20 fluid-head tripod and a Sachtler ACE fluid-head tripod (Figure 2.36).

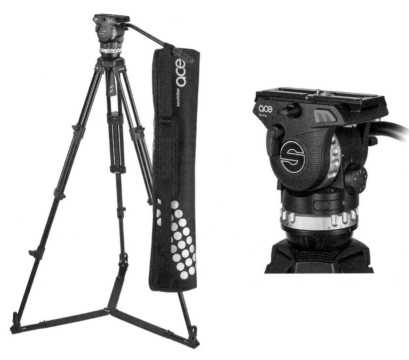

Figure 2.36: Sachtler ACE L head with tripod

Dollies are something you can have a little fun with. You do not need a professional Fisher dolly to get great results (if you happen to have access to one, go ahead and use it). Various types of dollies are available ranging from a simple tripod dolly to a full studio camera dolly.

Studio Dolly

Studio dollies are expensive and can usually only be rented from your local film camera or lighting rental house. For DSLR cameras, in general they are overkill. However, studio dollies have a key feature that is really not available in any other dolly: the hydraulic boom arm. The hydraulic boom arm allows you to boom the camera up or down while making a dolly move or push. If you have the budget and you have some shots that call for this type of move, then you need to rent a studio dolly and hire a good dolly grip to operate it for you.

Tripod Dolly

Tripod dollies (Figure 2.37) are really convenient and affordable. Typically a tripod dolly is a separate piece of equipment that attaches to the bottom of your tripod legs. It more or less adds wheels to each leg of your tripod and allows you to move the tripod easily. There are some issues with using this type of dolly for camera moves. First, you need a flat surface in order to move the tripod dolly. Second, your tripod and camera are very light and much more likely to add some sort of shake or bounce to the shot while you push the tripod dolly. Third, the wheels tend to rotate, so it is more difficult to push/pull in a straight line without causing some unwanted movement with the camera. The best use for tripod dollies is to move from mark to mark quickly to save setup time between shots.

Figure 2.37: Sachtler tripod dolly wheels

Track Dolly

Lightweight track dollies and track come in many varieties. The most common are made with skateboard wheels and some sort of plastic pipe. The drawback is again lack of weight. The key to a great dolly shot is the smoothness and lack of any outside force transferring to the camera shot. With these types of setups, the more weight you can add, the better the performance and the more your shots will look professional and smooth.

Portable Dollies

Instead of dollies that you stand or sit on, there are a variety of dollies that are smaller and more compact. They let you get low while maintaining the smoothness of a dolly shot and can get into tight areas a larger dolly couldn't fit in. Here are some of the most common ones you might want to check out:

CineSlider/Pocket Dolly Kessler Crane (www.kesslercrane.com; Figure 2.38) manufactures a couple of good products called the CineSlider and the Pocket Dolly. The CineSlider is a heavy-duty portable mini-dolly/linear slider.

After working with several sliders over the past year, we've found that the best slider for the price is the CineSlider. We like the full version and not the Pocket Dolly. The Pocket Dolly is great for traveling, but if you don't have to travel with everything in your suitcase, go for the full CineSlider.

CamTram System This is a hi/lo hat design that allows you many different mounting options (www.camtramsystem.com). You just supply the track (ladders, 2×4s, PVC

pipe, and so on), and you are ready to shoot in minutes. You can rent this system, or you can buy it from one of the dealers worldwide.

Dana Dolly This dolly is a great little workhorse (www.danadolly.com). It is fairly light, is portable, and is fast to set up. If you need a dolly that is small and versatile, then check this one out.

Tripod dolly wheels attach directly to your tripod, and you can grab your tripod and move it as if it were a handheld dolly. The drawback here is the wheels can sometimes fight against you and cause your movements to be a bit shaky. Even if you get a really heavy tripod, it will still be light for a dolly, and, as any good dolly grip will tell you, you need weight to produce consistently reliable dolly movement. You can make do with dolly wheels, but if you plan a lot of dolly shots, we recommend looking at the other options.

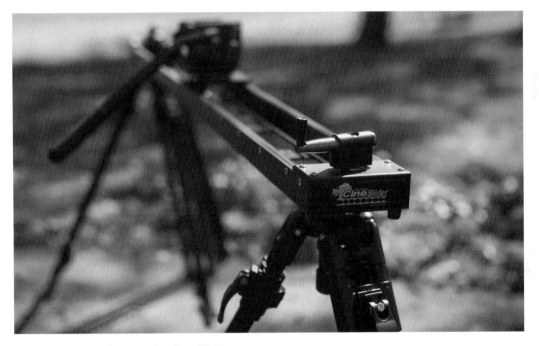

Figure 2.38: Five-foot Kessler CineSlider

Specialty Items and Miscellaneous

In certain cases, you will need other specialty equipment to help you get focus, mount your camera to a moving object like a car or boat, shoot in extremely wet conditions or underwater with watertight housings, or stabilize the camera for handheld scenes.

Camera Mounts

Do you want to shoot a car chase sequence? How about a boat cruising through the water? If so, then you might want to check out some specialized camera mounts in order to protect your gear and give you better shots than if you just held the camera. DSLR cameras are ideal

for mounting because of their light weight and compact size. Mounts range from standard mounting systems that can be purchased or systems specially designed for a specific shot or vehicle. Mounts are usually composed of some configuration of industrial-strength suction cups, metal rods, various grip gear, and screws to hold the camera steady during the movement. The mount needs to be able to keep the camera firmly attached so it doesn't fall off mid-shot and also to make sure that the camera is steady enough so that the final image is usable.

Follow Focus

One of the biggest problems with shooting on DSLR cameras (and to be specific, larger-sensor cameras) is focus. The extreme depth of field of these cameras (and the fact that we love shooting with little to no light) makes getting proper focus difficult.

Follow focuses come in two different varieties: manual and wireless. We use the Redrock Micro manual follow focus (Figure 2.39). This is one of the accessories, however, where many of the available products are good, so the choice is about personal preference. If you are able to get your hands on a few different follow-focus units, try a few and pick the one you like the best. The adjustable ARRI Mini follow focus is another great choice if you can rent or have some more money to spend on your unit.

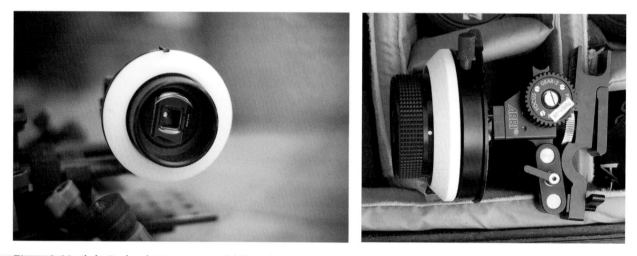

Figure 2.39: (left) Redrock Micro manual follow-focus unit and (right) ARRI follow-focus unit

As for wireless follow focus, there are really only two options we feel you should consider: Redrock Micro microRemote and BarTech. In our price range, the Preston is just flat-out too expensive. Unless you are jumping between the DSLR platform and traditional film/video jobs, then the BarTech follow focus (Figure 2.40) is relatively affordable and has great resale value. The build quality is extremely durable.

If you have never used or looked at a remote follow-focus unit, you should be aware of the remote follow-focus control and a separate motor. The two motors you want to buy/rent are the Heden motor and the M-One motor. Both work great and are field tested.

Figure 2.40: BarTech wireless remote follow-focus unit

Stabilizers and Handheld Rigs

Stabilizing mounts are important for fluid action during shots that involve movement. The goal of this gear is to keep the camera operator's twitches and motions minimized while the camera image stays smooth for the entire shot. Handheld operation greatly increases shakiness and camera bounce, especially with DSLR cameras. The stabilizers allow the camera operator to move rapidly over rough ground while shooting and still keep the camera steady. This freedom of the camera being attached only to the operator allows movement and tracking shots to happen quickly, allows them to happen with less setup, and provides more creative control for the camera motion. The more experienced and talented the operator, the better the overall quality; however, a quality stabilizer will improve all operators' abilities immediately.

We're not sure how many people are going to run out and buy a stabilizer, but there will be some. Also, most stabilizers are available for rent in almost any town. But if you are going to operate a Steadicam or stabilizer and have never used one, don't try it for the first time on the set. You will need to get the unit you want to use (either purchase or rent) well in advance and practice using it. Ideally, you should spend some money and attend one of the many workshops where you are forced to work 12 hours or more per day on techniques.

our recommendation is the Steadicam Zephyr (Figure 2.41). Tiffen
this model (it is replacing the Flyer model), which is on the higher end of
s. You can use something like the Pilot, but we feel that, depending
d the lenses you are using, the Zephyr will provide you with the best
ence and the best value for your money. Just note that most rental houses
e bigger video or film Steadicam models, so you might have to look around to
it you can rent or try. If you do decide to attend a workshop, they will have various
els on hand for you to try.

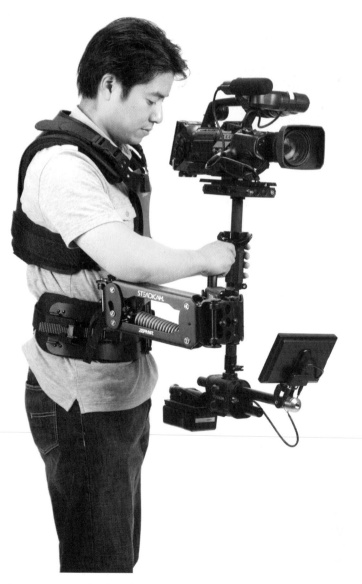

Figure 2.41: Tiffen Steadicam Zephyr

As great as a stabilizer is, sometimes the shot or the location calls for a handheld shot instead. In this case, some sort of shoulder mount or handheld rig is the better tool. There are systems you can rent or buy that allow for increased control over the shot and support the weight of the camera and accessories to reduce operator fatigue. They offer several points of contact with the operator and are designed to add balance to keep the shot steady and the movement deliberate.

The shoulder mount we own is the Redrock Micro DSLR Field Cinema Deluxe Bundle V2 (Figure 2.42). We used this on the filming of *The Shamus*, and we have since purchased it for our kit.

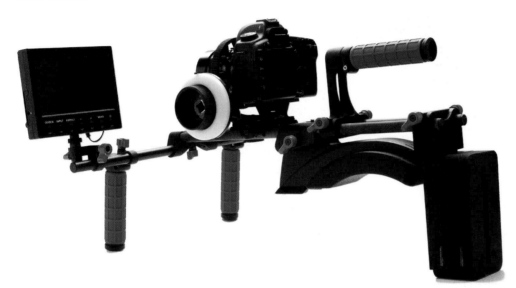

Figure 2.42: Redrock Micro DSLR Field Cinema Deluxe Bundle V2

Carrying Case

Don't use a cloth camera bag as your primary case for your camera and lenses. You need something that you can rely on to protect your gear from impact damage and from water. We own several (too many to count) Pelican cases for equipment. Make an equipment list for all the gear you are going to be running around with and get a couple of cases to fit everything. Remember, the beauty of DSLR filming is small and portable gear. You can probably fit all of your on-set gear, minus major lighting, for a small shoot into one or two bags if you plan carefully.

If you ever unlatch a case, leave the top open; when you close the top, make sure to close both latches. Inevitably someone will shut a case top without latching it tight, and some-one else will pick up the case thinking it is locked and all the gear will hit the ground.

We use Pelican cases (Figure 2.43) for all our gear. The company makes the standard Pelican cases as well as Storm cases. We have a Pelican 1510 carry-on for our 5D Mark III and a small shooting kit. In this case, we can hold a Canon 5D Mark III with a lens, Zacuto Z-Finder, 4-inch Litepanels light, set of Tiffen filters, Shure FP5 wireless microphone, RØDE Video microphone, Lexar CF card reader, G Raid 500 GB hard drive, two additional lenses, five batteries and a Canon battery charger, two Pelican hard cases for CF cards, a Canon intervalometer (TC80N3), random lens cleaners and clips, and a bunch of various tripod plates and mounts.

Additionally, we use a Pelican 1600 case with custom cut foam (from `Innerspacecases.com`) for our Zeiss Prime lens set.

The Pelican 1650 cases are perfect for the DreamColor monitors and can be converted to stands thanks to Shane Hurlbut and Darin Necessary. Visit `www.hurlbutvisuals.com/blog/` and search for *DreamColor* for instructions and how you can order their custom parts to turn your case into a stand for the monitor. Note: if you do a search for *Pelican 1650* on the HurlBlog, it narrows the results to the post that features the DreamColor monitor.

Figure 2.43: Pelican 1510 case

CF Cards and SD Cards

Your data storage card is as critical to your shoot as the camera and lens. The big differences between various CF cards are the brand, size of the card, and speed of the card.

For shooting video, the larger the card, the more footage it can hold. In general, that points to buying the largest cards available to cut down on the number of cards you need on-set. However, there are a couple reasons not to buy the largest cards. First, the more footage on the card, the longer it takes to transfer to a hard drive. Depending on your workflow, you could get caught in a situation where it takes so long to copy the card and back it up that you are waiting on the transfer and not shooting. Second, the sensors on some DSLR cameras tend to heat up with heavy use. If you are using a larger CF card, it means you are running the camera more often and causing the sensor to heat up. Third, it is better to back up more frequently and leave less footage at risk of card failure or some accident with the camera that could damage the card.

We think working with 16 GB, 32 GB, or 64 GB cards that have a speed of 90 Mbps are the best option. Also, we like both SanDisk and Lexar brands of CF cards. They both rate near the top in speed and reliability and have worked very well for us.

Batteries

There is one simple rule in DSLR filmmaking: buy more batteries. These cameras chew through batteries, and you need to have plenty on hand. Unlike professional video cameras,

there isn't really an option to bulk charge many batteries at once in a single charger. So, buy lots of batteries and an extra battery charger.

Alternative options include making a battery backpack, using a battery pack grip, and using electrical outlet adapters that will allow for continuous power as long as you are connected to a power source.

If you are trying to keep the footprint of the camera small and mobile, then you are going to stay with the camera manufacturer's batteries. Depending on whether your location will have power (so you can charge regularly), you may need more batteries than you think. We never head to the set without at least five batteries per camera. We have never had to stop production to wait on batteries being charged, but there were a few times when it was a lot closer than we would have liked.

You might not want to limit your power to just your internal camera battery. Our favorite external battery has been the Switronix PB70 battery (Figure 2.44). You can get any connection to any of the leading camera manufacturers so you can power any camera with this battery. It is also a V-mount battery you can use to power external monitors or other accessories you need on set. Additionally, there are P-tap connections directly on the battery so you can power your camera, external monitor, and wireless follow focus all from the same power source.

Figure 2.44: Switronix PB70 with a Blackmagic power adapter

Planning Your Gear Package

Gear is easy to pick when there isn't a budget. With very few exceptions, you just pick the top price point in every category, and you are good to go. It is also easy to pick gear when the budget is bare-bones, because you just pick the cheapest model and shoot. However, practically speaking, most of the time the budget requires some decisions. As you plan your gear choices, keep this philosophy in mind: don't sacrifice on your camera kit, but if you must sacrifice, do it on the additional items. Most projects can be shot without additional equipment, but if you cut corners on your camera kit, the entire project will be universally affected.

It is also nice to remember that DSLR cameras have allowed for impressive results with some very basic lighting, creative hardware store–rigged camera support equipment, and post-production setups. So if you are stuck with a camera kit, make it the top quality you can afford because the rest of the production can be creatively and cheaply assembled and still result in a high-quality product. If you must scrimp, scrimp on the add-ons, not the core gear. Often, the camera kit is a third of the overall budget, but this percentage can be increased if you are on a limited budget. The quality of your piece depends on a quality image; decide what items will most impact the image and prioritize those purchases. In most cases, this means that the camera, lenses, and tripods will be the first and most important purchasing decisions.

It is easy to get lost in the ever-growing list of extras beyond the basics you need for a shoot. Let's start with the basic items of camera, lenses, and tripod, and then we'll look at the extras and what is optional vs. what is good to have on any set.

Here are a couple sample camera packages that range in price for you to use as a guideline.

Low Budget

For most people, the problem is the lack of funds to buy or rent exactly what they want for their shoot. These are our recommendations for those people:

Camera: Canon T5i Body Only, $700 Other DSLR cameras have different frame rates, and some have a larger sensor or can be used with better results in low-light situations. With that said, the T5i is a great camera and can deliver unbelievable images. Don't let the desire for a top-of-the-line camera stop or delay you from shooting. It is sometimes best to get a good camera and spend some more money on extras to make your project look better. Don't blow your entire budget on the first item on the list.

Lenses: Rent Canon 50 mm 1.4 and Zoom Lens or Buy Nikon AiS Lenses and Use Adapter Ring Again, go into any camera rental shop, website, or catalog, and you will quickly have a list that is too long for the number of lenses you want to have available to you on your shoot. This package helps you keep it simple. If you are shooting your first project or you are a seasoned photographer, sometimes focusing on a few lenses can actually help you create more interesting shots. Make it a challenge on how to best set up and shoot with a single lens, and you will be surprised just how many great and interesting shots you will capture.

Tripod: Sachtler ACE Tripod Tripods are often overlooked, and if you are coming from a still photography background, you may not be aware of just how good a friend a good fluid-head tripod can be for shooting video. Since the cameras are so light and any movement will show up in your shot, we feel this tripod delivers great results for the price and is pretty easy to work with and move from location to location.

Independent Budget

Some people have a modest budget that allows them to get close to what they want but not quite everything they want or need.

Camera: Canon 70D or 7D Mark II or Panasonic GH4 The 7D/70D allows you to shoot with more frame rates, is built rock solid, and creates a beautiful image. The GH4 is a huge step up from previous GH models. All these cameras output HD video signals, which is a huge plus when pulling focus with external monitors. The GH4 can shoot 4K, so that might be a factor to consider.

Lenses: Rent or buy Zeiss ZF or ZE Lenses or Canon L Glass Zeiss lenses are well known for a reason. We like working with the ZF lenses with an adapter because the ZF lenses have an iris ring, so we can control the aperture independent of the camera. Zeiss is known for their lenses' ability to capture sharp images, high contrast, and color-neutral images.

You can also use Canon L series lenses. They are truly great lenses that can create beautiful images. A plus is that if you have a Canon camera and use the camera for taking stills, you can take advantage of the autofocus and automated features between lens and camera.

Tripod: Sachtler Video 20 Head with Carbon Fiber Tripod Sachtler fluid heads and tripods are great, well built, and awesome to use. The downfall is that they are big and heavy, and if you have only a camera with a lens attached, they make the tripod seem

too big for the job. Don't let that fool you. The larger the fluid head, the smoother the movement you can create. You won't be disappointed with the results, but if you move from location to location frequently, just be aware that these are not light.

Blockbuster Budget

For some lucky few, money is no object, and they can secure exactly what they want or need. Here are our recommendations for those folks:

Camera: Canon 5D Mark III In our opinion, this is still the best DSLR camera on the market, period. If you have all the money in the world, buy a couple of 5D Mark III cameras and get extra coverage. This camera creates the best image in almost any light condition, and the skin tones captured are unmatched.

Lenses: Rent PL Mount Dalsa Cinema Lenses or Buy Zeiss CP.2 Lenses If you want the very best lenses in the world, then you want cinema lenses. For all but a few people, buying these lenses is not an option. The good news is that cinema lenses are available for rent in almost every major city with a motion-picture camera rental house, or there are online rental shops that will ship them to you. You will need to rent or convert your camera to a PL mount. Be warned that this is not a cheap process to have done, but if you shoot enough, it may be well worth the expense. If you can find Dalsa Prime Cinema lenses, those are the lenses of choice for DSLR cameras. These cine lenses were made by former Panavision designers using the very best Leica glass in the world to create the Dalsa lens series. These are somewhat rare, so just be forewarned they are not going to be readily available wherever you are located.

If you decide to buy Zeiss CP.2 lenses, you will be getting the highest-quality lenses that are housed in cinema housings. What is great is these lenses allow you to interchange the lens mounts on the back of the lenses and mount the lenses to any current lens mount/camera on the market today. This investment can grow with you throughout your career.

Tripod: O'Connor 1030 Head and Tripod Again, a workhorse tripod in the film industry can be your best friend in the DSLR film world. This one is amazingly easy to use for any level of operator.

The Next Three Things You Should Buy

After you have your camera, lenses, and tripod, you should buy or rent the following items, in order of priority:

Viewfinder When trying to get accurate focus and check your lighting and exposure, this is an invaluable tool. Using just the LCD screen is hard (but doable), and this makes using the camera for those purposes so much simpler.

Camera Support Unless you are able to shoot your entire project on a tripod, you will need some sort of camera support that assists you in getting stable handheld shots. Without this, you cannot hold the camera and expect usable results in any sort of reliable fashion.

Monitor Once you have a handheld camera support rig, you will want a field monitor you can attach to the rig. Some camera support systems allow you to offset your

camera so you can use a viewfinder, but not all allow that. Also, operating handheld can be hard when you are pressed against a viewfinder or looking at the small LCD screen. A larger screen that you can position so you can see for framing and composition while shooting is a huge asset.

If you don't have the budget for a monitor, then buy Duvetyne black fabric so you can drape over the camera and/or a viewfinder.

Should You Buy or Rent?

Regardless of your budget, some things are better to rent, and some things are better to buy. In general, here is what we think you should buy, rent, or buy only if you can afford:

Lens Adapters Buy. They are cheap, and they are almost impossible to find as a rental.

Matte Box Buy if you can afford to. If you are likely to use a matte box for a longer shoot, it might be more cost-effective to buy.

Filters Buy. Any filter you need to use often is best to buy and have in your kit. However, if you have a short shoot and you are not planning to use a particular filter very often, then rent. Filters can easily be rented from the top online lens rental sites.

Lighting Buy and rent. For most of your major lighting and grip equipment, it is best to rent. If you are working on jobs that require a lot of C-stands, flags, and other major lighting setups, it is best to rent so you don't turn into your own lighting and grip company.

However, lighting is critical to your job and as such you will need to own some lights. Depending on what types of videos you will be shooting, we recommend a minimum of a three-light kit, but ideally you should have five to six lights to help you shape. We would recommend either some Kino Flo lights (Divas, Barflys, or Celebs), Lowel Prime LED lights, or Rosco's Braq or Miro Cube lights. You can pick your main three lights from these and then augment with smaller accent lights such as the Switronix Torch LED lights.

You should also order a wide variety of different watt bulbs and some dimmers so you can use existing light fixtures and control the light. The ability to change a bulb in an existing lamp or light fixture saves a ton of time on the set.

Audio/Microphone Buy. Sound is critical to your production, and unless you have a budget big enough to hire a sound professional, that means that capturing good sound will fall to you. You need to buy some basic audio gear so you can be flexible and capture good sound. You will need an external recorder (Tascam DR60D) and/or an external preamp (juicedLink Riggy) to connect to the camera, a good wireless lav (Shure FP5 mic and FP1 receiver), a good shotgun microphone (RØDE NTG3), and a good set of headphones to monitor the sound you are capturing.

Again, if you have the budget to hire a sound professional, they will come with equipment. Use theirs because they are familiar with their gear and will have everything they need.

Slate Rent. Unless you are using an old-fashioned manual clapboard, rent. Any digital timecode slate will cost a fortune and is not a wise investment for most filmmakers.

Dolly Rent. The cost to purchase a real dolly with a booming arm is way out of the league of most independent filmmakers. Call your local camera rental house or lighting and grip rental house and rent a dolly from them.

Slider Rent or buy. Again, depending on how often you need this during your shoot, it is most likely worth just renting and spending your money elsewhere.

Follow Focus Rent until you can afford to buy. Taping the lens and manually pulling focus on still lenses is at times frustrating and time consuming. When you can afford it, buy some sort of manual follow-focus unit and some gears for your lenses.

Stabilizers Rent. Unless you are going to pay a lot of money to attend some sort of training and learn the skills to operate one of the major stabilization rigs, then rent the equipment. Better yet, hire someone who knows how to operate them and has their own gear. You save time on the set, and your shot will actually turn out. It's not a skill you can pick up in a day and reliably get your shots to work.

Case Buy. You need to protect your equipment, and as you keep acquiring more equipment, you will need extra cases. Make sure to have enough cases to store all of your cameras, lenses, and accessories so you have a place to store everything on the set. It is very easy to lose or misplace equipment or have it stolen. If you know what is in each case, then you can quickly see whether you are missing anything before you leave the set for the night.

Gear That Goes Together

There are certain pieces of equipment that once you buy, you need to be aware that you will need or likely want to have another specific piece of gear:

Handheld Camera Support You will likely want to buy or rent a field monitor because it makes using the handheld rig that much easier.

External Battery If you decide to power your camera, monitor, or other accessories with a Switronix battery, then you need to get a battery plate. The battery plate will have a port that allows you to connect a P-Tap cable to your other devices that need power. Additionally, you will likely also want a D-Tap, which is simply a one-to-four–port cable that allows you to plug in four devices to one port.

Pelican CF Card Case You will likely be shooting with multiple CF cards, and keeping track of them and keeping them safe are of paramount importance. Pelican makes a four-card hard case that you can store your CF cards in, and once they are in the case, they are almost impossible to damage.

AC Adapter We always recommend buying extra batteries, but it is worth the investment to buy an AC adapter for your camera. When there is a plug-in available, why not use it and not worry about changing batteries?

Monitors and Cables What good is a monitor without a cable? Having a backup cable on the set will likely save you time and headaches.

three

Testing and Custom Settings

Every blog, expert, and article about

DSLR video mentions the testing process that the filmmakers go through before shooting a project. The results of the test are usually given via camera stats, glossy photographs, or recommendations on cameras, camera settings, or gear.

Controlling the look of the image is an important goal of the moviemaker; the color and the ability to create a look are parts of the flow of your project. When shooting in RAW, a preset may change how the image looks on the screen and also can be used for providing quick parameters when gauging a look; however, these settings can be removed or altered later in post and are not ingrained on the image. With DSLR video, the changes to the picture done in the camera actually become part of how the image is shot. We will give you a good list of things to test or be aware of prior to shooting until RAW video is more commonly available.

Camera-Specific Testing

However carefully you plan your shoot and pick out your gear, you will also have to test your equipment—most importantly your camera—prior to shooting. Obviously, you don't *have* to run a test, but then you will likely find yourself doing reshoots or trying to fix your footage in post. And let's face it, making it through production will cause plenty of headaches; don't add another one to the list.

The testing process often sounds like a mysterious technical frenzy where mad tech scientists run the world. In reality, the DSLR filmmaker needs to only keep these steps in mind when it comes to testing:

1. Shoot a test that is as close as possible in terms of lighting, gear, and camera settings as those you are planning to use when shooting your final project.
2. Pay attention to any problems that you are having and try to fix them while shooting, noting any changes you make.
3. Look at your footage while you are shooting and make sure it all looks correct.
4. Show the footage to crewmembers—specifically the camera operator, director of photography, and sound person—and when possible, have them shoot the test footage with you.
5. Do any post-processing you were planning to use on your test footage. Get input on your test footage and decide whether you need to make any changes before the start of your shoot.
6. Look at your footage again in the format in which you plan on providing your finished project (for example, online or DVD) and listen to the audio.
7. Keep making adjustments until you are happy with the outcome or when you reach the level you think is the best possible.
8. Proceed with your project.

This process sounds simple, but it can involve many hours of hard work shooting in the field and poring over your gear or camera menus at home. It may involve procuring more gear, restructuring shots to fit budget considerations, planning post-production color-grading decisions, and altering lighting setups, just to name a few factors.

The reality is that testing is your practice, and you should use it as such. Pretend you are shooting for real, because talking and reading about the technology are fabulous techniques, but nobody truly knows anything until they do it; testing is the first time you really get to *do* it. Even if you are stuck with makeshift gear and no budget for post, testing will let you know what your limits are and let you plan for ways to work around them. Creativity is often at its best when you are dealing with limitations and you are forced to improvise and use your imagination to get what you want.

Testing ISO

The camera you are using will have a variety of ISOs to choose from. Adjusting the ISO on a digital camera is the closest you can come to changing the speed of a film stock. The higher the ISO, the less light that is needed for exposure. The lower the ISO, the more light that is needed for exposure. This follows exactly with film speed; higher film speeds require less light, and lower film speeds require more light. Likewise, higher film speeds result in greater grain, and higher ISOs result in higher noise levels.

In the video world, prior to the adjustable ISOs in the camera, the closest setting was adjusting gain. DSLRs opened up the world of easily adjustable ISO to video.

However, there is a twist; sometimes in the DSLR world, the lower ISOs actually turn out to have more noise than the higher ISOs. One cause of this is that the sensor records a limited color space, and if is not enough light, the color space is dramatically cut down. This potential for a reduced color space by shooting a low ISO with not enough light can result in a noisier and much less-color-rich image. Color space is crucial to maintain with the DSLR-limited 8-bit compressed color space. In these cases, it is better to shoot with a higher ISO to maintain color space, especially if you're going to do any color grading in post.

Dynamic Range and Tonal Range

These terms are used for both images and sensors. The *dynamic range* is the ratio between the darkest and lightest parts of the image or what the sensor can capture. The dynamic range of a sensor can be affected by all sorts of characteristics, including ISO, and is described as a ratio between the highest brightness that the sensor can capture and the lowest darkness it can capture before being overcome by noise. The *tonal range* is the number or range of tones that are available to express the dynamic range. The dynamic range and the tonal range are interconnected.

As you test for ISO (Figure 3.1), look for what lighting will be necessary to keep your images rich and noise free. DSLRs handle low-light situations very well, but there are limits, and your objective is to find those limits and set your project parameters within them whenever possible. Test several shots using various ISOs to determine whether the ISO levels are adequate for the image quality desired.

Figure 3.1: ISO noise test shot at 320 ISO (left); test shot at 6400 (right). Notice in the face and on the sidewalk the red and green noise pixels.

The particular results of the same ISO setting will vary with different types of cameras. Some cameras handle higher ISO settings better than others. If your shots require high ISO settings, sometimes renting an alternative camera for a day is a way to solve a particular shot. If most of your shots require high ISO settings, testing several cameras on the same shot will be a smart approach.

If you are not controlling the lighting on your shoot, it is helpful to figure out what ISO maximum setting you are comfortable using. When you know your ISO limit, you may be able to make plans to adjust your lens choice, make aperture changes if possible, add filters if necessary, move locations, or sometimes just grin and bear it.

When you are testing ISOs, it makes sense to find out which ISOs your camera or potential cameras shoot the best. There may be variations with the different ISOs in terms

of image quality that initially seem counterintuitive. It is possible to have a better image with a slightly higher ISO if that ISO functions better in your camera. Sometimes the results may show that it is better to step up the ISO by one notch to get a better-quality image. There is a ton of debate and technical explanation as to why this happens, but if you look at ISO tests done by various professionals in many settings, it is clear that some ISOs produce better results even when all images are properly exposed.

For testing purposes, you are looking for ISOs that produce images with the least noise and are the cleanest looking. You can run several tests to look at the various ISOs available on your camera. The first is to run several black shots, changing the ISO for each shot, and then create color charts and shots of the same scene done with ISO changes and properly exposed. Now look at all of these images and take note of which ISOs produce the best results. When shooting black or with the lens cap, you are looking for red or potentially blue marks; in other shoots, you are looking for noise and loss of detail in shadows or highlights.

When looking at the images, take careful note of the dynamic range, the highlight, and the shadow detail. Test these ISOs with manual control, and if you plan on using manual control, retest with any priority modes or camera settings you are planning on using. Particular modes such as highlight priority can alter how the image looks with certain ISO settings. Some cameras will have a wider range of available ISOs than others, but regardless of what ISOs are available to you, testing them will help you make ISO decisions when you're on the set.

Native ISOs and True ISOs

The camera's ISO settings are internally controlled, and the process is fairly complex. Camera manufacturers generally like to keep such detailed camera maneuvers under wraps. The sensor in the camera will determine what ISO is the camera's "native" ISO. The camera's ISO settings are designed to match a comparable film speed when the film and the sensor are used in an identical situation with identical shutter speeds and aperture. The native ISO is simply thought of as the ISO that the camera's sensor was designed for and for which the sensor has the least amplification or change in the signal. You cannot change the native ISO any more than you can change the speed of a particular film. So, when you change the ISO setting on your DSLR, the sensor and camera take this native ISO and scale amplifier gains in a consistent pattern. This consistent pattern can result in a consistent pattern of ISO settings that operate close to the native ISO in terms of image quality. Sometimes people refer to this chain of ISO amplifiers that operate like the native ISO sensitivity as other *native* ISOs or *true* ISOs.

Some DSLRs also have ISOs that are at half stops or intermediate points between the more standard ISOs. These ISOs have undergone some digital manipulation in addition to the amplification pattern to be achieved. The camera may also have lower ISOs than the native ISO, and the circuitry will adjust in a decreasing pattern in an analogous way to how it amplifies as the ISO increases.

The original native ISO does not have to be a standard 100 or 200; in fact, the native ISO can easily be a nonstandard ISO. The camera engineers are attempting to design a sensor and camera that uses ISO manipulation to minimize any image troubles, so focusing on what ISO is actually native for information's sake alone is usually not worth the time. The dilemma with the discussion on native ISO is that most of the time the whole point is trying to determine what ISOs work best in the camera. It doesn't really matter if the best-performing ISOs are native; what matters is that you have a set of ISOs that offer a better picture than others. This is why you need to test the ISOs on your camera and determine whether there is a pattern or group of ISOs that look better and use them!

Testing Exposure and Color

During the testing phase, proper exposure for your conditions is one of the best things you can do to ensure that your shoot is successful. Eventually you should get so comfortable with the exposure that you will be able to shortcut it by eyeballing exposure on the LCD or monitor, knowing that the exposure you are getting will give you the desired result. But this shortcut works only if you have a lot of practice knowing what a proper exposure looks like on your DSLR.

Using In-Camera Metering Systems for Proper Exposure

Typically filmmakers use external meters to measure the light levels in the shot, and videographers use various monitoring systems to check light-related levels. Still photographers may be accustomed to light meters or in-camera metering systems; DSLR moviemakers are usually provided with in-camera metering systems. Even if you are not planning on using the in-camera metering system as your guide, it is important to know how it functions. Also, light meters are not always as accurate in function when using a DSLR because the sensor can pick up light in ways that are not consistent with how the same light works with a film scenario.

At the beginning of testing, it may be necessary to always use a metering system to check for proper exposure. The metering system gives you a backup for your eye when you are figuring out how to consistently get proper exposure for each shot. Using the metering system will allow you to get a precise value for exposure before you manually set the exposure values.

If you are not familiar with in-camera metering systems, test all of the systems that are available on your camera and read your camera manual (Figure 3.2). The first step is to find out what kinds of metering systems are available on your camera while you are shooting video. Also, if you are using manual controls, the metering system is not going to set what your exposure is but is there to help guide you with correct exposure. If you are not on a fully automatic setting, you may want to check what metering system your camera is using in these settings.

Figure 3.2: In-camera metering system: these icons mean (left to right) evaluative, partial, spot, and center-weighted-average metering.

It is also important to be comfortable reading the standard exposure-metering index that is usually shown at the bottom of the viewfinder when you are adjusting exposure. This will show you where your exposure is falling and give you an idea of what range is easily available. This is the time to test, first using the LCD and metering systems and then putting your test shots on the final format medium and viewing them in final product form. Following through with the entire process will allow you to see whether your camera consistently exposes in a way that needs to be universally adjusted. For example, sometimes people will find that their camera will overexpose every shot slightly more than they desire, and they will adjust for this in every shot.

The spot meter is often the best choice for using the in-camera metering system when shooting video. The spot meter allows you to choose what part of the shot you want metered and what part of the shot you want to concentrate your exposure around. The spot

meter can also assist you if you are accustomed to visualizing using the Zone System or if you want to double-check to make sure that your light ratios will give the correct exposure.

Exposure Latitude and Dynamic Range

Another important consideration is that with a DSLR system there will be more limited dynamic range to work with than with film or with high-end camera systems like the RED or ARRI ALEXA. DSLR cameras will likely have a range of up to 13 stops for larger sensors and up to 9 stops for smaller sensors (Figure 3.3); the highlights in particular may be limited. If you are from a traditional video background, this range will not be a problem for you to work within. If you are accustomed to film, the awareness that you have fewer stops is helpful, and you will need to be extra careful with in-camera settings and exposure.

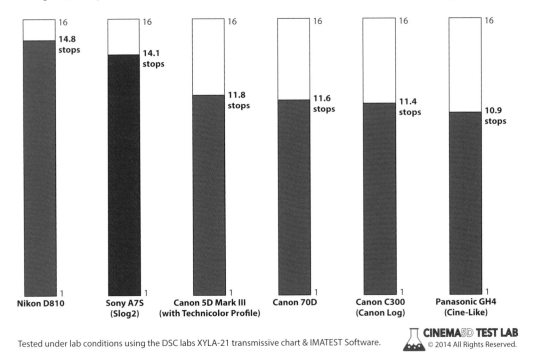

Tested under lab conditions using the DSC labs XYLA-21 transmissive chart & IMATEST Software.

Figure 3.3: A chart showing the various latitude ranges of a variety of DSLR cameras

Great exposure and latitude can be achieved within the limited dynamic range; however, it is vitally important that the exposure captured with the camera be proper. This is because, when using a DSLR, post will not be able to fix overexposed images much at all; anything blown out will be gone, underexposed images may not clean up as well as you are accustomed to with underexposed film, and clipped parts will be hard to improve. This doesn't mean that post-processing isn't possible or helpful; it just means it is crucial to get it right in the camera when you shoot. That is why much of your testing process will involve testing exposure of your various lighting setups and as many of your locations as possible.

If you have a video background, this limited dynamic range will seldom register as a concern, because how the camera deals with low-light situations will still be as good as or better than your previous ENG cameras. If you are accustomed to dealing with film or even solely RAW files, you will want to extensively test this limited dynamic range and how you deal with exposure latitude so that on the set and when planning lighting you know exactly

what your camera can accomplish. The DSLR cameras with the larger chips should have a greater dynamic range and broader exposure latitude potential.

If you are not going to do post-production work on your image, then how you expose your image on set should be as close as possible to how you want the final image to be. What you see on set is what you will get. The question now is how to see exactly what you are getting on set.

Don't rely just on the LCD or a monitor until you have properly tested the footage through the entire processing change, including the final format output, because the monitors or LCDs and other methods to check footage can be off enough that you will want to adjust your plans.

Using the Histogram to Help Gauge Exposure

The histogram shows the tonal distribution within the shot. A histogram tallies the darker tones toward the left side and the lighter tones toward the right. As you look at the histogram, you can see whether a large tonal range has been captured, with the graph showing a mixture of tonal values. If a full tonal range has not been captured but there are many tones that are dark or light, look at your shot to see whether you are capturing the tonal range you want.

The histogram can also be an indicator of exposure. If all the tones are dark or all are light with no range, you may need to change exposure to make sure your image has a nice range. Look at the histogram to make sure you are not losing detail or crushing blacks and that the highlights are not blown out (Figure 3.4). As you test each shot, check the histogram to make sure you are capturing as much detail as possible. If you are not doing any post-production work with the footage, you may choose for artistic reasons to work with some extremes present.

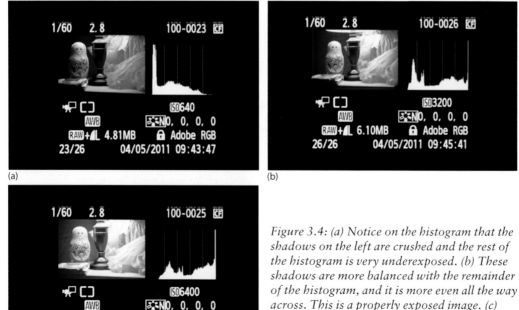

(a)

(b)

(c)

Figure 3.4: (a) Notice on the histogram that the shadows on the left are crushed and the rest of the histogram is very underexposed. (b) These shadows are more balanced with the remainder of the histogram, and it is more even all the way across. This is a properly exposed image. (c) There is little to no shadow on the histogram, and the highlights on the right are peaking. This image is overexposed.

Run exposure tests by shooting the same scene several times, changing the exposure until the scene is underexposed and then changing again until the scene is overexposed. You can shoot the scene as it is naturally, or you can shoot the scene with a gray card or even a visual zone reference included to give you a method to count steps if you find that easier. Between these two extremes of underexposure and overexposure is where your correct exposure will lie; deciding where you want to expose in this correct exposure range is where you get to play and have fun creatively. Sometimes there is a very limited spot to play in, and occasionally you may find that your desired exposure is not possible without major changes, Either way, now you know.

At the end of the testing process, you should be able to check exposure on the set very quickly and eventually will be eyeballing it using your LCD or monitors. Some people feel more comfortable monitoring the exposure with metering systems continually through production.

Testing Color Temperature and White Balance

As you do your test shots, take note of the white balance that is desired for each shot. The camera's automatic white balance settings may be perfectly fine. However, often it is necessary to adjust white balance to suit the look of your project. There are usually several white balance preset options in camera. These presets allow you to adjust for specific lighting temperatures. Additionally, it is crucial to understand how to manually adjust the white balance (Figure 3.5).

Figure 3.5: Datacolor SpyderCHECKR to judge color and white balance

The white balance and color temperature choices that you make while shooting will determine how the color is recorded in the image. Because of the limited color space, you don't want to have to make white balance changes in post. If you are utilizing a creative white balance or color temperature look, it is necessary to run the test shots through all of the post-production procedures. It is also helpful to have a consistent color temperature story for each shot so that the final product will have a coherent look in an individual shot.

The cameras also can have slight color casts or hues. Test shots will allow you to look at an image and make corrections if the camera records a little off or a little red or blue or if it records inconsistently in a mixed lighting situation.

If sunlight is the primary source of light for some of the shots, it will also be necessary to track any sunlight changes for the shoot. The white balance or color temperature may have to be adjusted in accordance with the sun changes. While testing, stay in the location and keep shooting for as long as you are planning to stay in the sunlight on the shoot. Look at the various shots to make sure you have any color temperature adjustments factored into your shooting or whether you need to change your shoot schedule to factor in natural light changes.

Testing Frame Rate and Shutter Speed

Most of the time you will want your project to be as cinematic as possible. For this reason, the standard is to pick the frame rate that is closest to motion-picture film or to 24 fps.

You might also want to shoot some slow-motion footage (assuming your DSLR camera allows), and in most cases that will mean shooting at 50 fps or 60 fps. Shoot both when testing and see which you like better. Before you walk onto the set, you want to work out whether you need to set a different frame rate for a particular scene.

Shutter speed is another thing you need to be aware of and test. On film cameras, you didn't have the ability to shoot with the options available on DSLR cameras. A traditional film camera's shutter is set at 180°. This would mean if you were shooting 24 fps, you would want your shutter at 1/50 (which is the closest you can get on a DSLR camera to the 1/48 that is on a film camera). This may be a problem if you are shooting in a country with 60 Hz power, like the United States. When shooting at a 1/50 shutter speed, you might get lines in your light source that move vertically from top to bottom in your footage. If you are noticing this problem, switch to a different shutter speed, and the problem should go away or at the least minimize the effects.

Testing Recording Length Limitations and File Size Limitations

Most DSLR cameras have recording length limitations for how long they can continuously shoot or file size limitations, as shown in Table 3.1. You can check your camera's specifications from the manufacturer. This means there is a time when the camera will stop recording a single shot and need to be restarted. When testing, make sure you know whether your camera has a limitation, and check your longest shot to make sure it fits. This is especially important if you are running a camera that is rigged and needs to be started remotely or a camera that needs to be rigged and cannot be started remotely. You don't want a rigged camera to run out of recording time midshot.

Table 3.1: ADD cameras and recording limits

Camera	Recording limit
Canon 5D Mark III	29 min 59 sec
Sony a7S	30 min
Panasonic GH4	No limit on recording times
Canon 7D Mark II	29 min 59 sec

Testing File Formats and Codecs

The end product and post-production are the primary considerations for this decision. At the advent of DSLR moviemaking, there were many file format issues with editing systems and various other considerations, but these problems have mostly been addressed. Just note that any new codecs or recording formats may not be supported in your current editing software at the time of a camera's release. Check any new camera's codec with your editing program to make sure you are set for the edit.

Do some test shots with your camera and then try bringing them into your computer, importing them into your editing system, and cutting a few shots together. Then export your mini-test project and send it to the medium you are planning on using for your real project. If you are going to the Web, export at the size and quality you want and see what it looks like. Did you have any problems? If everything works fine, you are set to go.

Make sure to periodically check for any firmware updates, because features can be added to your camera via firmware updates.

Testing Equipment Interactions

The camera is the eye of the entire shoot, and many components that interact with the camera will need to be tested or observed during the test shoots.

Testing Lenses

The initial test of lenses will be to make sure that all of your lenses are compatible and fit your camera. Take note of any crop sensor issues that you may have and adjust accordingly (Figure 3.6). You may also be lucky enough to be able to test various types of lenses for clarity, sharpness, and overall look with the camera. However, you also should run your lens through the paces even if you are dealing with a kit lens. It is good to know how your lenses react to the light, especially if they have a color tendency and if any distortion, breathing issues, or other issues may arise. Now is the time to admire the bokeh and plan for depth of field and aperture settings for each shot.

5D Mark III Full Frame
24fps
1/50
f11
WB: Daylight
85mm Zeiss ZE Lens

T2i APS-C (1.6 Crop)
24fps
1/50
f11
WB: Daylight
85mm Zeiss ZE Lens

Figure 3.6: Alcatraz shot with the same lens from the same position with a full-frame sensor and a 1.6 crop sensor

If you are not accustomed to handling cine lenses or lenses that have been de-clicked, now is the time to pull those out and shoot like crazy. (We will describe *de-clicking* a still lens in Chapter 4, "Cameras and Lenses on Location.") If you are planning on using a specialty lens (Figure 3.7), get it now, rent it an extra day if necessary, and plan the shot. If you are using lenses that you have been using to shoot stills, try them with movement in the shot. The same lens that you use for a still can produce very different results when there is motion. Distortion that is acceptable or even artistic in a still can go haywire with a little motion in a scene.

Figure 3.7: Russian Helios M42 Pink Flare lens

If you have never used interchangeable lenses, try as many as you possibly can and take notes. Take shots and stills as a reference guide as you make your lens plans for the shoot. Practice what lens will be used for each shot and then change the lens, change your composition, and change the camera's physical location to see what happens. If you are in a location where the options for movement are limited, it is even more crucial to figure out lens choice. Try to come up with at least two angles or two different lenses for each shot so that you have options on the day of shooting if anything changes, and also think about how the scene is going to cut together. How will you plan coverage with your lenses? Use your lenses with your actors; some people look much better with different lenses. Practice setting the focus marks with each lens for each scene in each location. Working out the tedious details now will save you tons of time when it really counts.

Testing Filters, Hoods, and Matte Boxes

We gave our recommendations for accessories in Chapter 2, "Gear and Recommendations," but you don't need to take our word for it. If you have access to various models or filters, do some tests yourself. You might find a solution that is cheaper or better for your project than what we recommend.

In terms of filters, the best thing you can do is get your hands on multiple cameras and put the same filter (but from different manufacturers) on each camera. Then just see whether you notice a difference or performance change. Do your tests with a color chart or at sunrise or sunset. Filters have their biggest differences when shooting colors and at dusk and dawn.

Testing Variable ND Filters

The following are things to look for when testing your ND filters:

Loss of Sharpness and Color Shift Good filters won't have any color shifting or loss of sharpness, but poorer-quality ones may have these problems. You need to take a picture or quick video clip at each stop of your lens. You should not notice a slight change in color or loss of sharpness throughout the stops on the lens. If you find either of these problems, get a new filter. If you are in a pinch and that is all you have available, make a note of which stops are still sharp enough and cause the least amount of color shift or loss. Then make sure you shoot only with those f-stops when that filter is on the camera.

Color Shift Color shifting can happen at any ND amount but usually is more apparent with darker ND settings. For your test, get enough light, set your ND to the maximum, and test shoot a color chart or a variety of colors. Look for the difference from no ND to the high ND images. If you notice the colors changing at all, you should get a new filter.

Vignetting Check for potential vignetting (Figure 3.8) on any lenses you plan to shoot with. Usually problems with vignetting with ND filters show up on larger lenses. If you check your longest lens and there is no vignetting, then you are most likely fine, but it takes only a few minutes to check all your lenses.

Figure 3.8: Vignetting on a 21 mm lens on a full-frame sensor camera with a circular polarizer attached

Change in Exposure While Pulling Focus Variable ND filters work like circular polarizers in that there are more or less two lenses attached to each other, and you can twist the outside lens to affect the amount of ND you want. Because the variable ND filter cannot be locked into place, it is easy to bump. Be careful as you pull focus because you can easily move the ND filter and change the exposure and therefore ruin your shot.

Testing Matte Boxes

Matte boxes are a bit tricky. Some people use them all the time, and others don't use them at all. This really depends on what you are shooting and if you like working with a matte box. The big things to be aware of are how the matte box attaches to the camera (does it screw onto the lens or mount to the support rails?), how many slots it has, what size filters it accepts, and ease of getting the matte box on and off when you need to change your lens. On film cameras, the matte boxes are designed to swing open (Figure 3.9) and allow easy access for the camera assistant to remove and change lenses and then shut the matte box and not have to reset. Out of all the accessories we have worked with, this is probably the most important one you need to try before you buy.

Figure 3.9: A swing-away matte box allows you to open the matte box and access the lens without removing it from the camera rig.

Testing Viewfinders and EVF

There are more eyepieces hitting the market every day, so the next greatest thing might hit the market after you read this book. We have owned three different eyepieces, and the only real way to tell whether the eyepiece will work is to have it in your hands and try it. We asked dozens of people for their recommendations, and some people liked each of the ones we bought. So, our best advice is to see whether you can use one before you buy it.

Stability The main uses for a viewfinder are improved focusing, better color, and stability of the camera. Since viewfinders attach in a variety of manners, it is best to put the viewfinder on the camera and shoot some test shots. Does using the viewfinder stabilize your footage enough, or do you need more equipment to help stabilize your shots?

Check for Moisture Just like any electronic equipment or glass, extreme moisture or temperature change can create moisture buildup on the camera, viewfinder, or both. Some viewfinders have an antifog coating. If yours does, check for moisture around the bracket. This shows up in extreme temperature changes. You don't want moisture to build up between the viewfinder and the LCD screen. If you find yourself in shooting conditions that are more prone to moisture, get into the habit of checking or removing the viewfinder when not shooting to let both the camera and the viewfinder breathe.

Diopter Some if not most viewfinders now have a diopter. A diopter can help you change the focus ability to adjust for someone who needs glasses and takes them off to view the camera. If you need to use the diopter, see how easy it is to use and whether you can quickly change it if you are having a director look through the viewfinder and then switching back to a camera operator or the director of photography. Some models like the Hoodman tend to twist on the back of the camera and are less user friendly when it comes to the diopter functionality.

Magnification Factor The magnification of various viewfinders ranges from 1× to 3×. In many cases, a 1× magnification is used when you need to use the viewfinder only as another stabilization point. It may not be enough to help you obtain better focus. On the other extreme, a 3× magnification can actually make it so you cannot view all of your LCD screen at one time. This can be a problem because you may not notice things like the boom mic in the very edge of the frame if you are not very careful and don't have time to review each take on a monitor.

Barrel Distortion Barrel distortion can come from a camera lens or from a viewfinder. The key is to find out whether the lens or the viewfinder is causing the problem. If you notice any barrel distortion when using/testing your viewfinder, record a video clip to see whether the distortion is from the viewfinder or from the lens.

Pixelization In lower-resolution LCD screens like the 5D Mark II, you can get what appears to be pixelization of the image, which is caused by the viewfinder. Don't panic, because the pixelization is not being captured in your footage; it's just something you have to deal with while shooting.

Figure 3.10: Zacuto Z-Finder EVF

The only real way to test a viewfinder is to put it on your camera and try shooting something with it. Some models will attach with rubber bands, some will have you glue a holder onto your LCD viewfinder, and others will have brackets that attach to your tripod and hold the viewfinder in place. Depending on what sort of shoot you are doing, some or all of these might work; others may spin or slide too much and won't be an ideal fit for you.

Recently manufacturers have introduced electric viewfinders (EVFs). Videographers are very familiar with EVFs (Figure 3.10), and they open things up so you don't always have to be looking at the back of the camera. Your decision will come down to price and extra features when choosing an EVF.

Testing Lighting: Color Temperature and Amount of Light

DSLRs took over with a vengeance because of their amazing capabilities to handle light, in particular low-light situations. This does not mean you don't have to consider the light when shooting with a DSLR. Even if you are familiar with lighting, it pays to test your proposed lighting. In general, you will be lighting one to two stops less in the overall shot to account for the DSLR sensitivity. Sometimes this means that instead of adding lights, you will be taking light away or taking it down a few notches.

This notion of reducing light means people who are accustomed to lighting for film will be able to use all of their knowledge with a little tweaking. Instead of adding light and then adjusting for the ratio and contrast, you may be in a situation of having to block out street lights or replace lights with dimmer lights. You may find you are also in sudden prodigious need of more flags and ways to diffuse the lighting. With DSLRs, you may run into overexposure more frequently than with the same lighting being used with other mediums; although this isn't a problem with some planning, while you are testing, you should keep a close eye on it.

If you are accustomed to lighting for video, you will continually be struck by just how much range the camera has in terms of lighting and how many scenes look fabulous in what normally would have been impossible lighting conditions. If you are a still photographer

and are not accustomed to continuous lighting, it's time to really focus on how to use your lighting knowledge in a new way. If you are using continuous lighting for still photography, you can even test the camera using your existing lights.

In addition, with DSLRs you can light scenes with unique lights, with sources found in hardware stores, or using all sorts of creative lighting options. This variety is available because the cameras are able to use low-light sources, so you can figure out the lighting ratio overall using nothing but low-light sources. This means that "run-and-gun" shooting can provide some interesting results and can be done in a wide variety of natural light situations.

If you are not already familiar with how various types of lights and light temperatures will register on camera, use the testing process to shoot as many different types of lighting as possible. Make color-correction notes, especially in mixed-type lighting shots. If the shot moves into another light source's light, the light quality will change, and color correction will not be able to fully balance this. Light temperature changes and different light source kickers are often used for creative effect.

If you are shooting on location, you may want to bring different types of lighting to either match or contrast with existing light. Ensure that the scene can be properly cut together with a coherent lighting plan. Now is the time to practice with gels or color filters and plan for your on-set supply list. Make notes for any lighting changes that must be made, keeping in mind the lighting ratios that will be necessary for proper exposure and detail in your shot.

Using and Calibrating External Monitors

You can shoot with just your DSLR camera, but the LCD screen is small and, depending on how you rig the camera, might not easily be viewable. In these circumstances, you will need to use a monitor of some sort.

Connections

It is key that you be aware of the types of ports on your DSLR camera. Unlike professional video cameras, your DSLR will most likely have an HDMI or other consumer video port. This is important because many monitors are designed for professional video cameras and may not have the correct input port for your DSLR camera. If your monitor doesn't have the correct port, then you need to add a converter box. Endless varieties of converter boxes are available that will turn just about any signal or cable into another signal or cable. They range in price from $20 to over $1,000. Unless you own or have access to a monitor that doesn't have the correct input for your camera, just buy or rent one that does.

Every time you add another cable, converter, or extra connector between the camera and the monitor, there is a chance for failure. The only real way to test your connections is to set up your camera, monitor, and any other equipment that is connected via cables. Connect all the elements and power on the camera and monitor. If any cables have gone bad, you will not be able to see an image. You must painstakingly remove each cable and replace it with a new one until you find the bad cable.

Color, Contrast, Brightness, and Resolution

Color, contrast, brightness, and resolution are critical for use with any video camera. You want to make sure your color is set so the image you are viewing in the monitor will match what you have when you get to the edit suite. Different monitors will have a varying number of colors they can display, different contrast ratios, differing contrast levels, and various resolutions. A good rule of thumb, as with most gear purchases, is that the more expensive the monitor, the

better it is. You want to get an HD monitor because all DSLR cameras record in HD and not standard definition. Some DSLR cameras when recording display only an SD signal, but before recording and during playback, you will need the HD monitor for best performance.

Once you choose your monitor, you need to do some sort of color calibration to set the colors so they are proper. There are various ways you can do this, but the most common ways are by using software and by using a colorimeter.

As you set up the shot or watch the footage, the color is a major component to check. Making sure that your field monitor is accurately translating the colors is an important step to ensuring accurate color.

Always make sure that the monitor is warmed up (it's usually a good idea to have it warm up for 20 to 30 minutes before you judge color using it) and that you are calibrating it in proper lighting so that you are able to accurately judge the colors. The best environment for color calibration is usually a darkened room with gray or black backgrounds, but in a field setting you should minimize as much ambient light as possible and avoid bright lights or glare on the monitor.

Cover the Monitor

If you do not have a tent or area where you can get out of the sun, then make sure to have a black cloth (Duvetyne works great) that you can drape over you and the monitor. Ambient light that hits your monitor has the greatest impact on degrading how you perceive color, contrast, and exposure. You can use a blanket or jacket in a pinch.

Sending Color Bars from Your NLE to Your Field Monitor

Depending on the type of monitor you are using, it may or may not have built-in color bars. If your monitor has them, then use the built-in color bars and adjust your color settings accordingly.

 If color bars are not available—which seems to be the case on the HDMI monitors used for many DSLR shoots—you can shoot a color chart or feed the monitor color bars from the editing software on your computer to calibrate your field monitor. Let's take a look at sending color bars from Final Cut Pro to your monitor. Most NLEs will be able to send a color bar signal, so don't worry if you have another editing program; the steps should translate.

1. Connect your computer to your monitor.
2. Have your editing software send a set of color bars out of the program. For example, in Final Cut Pro go to your Viewer window and click the Clip tab at the lower-right side of the frame.
3. Select Bars And Tone (Figure 3.11) and pick the signal you are shooting with.

Figure 3.11: Select the bars and tone you are shooting with.

4. Choose a setting that converts the color bars to monochrome; this might be named Mono or Grayscale on your setup. On a Marshall monitor, change the menu settings to Mono ➢ Check Field ➢ Mono (Figure 3.12).

Figure 3.12: The menu on a Marshall monitor

5. Adjust the brightness on the monitor. Start by turning it all the way down and then bring it up. You will notice a little black bar in the lower right (called the *pluge*: picture line-up generation equipment) start to disappear or reappear depending on your brightness settings, as shown in Figure 3.13. You want the black bar to be just barely visible. It's best to get it to fully blend in and then slightly adjust it until you see it.

Brightness all the way down

Brightness all the way up

The lower-right corner and the little strip that is barely visible

Figure 3.13: Varying the brightness

6. Next, on your monitor, adjust the contrast knob. Again, turn it all the way up so the blacks totally crush (Figure 3.14) and then down so the whites totally blow out. Then back it down until you get an even gradation all the way across. You are looking for an 80 percent gray for the white value.

Contrast all the way down

Contrast all the way up

Correct setting with the white being an 80 percent gray

Figure 3.14: Varying the contrast

7. Next, go back into the menu and adjust the colors. Start with the Blues menu or Blue menu ➤ Check Field ➤ Blue (Figure 3.15).

Figure 3.15: Menu setting for blue channel

8. Once you are set in blue mode, then adjust the color knob. You want to pay attention to the outer two columns on the monitor. The bar columns are tall with a small rectangle box near the bottom. The goal is to adjust the blues until both of the lower rectangle boxes match the larger columns above them (Figure 3.16).

Figure 3.16: Notice the lower box in each outer column before adjustment. The correct setting is where the lower box matches in each outer column.

Now you should get out of the menu on the monitor and view the color bars. They should look like Figure 3.17. If they do, then your monitor is calibrated and ready to shoot. Testing and calibrating the field monitor is just the beginning of the process. Any monitor that you are viewing the footage on in post-production should also be properly calibrated.

Testing Focus Pulling and Follow Focus

When shooting video, you are not going to be using autofocus in most circumstances. This means you are going to be dealing with focus for every single shot. As you plan the focus for every shot, account for any movement in the shot or focus changes you want to make.

Figure 3.17: Correctly set-up color bars

Canon 70D Autofocus Feature

Recent cameras such as the Canon 70D now are allowing users to autofocus during video recording. This trend should continue and more and more camera models will add autofocus features to their cameras. Just note that autofocus will remain a tool like any other feature, and you can use it when appropriate and forget about it when not.

DSLR moviemaking involves using a camera and lenses that are designed around still-camera technology. A full-frame sensor with a large aperture in low light can result in some situations where pulling focus is essentially impossible if there is any movement by the subject. Also, in these cases, if the focus is off your actor's eye at all, it must be because that is a creative decision. Watching an out-of-focus actor on a large screen is unbearable, and this focus problem is even noticeable on small screens. Double-check your focus on the monitor if you have one, and also check all of the focus in your test shots when you are checking your footage in final project format. It may become necessary to measure your focal plane and field of focus for every shot if you are having trouble achieving consistent focus.

If you are pulling focus in a scene or using a follow focus, test the entire shot with movement to ensure that you will be able to achieve focus for your shot. You may need to have a dedicated focus puller for several shots and if possible practice with that person. If you are using a follow-focus unit, make sure that it fits your lenses and that you have all the plates, lens gears, rods, or any other items that you may need for your system to work. Don't just practice this at home; practice this system in a situation that is as close to your shoot as possible.

Remote Starting the Camera and Rigging in Unique Spots

If you have shots that involve rigging the camera anywhere from simple rigs in odd set locations or complicated rigs on motor vehicles, it is best to test these shots extensively. The interaction between the camera setup and the rigging can complicate a shot, so doing a test of the procedure will be very helpful.

Even if you can't run the entire shot for budgetary concerns, get the camera and rigging in as close a scenario as possible. With the small size of DSLRs and relatively low cost, rigging with these cameras is fun. With the small size, you may discover rigging positions that you haven't been able to get before, and you may be able to use more cameras to get more angles on your shot. Make sure the movement works, the angle of view is appropriate, you know when the camera will start and stop, you know how to reset the scene, and you have a checklist for resetting. It is disheartening to be on the set and run an entire complicated motion scene with multiple cameras being rigged only to find out that a camera wasn't turned on for the shot.

If you are traveling to another country, remember to bring extra screws and spare parts for your rigging, along with the basic tools to adjust it. Different countries run on different measuring systems, and if you require a screw that is not a standard measurement in the area you are shooting in or the nearest hardware store is 100 miles away, the entire shot can fail over a simple piece that could have easily been thrown into your kit before the shoot.

Scenes that are extensive or have a large number of components must be tested the most. Figure out how the communication will work between all parties to make sure that the remote starts the camera. Make sure the rigging is tested thoroughly by running the shot and role-playing every step, taking notes along the way. Finally, compile a master check list to go over with every person involved in the shot.

Testing Camera Movement

DSLR video movement has some interesting challenges. These cameras were not physically designed with the intention that movement would be a major function of the camera like with a video or film camera. Plan all the movement that your project needs and run the camera through the paces. If you are planning to handhold your camera, check to make sure that the footage looks steady enough for your project, and make adjustments either

with gear or with technique if necessary. If you are accustomed to film production, test the movement to see how this camera handles your shot. Make sure all of the gear you need for a jib arm, Steadicam shot, or dolly shot is available. You have many options for your rigs to make movement shots more stable and controllable; using these rigs is not like using a video camera or a film camera, and it is necessary to do some planning to find out which one will work best with your operator and the shot's requirements.

Testing Off-Camera Audio

It is likely that the audio will be run from an external system. It is often still a good idea to run audio from the camera for quick checks. If there are syncing problems and audio must be adjusted, it can be nice to have the rough camera audio to use as a guide. Check to make sure that the audio is recording the best possible. Many small-budget projects use an audio person on set because the expense of purchasing audio gear is usually prohibitive and typically most moviemakers don't possess the talent or experience of an audio person.

Also, if external audio is being used, test the entire system in advance; take into account any issues that may screw up the audio on set or on location. Airplane flight patterns will potentially be a major problem; wardrobe may need to be modified or replaced if it makes distracting noises. Find places to locate the audio equipment, consider book microphones and lavaliere mics in relation to the number of speaking parts, and take notes of all field audio that is crucial for background, sound effects, or post-audio work. Keep in mind that wind patterns or other weather changes may be in play on the days of the shoot, so take notes and plan for inevitable problems.

The audio person will be the one most often disparaged on the set because they will be asking for levels to be checked, for quiet at crucial moments, or even for scenes to be reset or redone because of audio problems. It is in everyone's best interest to take good audio notes and work with the audio person the day of the shoot. Practice with the audio files and run audio tests through the post-production plan.

Testing Cables

Testing the cables is a simple but necessary step. An entire operation can be delayed if the proper cables aren't present or if a cable isn't long enough. Often the cables for the equipment will add up to hundreds or even thousands of dollars. Make sure that everything can be hooked up, powered on, and working at the same time. If there are crucial cables that are going to be heavily used, it is best to have an extra stashed somewhere.

As you run the testing, you will likely find out if you are missing a cable. This is your opportunity to note what cables are most likely to be heavily used or go down during a shoot. Plan where you can order extra cables if necessary, and make sure you have a master list of all cables, connectors, and power cords to ease last-minute ordering.

More Things to Test

One of the basic things to keep a tab on is power, including where your power supplies are, how long your batteries function, how long it takes to recharge them, if you need a battery system, and what sort of power is available on set. It is also important to go through the entire data-management process that you are planning to use. Make sure you've covered all your bases. As you plan your on-set workflow, make sure your computer has the proper number of ports, cables are at the ready, and you have plans in place for data management.

Put your footage through all of the post-production plans you have. Check all the software you are planning on using, run color tests, and plan quick color changes that can be done on the fly on set so you can see whether you are getting the look you want. Run some of the test footage all the way through to the final product and view it in the form in which you want it to be viewed.

Using In-Camera Presets

You have in-camera options that control various aspects of the image or picture. The technical terms and menu controls vary depending on the camera manufacturer, but they are similar for all brands. These setups are as follows:

- Picture-style settings for Canon cameras
- Picture control system for Nikon cameras
- Picture modes for Olympus
- Film modes for Panasonic
- Log profiles
- Color gamuts

A camera may have up to nine modes or presets, and these settings are easily accessible on your camera's menu options. These are preset combinations of different sharpness, contrast, saturation, noise reduction, and related variables; each preset can be altered in various ways. These options allow you to choose various aspects of how the image will be adjusted, and they can be used to enhance your image and increase your post-production options.

DSLR cameras offer in-camera control over several aspects of the picture. These controls are usually offered with several manufacturer presets and usually with the option to design your own custom adjustment setting crafted for any particulars such as lighting, lenses, specific looks, or whatever different parameters may be in play for your shoot.

If you don't choose an option or change the picture style, the camera will pick one for you. A picture mode termed Standard or something similar will be the default. So, even if you don't think you are making a decision regarding picture style, no decision is still a decision. You may be fine with the standard settings, and many people just leave all of these controls alone. However, you can move to another level of creating a look if you understand how to manipulate the picture-style settings and when to make changes.

We suggest using the equivalent of Portrait mode if you are not planning on using any post-production color correction or adjustments. This will give you the best skin color rendition right out of the camera.

If you are going to do any sort of post-production color correction, then use the equivalent of a neutral picture style. This will give you the greatest ability to change and modify your image in post.

Native Canon Picture-Style Settings

The initial step is understanding how these settings can be used to affect the image. It is important to understand the in-camera settings that are preset by the manufacturer. These options may change slightly depending upon your camera. For the following discussion, we will show many Canon 5D images. We picked this camera because it is commonly used for situations where the picture-style settings are adjusted. If you are using another camera, this

discussion is also relevant because your camera will have correlating settings or in the case of other Canon cameras be nearly the same. Figure 3.18 shows some common presets on the 5D.

Standard This picture style is designed for average photographers to capture a sharp snapshot. Color tones and saturation are set higher to achieve much more vivid colors.

Portrait This picture style is designed to render better color tones and saturation for capturing natural skin tones. Also, sharpness is a bit toned down to show fewer blemishes in the subject's skin.

Landscape As you may have guessed, this picture style is designed to capture vivid skies and lush greenery. Color tone and saturation are set to capture the blues of the sky and green leaves of the trees and bushes. A little extra sharpness helps the outlines of buildings, trees, or mountains stand out a bit more from the background.

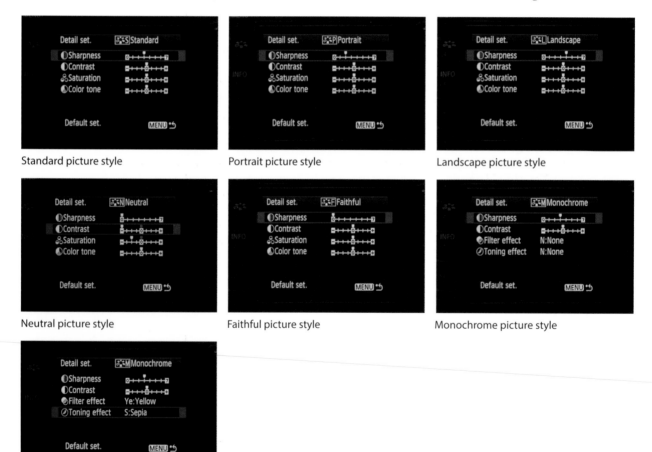

Standard picture style

Portrait picture style

Landscape picture style

Neutral picture style

Faithful picture style

Monochrome picture style

Monochrome picture style with a filter and toning effect added

Figure 3.18: Picture styles on a Canon 5D Mark II. Note that, except for the Neutral style, only the Sharpness value changes.

Neutral This picture style is designed for photographers who are planning on doing post-processing and not expecting final results from the camera. Little to no sharpening is done in the camera with this setting.

Faithful This style works like an automatic white balance. If you shoot under lights that are 4800K, the color is adjusted to match your actor's or subject's color.

Monochrome In this picture style, the sharpness is turned down a tick, and contrast is set in the middle. You then have access to a Filter effect (Ye: Yellow, Or: Orange, R: Red, and G: Green) or a Toning effect (N: None, S: Sepia, B: Blue, P: Purple, and G: Green). It is like having an in-camera darkroom.

The Monochrome option and the alterations you may do quickly are a shortcut to shooting with sepia or black-and-white. However, if you choose this option, the footage cannot be changed back to color.

Testing and Setting White Balance

As you consider picture-style settings and changes, keep white balance in mind. Some picture-style settings may influence the saturation or look of certain colors. As you make changes, recheck your white balance to make sure it fits your goals. If you are using the Auto White Balance or Custom White Balance setting, double-check the overall look after you have applied picture-style settings to ensure that your image's look is in line with your goals.

Most of the settings we just discussed are from the Canon platform. Nikon models will have some or all of following presets: Standard, Neutral, Vivid, Monochrome, Portrait, and Landscape. You should always check your camera manual to see what presets are available and then see what these presets do to create a look and in terms of setting specifics. The next step is learning how these presets are adjusted by your camera controls.

The Nikon D3s also has the Quick Adjust option, which allows for adjustments of many of the presets (but not custom picture settings) that may be created. Other cameras may have different presets with differing variables.

Changing the Camera Presets for Image Control

You can have more control over the image by creating unique user-defined settings. There are two ways to create such settings:

* Adjust the camera's presets that relate to pictures.
* Design a highly customized setting by using a RAW image and software to adjust the settings and then put this unique setting back in the camera as a custom option.

If you are shooting with more than one camera body, it is imperative that you set up both cameras with the exact same settings. If you don't, you will never get them to match in post.

Making Your Own Preset or Style

Here are a few things you should be aware of if you are going to mix and match your own picture style:

- Soften, never sharpen; it's easier to sharpen in post.
- Decreasing sharpness can decrease a moiré effect.
- Always keep skin tones in mind.
- If skin tones get too desaturated, it may be hard to bring them back.
- It's easier to increase contrast in post than to decrease it.
- Your changes may affect your color.
- All of the picture-style changes in the world can't fix a lighting problem.

Customizing a Camera Preset

Let's examine the easiest way to customize by just using in-camera controls. To do this, you adjust one of the camera presets based on your requirements (Figure 3.19). You can save these changes in the camera either as a separate preset or within the existing preset. But you don't have to save the customized setting; you can shoot with this setting adjusted but not saved.

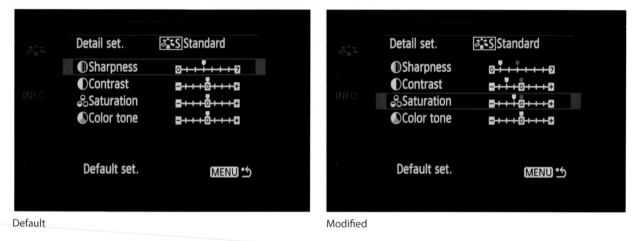

Default Modified

Figure 3.19: Default standard picture style

Once you see what settings can be changed, pick the preset you are going to start with and alter this preset. The general notion of what can be changed is fairly stable from camera to camera, so we will go through the 5D options for the explanation. If your camera has different or more areas of adjustment, play with them to see how they line up with this discussion. Even though each preset looks like it starts at a zero value, in reality the picture-style preset has already adjusted the image; any changes you make are further changes to the image (Figure 3.20).

Figure 3.20: Modified Standard setting saved as a custom, user-defined style. On your Canon DSLR, you must turn the knob to C1, C2, or C3 to save or access your custom picture-style settings.

Setting Up and Registering a Camera User Setting

If you have your camera in M (manual) mode and change any of the sharpness, contrast, or saturation and want to save it to a user-defined setting, you *cannot* do that by turning the camera knob first. If you simply turn from M to, say, C2, it will default to the current C2 settings that were stored in the camera.

If you set the sharpness, contrast, or saturation *while* the camera's dial is already on a C setting, then the setup will be automatically saved.

The other way you can set and save custom camera user settings is to use the EOS Utility and set your sharpness, contrast, and saturation there. Once your setting is saved, it updates to your camera.

For example, if you look at all of the presets, you may see that they all show saturation at zero. Clearly, there are differences in desired saturation between picture styles, but the controls are all set to zero to allow for adjustments to be made in a logical fashion. This means that when you are changing various aspects of the controls, which picture style you start out in is crucial, and changing the picture style will dramatically influence how you can change the image. In other words, all of the presets can be changed in a similar fashion and with the same variables, but the presets do not start out the same, and therefore the same increase in one variable will look different in each preset.

For example, Figure 3.21 shows a frame from a video file taken with the default Neutral picture style. Pay attention to the actor's face. It has a little too much red in it. In Figure 3.22, notice the face of the actor in this frame. The color in his face is much more normal and gives you more latitude if you are going to do any adjustments in post (Figure 3.22), and if not, you have a more true flesh tone to start with.

Figure 3.21: Default Neutral picture style on a 5D Mark II and a frame taken using this setup

Figure 3.22: Modified Neutral picture style on a 5D Mark II and a frame taken using this setup

As you make your decisions, consider what aspects of the image can be adjusted. The four major settings on the 5D are Sharpness, Contrast, Saturation, and Color Tone.

Sharpness Image sharpness is a key variable on film. Film is clear and crisp but not necessarily sharp. If the look you are going for is more cinematic, sharpness is a first-order area to test for potential changes. Another reason to look at sharpening is because you want to keep the sharpness consistent; you don't want the camera getting to pick how sharp the image should be as the shot progresses. Changing your sharpness can also have an impact on a tendency for a moiré effect and aliasing artifacting. Softening things a bit can lessen your chances of having this problem.

Contrast The Contrast control allows you to adjust the way various color tones are distributed in your shot.

Saturation This control alters the overall vividness or chroma of the image. Saturation does not impact the brightness of the image, but it can influence how bright we perceive the image to be.

Color Tone This setting influences the hue of the colors in the shot and adjusts the colors universally. One notable aspect of color tone is that any adjustment of this control can change the skin tones greatly. Skin tones can take on red or yellow casts.

Other colors will also be affected, but because skin tones are usually a benchmark for a shot, this is the most crucial thing to keep in mind when adjusting color tone.

Other cameras may have Hue and Brightness options or other options.

You can change these presets by changing any of the parameters. On the 5D, the setting range is shown by a scale from 0 to +7 for Sharpness and from −4 to +4 for other options. As you make adjustments, the original placement will still be shown but will turn light gray (Figure 3.23).

The best thing to do is to play with these controls. Change them, shoot footage, look at the footage not just on your camera but also on a monitor or a screen or online, and then do any post work that you may choose and recheck everything. Once you choose what preset you are going to shoot with, either a manufacturer setting or a uniquely tailored preset, then your footage will have these parameters, and you can't undo them in post. Therefore, every decision leads to your footage being affected, which will create the look of your project.

Figure 3.23: The white arrow shows the modified setting, and the gray arrow shows the original setting.

Creating a look isn't an easy process. It is helpful to read what other people are doing, check out unique settings that others have used, and look at what they have done with it; however, ultimately your look is up to you.

Creating a Unique Custom Setting from Scratch

Another way to get even more custom control is to design your own custom setting (Figure 3.24). To do this, you will need to use a still image from your camera and make adjustments based on this image. The things you need are the image, the camera, and your computer with the camera manufacturer's software installed. (The software usually comes with the camera or is available for download from the manufacturer's website. For example, the 5D comes with an EOS Digital Solution Disk that contains the Picture Style Editor, or you can look online for the download.)

Figure 3.24: This still was used to design a custom picture-style setting.

This section is a general description for any camera owner. Later in this chapter, we walk you through setting up and customizing your own picture style on a Canon camera.

Starting with a RAW Still Image

Start the process by supplying your own RAW still image. To make the process work most effectively, this image should be taken with as many variables that will be used on the final shoot that will also take advantage of this picture style as possible. For example, if you are planning on using the picture style with a certain lens and lighting, take the image with that lens and lighting. Use the planned ISO to keep all of the visuals consistent.

The image you are adjusting and creating your unique setting around is a RAW image. You are going to be using this preset with a JPEG or similar compression. However, there is a reason that you are starting with a RAW image: the data of a RAW image is less processed than that of a JPEG. RAW isn't exactly a file format in itself; it is a file that has all of the information from the camera settings (the metadata) and the data, but the camera settings do not permanently affect the data the way it does with a JPEG format.

The JPEG image has undergone compression and is influenced permanently by some controls in your camera. The process of creating your own unique setting includes making sure the JPEG is recorded as close to your specifications as possible. The RAW file is influenced by ISO settings and the amount of light hitting the sensor, so exposure is key to this image. The JPEG format is influenced by many more processes in camera and out of camera including the exposure, ISO, white balance, contrast, saturation, sharpness, potential interpolation, and compression. Starting with a RAW file allows you to set some aspects of how the JPEG file will be influenced by the camera in terms of these criteria, which are possible to adjust via the picture editor or similar camera software.

Adjusting the Picture Style

The particulars of exactly how you adjust depend on what manufacture software you are using. Some basics, however, remain the same. You may have to pick a picture style to start with; in these cases, pick whatever style is set at Neutral. If you don't have a Neutral setting, look at what picture style represents the colors evenly and doesn't have spikes in saturation or contrast. Then deal with basics like what white balance is desirable.

The next step is to adjust the color of your test image according to your specifications. Think of the color in terms of three properties: hue, saturation, and luminosity. As you adjust, look at these three properties to make sure your end product is meeting your needs. There is no right way to do this, but pay particular attention to specific colors and how they are being altered. As you make these changes, you are essentially remapping how the color is being read by changing what the current numeric value of the color is and redirecting it to what numeric value you desire it to be. In fact, knowing the numeric values of the color may be a great shortcut for changing the color. To do this, you will need to understand what color expression system is in use.

Test and modify settings with multiple images. If you work with only one image and don't do any testing, you'll have no way to see every possible color or lighting setup. You work with one image to get close and then test with other images captured in the same location and/or lighting setups.

If possible, examine specific colors to see how they have changed (Figure 3.25). If these tones are going to be present in other parts of your shot that are not in the sample still image, they will be processed in this manner. For example, if you have a small sliver of avocado green that is now registering as emerald, then every incident of avocado in your shot will be emerald. This can be excellent or have unintended color ramifications.

Figure 3.25: When the custom picture style was applied to a close-up, the shadows, dark clothes, and hair all became distracting shades of purple. If there are colors that were not in the shot you started with, you may or may not like how that setting affects every color.

Another point of interest is that often Hue and Saturation controls are linked, so if you change one variable, the other one will change in a parallel manner (Figure 3.26).

Checking the Histogram and Curve Levels

As you make your changes, keep an eye on the histogram to make sure that all changes keep exposure parameters and detail levels solid. The histogram is a nice tool when you are trying to see whether your changes are helping increase your detail, especially in shadows. Learn how to read your histogram to check for any blacks being crushed or whites blown out. Histograms also help gauge saturation levels, and you should check all changes you make, not just visually but with your controls.

Tone curves, custom curves, or gamma curves are a major area for adjustment (Figure 3.27). The Picture Style Editor, Picture Control Utility, or other software should have a gamma curve adjustment tool. This will adjust the tonal curve characteristics of the image.

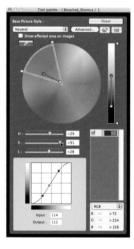

Figure 3.26: The lines and dots show the Saturation parameters based on current Hue selection.

A gamma curve tool is adjustable in a nonlinear fashion, which means you can adjust one part of the tonal curve without affecting other points. For example, your adjustment in the mid-tones will not affect the darkest and lightest points. This tool will take the selected tones and either compress or stretch them into the desired range. Compressed tones have less contrast, and stretched tones have more contrast. The compressing and stretching are easy to visualize; as you drag your curve tool around, observe the change in the line and what tonal area is being adjusted. Adjusting the gamma curve will change the dynamic range of your image. These adjustments will affect the entire image universally and usually should be done after you have dealt with individual colors.

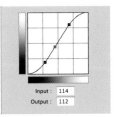

*Figure 3.27:
Gamma curve with
three points for
adjustment*

S-curve and Inverted S-curve

These names come from the simple shape shown in the curve. An S-shaped curve results in adding contrast to the midtones at the expense of shadows and highlights in the image. An inverted S-curve has the opposite result. This is an easy test. Look at your curve shape: does it match your goals?

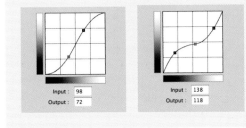

At the end of this process, it will be necessary to test the new user-defined setting. You can also save many such settings to transfer on and off your camera, use other people's shared settings to expand the range of available presets on your camera, or give your setting to other people or other cameras.

Should You Bother Creating a Preset?

Maybe you won't ever need or want to create a preset, but the reality is that after using the camera presets for a while or shooting with interesting lighting conditions, you may find that you just aren't able to get the look you are going for in your shoot. Designing your own custom preset is part of the creativity and detail work necessary in creating your look. If you find that certain factors aren't being accounted for with the existing presets, this is the time to experiment with a custom setting. Or if you are testing post procedures and find that you really want to keep your color options as open as possible, a custom preset may help. This is an area to have fun with and to explore how much you can really influence your footage.

To decide how you are going to use these settings, you also must decide how you plan on using the tool. There is one simple question that determines what path you are going to travel: are you going to do any post color grading or changes? If you are, then you will want to use the controls to maximize your post-production control and maintain your desired look. If you are not doing any post-production, then use the controls to get your picture to look as close to your vision as possible.

Settings That Prepare for Post-Production

The choice to alter the picture when you are doing post-production is an easy one. In this case, you are not worried about how the image looks when you are shooting as long as the image that you end up with after post meets your specifications. This means that while you are shooting, your image may look very different from how it will look after post.

A custom picture style changes the way the camera processes the information from the sensor. The goal of designing a picture style that works with your post-production technique is to make sure that the picture style processes the color information in a way that keeps as much of the color data as possible. In essence, you want to save data so you can change it later.

If color grading is going to happen in post-production, all setting alterations should maintain color information and give the greatest possible range for color grading in post. DSLR video has a limited color bit, and making sure that the color information is retained and captured while shooting is key. One way some colorists prefer to maximize color is to have a flat image.

Increasing Dynamic Range with Settings

The goal is to get the light and dark parts of the image, or potentially slightly over- and slightly underexposed parts of the image, to have detail. The reason why you want to increase dynamic range is to allow for post-production processes to have more room to move around. After changes are made, ideally there should actually be detail in the whole image. Post-production color grading and processing work best if there is color information recorded for the entire image. Only color information that is actually recorded can be tweaked. So, how can you get more color information? Check to make sure you aren't losing anything that is blown out or clipped, adjust lighting, and make sure there is a proper exposure. Shoot with a picture style that orders the camera to record as much data and detail in the whole image as possible. One way to do this is to shoot the image flat and design a flat picture-style setting, or you can simply use the Neutral picture style on the camera.

The "Shooting Flat" Option

To "shoot flat," you must minimize all saturation and contrast in the entire image. You can do this by adjusting it in the camera, but you can more effectively do this by designing a setting. You may also be able to download a predone setting and use that. Shooting flat will increase the latitude and dynamic range of your footage and allow for freer color correction.

What Is "Flat"?

A flat image or flat picture style means a setting or image that has very low contrast and low saturation. The point of having less contrast in the original capture footage is that you retain detail in the highlights and shadows that would not be there if it were captured as a high-contrast image. To the untrained eye, if you see footage that is shot flat, it looks very unappealing, because you are used to viewing footage that has a much higher contrast ratio and saturation levels.

Shooting flat makes it easier to match your footage from shot to shot and from scene to scene because each shot has room for correction (Figure 3.28). Your overall look can be incorporated into the entire piece, and you can have separate looks for particular scenes or

parts. Your piece may have a wide variety of lighting schemes, times of day, night, or other diverse settings, and your look will need to be applied to all of these shots. Consistency in the look and scene is a key component to a coherent look, and having footage that takes well to color grading makes it more likely that your look can be applied evenly (Figure 3.29).

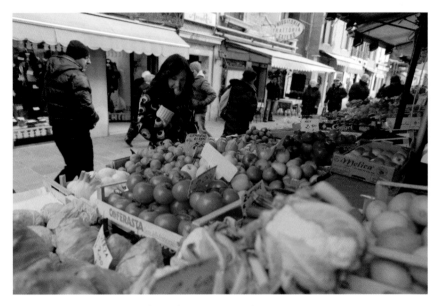

Figure 3.28: Footage still from flat picture-style setting

Figure 3.29: Same flat still color corrected for final look

The point of increasing dynamic range is to allow for greater potential color grading options in post. The shot may actually look worse on set, on the LCD, or on the monitor.

If you shoot flat, keep several things in mind (Figure 3.30). It is easy to run into problem areas when the only emphasis is in keeping everything flat. Keeping skin tones in proper ranges so that they look like normal human skin tones is important. If you shoot too flat, you may not be able to bring the skin tones back to a proper tone. Judging proper exposure and white balance can be tricky when you are looking at an image on the set that is flat and looks washed out.

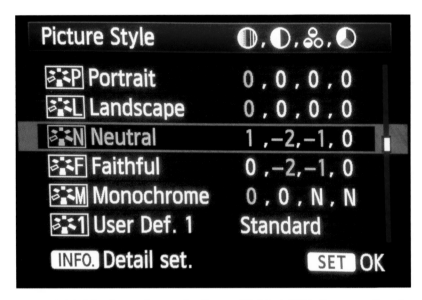

Figure 3.30: The flat setting on the Canon 5D Mark III is Contrast −2 and Saturation −1; I use this setting all the time.

If you do not intend to do any sort of post color correction, then by all means do not use a flat picture style. Use a Standard or Portrait setting that will give you more contrast and more saturation in your original footage.

Settings to Work without Post

One of the magical things about DSLRs is that they can be used on low-budget projects or projects that have a short deadline. For "run-and-gun" shooting styles or situations where you aren't in control of your set lighting, you may need to adjust your picture style settings on the fly and leave the results slightly up to fate. If your project isn't going to have image post-processing work done, then your goal is to get the look in the camera while you are shooting.

Sometimes the decision to do post or not is also determined by what the final output is going to be: are you getting this ready for the Web or a movie theater? These are obvious differences that help you decide where to allocate budget. Another consideration is time savings; getting the image close in the camera saves a huge amount of time, and the dailies are immediately available. The H.264 format is problematic, but it does have the benefit of being immediately playable. Post-production is fun, and the final look is rewarding, but let's face it: budget, ease, and time savings are not small considerations. There is also the peace of mind knowing that you aren't alone; many people find that the limits of DSLR video and

compression make color grading less effective than simply shooting it in the camera, and your in-camera color-grading efforts will keep the need for emergencies (where extreme manipulation is necessary to save a shot) to a minimum. Sometimes the ability to fix it in post causes problems because the safety net is over-relied on; shooting it in the camera creates the sense of urgency necessary for excellence.

If you know that you aren't going to be doing any post work, pay attention to the same things you would if you were doing post. These are perfecting the in-camera color temp and white balance, making the most of potential filter options, obsessing about your exposure, being vigilant on lighting, checking your skin tones, and making creative use of gels or light temperature if necessary. Something you *won't* be doing is worrying whether your method of shooting allows for latitude for change in post. The picture you are viewing is going to be the end product, so you don't have to try to visualize how the end product will look. Because you are viewing the end product, make sure that your monitor or LCD screen matches what you are hoping for in the final viewing format. Your image is going to be processed solely in the camera, and you don't have to worry if you aren't saving room for post or expanding latitude.

Highlight Tone Priority

The purpose of Highlight Tone Priority (HTP) is to increase the effective dynamic range of the camera in the highlight area of the shot. This effectively reduces blown-out highlights and may reduce noise in the highlight areas. This help in the highlights can be important because highlights on DSLRs are prone to blowing out easily. However, there are problems with using HTP, and they can be significant. There will be more noise issues in darks/midtones, but these are largely limited to the shadow areas. Some ISOs will not be available, and the midtones and shadows are effectively underexposed because the setting does exactly what it says—focuses on the highlights.

The decision to use HTP is up to you. If you are baking in your color and look while shooting, it may serve a purpose. In the event HTP is used, double-check your exposure and recognize that it is best used in daylight situations where the focus is on the highlights, such as the sky and lightest areas, so if your action is taking place in these areas, it may have a potential usage.

Often factory presets are designed for people who don't want to do any post-production and who want the look out of the camera. If you are going to be making many lighting changes or trying to match shots in post, you may have to consider several different picture styles or in-camera settings as the shoot progresses. You must plan for this in preproduction, and even though you aren't doing post, it never hurts to test the process.

If you are doing all of the work in post, you also will need to make sure that there is continuity between shots that are going to be cut in the same scene. Obviously, this needs to be done anyway, but keep in mind that you have no latitude to change the shots, so you must get it right the first time. Also, make sure that you color match your cameras if you are doing a multiple-camera shoot. Again, this is necessary regardless, but you have less room for error when using cameras that shoot with 8-bit color space.

Customizing Your Picture Style: Steps for Canon DSLR Cameras

If you are ready to customize your own picture style and create a look specifically for your shoot, then follow these steps for creating, loading, and using your new custom picture-style settings:

1. Take a RAW still image from your location scout for the scene or lighting conditions you want to create your look for.
2. Connect your camera to your computer and turn it on.
3. Open EOS Utility if it does not happen automatically for you when you first turn on your camera (Figure 3.31). (EOS Utility is on the EOS Digital Solution Disk that came with your camera. If you have not yet installed it, do that before going any further.)

Figure 3.31: EOS Utility splash screen

4. There are two tabs at the top. Click Accessories, which takes you to the window with the option for the Picture Style Editor (Figure 3.32).

Figure 3.32: After clicking the Accessories tab, you will see this screen.

5. Open the Picture Style Editor and drop the RAW picture onto the screen (Figure 3.33).

Figure 3.33: After you drag your RAW image onto the Picture Style Editor, this is the default view.

6. Depending on how you like to work, you can leave the image as the whole screen. Click the second button on the bottom left to show the original file on the left and the one you are correcting on your right (Figure 3.34), or click the third button from the bottom left to have the original image on the top and the one you are manipulating on the bottom (Figure 3.35).

Figure 3.34: Side-by-side view when creating your custom look. Original image is on the left and corrected image is on the right.

Figure 3.35: If you prefer, you can tile the image horizontally. Original image is on top and corrected image is on the bottom.

7. The tool to use here for your manipulation is the gamma curve. In the lower-right corner are a grid and a diagonal line that represents the gamma curve (Figure 3.36).

Each time you click the curve, you will add a little point to the curve that you can adjust. The best practice is to place three more or less equally spaced points on the diagonal line (Figure 3.37).

Adjusting the lower point adjusts your shadows, adjusting the middle point adjusts your midtones (anything not shadows or highlights), and adjusting the top point adjusts your highlights.

Any adjustments here should be minor, because the more you adjust the curve, the more extreme the

Figure 3.36: Standard grid that represents the gamma curve. You need to add points on the diagonal line in order to make any changes.

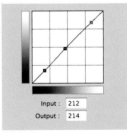

Figure 3.37: Three points added to the curve. From here you can drag any point left, right, up, or down.

look will be (unless your project calls for a very extreme look). The goal in creating the custom picture styles on these cameras is to increase the latitude you have in post (remember, you are working with the limited 8-bit color space).

8. To flatten out your image, adjust the top point to the right, which will lessen your highlights. Adjusting your point at the bottom to the left will "open" up your blacks and flatten the image a bit. If you go to the right, you will be adding contrast and "crush" your blacks. Do that in post, not at this point.

9. Spend time adjusting your three points until you are happy with the image. Once you are happy and ready to move on, you need to save your newly created picture style. Go to File ➢ Save Picture Style File (Figure 3.38).

Figure 3.38: Whatever name you place in the Caption field is what will show up on your camera—not the Save As name of the file.

The name you put in the Caption field is the name that will show up on your camera (Figure 3.39). The name of the file will *not* be the name that will appear when loaded on your camera (Figure 3.40)—unless they are the same name.

Figure 3.39: Notice that Bleached_Look.pf2 *is the name of the file from the Save As field.*

10. You now need to load that picture style into your camera. Go back to the EOS Utility application and click Camera Settings/Remote Shooting (Figure 3.41). (The camera must still be connected to your computer and turned on. If you are not able to click Camera Settings/Remote Shooting, then disconnect your camera, turn it on and off, and reconnect.)

Figure 3.40: *When the file is loaded on the camera, the caption name is displayed in the drop-down menu, not the name of the file you loaded.*

Figure 3.41: *EOS Utility splash screen where you can access the camera settings or remote shooting*

11. A window should appear with a control panel
 that has all your camera's current settings displayed. Click Picture Style to display all the default and user-defined picture styles (Figure 3.42).

12. You have three custom, user-defined "slots" you can store on your camera at any given time. If you are using only one custom user style, we recommend C3, so it is at the far end of the dial. Click the User Def. slot you chose (Figure 3.43).

13. Choose Register User Defined Style (this will not be available to select if the camera's dial is not set to C1, C2, or C3) (Figure 3.44).

Figure 3.42: *Control panel window displaying all the current camera settings*

Figure 3.43: *After you click Picture Style, you will see all the defaults and User Def. 1, 2, and 3.*

Figure 3.44: *We used User Def. 3 as the location where we will upload the custom user style.*

14. The Register Picture Style File window will appear. There is a drop-down listing all the standard picture styles (Figure 3.45) and any custom picture styles you created.

Figure 3.45: Drop-down list with all the defaults

Click the File button to the right of the drop-down menu and navigate to the file you saved from the Picture Style Editor.

15. You will now see your custom picture style selected in the drop-down menu and the details from the settings below it (Figure 3.46). Click OK.

Figure 3.46: Once your custom style is selected, click OK.

16. If you select Picture Style from the menu on the back of your camera, you will see that the name of your custom picture style is now next to the custom, user-defined slot you chose.

When you select and shoot with this picture style, it uses the parameters you set in the Picture Style Editor. If you create multiple picture styles for a shoot, you can easily change from one to another by selecting the user definition you want. (Note that if you have more than three, then each time you load a new picture style, you will overwrite an existing one. Just be aware and manage which picture styles you need for each day of shooting and program those picture styles before heading out to the set.)

Using a Third-Party Picture Style (on the Set)

You can find many custom picture styles online. You might chat with other filmmakers or friends who have created their own custom picture styles on projects you think have a nice look and might work for your project. Also, if you are working with a post house or colorist, they may create the custom picture style you end up using for your shoot.

If you get a custom picture style setting through any of these means, then you can quickly and easily get it into your camera and start to shoot. Just start at step 10 of the previous steps for the entire process.

Technicolor's Cine Style

Cinematographer Shane Hurlbut, ASC, has written an article about a flat picture style from Technicolor named Cine Style. It is not only a valuable reference about this specific picture style but also a great model about how to use custom styles:

www.hurlbutvisuals.com/blog/2011/05/08/technicolors-new-picture-style-cine-style/

four

Cameras and Lenses on Location

The DSLR movement has exponentially

expanded the number of available cameras, lenses, and formats that a filmmaker can work with. It is now more important than ever to understand the tools and be aware of the available choices and the reasons to choose your camera and lenses when shooting on location.

Using Cameras on Location

Before you actually use your cameras on location, there are a few things you need to do to prep the cameras. Prior to stepping on set, you should choose whether to use the factory presets that your camera shipped with or to modify and create your own custom picture style. However, sometimes you may need to create a setting quickly on set to deal with unexpected lighting or look requirements. It is important to be aware of camera models and their settings before you head out onto the set.

Mixing Multiple Cameras, Makes, and Models

If you are shooting with multiple cameras, you should be aware of a few things before you begin shooting. Ideally, on a multiple-camera shoot, you would use the same camera model and brand so that your video images from the different cameras match each other as closely as possible. In some cases, you may not have access to the same camera or model, or you might actually need a different model because of some limitations in your set or shot. Either way, some adjustments may be necessary to ensure that the footage from all of the cameras matches closely.

Matching the Color

How the color in your recorded image looks can be vastly different between camera models or brands. Even different cameras of the same make and model can have slight variances in

color. It is important before you head out to the set to set up and test the cameras you will be using and to make sure you set up custom settings to help match the footage coming out of the camera. Remember that this differs from color grading the final edit of the mixed footage. It is always best to start with footage from different cameras that has been matched as closely as possible in the camera before your final color grading. The farther off the color in the footage between the cameras, the more likely you will not be able to accurately match the footage or fix it during the final color grading of your footage.

Figure 4.1: Find the different frame rates at which your camera can shoot in your camera menu.

Matching the Frame Rate

When you select the camera or set of cameras for your shoot, pay attention to the available frame rates at which the cameras can record (Figure 4.1). Some of the cheaper DSLR cameras allow filming only in 30 fps, whereas some of the higher-end DSLR cameras allow multiple frame rates ranging from 23.97 to 60 fps. It is best to shoot at the same frame rate for the entirety of your production. The only exception is a camera that is getting coverage such as a slow-motion shot or a stylized clip to be used as a cutaway for the scene. Editing A-camera and B-camera footage that is shot at different frame rates with synced dialogue is nearly impossible.

Powering Your Camera

Most DSLR cameras were never intended to be used as full-blown video cameras. Using DSLRs in video mode tends to drain the batteries quickly. As a filmmaker, you have these power options to help keep you shooting:

Multiple Batteries If you are going to be shooting all day long, you must have more than one battery, or you will waste a lot of time recharging your battery. Also, if you won't have power to charge during the day, then you will require many extra batteries. For most of our productions, we have seven batteries for our two main cameras and two chargers.

Battery Grips Many camera models have battery grips that you can buy or rent. For instance, the Canon 5D Mark III can be paired with a Canon BG-E6 battery grip. The battery grip can take two standard Canon LP-E6 batteries or six AA batteries and add extra battery life to your camera without having to switch batteries in and out. Just note that because shooting video drains the batteries fast, if you are using AA batteries, you will go through a ton of them; it is best to stick with using the two slots of LP-E6 batteries. Also, the battery grip makes the camera itself a bit bigger. For some, the added size and weight are appealing because they can make the camera easier to hold, but for others these additions are undesirable.

AC Adapter If you are shooting in a location with available power, then getting an AC adapter can be a great choice (Figure 4.2). The trade-off with an AC adapter is the lack of mobility. You are mostly constrained to tripod shots or dollies with an extension cable.

Figure 4.2: The Canon ACK-E6 AC adapter. Notice the small rubber flap on the inside of the camera that you can move to place the cable. The door for the battery must be fully closed for the camera to function.

Battery Pack and Adapter If you are going to be powering your camera, external monitor, and other power-hungry accessories and you won't be shooting where power is readily available, consider using an external battery pack.

Another great benefit of using an Anton/Bauer, IDX, or other professional battery pack is that there is a standard connection, called a P-Tap, that allows you to connect multiple devices without having to make your own custom power cables. By choosing a well-established battery and power system, you can use the standard cables and attachments available in many rental houses around the country (Figure 4.3).

The availability of power on location can vary greatly. If you are shooting in a remote exterior location, you may be living off battery power only, and if you are shooting inside a house, you may have power outlets every 10 feet. Make sure you don't overlook having extension cords, power strips, plug adapters, and batteries on hand. Another option is to rent or buy a generator for exterior locations where power is not

Figure 4.3: P-Tap cable/connector

available. Generators tend to be loud, so if you are shooting sound, you need to make sure you have the ability to place the generator far away from where you are shooting. As added insurance to make life easier on set, it is a good idea to have moving pads, blankets, or other means of setting up a sound barrier between the generator and the shooting area.

Understanding Recording Time Limitations

One major perceived drawback of DSLR cameras is the limitations in recording time for one continuous shot, but this is really a nonissue (unless you are shooting long-format productions such as a wedding or play). A 1,000-foot roll of 35 mm motion picture film will record 11 to 12 minutes of footage and then must be changed. In reality, shooting on a DSLR camera has a similar limitation as shooting film for the duration of a single shot. Most DSLRs limit you to around 30 minutes of recording time and limit the file size as well. You should consult your camera's manual for specifics.

Note that many recent cameras allow you to take a clean feed out of the HDMI port and use an external recorder. If your camera will give you a clean feed, then the external recorder can allow you to record all day with no limitations (outside the size of your storage in the external recorder).

If you are new to the camera you are using, make sure you find out the limitations for recording. You should always test the limits yourself by recording a video clip on your camera and timing it.

The recording time limitation will be a problem only if the shot you are trying to get is longer than what your camera can handle. However, with the current limitations and the ability to use external recorders, you need to have a pretty compelling reason for letting the recording time limitations stop you from using a DSLR camera for your next shoot.

Managing Memory Cards

Treat your memory cards as you would film stock—like gold. Make sure you have plenty of memory cards so that you don't have to stop filming while footage is being copied to backup drives (Figure 4.4). Things to remember when it comes to memory cards include the following:

- Make sure you have enough CF/SD cards for the shoot.
- Protect and label your CF/SD cards.
- Back up your footage as often as you can, and make sure to have a safety backup before the card is cleared and sent back into the field.

One thing to note is the read/write speed of your cards. Shooting video requires a card that has higher write speeds than you typically need for shooting stills. No one speed fits all cameras, but ideally you need 60 MB/sec or more. The newer and faster cards will ensure the video is being recorded properly with no lost data.

Another thing to note is that larger-capacity cards can contribute to your camera overheating. Any time you are using anything that allows you to run your camera more frequently and for longer time periods, it can increase the chance of your camera overheating. Make sure you give your camera a break to cool down from time to time.

We discuss managing your memory cards in more detail in Chapter 8, "Organizing and Storing Data in the Field."

Figure 4.4: Labeled cards in a Pelican hard card case. Make sure to notice the speed of the cards when you use or buy new cameras.

Using Lenses on Location

Using a variety of lenses and perspectives to shape the image is unique to photography and motion pictures. If you were watching a theatrical play or a baseball game in real life, your eye would see everything from a variety of focal lengths but from more or less a single perspective. But in a movie, you see the perspective (or perspectives) that the filmmaker has chosen to tell the story.

Your lens choice will shape how your audience sees the shot and what parts of the image will draw their attention. The lens choice influences not only what the audience sees but also how they feel about the image. Lenses can work like the

human eye, but they can also operate in ways that shape the perspective and look of the image in ways that the eye does not.

Perspective

Normal perspective is more or less how a scene would look to the naked eye. A lens with normal perspective will show images where the size of objects in the foreground and background and the distance of objects between each other look exactly like they do to the naked eye; object size is relative depending on their distance. The size and distance of objects are diminished as they recede toward the background of your shot or your vision. If you are shooting on a full-frame sensor camera, normal perspective would be anything shot with a 50 mm lens.

It is always possible to choose a lens that is normal perspective for your camera and the camera's sensor size. However, to create the look of your project and to understand the lens choices available, you must be familiar with *forced perspective*. Long lenses (or telephoto lenses) and wide-angle lenses change the perspective of the image away from normal perspective. Anything that is not normal perspective is forced perspective. Ultimately, you can make many interesting shots by deciding between wide-angle and telephoto lenses to create your forced perspectives in your film.

Probably the widest angle forced-perspective lens that you would use for your film would be a 15 mm lens (Figure 4.5a), but potentially for certain effects you may go as wide as a 10 mm. Any lens between 15 mm and 50 mm will be of varying extremes of your forced perspective (Figure 4.5b).

On the other hand, the longest telephoto or forced-perspective lens you will use will generally be a 200 mm, but in some cases you might want a 300 mm or at the far end an 800 mm lens. Again, any lens between the 50 mm and 800 mm lens will vary the degree of your forced perspective (Figure 4.5c).

Why Pick a 50 mm, or Normal-Perspective, Lens?

Most movies are about people. Our entire lives are about interacting with, talking to, and watching people living their lives. When we watch a movie, we expect to see parts of the movie as we would see them in real life. Both the lack of distortion and the relationship of objects and people to each other help transport the audience into the world of the movie they are watching. This is why many other filmmakers and books will tell you to start with a 50 mm, or normal-perspective, lens. In later parts of the movie, once the audience has connected with the story, a filmmaker can change perspective and play with distorting how the audience perceives their world.

Changing Perspective via Camera Angle, Camera Height, and Lens Choice

The physical position of the camera will affect the look of the shot and how the lens characteristics influence the shot. The angle, height, and distance of the camera from the subject are all important factors as you compose the shot. Knowing how the angle and height of the camera interacts with your lens is useful, but in the end you must remember that even with the right lens, the camera still needs to be properly positioned in the room, set at the right height, and angled appropriately for the scene. Only after you fully understand these elements should you introduce camera movement, and when movement is introduced, you must plan the shot so that the camera angle, height, distance, and lens are conducive to the movement both of the camera and in the frame.

a b

c

Figure 4.5: Images demonstrating field of view and perspective with (a) 18 mm lens, (b) 50 mm lens, and (c) 200 mm lens

Resist the urge to just set up the camera, look through the viewfinder, and make all adjustments at that height. It is better to determine where and how the camera should be set up than to design the scene around a particular camera placement.

As you plan the shots and block out the scene, note where each actor is physically, and take into account where the action will take place in the scene. After you have these factors in mind, plan the angle and height of the camera to reflect each perspective. This is especially important in suspenseful scenes where a camera height or angle can reveal too much too soon. Changing the angle and height of the camera allows you to tell the story at the pace you choose. If a scene feels like it is unfolding too quickly or too slowly, changing the height or angle to allow the audience to see more or less of the action may be a solution. Even if you shoot the scene with an objective perspective, some camera changes with height and angle will allow you to tell the story and film the details.

Low Camera Height
Low camera height is simply any camera height that is below the eye line of the subject of the shot. It can be so low that the camera is placed at ground level and only the actor's feet are seen, or it can just be a camera level that is below the eye line. Low camera height can

create shots that show the audience an unexpected perspective or provide details that they normally wouldn't notice.

Low camera height can influence which lens you use in the shot. In general, a low shot will emphasize the foreground with any lens you choose. Often low shots use wide-angle lenses to increase the effect of the foreground emphasis. If you are shooting an actor, the low camera height can have the effect of increasing the size of the lower body and making the upper part of the frame look smaller. The lens choice will affect the look in various ways; a wider lens will exaggerate the size difference, and a longer lens will minimize the difference.

High Camera Height

High camera height occurs when the camera is placed above eye level. This can make the shot feel taller than the actors or make it appear that the audience is looking down on the scene just a little bit or all the way up to a bird's-eye view. An extreme example of this is an over-the-head shot or an aerial view from a high vantage point. Usually an extremely high camera height can take the viewer out of the immediate action and give a slightly godlike view of the scene. High camera height can also be subtle, such as in a situation where the subject is supposed to look defeated or smaller; a higher camera height emphasizes this feeling. You should use high camera height when the camera is showing the perspective of a character, plane, or security camera, for example, that is supposed to be at a physically high location.

Level or Eye-Level Camera Height

The camera is often placed where the audience perceives the actor's eye level to be or at the typical eye level of most normal interactions. When the camera height is at eye level and is not tilted, distortion of all types is minimized. At this height (and if the camera is kept level vertically), lines will stay vertical throughout the shot and never converge.

Eye-level height often is not the height of the camera operator but rather should be determined based on the eye level of the actor. For example, if the actor is sitting down, the camera should be placed at the actor's eye level while seated, not at the camera operator's level, to achieve a true eye-level view. This is especially important because tilting the camera drastically affects the feel and perspective of the shot, and simply tilting the camera from the camera operator's height rather than lowering the camera can change the entire feel of the shot.

This height is often used for point-of-view shots. It is crucial that the point of view feel as though it is logically from the eye of the person it is supposed to be portraying. To further enhance the perspective, creative lens users may choose specific lenses, such as using a fish-eye lens with distortion to show that the shot is from a security camera or using a normal-perspective lens to show that it is the perspective of a person viewing the scene.

Tilted Camera Angles at Various Heights

A camera can be tilted from any height. The tilted aspect can give a completely different feel to the shot and, importantly, can also affect how the lens works with the shot perspective. A high-angle shot is any shot where the camera is tilted down toward the actor or down to get the shot. A low-angle shot is any shot where the camera is tilted up toward the actor or upward in the shot. For either of these shots, it does not matter what the camera height is; a shot is considered high angle or low angle based on the degree of tilt, not the camera height.

The degree of tilt can be slight with the camera set at eye-level height and tilted down to mimic an actor looking at a seated subject, or it can be extreme with low angles that start below a subject and tilt all the way to the sky. With all degrees of tilt, it is important that the tilt not be so slight or off-level that the tilt looks accidental or like poor camera setup. The tilt must be uniform and provide a deliberate angle.

When adjusting the angle and height of the camera, using a bubble level will help ensure accuracy.

Objective, Subjective, and Point-of-View Camera Angles

As you plan your shots, figure out whether you want the shot to be from an objective, subjective, or point-of-view perspective. An *objective* perspective is a shot that shows the view of the audience or an observer to the scene but not from the perspective of anyone in the scene or story. You should devise the shot to feel like it is outside the action but looking in.

A *subjective* shot is one that shows the perspective of someone interacting within the action or from the point of view of a character in the scene. Here the camera should act as the eyes of the subject from whatever perspective you intend to be showing. This means that angle, height, and perspective are designed to mirror the intended subject's perspective exactly as though shot from the eyes of the subject.

A *point-of-view* shot is simply a shot that mimics what the audience would see if they were standing by whatever the character is interacting with in the scene, but it does not exactly mimic what that character sees. Point-of-view shots are almost objective and almost subjective but not either. This sounds confusing but is easy to see in practice. A simple examination of most dialogue scenes likely will demonstrate a point-of-view shot in action. Most of these scenes have shots that switch back and forth from character to character as each actor speaks. The shots are designed to give dynamic interaction but show all characters involved in the action. They do not mimic just one perspective or set of eyes, and also they are not a completely objective, outside-of-the-action perspective.

Shooting with Actors at Different Heights in the Same Scene

Often a scene will have several different heights that are important in the shot. For example, this is common in a dialogue scene where two characters are at different heights within the frame. You can change the camera height to accommodate each character when switching between shots, but you must take more care with switching lenses. When shooting dialogue between two actors, it can be awkward to change focal lengths too drastically. Extreme differences in focal lengths can make the actors appear to not be in the same space.

You can use more extreme differences in focal lengths within a scene when you shoot two actors who are having a dialogue at different heights within the scene. Often you can simply tilt the camera up or down in sequence to indicate the perspective of the actor who is speaking/listening.

When in doubt, if you change lenses, change focal lengths, or tilt the camera, it is often best to keep the camera height the same when you are getting coverage for a scene. This is because a change in both height and lens can make the continuity of shots difficult without careful planning and storyboarding.

Dutch Angle/Dutching

Sometimes referred to as *canted angles*, *dutching* means the camera is tilted so that the horizon looks tilted or at an angle in the shot. This angle can be used to cause a disjointed image when items within the shot run at counter angles to the camera.

To take the Dutch angle to its extreme, shoot from a low height at a low angle with a wide-angle lens; the entire frame will have a jumbled look, and the entire image will slant. A Dutch angle on items that are not adjustable, such as buildings or interiors of rooms, can provide interesting tilt effects; however, as you shoot, be careful that the tilts will not run counter to each other in edits.

Depth of Field and Focus

When shooting with a full-frame sensor camera, you are able to achieve an extremely shallow depth of field (DOF). This doesn't mean every shot will have a shallow DOF or that you should have a shallow DOF. However, if you are shooting in low-light situations, it is important to note just how shallow your depth of field will be. If you have a fast lens, say a 1.2 f-stop, you can capture a good image for your scene if there is little to no movement. On the other hand, it can be nearly impossible to keep or pull focus for a shot that has motion or movement when shooting at low f-stops. If you need to use these low f-stops in the shot, it is advisable to plan static shots and not have much motion within the scene. If you are shooting an actor at a distance of 3 feet while at a 1.2 f-stop, you will be trying to focus with a depth of field that is 0.84 inches deep. Without careful planning and practice with your actors, it is likely these shots will produce nothing but unusable footage. If you want movement in the shoot, make sure to plan movement from side to side so the action all takes place in the plane of focus rather than coming closer to the camera so you have to adjust critical focus during the shot.

Regardless of whether you are shooting with a full-frame sensor camera or a crop-sensor camera, you can always use tools to help you cheat the look of a camera you don't own. You can increase your depth of field on a larger sensor camera by adding more light so you are not shooting near wide open on the camera. Or if you are shooting on a crop-sensor camera and want a shallow depth of field similar to that of a larger-sensor DSLR, you must stop down the camera with ND filters in locations with a lot of light to obtain that shallow depth-of-field goodness in your footage.

Know the Lens's FLM

Because of the explosion of digital photography and the popularity of smaller camera sensors, manufacturers have begun to develop lenses that are designed for the specific sensor sizes of digital SLRs. In general, a DSLR with a smaller sensor size can use a lens that was designed for a larger sensor size but not vice versa.

Lenses are designed with a minimum focal length multiplier (FLM). A full-frame lens is designed for an FLM of 1 but can be used with smaller sensors. However, a lens with an FLM of 1.6 cannot be used on a full-frame camera.

Interaction of Depth of Field, Focus, and Lens Type

A normal-perspective lens characteristically has an out-of-focus foreground, with the background and middle section of the shot in focus. This type of lens is helpful if you are adding out-of-focus details to be "visual candy" in the foreground but want the subject in the middle of the shot and the background to be in focus.

Wide-angle lenses have deep focus that can include the entire shot or whatever is in the foreground, middle of the shot, and background. If all parts of the shot from near the camera to the background must be in focus, a wide-angle lens is probably the best choice.

Long lenses or telephoto lenses have a narrow area of focus. With a long lens, only part of the shot will be in focus. Often you can choose what part of the shot you want in focus—close to the camera, the middle, or the background—but you can't pick all three.

Focus on the Eye

When you pull focus or plan the focus points for the scene, make all of your focal measurements exactly to the eye of your actor. As the actor moves, make sure the eyes are in the plane of focus throughout the entire shot. Humans track other human faces effectively, and the audience will immediately notice any problems with focus if the actor's eyes are not in focus.

Calculating Depth of Field on Set

To calculate depth of field, you need to know three variables:

- Focal length of the lens
- Size of the aperture, in other words, the f-stop
- Distance from the subject to the camera film plane

You can use depth-of-field tables that to determine these calculations. For practical purposes on set, a depth-of-field calculator will be most useful because it can give you calculations for nearly every possible variable. These calculators are easily available in several formats, including for iPhone applications (Figure 4.6).

The depth of field should be expressed as a range showing the closest point of focus to the farthest point of focus available. This area will determine where the movement in the shot can occur and still maintain focus. It is also important to know the range in case the shot requires actors to move into focus or out of focus without camera movement. It is helpful to keep in mind that focus is incremental; it gradually decreases to the point where it is sharp, and it gradually becomes blurred to the point where it is considered out of focus. Usually the sharpest part of focus on an actor should be measured to the eyes.

Depth of field is important to determine focus and not just for technical considerations. It is also important for dramatic purposes because your actors need to know where they can physically play the scene. The depth of field will dictate exactly where an actor can stand on the set, how far they can move forward or backward, and even how far they can turn their head. These issues are exacerbated when shooting at lower f-stops in low light and are complicated when shooting on larger-sensor cameras. If you can't visually show

Figure 4.6: The iPhone depth-of-field application DOFMaster

the actors where they need to hit their marks, you will not be able to get a scene where your key elements are in focus. This information is critical for camera operators, focus pullers, actors, directors, and extras. Make sure you know the depth of field needed for all your shots; you may need to add light so you can stop down to a higher f-stop and increase the depth of field to get the scene in focus.

Eye Lines of Actors

Where the actor is looking is a critical point for every shot. Often the actor will need to look at something or some other actor, and shots will be cut between an actor looking at someone and the person they're looking at. The sight line of the actor must match in the cut, or the audience will feel that the actor is looking at the wrong angle or in the wrong direction. Often the actors are looking toward the camera for dialogue or action scenes; they must know where to look to make sure the audience can properly track their eyes.

The first consideration is that an actor's eyes often convey what the shot is about and must be in focus. For example, if the actor is portraying that he is tense, often his eyes will be scanning all around the scene as though looking for something. Focus on the actor's eyes and then run through the scene with the eye movement, making sure the eyes stay in focus.

The second consideration is that you must know where actors on set should look to make it appear in the shot that they are looking at the correct height and angle. Often where actors should look is not exactly where they would physically look if the action was viewed with the naked eye in the real world. Experiment with the actors and several shots to make sure they know where they should be looking and that this feels right. This is an area where experimentation will give you the right eye line.

Often there will be an eye-line change in the scene. This can indicate several things but most commonly is used if a second character approaches or if the actor is surprised and looks at the source of the distraction. The camera height should usually but not always stay with the first actor, and often you will pull focus between the first actor and the second actor (or whatever drew the actor's attention). This focus pull follows the eye-line change of the actor. As with all changes in focus, it must be done at the correct time, and the change in focus introduces the new actor into the scene.

Looking Directly into the Camera

In general, actors do not look directly into the camera, because this can break the feeling that the audience is watching a self-contained story; it can make the audience part of the action, not just in the role of a character but as the audience. When an actor looks directly into the camera, it should be for one of the following reasons:

- The actor is directly communicating with the audience; the character is outside of the story and involved in a bit of meta-theater.
- Subjective camera technique is being used, and the character in the frame is speaking directly to the character whose perspective is being shown by the lens.
- It's a newscast, interview, or documentary-style shot where it is acceptable that the shot be directed to the audience.

Reflected Surfaces

If you are using a reflective surface, watch for any apparent changes in eye line that need to be corrected. Occasionally the actor's reflected eye line will look "off" from the actual or "cheated" eye line and will need to be adjusted so that the actor's eyes remain in focus.

Using reflections is a common film technique that you can use to reveal action in an interesting way or to create tension by revealing choice parts of the image. If you are using a mirror or other reflective surface, your lens choice will be dictated by how you are using the surface; often the reflective surface is used to show one actor and then reveal a piece of action taking place behind the actor. The lens must be able to accommodate both planes and still keep focus and accurate spacing. For example, if you use a wide-angle lens, the action behind the actor can appear to be distant, and if you use a long lens, the background may be blurred.

Perceived Distance and Compression

As we said earlier when describing normal and forced perspective, lenses allow the movie-maker to play with distance and depth perspective. Sometimes a lens will compress or widen the perceived distance between objects in an image. Objects in the back of the image and objects in the front can appear to be on similar planes. This illusion is the result of lens choice and object or subject placement in the field in relation to the other objects/subjects and to the camera distance from the objects/subjects. The placement of the camera is a key factor to achieve compression; if the desired compression is not happening, you may have to move the camera back. Compression of distance will happen with longer lenses when the camera is at a distance and can be done for dramatic or visual interest (Figure 4.7a). If you use a wide-angle lens instead, the opposite effect can happen, and the distance between subjects and background will be perceived to be widened (Figure 4.7b).

a b

Figure 4.7: (a) An image shot with a 200 mm lens at a distance; (b) the same shot with a wide-angle lens

Long-Lens Technique

There are several ways to use a telephoto or long lens on set that highlight the characteristics of the long lens.

Often when doing a stunt, long lenses are useful for their compression characteristics. These lenses are key to providing the illusion of contact in fighting because the distances are foreshortened; it will look as though actors are actually hitting each other when they are not. The compression will occur for all types of framing, so there is freedom for shots that are framed wide compared to closer-framed shots.

You can also use long lenses to provide a sense of increased speed or motion of any action in the shot. When an object or person is moving within a scene that is being shot with a long lens, that motion can appear to be much faster than it actually is. For example, a long lens will compress the background of the scene and it will appear to be close to the object (such as a car) or a running actor. If you pan with the action of the object or actor, then the background will whip through the frame and help make it appear things are moving faster than they are.

You can use long (or telephoto) lenses to direct the attention of the audience by using focus characteristics unique to long lenses. By putting the background out of focus and using a long lens, you will direct the attention of the audience to the part of the frame that is in focus. Using a long lens allows a small amount of the image to be in focus and the rest of the frame to drop away, focusing the audience's attention exactly on what you want them to be watching. The human eye naturally seeks out areas of focus or brightness.

Often long lenses are used for close-up shots of actors because they have the ability to keep the actor in focus and provide out-of-focus backgrounds that keep the actor as the visual hub of the shot. Long lenses are often used for shots where you are a distance from the subject or the item that you are trying to keep the focus on, but long lenses are useful even in relatively small areas. You can use a long lens for an actor or object of importance that fills the screen. For example, many shots taken of people riding in the backseat of a car use a long lens on a camera that is positioned in the front seat of the car. Using a long lens in this confined space keeps an actor's face in focus while visually separating the actor from the rest of the car.

If you want to shoot with a long lens or an extremely long lens to compress the distance between your actors, or between the actors and the background, be aware that you need to back your camera away from the actors. By moving the camera away from your actors, you will be able to keep the foreground and background in the frame.

Wide-Angle Technique

Wide-angle lenses can be used in a variety of shots that highlight their specific characteristics. Wide-angle lenses can be used to open up the feel of tight or confined spaces. Small or really tight spaces can look bigger when shot with a wide-angle lens because they show more of the location in the frame.

This ability to show a large physical location in the frame is useful for establishing shots or to give perspective. Wide-angle lenses are often used for shots that set the stage or show the realm in which the actors are going to interact. Their ability to show a large part of a physical location and to provide focus on multiple planes allows them to show a lot of action.

Wide-angle lenses can also influence how motion within the frame is perceived. One effect a wide-angle lens can have is making objects physically closer to the camera lens appear larger, thereby influencing how movement within the frame feels. Movement toward the camera will feel faster or exaggerated. The effects of the wide-angle lens will make the movement feel quicker and more intense, especially when the subject is close to the camera and moves toward it. However, most of the time, forward motion must be exaggerated while shooting in order to show up as forward motion on the camera. For example, if the actor is going to lunge at a camera using a wide-angle lens, it may be necessary for the actor to exaggerate the motion and lunge much farther than feels comfortable for the action to show up on camera with the proper feeling of movement. This rule also works in reverse if the actor or movement is going directly backward from the camera.

> Sometimes you may want to distort the actor or an object in your scene so that it appears much larger than the background. In this case, you need to move your camera closer to the actor or object.

Blur and Distortion

Bokeh comes from the Japanese word for "blur." It is the aesthetic quality of the blur produced in the out-of-focus areas of the frame. If the frame has parts that are out of focus, then how the blur looks will be important to the overall look of your piece.

As light from areas that are not in the depth of field hits the sensor, it forms a circle. The exact shape that the light forms will depend partly on the shape of the iris in the lens itself, but ideally the light should be uniform and circular. These circular images show up in the out-of-focus areas. The shape and design of the lens, particularly with the aperture and the f-stop, impact the look of the bokeh. In general, bokeh that is smooth and enhances the circular effect is desired (Figure 4.8).

Figure 4.8: From a scene in the movie The Shamus: *notice the bokeh of the lights in the background.*

While on set, pay attention to what parts of the image are out of focus and what colors, lights, or patterns will be affecting the bokeh of your shot. The out-of-focus area of the shot is as important as the in-focus area. The effect of the bokeh is most evident when the out-of-focus areas involve light sources, and adding light to out-of-focus areas can change the visual effect of your bokeh by making it more or less noticeable. If you have lenses that provide beautiful bokeh, it may be worth adding some low-light sources to your background and adding some color that fits your color story to highlight the aesthetics of your out-of-focus areas.

Remember that out-of-focus areas in a frame are a technique, not the point of the shot. No matter how beautiful the out-of-focus areas might be, they are there to serve the action, not be the point of the shot. Many shots in your piece will likely not have noticeable bokeh because deep depth-of-field shots often do not have bokeh that is particularly noticeable. This is also a nice thing to note if you are using lenses that provide less than ideal bokeh; simply design shots with a deep depth of field whenever possible.

The bokeh of a lens can be created or changed into distinct shapes, words, letters, or patterns with an add-on item to the lens. This technique involves creating a matte or glass filter with the desired shape cut out or imprinted in front of the lens. The bokeh then takes on the cutout shape while filming. You can also achieve this effect with a LensBaby lens (www.lensbaby.com).

Types of Distortion

Lens distortion is present in every lens. You need to know what distortion is present in the lens you are using and how to either eliminate the effect in the shot or use it to your advantage. Some lenses produce little distortion, with the most obvious being cinema lenses. Cinema lenses were designed to be used for filming motion, whereas still lenses were designed for taking still images. Some still lenses reduce or eliminate distortion, but you will have to do some research to find which ones work best. A rough guideline is the more expensive the lens, the less distortion there will be.

If you are using lenses that are typically used as still lenses, distortion will be more likely, and what was once a slight aberration in a single frame can be intensified throughout the entire shot. This most commonly occurs in wide-angle lenses and has little to no effect on standard or long lenses.

Wide-angle lenses are useful because they allow a wider field of view; however, they are prone to distortion, which becomes even more distracting with movement. With a wide-angle lens, the subject can appear large, and foreground details are emphasized. The wide-angle perspective may also exaggerate the relative size of the subject in shots. This may work fine on a static shot, but if the camera is panned, the distortion will be exaggerated, and the overall effect could be disconcerting to say the least.

Wide-angle lenses are prone to *perspective distortion*. If the camera sensor plane is not parallel to the subject plane perspective, distortion could occur. Perspective distortion exaggerates the scale of the subject so that the foreground and the part of the subject in the foreground appear extremely large in comparison to the rest of the frame. As the focal length changes, the subject appears to rapidly decrease in size or curve in a way that does not correspond to the normal view of the subject. Please note that the lens affects not only the distortion in your image but also the placement of your camera. Choosing to place the

camera above your subject or below it will have an impact on the distortion or lack thereof in your final image.

Another kind of distortion typical of wide-angle lenses is *barrel distortion*. Once again, this distortion will be more pronounced as action plays out in the scene or if the camera moves. Barrel distortion is evidenced when lines at the top and sides of the frame bend outward roughly in a barrel shape. If barrel distortion is present, use the lens for a static shot, and keep straight lines away from the edges of the frame. Obviously, if you are looking for a particular effect that is created by the distortion, then it pays to experiment and find a lens that emphasizes the exaggerated effect. Employing a fish-eye or semi-fish-eye lens is a great example of using extreme barrel distortion for an effect.

Pincushion distortion shows up when the center of the image looks pinched inward or when lines at the top and sides of the image are curved inward. This can be a lovely effect, or it can make the audience dizzy as the scene progresses. This kind of distortion is most common with super-wide-angle lenses and some telephoto zooms, usually on the extreme end of the zoom. If you use a converter, the distortion will be amplified.

It is possible to have multiple types of distortion in a single image. Wave distortion is a combination of barrel distortion and pincushion distortion and occurs most frequently with zoom lenses and wide-angle lenses. Outward-bowed parallel lines near the center and lines that are squeezed inward toward the edge of the image define wave distortion.

Chromatic aberration, or fringing, occurs when the colors (different wavelengths of light) are not focused on the same area or when the colors are focused at different lengths or are on different focal planes. Usually these distortions are most common in telephoto lenses or lenses with large apertures (Figure 4.9).

Lens Flare: How to Get It or Avoid It

Lens flare occurs when stray light enters the lens and, instead of progressing in a standard path and hitting the sensor, bounces back and forth, reflecting internally in the lens. Usually this light is outside the picture area and is particularly apt to occur when the light source is intense. The result of lens flare can be streaking; odd light shapes can wash out the contrast of the entire image. Filters can also either reduce lens flare or give the stray light another surface to bounce off and increase the flare. Lens flare is highly likely when a bright light source is to be included in the image.

Figure 4.9: Purple fringing is a form of chromatic aberration.

Lenses are usually manufactured with antireflective coatings to reduce flare. You should give special consideration to wide-angle or zoom lenses, which are more likely to have flare problems. With wide-angle lenses, there's a greater likelihood of the sun or a bright light source being near the angle of view. With zoom lenses, you increase the potential for light to bounce around, so these lenses are particularly prone to flare. You can also reduce flare by physically blocking the light with a lens hood or flags, changing composition, or moving lights when possible.

If you *want* flare in the image, do the reverse: use a flare-prone lens, have a giant light source near the light that is producing the image, or use post techniques (Figure 4.10). If you want lens flare, also be aware that the size of the lens iris will change the look of the flare, so if you change the aperture, the look of the flare may also change.

Figure 4.10: Lens flare from the sun captured in camera

Sharpness

An image that is *sharp* (or has definition) has crisp detail, clearly defined lines (especially on edges), and easily delineated contrast. An image is usually perceived as sharp when the transition between edges has strong contrast. The more gradual the tone transition, the less sharp the overall image will be perceived. Sharpness is a result of many decisions that encompass the entire DSLR workflow; decisions with resolution in the DSLR world include the ISO, the resolution, the lens and lens settings, the contrast and sharpness of in-camera settings, how the image is projected or viewed, and post-processing.

The characteristics of sharpness that concern filmmakers relate to making sure that the final image is able to be shown in such a way that the viewer's expectations for image clarity and sharpness are met. An image can be in focus but not sharp enough. Though an image can never be too in focus, it can be too sharp.

Image Sharpness

The resolution in a digital camera is confined to the digital sensor. The more resolution that is available, the higher the level of fine detail that can potentially be captured. A high detail level means that a high level of sharpness can be achieved. *Resolution* in this context is a measure of the camera's prowess at differentiating between details in close proximity and is roughly measured by the frame size, pixel type/number, and pixel organization. The type of digital sensor that is in your camera fixes the resolution limit. Although that sounds intimidating, the good news is that if you are shooting on a DSLR camera, it is almost impossible not to have the necessary resolution to produce a sharp image.

To have a sharp image, a certain level of noise or grain is tolerated. However, at some point there will be too much for the viewer, and the image will no longer be considered

sharp enough. The ISO choice may influence how sharp your final image appears simply because the level of noise and type of noise can influence how the image is perceived. High ISO settings can result in an image that looks less sharp simply because of the increased noise. Oddly, if an image has too little fine detail noise, it may be perceived as less sharp than an image with a higher level of fine detail noise.

Lens Sharpness

One of the factors for the overall sharpness of your final image is the sharpness of the lens used. Defining lens sharpness involves all of the same factors as defining image sharpness. Lens resolution is about how much detail a lens can capture; can the lens capture the detail in the image? All light that goes through a lens is degraded or blurred even if just infinitesimally, and a lens that has a high resolution will have a better ability to distinguish details. The sharpness of your lens will even affect how the color of your image is viewed; a less sharp lens will not be able to show the minute color detail, and the entire image will lose some of the color range.

Lens sharpness is also a product of contrast; can the lens transmit the difference in tone in the detail of the image? Contrast is usually used as a way to talk about the overall image, but contrast when used in terms of lenses is a bit different. *Microcontrast* means how well the lens differentiates between small details of similar tones that are next to each other. A lens with good microcontrast would show fine details with high contrast, or a good differentiation between the lightest and darkest parts even within the same tones or hues. For instance, a lens with good microcontrast can show detail within the shadows, not just the difference between black shadow and white light.

In general, many of the lenses available are capable of producing a sharp image; however, even with a capable lens, several factors can enhance sharpness. Some general lens rules are that the better prime lenses will beat zoom lenses at their focal length and that filters can degrade sharpness; if you use a filter, make sure it has high-quality glass.

Microcontrast and Macrocontrast

Microcontrast is concerned with contrast in details or between closely related hues. Macrocontrast is contrast over large areas, in other words, the overall difference between the darkest parts of the image and the brightest parts of the image.

A lens can also influence how clear or blurred the edges are perceived or recorded onto the image. Edge clarity, or *acutance*, is the third area of sharpness that a lens can influence.

Aperture and Sharpness

Every lens aperture has a sweet spot for sharpness. The general rule is that the lens will produce the sharpest image about two sizes smaller than the maximum aperture of the lens. Diffraction occurs when light passes through a small iris, and this scattering of light makes the image less sharp. Aberrations tend to be the worst at large apertures, and these distortions diminish the sharpness of the lens. These two issues in combination mean that often it is wisest to shoot at the middle available apertures of the lens. Occasionally, in order to avoid the smallest apertures, a neutral-density filter may be helpful. However, it is also true that if you are going to buy a lens that is designed to be fast, the lens will likely be sharp at the maximum aperture simply because the manufacturer has probably designed it with that in mind. In general, test the lenses if you have a specific aperture or depth of field

necessary for the shot and you worry about not having a sharp enough image. Often, the overall impression of sharpness is about having contrast in the image between parts that are sharper and parts that are softer.

Other Factors for Sharpness

When dealing with sharpness, it is important to keep in mind what the final image format is going to be and how the resolution needs change depending upon your final format. The sharpness needed to project your movie on a theater screen is different from the sharpness needed for it to be viewed on the Web. The camera likely will have in-camera settings that affect the sharpness of the image obtained, and the settings may need to be altered depending on the shot or the effect. Many post-production aspects can increase some aspects of sharpness, but occasionally if an image is too sharp, post-production possibilities are hampered. For example, post-production can usually increase acutance, but if the image is too sharp, it can be difficult or impossible to appropriately soften it.

Image Stabilization and Vibration Reduction

Lenses with image stabilization (IS) technology do have the ability to make movement smoother, and in the event that a handheld camera is the only option, they will be helpful. In general, however, any lens with image stabilization will be less effective than a monopod. Lenses with image stabilization technology also have noise issues that can interfere with your audio because the image stabilization technology uses gyroscopes and motors inside the lens (Figure 4.11). These moving powered pieces also will be a drain on your battery. Additionally, the IS feature is trying to stabilize a still image so if you want a little movement in your video, the IS will actually fight what you are trying to achieve.

Figure 4.11: IS switch on a Canon lens

The *Jell-O effect* is a problem with most DSLR cameras. If you are shooting a panning shot from a tripod, using an IS lens rather than a non-IS lens will produce less of this effect in your shot.

> Sony cameras have stabilization built into their camera body rather than in the lens like Canon and Nikon cameras.

Focusing

Focus is one of the most frequently discussed issues on a set with a DSLR. An image is in focus when it is sharp and clear. Factors such as monitor clarity, light changes, and operator ability will help or hinder your ability to achieve accurate focus.

Focus without Autofocus

The general rule is that autofocus is not an option (Figure 4.12). This is a good thing. The shot's focus is the most important part of any shot, and having complete manual control is paramount. Once you decide what the focus should be on and physically set all of the variables, the focus will not change without your control. Often, for a static shot, you will determine where the focus should be; ensure that your subject is within the focal plane, and the scene will roll flawlessly. However, when there is movement or when the shot has a change of focus, it will be necessary to pull focus to keep key elements in focus.

Figure 4.12: Autofocus/ manual focus switch on a Nikon lens

Focusing When Using a Mirror or a Reflection

Focusing on a mirror image can be incredibly tricky because of the light reflection and relative distance created by the mirrored image. If you have any shots that involve focusing on a mirrored image, recheck your focus. Focusing on a reflective surface that has slight movement or is not as reflective as a mirror can be even trickier. In these cases, using autofocus is not advisable; you must use manual focus in order to make sure you are getting the proper area of the reflected image perfectly in focus.

Splitting Focus

If there is a scene with two actors who are at different distances from the camera, you may want to have both of them in focus. In this case, you will have to split the focus between the two actors. This can be tricky because sharp focus usually depends on exact distances, and the actors may be on the ends of the depth of field.

In many cases, it will be better from a focal perspective to simply shift the focus between the actors throughout the scene or just keep the focus on the actor you would like the focus to be on throughout the entire scene.

Pulling Focus and Follow Focus

Follow focus means forcing the lens to change its focus plane to follow either an object or a person as they move through the shot. The most common shot is when an actor is walking directly toward the camera. As the actor walks toward the camera, they would walk out of the focus plane unless the camera operator (or focus puller) somehow forces the lens to change the focal plane so that the actor remains in focus during the entire shot.

The necessity for follow focus is compounded when shooting in low light or with a camera with a larger sensor. Both will cause the depth of field to be narrow, which means there is less room for error in getting proper focus; it also means you need to change the focus much faster because the depth-of-field plane needs to travel a greater distance than a wider field of view would.

Often the focus will need to change as either the action moves or the emphasis varies. The basic way to do this is to physically change the lens to the proper focus at the appropriate time; this can be a matter of speed, smoothness, and exactness. Often one person will be in charge of changing, in other words, *pulling*, focus. There can be several focus changes during a continuous shot, and every change must be exactly on for the shot to work technically. It will be necessary for the actors to hit their marks or the action to take place in the position that is planned when the shot is designed; the focus mark's accuracy on the lens or follow-focus unit depends on the exact position of the part of the shot that must be in focus. Rudimentary marks can be made on the lens for the focus puller to know in what position to move the lens.

For some situations, you can use a follow-focus unit. Lenses can be tricky to adjust perfectly. A follow-focus unit is a geared ring that attaches to the lens and has a system that allows you to note the focus marks so that the focus can be pulled more smoothly, with a decrease in operator mishaps.

For other situations, you can use a remote follow-focus unit. These systems allow the focus to be adjusted by an operator who is some distance away from the camera. The focus marks are set, and the operator adjusts the wheel at the appropriate moment, so the lens adjusts focus.

Methods of Pulling Focus

Several solutions are available for helping you pull focus while you are shooting. You can use a cheap and easy solution if you're on a budget or buy/rent a complete follow-focus system.

Figure 4.13: Lens with tape and focus marks on it

"Poor Man's Focus Ring"

If you are on a budget or just don't like to add tons of additional gear, then making your own "poor man's focus ring" is a great solution (Figure 4.13). Just place a piece of masking tape or some other lightweight tape around the barrel of the lens.

You now have a focus ring where you can note your focus marks right on the lens. This isn't a perfect solution, but if you have the time for a few extra takes or don't want to stand out as a filmmaker in a public area, this is a great technique.

In general, use this method only if it is your only option. Because still lenses are designed for autofocus and for the camera to change focus quickly, there is little distance between focus marks. So, changing focus on the lens by hand means you might have to move the lens a few centimeters to your new focus mark. This is hard to achieve with reliability. If you need to use this technique, then adding more lighting to your scene so you can shoot with a higher f-stop is highly recommended.

Gearing Your Lens on Location

The next step up from taping your lens is to use a lens gear adapter and a follow-focus unit. A lens gear adapter is a round ring that you slide over your lens and fasten to create a geared ring to interact with a follow-focus unit (Figure 4.14).

Figure 4.14: Redrock microFollowFocus gears

Lens gears come in various sizes, so you should measure the circumference of your lens and order the correct size so it fits tightly around the lens. Once you attach the lens gear to your lens, you can hook up a follow-focus system to fit into the lens gear (Figure 4.15). Now you can use the lens more like a professional film camera with a follow-focus attachment.

Figure 4.15: Bartech wireless follow-focus unit being used on the set of Incident on Marmont Avenue

This is a better option than taping your lens, but there are still some limitations. Try to get focus rings that are fat in size, because the fatter the ring, the more distance between your focus marks. This means you are adding more distance between one focus mark and the next. This greatly helps your focus puller hit the marks and have a fluid and smooth motion. Another benefit is that the gears work on still lenses that have no hard stops.

The barrel size of your lenses will vary in diameter, but adapter rings come in a variety of sizes to allow you to attach to different lenses. Some fit better than others, but there is a tendency for the rings to slip a little from time to time. Even a little slip will cause you to have to reset and remark your focus ring. This is also a problem because of the lack of hard stops. If you overshoot your focus, you may have to reset your focus marks because the exact position of the lens's focus can change on non-hard-stop lenses. If you have time, it is easy to work with these limitations, but if you are really short on time and need a more reliable solution, this is not the best choice.

Permanent Gearing

If you are sure you will be shooting a lot with your lenses for motion work, then you might want to get your prime lenses permanently geared. Instead of using aftermarket lens gear, you can send your prime lenses to a place like Duclos Lenses in Los Angeles and have them permanently attach a gear ring (Figure 4.16). The benefit of doing this is that there is no chance that the lens gear can loosen or slip while recording. Also, there's one less piece of equipment that you have to take on and off, which can greatly increase the speed of lens changes on set.

Figure 4.16: A permanent gear that is attached to a lens cannot be removed.

Without a doubt, permanent gearing is the best option for accuracy and ease of use. Having a gear physically attached to a lens means that there is no slipping of the gear and that you get repetitive and consistent focus marks. However, this cannot be done to still lenses that do not have hard stops. If you have still lenses without hard stops, then the adapter gears are your best choice.

De-clicking a Lens

Another result of the DSLR revolution is the influx of manual still lenses being used for motion-picture projects. While the existing manual lenses being used are excellent examples of optical design, they are far from suitable when it comes to mechanics. This is not a comprehensive look at all the flaws when shooting a motion picture with a plastic autofocus lens. We'll concentrate on one of the quickest and easiest ways to make your still lenses perform more like cine lenses.

There are a few good candidates for shooting motion on a DSLR. Zeiss ZF lenses (Figure 4.17) are a great choice because they are high-quality lenses, they have hard stops, and the iris control is on the lens and not controlled by the camera.

Figure 4.17: Zeiss ZF lens

A few other candidates are older Nikon AI-S lenses (Figure 4.18), Leica R lenses (Figure 4.19), and the older, rarer Zeiss/Contax primes (Figure 4.20). All are intended for still photography yet are easily adaptable for motion picture.

Figure 4.18: Nikon AI-S lens *Figure 4.19: Leica R lens* *Figure 4.20: Contax lenses*

All of these lenses have a common feature: a manual aperture ring that clicks into place at varying intervals. Some click at every third stop, and some click at every half stop. Regardless of the interval, it is an annoying feature that doesn't help motion-picture shooters at all. This feature is in place for a couple of reasons, mostly to allow the user to feel the clicks and know how many stops are being adjusted without having to look at the scale (assuming you know where you started). Also, some manual aperture lenses are spring-loaded to keep the blades tight and reduce any play in the actual aperture opening. The clicks keep the spring from pulling the aperture closed or open.

Removing the "clicks" leaves a single, fluid movement that allows seamless aperture adjustments. The procedure is different from lens to lens but always requires disassembling the lens to get to the mechanism that provides the clicks. Figure 4.21, Figure 4.22, and Figure 4.23 show how it is done on one particular set of lenses.

Figure 4.21: Removing the mount to access the aperture control ring (courtesy of Duclos Lenses)

Figure 4.22: Removing the aperture control ring to access the click mechanism (courtesy of Duclos Lenses)

Figure 4.23: Dampening the aperture ring for smooth, viscous movement (courtesy of Duclos Lenses)

You are probably asking why this is important. If you need to change your aperture while you are shooting, a de-clicked lens will allow a gradual seamless transition from one aperture to the next. A non-de-clicked lens will jump from stop to stop, giving you an unpleasant and noticeable jump between stops.

So, is the de-clicking procedure a necessity? No. But it makes DSLR footage that much closer to a professional motion picture, a goal all DSLR shooters should be aiming for.

Zooming

In general, zooming has fallen out of style as a regular cinematic technique. Go watch 1970s movies and TV shows to see brilliant uses of zooming and composition in filmmaking. Today you are more likely to see a quick zoom in (or out), and this technique is more popular in television than feature films. Zooming is also an effective tool in documentary-style projects.

If the shot simply must have a zoom, it may be worth renting a fluid zoom drive (Figure 4.24). This will ensure that the shot stays smooth and that the zoom looks artistic as opposed to accidental.

See Chapter 6, "Lighting on Location," for more on using zoom lenses for a visual effect.

Figure 4.24: Zoom drive

Variable-Focal-Length Zoom Lens

If you don't have a fixed-focal-length zoom lens, you must be aware that your exposure will change during your zoom. If you have to do a zoom shot and only have access to a variable-focal-length lens, then you need to work out how to manually adjust your exposure as well as execute the zoom.

five

Camera Motion and Support

Stop looking at camera support

equipment as simply gear. Think of it more as a way of adding movement or taking movement away from your shot. The type of equipment you will use depends on the type of movement you want to add or control.

Camera Motion

You need to ask yourself three questions for each scene you will be shooting:

- Do I want movement in the shot?
- What type of movement do I want to have?
- What equipment do I need to execute that type of movement?

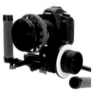

You should start by choosing the sort of camera movement you want to have in your scene and then think about what equipment will best help you deliver that movement. To do this, you need to know the various types of camera movement and the most common equipment used to achieve those types of shots. You can't have one without the other.

The reasons for adding movement to a scene are dictated by your philosophy of movie-making and the parameters of your scene. If you want movement in the shot, you should examine why you want the motion. The motion should come from the script and the story you want to tell. Knowing when you want motion and what kind of motion is an extension of knowing your story. If you decide that you don't want motion in the shot, that decision is also an extension of your narrative and perspective. How the camera moves is as important to the telling of your story as the sound, dialogue, and lighting.

In theory the type of movement obtainable is limited only by your imagination, but in practicality usually it is dictated by the budget or location where you are shooting. As you envision the types of motion that you want for the scene, think about the final shot. How do you see the story in your head? This is the only part of the decision that isn't technical. You must answer this question by looking at the script, envisioning the story, and dreaming about how you want it to look and feel. If you aren't coming up with a good visual image,

you may want to go to potential locations and walk through your story or even watch movies that tell the story effectively through motion to search for inspiration. After you have done the dreaming, it is time to get back to the practical world of gear and planning how to execute the motion.

When you have an idea of what kind of motion you want, you will need to figure out whether this is practically possible. You will need to pick and plan the gear and crew that are needed to achieve the shots. As you make your motion plan, break down every shot in terms of gear and crew.

Why Add Movement?

There are many reasons why you would go to all the trouble and extra work of adding camera motion to your shots:

Show Perspective Movement shows perspective. It can show the internal view of a character by showing what the character is seeing and by moving in the way that the character's eyes move over the scene. In these cases, the camera movement is dictated by how that character is moving and reacting. The movement can also show what the character is feeling or thinking even if it isn't showing the physical perspective of the character. The character may be shot with camera movement that describes the internal state of the character.

Add Emotion The speed, angle, and type of movement can cue the audience about what they are supposed to be feeling or what kind of scene they are watching. The next time you watch a scene with high emotion, examine the camera movement. If it's an intense scene in a scary movie, does the tempo increase, is the movement jittery, or is it suddenly rapid and slightly off-balance? How does the camera movement increase the tension, and when the tense moment is over, how does the camera motion change to reflect this lull?

Show Emphasis or Direct Focus If the camera is moving to follow a character or object, the audience is naturally drawn visually to what the camera is following. The motion leads the eye directly where to look, just like we turn our head to follow objects or because we want to see what emitted an unexpected noise. The motion can also dictate what elements the audience is not looking at or what they are not noticing as much. By directing focus, you are showing the audience what to look at but also selecting what elements the audience will *not* be paying attention to. Whatever you are matching the motion with or what is creating the need to move the camera will be the visual focus of the shot. This is true if the camera is moving because it is showing the point of view of a character who is visually searching a scene. What is the important part to be watching? Whatever the camera is moving on.

Motion Makes Eye Candy Sweeter

Motion creates eye candy by showing interesting things for the audience to take in as they view the scene. As the camera moves past colors and light, the colors and light often create an interesting blurred effect. The motion also keeps the eye busy, and adding motion to the camera and within the frame creates layers of motion that provide visual interest. We are hardwired to be attracted to motion and the effects it generates.

Restricting Movement

Every moviemaker will want to restrict unwanted movement by the camera. Even if the shot is wildly spinning, some camera moves will need to be restricted by the operator and the gear. The simple tripod that most people use the first time they shoot a movie best illustrates the elementary way the camera movement is restricted. The tripod is used to keep the camera steady and allow the operator to direct the movement. We don't usually think of our gear as restricting movement, but essentially that is the entire point of camera support gear: to restrict any movement that is uncontrolled by the operator. Camera support gear is used to restrict shaking, bouncing, wiggling, and other erratic changes in motion that ruin the shot. The best camera operators have spent a lot of time learning how to restrict unwanted movement and how to best control the movement to get the desired shot.

There are also times when camera movement is restricted by the story or even the style of the piece. A few—very few, really—modern major directors use sparse motion in their films. The good news is that if you are limited by budget, time, or location and don't have enough capital to invest in motion, it is helpful to look at films prior to the extensive use of motion or at current films of directors who don't use a lot of motion.

On-Screen Action and Position with Movement

Another thing to consider is how the movement in the shot complements or contradicts the movement of the camera. There is a visual relationship between the camera movement and the movement of the subjects or objects in the scene. For instance, if you dolly screen right to follow a car, also moving to screen right, you have both movements complementing each other. On the other hand, if you have a car coming directly at the camera and you add a dolly or job arm push toward the car, the movements are acting oppositely. This conflict can help create an enhanced feeling of speed for the car coming toward the camera.

The camera movement also interacts with the position of the subject or object in the frame. Moving on a subject that is very close to the camera will have a different effect than if the camera is far away even if the movement is the same. If the subject or object shifts position in relation to the camera while the scene is playing, the look and feel may be altered.

Types of Camera Movement

As you think about camera movement, think about all of the directions that the camera itself can physically move. It can move forward, backward, side to side, up and down, at a tilt, and at an angle; it can be made to look like it is flying, and it can even be brought back to retrace the movement. Within the camera and lens system, there are also movements with focus. A push-in or pull-out is possible with zoom lenses, and the camera can also stay in a stationary position but pan or track to give movement to the shot. If you can imagine the movement, it has probably been done with a camera.

The beauty of DSLRs is that you can capture more movement easily with less equipment. Also, a huge variety of movement options have been opened up to moviemakers because you can now place the camera in ways that were not possible only a few years ago. The size and weight of the camera make a lot of the gear more affordable and attainable to smaller budgets or sleeker projects, and since perfecting motion is often about practice, having the camera and gear in your hands is half the battle.

The movement you can achieve can be limited, however, by one thing. Sometimes the limitation is a gear limitation. If you don't have a crane or jib arm with a rotating head attached to a remote, it is going to be impossible to get a shot flying in the air and through a window. Sometimes the limitation is with the location. If you don't have enough room for a dolly track to form a circle around your actors, you will have to change your shot or the gear. Sometimes the limitation is time. Some movement shots are very time-consuming to set up and perfect, especially since they often influence the lighting and set design. Sometimes the limitation may be linked to the DSLR camera capabilities. Certain fast pans with the sensor may cause distortion or the dreaded Jell-O camera effect on your lovely landscape. But probably the most important limitation will be the story and the effect you're after. If your story doesn't call for rapid kinetic movement, you won't be ordering a helmet cam.

Here are some basic movements to keep in mind; this is by no means a comprehensive list but rather a starting point to expand upon in your project. It is also important to note that often a shot will incorporate several different types of movements, and therefore the movements will be linked together. If you are doing multiple movements, timing becomes your biggest challenge.

Pan and Related Movements

A *pan* is achieved when the camera is rotated or moved horizontally on a tripod or other point (Figure 5.1). The movement here is directional and on a single plane unless combined with another movement. Pans are often used when it is necessary to get more physical space into the shot. They can be used on a wide scale for landscapes or on a smaller scale when the camera pans from one character to a character sitting nearby. Panning can occur on or with a moving piece of the scene or be stationary. It is important as you pan to keep in mind the composition throughout the shot, particularly the composition of where the shot lands.

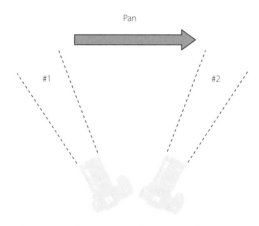

Figure 5.1: You rotate the camera from one side to the other but add no additional movement.

A vertical pan where the camera is panned on a vertical plane is referred to as *tilt*. If the camera is panned up, it is a tilt-up; if it is panned down, it is a tilt-down (Figure 5.2). A tilt is used for the same reasons as a pan is used, and the care of composition, timing, and smoothness of operation are areas to focus on for this movement. A boom is a vertical movement that is not on a fixed axis, so a boom move will simply move up or down on a vertical plane. Usually these moves are made more dramatic with cranes or arms.

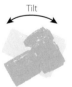

Figure 5.2: You tilt the camera up or down but add no additional movement to the camera.

For DSLR cameras, the weight of the camera will not make panning physically difficult as long as the camera is attached to a solid head. However, sometimes having a very lightweight camera can make it hard to judge the speed of the pan. The keys to any type of pan are the head that the camera is attached to and the deftness of the operator. With film-movie cameras, pans are usually done with considerable stabilization gear, but with DSLRs, pans can be achieved simply by holding the camera. If your panning is jittery or the speed is off, you are likely in need of at least a decent tripod with a fluid head. Adding

weight to your camera and/or tripod will help you achieve smoother movements. If you must handhold for the pan, try bracing your body against a wall or solid object and pulling the camera in close to restrict the extra movement and reduce any physical arm fatigue.

Whip Pan

If you get the panning motion down, a whip pan is an easy second step. A *whip pan* is a really fast pan where everything is blurry in between the start and stop of the pan. It almost feels like the movement is done with the flick of a wrist. Obviously, the move involves more than flicking the wrist, and the exact movement will depend on your camera, lens, and setting. It is an exceptionally rapid pan often used as a quick image change. As the pan happens, all of the background and the entire moving image will be completely out of focus and blurred (Figure 5.3). For part of the shot that will be out of focus, you can plan striking colors or lighting that will be eye candy during the move and increase the impact. A whip pan can also be cut into another whip pan to transition from one shot to another or even into another location.

The whip pan is one area where the propensity to Jell-O effect will not be a problem. The pan happens so fast that the distortion becomes part of the effect. If you move the camera fast enough and stop it fast enough, any potential distortion will simply be viewed as an effect of the whip pan and not a sensor dilemma.

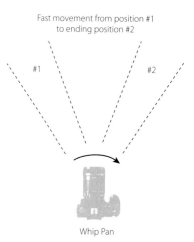

Fast movement from position #1 to ending position #2

#1 #2

Whip Pan

Figure 5.3: You start with something framed in your shot but then really quickly whip pan to reveal something else in the frame. With this type of movement the audience sees nothing but a blur between your movements.

Zooming

A *zoom* movement is possible when using a zoom lens (Figure 5.4). The speed at which you zoom the lens will change the effect and depend on the desired look, which can range from an extreme visual change to a subtle shift. There is a great variety of degree of zoom; sometimes a slight movement is a way to provide emphasis, while an extreme zoom gives total focus on a particular piece. The zoom can also be paused and used as the scene progresses. Zoom moves can be useful on low-budget sets where time and cost are at a minimum. Zoom moves usually involve very little actual camera movement, and the operator works solely with the lens.

If you come from a video background or have used zoom lenses in still photography, zooming is a common practice that you may continue using unconsciously in your DSLR moviemaking. However, zooming is not an overly common film technique in today's cinema, even on film sets where a zoom lens is used. This is one time where using still lenses to make your movie may cause you to miss some of the other camera moves that can be used for the shot.

Zoom— Changing your framing with the lens while the camera isn't moving.

Figure 5.4: To zoom in or out from your actor you make the movement with the camera lens and not by moving the camera itself.

Push-In

This shot is exactly what it sounds like. A *push-in* occurs when you push the camera in or move toward an object or a subject so that it naturally feels like something has changed or

you are introducing a new element (Figure 5.5). As the push-in occurs, pay attention to the timing. If the push-in happens too soon and nothing has really happened of note, the audience can be left trying to figure out if they missed something. A classic example of a push-in with a dolly is a window push, where the camera starts outside the window and pushes in on the scene, letting the audience enter the building using the window as an internal frame. A push-in can occur with a dolly or a zoom lens.

Depending on what gear you use to achieve the push-in, the effect can be very different even in the same scenario. The clearest change will be seen in the background, but the compression can also look very different depending on your gear choice. Another factor for the look of the push-in is the lens, and if the push-in feels distorted or ends on a shot that has odd perspective, you may need to adjust the lens or camera.

Pull-Back (or Pull-Out) and Widen-Out

A *pull-out* occurs where the camera moves backward away from the subject; it's often on a dolly but can be done handheld or with a combination of a crane or lift and a dolly. Typically a pull-out move shows more of the scene or important elements. It can be used as a way to reveal elements or to give a different feel to the shot (Figure 5.6).

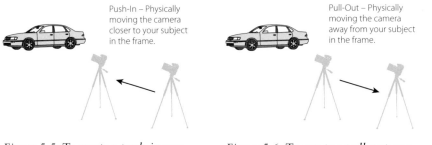

Push-In – Physically moving the camera closer to your subject in the frame.

Pull-Out – Physically moving the camera away from your subject in the frame.

Figure 5.5: To create a push-in you need to move the camera physically closer to your subject.

Figure 5.6: To create a pull-out you need to move the camera physically farther from your subject but not use a zoom lens to get farther away.

A *widen-out* is a type of pull-out but achieved with a zoom lens. When widening out with a zoom lens, the effect is different because it is more of a perspective change and it widens the field of view rather than being a complete camera move. The background and final shot will be very different than a pull-out. Either of these moves can be done at different speeds to fit the desired effect. As you plan the speed, take into account whether the items in the shot are moving and whether you are going to match the speed or move at a different speed from the action. If the camera is moving slowly, it is said to be creeping along. You will also need to plan if the speed is going to remain constant or vary.

Combined Push-In and Pan

Many times shots incorporate two movements, and sometimes these two movements go together so well or so frequently that the combined movement becomes its own movement type. The push-in and pan combination begins with a push-in and then partway through adds a pan. The pan is done to reveal some visual information that is important to the scene,

usually another person or part of the setting that is important (Figure 5.7). Sometimes with this move there will also need to be a focus change if the pan moves to an area that is not in the field of focus. It is best to start the focus with the subject that the push-in is focused on and change the focus as you pan to reach critical focus when the next element is properly composed in the frame. This movement may then be added onto with additional movement if necessary, but keep in mind any focus issues that may be present if there was an initial focus pull during the pan.

Combined Push-In and Whip Pan

This move is intense and when done rapidly can signal a powerful story move or reveal. In this move, the camera moves in toward the action and then, usually to match a quick move on the screen, whips over to catch or move with the on-screen movement (Figure 5.8). The whip pan in this move is the decisive moment. Sometimes the on-screen movement is a direct action, but it can also work on a powerful line of dialogue that, when combined with the push-in and whip pan, can feel aggressive.

Circling

Moves that spin around a group of people are often *circling* dolly moves or a 360 dolly. The track is set up in a circle around the subjects, and as the scene progresses, the camera moves on the dolly around the track (Figure 5.9). This is one time where having a dolly track is necessary. It is almost impossible to move a dolly off a track in the same path for the entire scene. These scenes are also usually done on a dolly because the same camera moves will need to be repeated and used to cut into the other footage that is shot to cover the whole scene. Handholding or Steadicam operation will not be able to achieve the accuracy in repetition of a dolly on a track. The position of the track and radius of the circle can change the circling move into a spinning dolly move. Some circling-type moves can be done on a tripod or handheld if you don't need to cut the same shots in sequence, but the traditional circling move is done with dolly track. Circling is one area where DSLR moviemakers are advised to stick with traditional filmmaking techniques.

If the subject and the camera are moving in opposite directions, a counter move is occurring. When the action on screen and the camera are moving in opposing directions, it is a counter action or movement. For a counter move, the camera direction will be against the subject direction and move around them in a circle. It is still a circling movement by the camera. Sometimes counter moves are considered any moves that go counter to the camera movement, but they are usually used with circling setups.

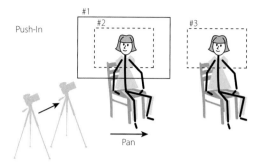

Figure 5.7: Push in on the person at the left of the table and then pan over to the person they are speaking with.

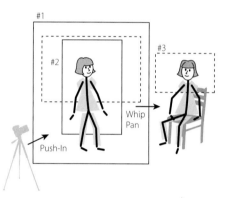

Figure 5.8: Push in on the person entering the door and then whip pan over to reveal the person waiting for them.

Figure 5.9: The camera will move around the table to continually reveal each actor at the table as they speak.

Dolly Moves

Dollies usually move forward or backward on a track and stay on the track until the gear is reset. A dolly also often has an arm that can be raised or lowered by the operator, so several motions may be possible at one time all from the dolly. The dolly is normally steered or moved from the back wheels, and the motion forward or backward will be determined by how the dolly is moving in relation to the scene or action.

> The vocabulary for dolly moves is consistent with other camera movement terminology. *Moves* are moves that happen when the camera moves parallel to the action and the camera continues with it. *Tracking*, or *trucking*, is done when the dolly is in motion for any movement. The camera can also move across the screen, usually with a pan for a lateral move, and this can occur by the camera on the dolly. When the camera on a dolly moves vertically and on the dolly track, it is a *compound* move. *Retracking* on the dolly is simply moving backward over the steps that the dolly took on the first pass.

Tracking Lateral Movement through Space and Retracking

Tracking movements occur when the camera moves forward to tell the story. Usually tracking shots are done with a dolly but can also be done with handheld rigs and Steadicam shots. As the tracking moves, the speed can be changed. If you're using a Steadicam or handheld rig, pay attention to camera sway when the tracking move stops.

Retracing occurs when the camera, usually on a dolly or handheld support system, goes backward over the same path as the previous forward motion; essentially, it is a continuation of the shot but in reverse.

Figure 5.10: The camera can dolly or crane with the person entering the door but then continue to travel through the side window to frame the person now standing in the room.

Moving or Tracking through Solid Objects

You can set up many cool moves where the camera looks like it is going through doors, windows, whole buildings, or other solid objects. The small size of a DSLR makes these shots possible (Figure 5.10). To get these shots, the objects are cut apart so that the camera can fit through them, and usually the camera is attached to a remote-controlled crane. Often in movies, cutaway sets are in use, or specialized miniature cameras are in play. If you need an elaborate move through a solid object, take into account the size of the object and your camera. This is one of many types of shots where you need to design the set and the motion in the shot together.

Pendulum Pan

A *pendulum pan* is a variation on a typical pan that takes the pan to a more forceful level. For a pendulum pan, the camera stays mostly still, moving just enough so that the moving subject is properly framed. The camera stays in this calm, more passive state until the moving object has passed by. As the subject passes, the camera

moves into the space that the moving object or subject was in and pans after the subject as the subject continues to move (Figure 5.11). You can choose either to stop or to continue the camera movement. The exact timing and speed of this move will depend on the desired effect and the set. This film move is easily possible with a DSLR and minimal gear or a handheld rig but adds a level of interest that goes beyond a traditional pan.

Pendulum Pan

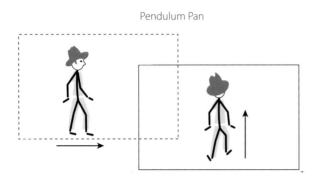

Figure 5.11: The camera will pan with the actor in profile, and the actor, not the camera, will turn and walk directly away from the camera revealing the back of their head.

Crane Moves

If you want to make your DSLR project feel high budget, invest in a few crane shots. Cranes were designed specifically to get movie shots envisioned by directors and operators. Cranes vary in their abilities in terms of scale, but regardless of use, they can add drama to a scene. In general, if you are using a crane, you will want to use an experienced crane operator. Cranes can move up and down from eye level to reveal a new perspective, ranging from a low-to-the-ground shot all the way to a towering shot high above the actor or subject you are shooting (Figure 5.12). The crane can also move toward or away from a subject. The crane can move quickly or slowly, and you can design a combination of directions and movements for your shot.

Cranes can be used for shots that feel like the camera is going over the top of objects or moving on top of tall areas to give audiences large-scale views.

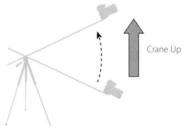

Figure 5.12: A crane can start with the camera low to the ground and then be raised so the camera is high above the action on the ground or to frame up an estate in the distance.

Rigging for Motion

Some shots, like flyovers or moving car shots, can be achieved only by rigging the camera to a moving object. If you need this type of shot for your project, rigging for motion will become a budget item. DSLRs can be attached to a limitless array of moving objects from planes to remote-controlled cars. The camera can be rigged stationary or with a remote moving head and focus to get complex levels of movement. For situations with fast-moving objects, it will be worthwhile to invest in an experienced rigger.

Movement with a Jib Arm

The jib arm lets you get shots that incorporate a range of height and, when combined with a remote head, that move in smooth and interesting ways (Figure 5.13). With a jib arm and a crane, shots can take on a grand scale and still get the details.

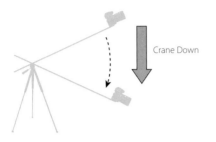

Figure 5.13: A jib arm can start high, showing a car driving toward the camera. It can be lowered to normal level to allow the actor exiting the car to be perfectly framed.

The speed of the camera movement will affect how the entire shot looks and feels. As you work with the speed, think about how it relates to the characters and the tenor of the scene. There is a big difference in the camera lunging at the character and a soft glide forward as she looks out the window. Sometimes a slight change of movement can give the audience an anxious feeling. Even very subtle changes cue the audience in and can influence the effect of the scene.

Think through the motion every step of the way. You will need to plan the movement steps and where the movement should rest or stop if necessary. Often the movement will have a flow with resting points for pauses or beats in the action or dialogue. This means you can adjust the speed and even style of movement within the same shot to match the changing action. Obviously, this is another thing that you'll need to coordinate with the operators and the actors.

Matching Cameras

If you are using a two-camera shoot and are having movement in the same scene with both cameras, the speed and timing of camera moves will be key. For example, say you have set up a shot where you are going to dolly in with both cameras toward the same characters and get two different angles; if the speed and any pauses don't match, editing will be a disaster. Or, if you are going to be catching one character on a Steadicam and have a wider shot with a camera mounted on a jib arm, the movement style and speed should work together unless the edit is going to be done from completely different perspectives. As you work with multiple-camera movement, keep in mind what angles you're choosing so that you won't break the 180-degree rule or cause the edit to look a bit off.

Planning the Motion

The motion starts with the script. Motion clues are likely to be integral to some scenes. There may even be a few motion words present; this is motion that happens outside of camera motion but will need to be incorporated in your motion structure. There will also be shots where no motion is mentioned in the story; however, you will likely have actors moving on set or moving pieces of the set. As you read the script, you can make notes of the motion that is happening within the story and the motion you want to include in blocking.

Some motion will be inherently necessary within the action. Characters or objects will be moving in the story, and you will have to incorporate that into the shots. But the biggest consideration will be planning how you are going to move the camera to show the story. The narrative will reveal the action and establish an emotional flow through the motion of the camera. As you pick locations, think through the motion requirements, or if you are given locations, decide how to use them to fit your motion story.

Blocking and Previsualization

After the locations have been chosen, it is helpful to walk through the set before shooting begins. Check the lenses and proposed camera movements to see whether they work as envisioned. Pay particular attention to lens choice because of the different characteristics that lenses impart on motion. When you are on the set, measure the space to make sure even small pieces of gear can fit. If you are using a small location, your tripod may quickly dominate the corner you are using to set up. Practicing with as much of the planned gear as possible is ideal; however, if you cannot afford to rent all of the gear you need, check for any physical accommodations necessary. For example, if you are using a crane, how high are you planning on taking it? Is the camera head going to be controlled by a remote system? When is it going to move, and how will you tell the operator what to track?

If you are using camera operators for some of the motion techniques, it is necessary to have a clear vision that you can communicate to them in order to get the best shot possible. Experienced operators will be able to work with you to get the best shot possible; their opinion is invaluable and should not be overlooked. For this stage, using stand-ins is helpful, and you can take several shots of the scene to use with storyboard changes or to give you a better idea of what to expect with the movement in the scene.

Storyboarding and Diagrams

When you are storyboarding, you may want to diagram the camera movement. This will give your crew a better idea of what you are anticipating and help you determine whether the gear you have will work and how the motion fits with the narrative. You can also ideally discover whether any potential camera moves are impossible to accomplish and need to be revised. You can use simple diagrams to show the movement, or you can take some sample shots to use along with the storyboard. You should plan out each cut and shot with the movement shown clearly.

Rehearsals and Run-Throughs

Rehearsals are the best-case scenario for many technical aspects of the film, including planned camera motion. However, at the very least, you will need to do several run-throughs prior to actually shooting to make sure that the blocking, camera motion, and lenses are working together well. It is also important for the actors to know where to move and whether they have any very specific motions to deliver and, if so, the timing of the movement.

Gear for Designing and Controlling Movement

The top question on most moviemakers' minds is what do I need to get the shot? In some cases, you can achieve the same movement with different types of equipment. If you know what each piece of support gear is best used for, it will help you decide what gear you need on set without having to rent or buy extra equipment.

Tripods

Tripods are used to stabilize the camera and keep any camera movement out of the shot. But you can combine a tripod with a head to *create* motion to make the shot. Many people

think of tripods as a single unit consisting of the tripod legs and the tripod head. In reality, you need to think of them as separate pieces of equipment that can be mixed or matched with other pieces of support equipment (Figure 5.14).

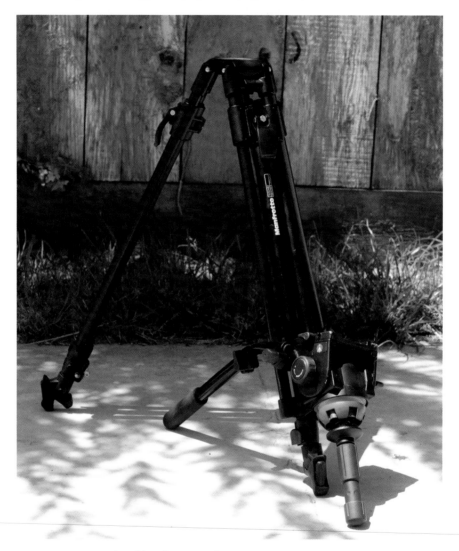

Figure 5.14: Tripod and head separated

Often with DSLR cameras the temptation is to go to the set with the smallest, lightest, and least expensive tripod available. Don't let the light weight of the camera fool you into thinking that having the smooth control of a fluid head and steady tripod isn't crucial. The tripod will need to handle the weight of a large lens. And when you are shooting video, you are shooting movement, so the tripod head must be designed for movement, not stills. In video, it is also important that the tripod be perfectly balanced so that the shot is not crooked. In a still image, a slight tilt is not usually problematic, but with a video image, this tilt may focus the viewer's eye away from the action unless you designed the shot with a tilt in mind.

When possible, use a tripod and a head that are designed for cinematography. These tripods and heads are bigger, heavier, and bulkier than all of the tripods used for still work and video work. You may even feel a little odd putting such a small camera on top of a giant setup; however, the rewards are worth it. Gear that is designed for cinematography is designed to move. It is designed for smoothness, endurance, and consistency. This gear has been field-tested in crazy conditions and made to hold weight way past what a completely stacked DSLR can even come close to. In fact, one of the only problems you may have with cinema gear is that the camera doesn't feel heavy enough. If you use a cinematography head, you will need a tripod that can handle the weight of the head and remain balanced. Make sure that your tripod has all of the tilt functionality that you may need (Figure 5.15). A cinematography tripod is a huge investment, but it will pay off.

Figure 5.15: Large tripod with head tilted

If, however, you are doing "run-and-gun" shooting, you will need to have smaller and more compact tripods. These smaller tripods and heads can function well for motion, especially if you look for gear designed for video work. If you already have tripods and heads for still photography or other work, these may function as excellent second-camera tripods for locked-down coverage shots. When you pick your tripod, make sure that even if you are using a lightweight camera, you test it with the full loaded weight of your camera, lens, and any accessories that are attached to your camera.

If you are using a lighter or less-stable tripod, you may be able to add a sandbag to an attachment or even to the legs to add some quick stability. Sandbags are always a good item to have on set. When traveling, you can get sandbags that empty and can be filled with any sort of heavy granular material on your location. You can also place the camera on sandbags for very slow, stable shots. This helps keep your gear protected and off the ground.

When setting up your tripod, always ensure that it is level and that if your tripod has spreaders they are being used. As you set up, check the horizon and make sure you are level and appropriately balanced (Figure 5.16). To expand the tripod, make it taller by extending the thickest leg segments first and the thinnest segments last. Check all of your gear, and get it set before mounting your camera. Double-check to make sure that the sliding base plate is secured and that the camera mounts securely. Remember, the sliding base plate may slip, but the camera won't fall off if it is attached properly to the plate (Figure 5.17).

Figure 5.16: Check your bubble level, and make sure the air bubble is in the inner circle, confirming you are level. Check the drag setting on your pan to make sure it isn't too loose or too tight for the shot you are trying to get.

Figure 5.17: Some ball-head tripods have a post below the head that you need to straighten to make sure you get the head level. In some extreme cases, like on a steep incline, you may need to adjust the post to help level your head.

Always listen for the click to make sure that the plate and camera have locked into place. As an extra precaution, after you mount the camera, move through the entire range of motion and check for any looseness. This is important because inevitably you will be moving the tripod with the camera attached, and the last thing you need is for something to fall off.

After you put your camera on the tripod, make any adjustments to the head that are necessary for the camera to be neutrally balanced. This means that the camera doesn't tilt either forward or backward but stays properly and centrally positioned. You can use the sliding plate to reposition the camera to achieve the perfect balance without changing any of your camera setup. These adjustments will have to be tweaked every time there is a lens change or tripod position change. A properly balanced head (Figure 5.18) will stay level when you let go of it even with the camera and lens attached. If you need to walk away, lock it into place. When you are operating the camera, you will be able to get more fluid shots with less effort with a properly balanced head.

Figure 5.18: Tripod properly balanced with a camera and lens attached

Using a Fluid Head vs. a Nonfluid Head

A simple way of differentiating between a fluid head and a nonfluid head is that a fluid head is designed for creating movement with the head. A nonfluid head is designed to hold a camera in one position without movement. The tripod head is a top-level concern on location because the smoothness of most of the motion depends on the tripod head. Filmmakers accustomed to film or video work are usually very competent on the control of fluid heads. They also likely have used heavy, professional tripods in the past simply because film and

traditional video cameras are heavy and need movement to get the shot. However, a tripod head used for stills is likely not usable on location with a DSLR.

Part of the appeal of a fluid head is the ability to adjust the friction of the fluid head itself (Figure 5.19). You will often need to adjust the drag friction after you set up your camera and plan the shot. This setting allows you to control how much force is needed to move the head when shooting movement. A fluid head helps you control the smoothness speed of the motion through how much or how little friction is applied in the head itself.

Figure 5.19: There is a knob to control the tension of the fluid head to help control the speed and motion of the head.

Monopods

Monopods are unique to DSLR moviemaking. Most other moviemaking cameras are simply too heavy or not built to be used with a monopod. However, because DSLRs are built with a still body, they can be used with a monopod with great success. Monopods can help you get a better shot if you are in a situation where a tripod isn't practical. Using a monopod as an extra support for your camera will keep the shot much steadier than handholding, especially if you are using a heavy lens. They are also useful if you are using multiple cameras in a crowded real location and can't use a tripod, large rig, or elaborate setup. Take advantage of the size and still camera look of a DSLR (Figure 5.20) and use a monopod for shots in real locations.

Figure 5.20: Monopod with camera attached

When using a monopod, you should use one with a fluid head attached so you can increase your movement possibilities and maintain flexibility to shoot in almost all circumstances.

Tripod Head Plates

Interchangeable plates and quick-release plates are key to moving the camera on and off various gear setups quickly and securely. You should find an interchangeable plate you like and buy one for each of your support systems so you can move your camera from rig to rig quickly and easily.

Accessories for Camera Angle

You can get tripod legs that allow for extremely low and higher than normal heights. You can also attach different heads to tripod legs of various heights to get the shot you need. Some dolly systems are essentially vehicles attached to tripod legs and moved. In these cases, tripod legs adjusted to various heights can increase your options (Figure 5.21). Tripods can also be used in the backseat of a car and other areas, and these tripod options can prove useful in getting the occasional hard-to-manage but necessary shot.

You can achieve angles in typical ways with your tripod and a standard head. High-angle, low-angle, eye-level, and bird's-eye views are all easy to achieve. If you want an angled shot and then will need to repeat it, you can make marks on your head and camera that you can line up when you need to come back to this shot. Often, the head itself will have hash marks that are easy visual reminders.

Usually, Dutch or canted angled shots are handheld in the DSLR world. If you are doing a project with many funky angles, you may want to look into a specialized head. There are angled heads that can be attached to your tripod or legs, and these heads give accurate, repeatable angles throughout the entire shot or scene.

Figure 5.21: A short or mini-tripod to capture a low camera angle

Stabilizing Your Camera Motion

Since the dawn of movies, stabilization equipment has been used on most sets around the world. As cameras became lighter and sound techniques were mastered, the camera became more or less free to move in any direction; it can now be attached to almost anything. This freedom has ushered in a popular visual style in recent history where a camera is simply handheld and the subtle shake and drift of the camera add to the visual storytelling. If you have worked with a video or film camera before and are used to handholding your camera, you may not always get the same results with a DSLR camera without some sort of stabilization rig.

You probably have heard that DSLR cameras are susceptible to what is called *rolling shutter* or the *Jell-O effect*. This effect is unique to any camera with a CMOS (which stands for complementary metal-oxide semiconductor) sensor and is particularly a problem in DSLR cameras. We will address these issues more in Chapter 9, "Troubleshooting."

Why Stabilize?

You need to take seriously how you are going to stabilize your camera for your shoot. Let's first look at why the size and shape of the camera are not ideal for shooting and handling.

Weight

The average motion picture camera ranges from 20 to 30 pounds, and the typical ENG (electronic news gathering) camera, such as RED or Arri Alexa, runs between 12 and 20

pounds. In comparison, most DSLR cameras range from 1 to about 5 pounds. For instance, a Canon 5D Mark III with a standard Canon battery, a telephoto lens, and a small monitor could reach 6 to 7 pounds.

Because these cameras are so light, they are very easy to move when they are being handheld. In fact, DSLR cameras are so light that a simple breeze or the slight shake from a tired arm will cause the camera to move from side to side and up and down. As an analogy, think of a ship on the ocean. The calmer the sea, the steadier the ship. However, even on the calmest sea there is some motion acting upon the ship. The larger and heavier the ship, the less the ship moves or the movement is felt by the passengers. The smaller the ship, the more the ship moves, and the more the passengers feel the movement of the ship.

Sensor

Since DSLR cameras have CMOS sensors, they are more susceptible to jittery and shaky images than more traditional CCD (charge-coupled device) video or film cameras. The sensors are also prone to the Jell-O effect or distortion. The reason that CMOS sensors are prone to the skewing and distortion is most of these sensors are not global, which means they record line by line starting at the top of the sensor and going to the bottom. The faster the camera's internal processors, the more they cut down the amount of skew and/or distortion, but until camera makers move to all global CMOS sensors, this will remain an issue.

Design

DSLR cameras were designed with the body of a still camera that was meant to be handheld or mounted on a tripod. This kind of still camera is ideally made for shooting close to the body or on a tripod while the photographer looks through the viewfinder for composition and technical controls prior to taking the picture. This camera body is not inherently designed for motion. There is no easy way to stabilize and hold the camera while executing smooth shots with motion. For a motion shot, the camera is usually held a bit from the body to allow for swing and shift but stabilized by various points of contact with the body. This camera comes with a strap that can be a point of contact, and the viewfinder often doesn't even work as a point of contact unless you are using an added-on viewfinder. This means that if you are going to be using motion, you must decide how to best move the camera to achieve that motion, and usually that decision involves some quantity of gear, even for a handheld shot.

An additional problem with the design is that the cameras are not comfortable to handhold for long periods or even to get a continuous shot without some fatigue. Getting a still involves a fairly limited amount of time frozen in one body position. Support rigs cut down on muscle fatigue by putting the camera in a position where the arms and body are not held at odd angles for the sake of the motion.

Motion Benefits

Increasingly complex and interesting motion can occur when a variety of stabilization equipment is used. In general, never operate the camera without some sort of stabilization gear, or your project will suffer the dreaded "shaky cam" effect (unless that's what you're after). Even with handholding, stabilization tools will improve the look and grace of the handheld image. These systems are designed to give the operator extensive control over what type of movement is possible. Some systems allow for any camera movement that the body can handle. The operator wholly dictates the speed and angle. The stabilization gear helps hold the camera for the operator and keeps the camera closer to the body's center of gravity to allow steadier, more controlled motion.

The goal is for the operator to decide what the movement will be, not fight unwanted movement. These rigs free up the motion and give an immense range of motion possibilities. With stabilization rigs, the entire special perspective and area where movement is possible is expanded. However, if you are taking multiple shots, the accuracy of repeating a motion is also up to the skill of the operator, so if you need a highly exact repetition with a shot, consider how the camera support rig will influence the gear decision.

Visualization Benefits

Many types of equipment allow for a monitor to be attached to the rig. The monitor helps the operator focus and compose the shot. Because the design of DSLR cameras does not allow for easy monitoring while shooting, having a monitor that is designed to be in the operator's field of view while operating the camera is a huge benefit.

Gear for Motion

Handheld, Steadicams, dollies, jib arms, and many more creative stabilization setups have been used on a variety of both film and video cameras. These afford the freedom of handheld motion with the support of other, more grounded setups. Such systems are highly dependent on the operator's skill. This makes testing and hiring a crew an important component for using rigs for motion. Test in pre-production as many stabilization systems you can, and pick the ones that provide the best images for your project.

Stabilizing Rigs

Stabilizing rigs are mounted to the operator's body and are systems for the operator to handhold more effectively. A camera that is attached to the rig will have smoother footage that feels much like it is gliding through the space and distance. These systems make complex moves possible in tight situations in any location you can imagine. If you need to track your actor through a rugged landscape, track them up or down stairs, or make intricate forward/backward and boom moves to keep your actor in focus, these rigs can do it.

Operator-Based Stabilizers

These rigs are attached directly to the body of the camera operator. They put the camera balance and weight onto the operator and make the body's center of gravity the focus for movement. Basically, the rig can follow any move you need as long as the operator is capable of performing the move.

The most common and widely used operator-based stabilizer used for moviemaking is the Steadicam. There are other similar rigs from other companies, and the theory of their use is similar, but the Steadicam is amazingly effective. If you are serious about Steadicam work, it pays to take a course and learn the process from the people in the industry who have used it since its invention.

Steadicams and related stabilization rigs often have a little more sway and floating in the frame than a dolly and track. If you have a scene that must hold steady in one place, a Steadicam shot will still have minimal sway and movement (Figure 5.22). If the shot has a lot of stuff going on in it, the sway may not be as noticeable, or the sway may even add aesthetically to the shot.

Figure 5.22: A camera on a Steadicam

Shoulder-Mounted Rigs

Shoulder-mounted rigs usually have the goal of getting the camera tighter and closer to your body either physically or with multiple points of contact. They also balance the camera and are designed to allow the operator to pick the camera location in relation to the body. Using a shoulder-mounted rig keeps the camera balanced and stable.

An additional advantage is that this system also helps the operator have a place to keep a monitor or look through a viewfinder. The operator can move in any direction or angle to get the shot. These rigs improve the steadiness of the camera and thereby improve the camera motion. It is also important to be able to change the focus or adjust the lens if necessary, and a rig may allow the operator a free hand in order to make adjustments that must happen while shooting. Often DSLR shooters are also responsible for pulling focus while shooting. This is impossible to do if both hands are being used in holding the camera during the actual shooting.

Here are the steps for setting up a shoulder-mounted rig. Each manufacturer will have different parts or a different way to assemble them, but this will give you a good idea of what you will have to go through. For this example, we are assembling a DSLR Field Cinema Deluxe Bundle V2 rig from Redrock Micro.

1. Make sure you have all the pieces for the mount you want to assemble.

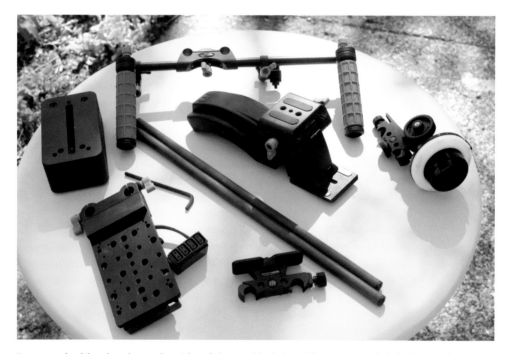

2. Loosen the blue knob on the side of the padded shoulder rest, and slide both of the long poles into the holes. Place them so they are overhanging the back of the shoulder rest a little to allow room for the counterbalance weights you will install later.

3. Attach the handle to the front of the two long poles. Make sure to tighten the blue knob on the bottom to secure the handles to the rig.

4. Slide the back plate onto the back of the rig. On this plate, we have an additional Anton/Bauer mount with a D-Tap adapter.

5. If you need to use counterbalance weights, you need to add them before setting up the rest of the rig. You will need the plate, the two weights, the screws, and an Allen wrench.

Attach the first weight to the plate and use the center groove to line up and place the screws into the plate. If you are not using a plate for a larger battery, you can do this on the side of the plate where it works best. If you are using a plate for a larger battery, then test and see whether your battery plate can work on either side or whether you are limited to the inside or outside of the plate. Then attach your weights accordingly.

6. Attach the second weight by using the outer upper or lower holes on the second weight. Screw in the remaining screws, and you are good to go. Just note that the screws will fit only into certain holes on the weights and the plates, so pay attention and make sure everything lines up.

7. Place the plate with the weights on the back of the rig and tighten the blue knob. Make sure it is tight enough so if you tilt upward, the weights won't fall off.

8. Attach the camera mount to the front part of the two long rails in between the shoulder rest and the front handles. You'll need to adjust the exact placement based on the length of the lens you are using and the extras you have attached to the camera, such as a matte box.

9. Screw the camera onto the camera mount and secure the camera. If you want, you can do this step before you place the mount on the rails.

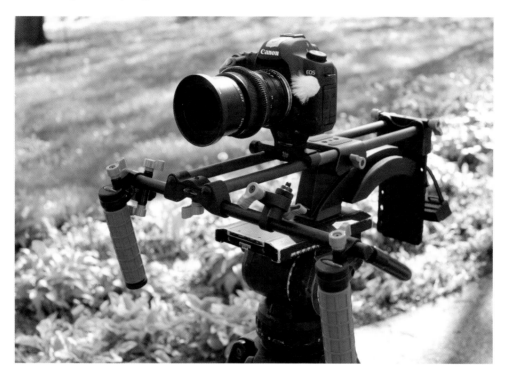

10. Attach the follow-focus unit. You need to loosen a screw on the side to attach the follow-focus unit onto the rails. Additionally, you must be aware that you need to loosen the lower screw and allow the follow-focus knob to extend as wide as it can. If you forget to do this, you may not be able to attach the follow-focus unit to the rails because the focus knob and gears will run into the lens.

11. If you have the follow-focus unit all the way open, you can slide it into place and visually line up the follow-focus gear to the gear on your lens.
12. Once the gears are lined up, you can slide the follow-focus unit closed so the gears slide into place. Don't force the gears into place, but make sure they are firmly in contact so you don't have any slipping when pulling focus. Tighten the screw on the side of the follow-focus unit as well as the one on the bottom so the gears don't slide apart.

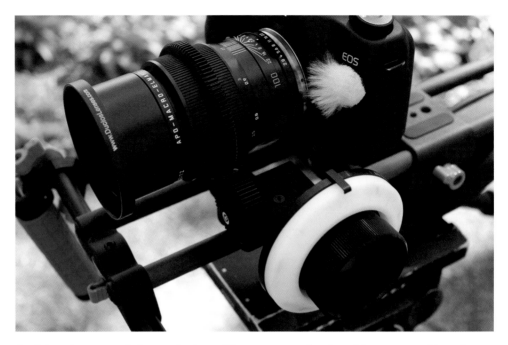

At this point, your rig is mostly done. Here are some further things to consider when you set it up:

- If you are using a separate audio-recording device such as the H4n Zoom, you can attach it to the handlebars with the supplied screw mount.
- In some cases, you might want the follow-focus gear to be on the opposite side of the camera (for example, to allow for an audio recorder or external viewfinder). This rig will allow you to just mount the follow focus the opposite way on the rails, and you can have an assistant help you on the opposite side of the camera.

- For this example, we have been showing lenses that have been permanently geared. If you are using still lenses without gearing, then you will need to attach a gear to your lenses.

 You can get gears for different diameters of lenses. Slide on the one that fits your lens the best and tighten the screw to secure the gear into place.

 Make sure the screw mount area of the gear is placed so it doesn't hit your follow-focus gears. Put the camera on the rails and line up your follow-focus unit, and you are ready to shoot.

Many of the shoulder rigs are reconfigurable and can be made into handheld rigs or pistol-grip rigs. Several of the shoulder-mounted rigs are essentially handheld rigs that have a shoulder mount added. These rigs allow for more flexibility with camera position.

Handheld Rigs

Handheld rigs are not directly mounted onto the body and are not designed as a shoulder-supported rig but are still a camera support rig. These are usually simple systems that give extra balance and stability to the camera. They also can dampen any camera motion and are a quick way to increase the value of your handheld footage.

Cages

DSLR support rigs often are designed so that you can build a cage to support the camera. The cage concept is simple. Essentially various rods and plate-like components are put together to form a support system for the camera body and lens. This cage can often be used by various support systems or have accessories added easily. The cage module makes it easier to mount and balance the camera with the rest of the support system.

Figure 5.23: Redrock Micro's manCam handheld rig

A handheld rig is one of the best purchases for any DSLR operator. It is usually very easy to assemble and disassemble, it can fit into small cases for transport, and the learning curve is relatively simple. These rigs are also great to have on hand for an impromptu handheld shot or even to use with a second camera (Figure 5.23). They still have all of the advantages of the other, more complex support rigs. Granted, you are not going to be able to shoot as long or get as many beautiful complex moves with a simple handheld rig when compared to a professional Steadicam operator. However, the jump up in quality of footage and motion control is immense. Often, having more designed motion in your shooting will improve the project.

The size and complexity of the rig are not always indicative of its handling and effectiveness. Some handheld rigs are essentially just a rod and pistol grip that the camera is mounted

to. Even very simple rigs can be helpful to increase points of contact, decrease shaking, and reduce fatigue.

Using a Loupe with a Handheld Rig

Using a loupe or Zacuto Z-Finder can help stabilize the camera and the shot. These items provide another area where the body supports the camera rig or camera. When using the adjustable eyepiece, make sure that you don't leave it pointing to the sun, or the heat magnification can cause damage to the LCD screen.

Rods

DSLR support rigs often use rods as another build component. The rods are then connected to form various configurations to support the camera, provide stability, and raise up the camera, and they often can have accessories added. The rod system is handy because once you configure the basic settings, you can often move it from various rigs or systems and not have to remake the entire thing. Although these kits may look like a complex building set, they shouldn't take too long to figure out. Frankly, if you buy a kit and the rods feel flimsy or it is impossible to put them together tightly, you probably need a different kit. Once you have a basic support plate or rod system, you may even be able to use it to attach the camera to articulating arms, shoulder rigs, or more complex gear.

Dollies

A dolly is usually one of the easier things to spot on the set; it's the item that looks like you can drive the camera around on it. A dolly is a wheeled platform that the camera can be mounted on and then moved on tracks; occasionally you might use a doorway dolly without tracks. The dolly usually also supports the camera operator and any accessories that may be

necessary. Often a DSLR will be mounted to a head and tripod, and then the entire assembly will be placed on the dolly.

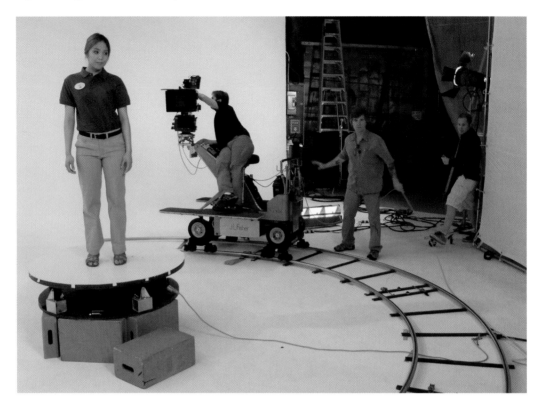

DIY Dollies

Cheaper and do-it-yourself dolly options are available. A quick Internet search will yield plans made with hardware store parts and skateboard versions that run on PVC pipe. Small, easy-to-use CamTram versions and dollies that attach to tripods are simple options that DSLR users can take advantage of because of the lightweight camera and simple setup.

Sliders

Sliders are devices that you attach a camera to and move it from side to side (Figure 5.24). They sound much more complicated than they are. Essentially they are small versions of a dolly. They have a track and either a platform or a place to attach a tripod head that slides along the track. You can usually move the camera by placing your hand on the mount and pushing it or by using a wheeled control on one of the ends.

These types of sliders come in several sizes and with various features, but the main components are identical. They can also be used with timed remote systems for controlled movements down the pole and with the camera head. These are uniquely suited to DSLR

cameras because most other cameras are too bulky or heavy to use. By using a slider or a pocket dolly, the DSLR shooter can get shots that look like big-production moves.

Figure 5.24: Glidetrack with a Manfrotto 3130 head attached

Jib Arms, Cranes, Lifts, and Other Aerial Rigs

Since the beginning of movies, directors and camera operators have been looking for ways to get the camera up higher or down lower and get it to swing in wider arcs while keeping it under control. Jib arms are long pole-like devices with the camera mounted to the longer end that has the most movement (Figure 5.25). The operator and controls are positioned at the other end. Jib arms are usually operated by hand, but they can be used in conjunction with remote camera head-and-focus systems. These additions are beneficial because the operator is obviously not able to look through the viewfinder while operating it. Complex systems for pans and tilts can make movement combinations, with the help of a jib arm, impressive. The arm can boom or go up and down by using counterbalance and a control system at the bottom end. The jib arm is not confined to simple up and down movement but can extend beyond the vertical plane into wide arcs and swinging motions.

Watch the height. You do not want to hit ceilings or any low-hanging lines with a jib arm.

Figure 5.25: Kessler Crane 12-foot jib arm/crane

The term *crane* is often used interchangeably with a jib arm, but usually when a crane is used, it is a higher and larger pole system that is less hand operated. Cranes often have remote-operated heads that control complex camera movements as the crane moves the camera through the scene. There are also lifts and other rigs that can move the camera up even higher or move the camera and a camera operator through the scene, giving full control of the camera to a hands-on operator. At these levels, a professional team of operators is necessary.

Articulating Arms

These devices are like robot arm extenders. The camera is mounted to the end of a system that is fashioned with rods and joints to move the camera in ways that resemble a huge double-jointed robotic arm. They are usually mounted to a camera support rig to give extra length or height to the camera reach and can be swung and moved to provide interesting movement.

Unique Movement and Support

An awesome aspect of DSLR cameras is that you can mount them to almost anything or rig them to things that previously took entire rigging teams to handle. DSLR cameras can be rigged to almost anything that moves, including the traditional planes, cars, and helicopters. But now you can rig several at one time or even rig them to smaller moving objects such as remote-controlled planes or balloons. Imagine the creative movement possible with simple solutions such as helmet-mounted cameras—throwing your camera, mounting your camera to a bar and swinging it, or finding tight spots to rig an extra camera while you run through the scene (Figure 5.26).

Figure 5.26: Helmet camera setup

You may not have the money or equipment to be able to get the exact same shots that large productions can get all of the time. So use your creativity and think about what unique shots you can achieve with the advantage of the light weight and mobility of the DSLR (Figure 5.27).

Figure 5.27: You can attach the camera to the end of a pole and get a point-of-view shot not previously possible to achieve.

Follow Focus and Remote Heads

When rigging or setting up in places where you can't actually reach the camera to turn it on, make sure you plan your shot's timing. If your camera has a limited shot time, you will need to factor that in when setting it up. A remote start option can be helpful. Also, if you can't adjust the camera physically, you may find that remote heads provide the necessary movement while the camera is being used to shoot away from operator reach.

Motion, the Edit, and Cutting

Often if you have a shot with motion, it will not be able to be cut or edited without planning. Some shots can't be cut midway through the motion and then edited in a coherent fashion with another take that uses a completely different kind of motion. Because of this, when you have a shot with motion planned, it is doubly important to plan the shot and think through the edit. This also means that on set you need to know what shots must be perfect for the entire duration because you will need to use the complete shot for the final piece. If you are going to edit or cut the shot, plan various compositions or changes that can be made in the longer motion shots to allow for natural edit or cutting points. At these points in the shot, make sure that there is a clear composition that can be duplicated in the coverage shots and that the camera angles and position can be logically changed or continued.

Different kinds of motion can be intercut when they are the perspective of multiple characters. If you are moving from different viewpoints in the scene, you can intercut different types of motion both in style and in speed as long as the motion stays consistent to the perspective that you are showing at the time.

When doing motion shots, plan for the places where you are going to cut into the shot with another perspective or shot. As you plan a motion sequence, carefully plan for the pauses or locked-off shots for coverage if you are planning on getting coverage. If the feeling of motion is supposed to continue for the entire shot and be picked up after the cut, make sure that the coverage shots incorporate the same feel and match the longer motion shots.

For example, imagine you are doing a long-running sequence where the main character is going to be dynamically moving through the scene with a Steadicam shot following; then he is going to run up the stairs where there will be a close-up of his face turning around, and then he is going to continue running. When you go in for the close-up of his face, keep in mind that the audience has just seen him with the sway and movement of the Steadicam; if the shot at the top of the stairs will be done with a locked-off camera on a tripod, decide how to keep the same feel and motion with the locked-off shot. This may mean that the locked-off shot will include some panning or slight push-in, or the change may signal a natural change that occurs for the story, so consider how to transition the change.

Frequently motion will be used in shots where cuts and editing are being limited. Long, continuous shots are regularly made possible by motion planning, and this is where the art of moviemaking can really shine. These shots usually must be highly orchestrated by all members of the crew and will take some planning and likely several rehearsals and potentially retakes to get everything perfect. The simplest version of movement in a long shot is just to pan the entire scene moving back and forth as the action takes place or to get dialogue and reactions.

Intricate Steadicam work can often lead to wonderful moving shots for action sequences. There are also motion shots designed to look like there hasn't been a cut, even though technically one shot would not have been possible; look for examples of these shots when a crane or jib arm is used. When the action gets close to the ground, a Steadicam operator keeps the shot moving with the shots matched visually and usually cut on a solid, inanimate object so that the frames can be matched perfectly in post editing. Shots with a deliberate cut that is designed to look continuous involve as much planning as completely continuous shots.

six

Lighting on Location

In its simplest role, light is necessary

for exposing the image on your camera. But after this fundamental role, lighting becomes art. Even with natural available light, you can alter the look of lighting by choosing how your subject will interact technically with camera settings, what location you choose, and how you set up the shot. Using artificial light and a set provides a blank canvas to tell the story with light. Regardless of your lighting options available, you will be making many decisions about lighting while on location.

On your shoot, you may have only a couple of lighting people, or you may even be doing it all by yourself. On a large movie set entire teams of people are responsible for the lighting. At the end of the day, the same issues and decisions will come up on blockbuster movie sets as much as one-person shoots. How can the lights tell the story? Do you have the proper lights to technically be able to get the shot? What lights do you have? Where should you put them? What can you do with them?

Planning the Lights

You should plan the lighting during pre-production, if you can, so you can rent or purchase the appropriate gear. You must plan the lighting based on the blocking and the image composition; part of the composition of a frame is the lighting, and establishing the lighting composition is as important as framing the image. In fact, during pre-production, it is beneficial to sketch out the lighting setup so that you can gather the equipment and provide a blueprint for all crew members. Communication on set saves time, and saving time saves money. Anything you can do ahead of time to help you be better prepared will be better for you and the production.

The plan should include the types of lights, proposed angle and location, any grip equipment that is needed (because most likely on your set the grip/lighting assistants will be the same person or even you), camera and initial setup, major landmarks, initial starting point of actors, cardinal direction or GPS location, sun position, or any existing lighting you are planning to use graphed with details about the type of light and the shots/scene numbers or desired time of day you're trying to capture. There is a lot to keep track of, and not all of these will be applicable on all productions. Rather this gives you a guideline for many things you should be aware of ahead of time.

Grip Equipment

Grip equipment is any equipment that helps hold or support the camera and lights on a set. This covers tripods, C-stands, flags, dollies, and any other equipment used to support cameras or lights but does not include the camera or lighting equipment. Anything that is attached to a light is the responsibility of the lighting department. Anything that is not attached to the light but still affects the lighting is usually in the purview of the grip, but practically speaking, many grips will be involved with adjusting lights and light attachments.

You should create a new lighting blueprint for any major lighting changes or setups. You can give these blueprints to all pivotal crewmembers and include them with the storyboard for on-set reference. The blueprint is likely to change, but it gives you a starting point for lighting ideas on the set. It is important to carefully plan any intricate lighting setup or tricky situation.

Timing: When to Set Lights

On set, the lighting will be at least partially set up according to the plans, but most of the lighting work will take place after you've done the blocking. If you are prelighting, start with the background and then light forward, saving the last lighting decisions for the details in the actors' faces or for tweaking. At this point, ask yourself, "What will the major light sources be, and where is the source light?"

After the rehearsal, lighting tweaking will take place and will cease prior to the first shot. During the rehearsal, the blocking and the camera movements are connected to how the lighting will need to fall over the entire scene. This is the time to also look past the first shot and examine the *coverage*, the series of shots or setups that are planned to be shot, on that location and that day. Lighting can be a bit like chess, and thinking ahead to the next shots will save time and headaches down the line.

The lighting often has to be reset or tweaked with each setup or shot, as well as every time the camera moves or the blocking changes. Often with a small crew or even on a full-scale set, some people in the lighting department will be involved with moving light as the scene progresses or at the least holding or adjusting bounce cards to control light during the shot (Figure 6.1).

Figure 6.1: A white bounce card, bringing some fill light to the actor

Choosing Lights

DSLRs allow for extensive creativity and flexibility in lighting. Most types of bulbs and light will be effectively read by a DSLR. You can use professional light kits or a variety of lights picked up from your hardware store.

In this arena, what is often more important than the exact type of light is what you do with the light. Position, adjustment, and shape of the light are ultimately what matters with your lighting setups. As you choose your lights, take note of the different types of light that are either present on the set/location or available for you to position on the set (Figure 6.2).

All decisions must start with the quantity and brightness of the light. Simply put, what are the light requirements for proper exposure and desired depth of field? Even if you are using natural lighting, you may have to augment to get the exposure you want or the depth of field you need to get your shot in focus. Pay attention to how much light may have to be added or what exposure you may be dealing with if conditions aren't ideal on the day of shooting (Figure 6.3).

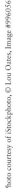

Figure 6.2: (a) A light setup on set. (b) A lamp (called a practical) can be used or added to help light the scene. (c) In a pinch, you can use the headlights of a car as ambient or direct lighting for your scene. (d) A great help is using windows and natural light to light your scene. You can use direct sunlight or use curtains as diffusion to soften the light.

Distribution and Shape

Different light sources distribute the light differently. Light may also take on a shape depending on the shape of the light source or if something gets in between the light source and the shot and adjusts the shape of the light. The light can be forced into patterns depending on what is placed in front of it.

Figure 6.4 shows that you can point your light at a simple broken mirror to create an interesting lighting pattern. If you have the time, you can glue pieces of broken glass onto foam core or wood and make a larger target to bounce light for any scenes that require a larger area to light.

Figure 6.3: Metering the light on set

Figure 6.4: A broken mirror can create an interesting lighting pattern.

Color

Light is often not a pure white; it usually has color or a slight color cast that is measured in degrees of Kelvin temperature. The color of the light is not merely about setting proper white balance. The color of the light can influence the overall look of the piece in desirable ways, and you may want to pick the light based on its color, shoot at the magic hour to get golden hues, or adjust the light to manipulate the color of the light (Figure 6.5). The color is a result of the light temperature, gel on the lights, or filters on the lens or camera.

(a)

(b)

Figure 6.5: (a) A street scene with mostly one color light temperature and one type of light. (b) A street scene with a variety of colored lights and light temperatures.

As you pick the light, you will need to determine what light temperature and color fit your production. Often you can add visual interest by using a small bit of a contrasting color temperature light in the background or by playing with cool and warm tones in the shot. Usually proper white balance is desired; however, sometimes the color can be changed for effect by altering white balance, for example, by allowing fluorescents to go green in a shoot (Figure 6.6). Color can also be affected subtly by using filters or in controlled areas by gelling windows or individual lights.

Light temperature may change or the light may grow dimmer as the battery is drained, as the light heats up, or as the bulb gets older in the fixture itself. As you shoot, pay attention to any changes in brightness or color temperature that may be affected (Figure 6.7).

Figure 6.6: An incorrectly balanced hallway with fluorescent light produces a green tint on the scene.

(a) (b)

Figure 6.7: (a) Light at the beginning of a four-minute scene. (b) Light at the end of a four-minute scene in the same shot.

Principles for Setting Lighting

When you are starting the lighting process, it can be helpful to consult a few general philosophies on the lighting process to spark ideas.

Adding Depth and Dimension

Light separates the subject from the background. Light establishes space and dimension and shows that the scene is taking place in the real world. Lighting often helps shape the different dimensions of the subjects in the scene. By using light to define the foreground, middle ground, and background, the entire shot will have dimension throughout.

To visually distance the subject from the background, you can either backlight the subject with light that doesn't hit the background, light the background and the subject separately, or use a background setting that contrasts with the visuals and color of the subject. By doing this you are allowing bokeh to separate the elements between the foreground and background. Depth and dimension are important regardless of where the focus is and can be altered if you want a different visual effect.

Lighting the Entire Scene

The lighting composition must work with the framing composition of any given shot. You must look at the lighting in the entire frame, from front to back. The world of film is a three-dimensional world, and understanding that will help you make sure that all aspects of your shot are considered.

In Figure 6.8, the addition of the light on the ground helps establish depth in the scene as opposed to a black wall behind the actress.

> You can add visual interest to the lighting by increasing complexity or adding detail to what the eye can see. Having contrasting light temperatures in the same scene—in other words, light that changes from hard to soft, pops of color or color wash that adds to the story, a play of shadows and light, or other lighting detail—adds eye candy to the piece.

(a) (b)

Figure 6.8: (a) Shot of actress with existing light with only a small bounce card lighting her face. (b) Shot of actress with a key light (with a different color temperature) and a kicker light hitting the ground over her left shoulder to add depth.

When looking at your location, think about what you want to light and what you want hidden. If you are shooting continuous shots that turn 360 degrees, you may need to mount many lights from above and hide the rest by using parts of the set dressing. You need to think about lighting the whole scene, which includes the entire room, when scouting a location, not just your talent.

Using Logic to Create a Natural Look

You see light every day, and you naturally respond to the light depending on its source. When you see light, you want to know its source; if the lighting source seems to come from nowhere, you feel something is amiss. As you plan the lighting, imagine where the light would actually be coming from in the scene. If there are windows, does the light you choose look like what light would be coming in through the windows naturally? You must find or create light sources in the scene to provide a logical lighting scheme for the entire set. You can then use other lights to augment them where needed. If your scene is outside, it pays to examine your lighting to see whether it incorporates sunlight or if you need to create entirely different lighting than what nature provides. You must determine whether what you set up with artificial lighting fits the light that the audience would expect to see in the scene based on light sources that are present (Figure 6.9).

Sometimes you may want to make the light source illogical or not based on what the audience expects. This mysterious light can add something to your scene visually. However, if you aren't planning for a mysterious effect, it's important to keep the lighting consistent with audience expectations. You can't always rely on the lighting that is in place or even replicate exactly how the lighting would look because you may want to emphasize some objects or even tweak the lighting to make them look more interesting, but keeping an eye on the logic of lighting sources will make your piece more realistic.

If you are attempting a naturalistic light scenario, it is easy to just use natural and available light so that all of the light sources will be logical. But be careful with natural light because it changes. If you are relying on sunlight, remember that the light moves and changes color temperature over time. If you are shooting over the course of several hours, then you need to be aware that shots taken closer to the start will look very different from those taken at the end of the shoot. The light changes so subtly from shot to shot that you might not realize the difference until you look at your footage in post. This change of light over time is the opposite of what you want and might expect with using natural light.

Photo courtesy of iStockphoto, © Giorgio Fochesato, Image #17011818

Figure 6.9: The natural light sources at this location are primarily the street lamps. Alternate light sources are the reflections in the water on the street, possibly the moon, and any lights in the windows or doors along the street.

It is better to have good lighting than to be a slave to the accuracy or realism of the existing lighting.

Reflecting Mood and Emotion

As you look at the light, think about how can you create emotion with the lighting and/or portray the mood of the scene. There isn't just one way to show mood or emotion, and this can be a challenge for the lighting team. As you plan, ask yourself these questions: How does the light tell the story? What is the light supposed to show in this shot? What is the tone of the story? What world do the characters inhabit? What does the script say about the lighting? Does it match the mood or emotion of the scene? Ultimately, the right lighting

is based on a feeling. Does the light feel right for the scene? That is the art of lighting. Sometimes it comes down to a feeling that you have or that you want to create. Just because it doesn't make sense to others doesn't always mean you shouldn't try it. Experiment and try new things.

Setting Visual Priority and Focus

As your eye first looks at any scene, it searches for what to focus on. The light should lead the eye to a point or element that is supposed to be emphasized visually. Even if you're setting a master shot, you should use the lighting to lead the eye through the shot. The eye will pick up the brightest areas first and then stray from there. You can plan what you would like the audience to look at initially by increasing the light levels on key points. If you change shots, the lighter areas will be tracked quickly, and if there are quick cuts, the audience may not have a lot of time to scan other parts of the shot. This means you must think about what to emphasize visually and plan for those elements in the lighting scheme.

As you figure out the mood of the piece, you are really deciding how it is going to accurately reflect your story. How you want the scene to look will determine where you place the lights or where you place your subjects in the location.

Types of Fill Light

By just changing the intensity of the fill light or the ratios of the various lights, you can completely change the look of your lighting (Figure 6.10). Achieving proper lighting often requires a decent amount of tweaking even after the lights have been set up. If you have a lighting setup and something feels off, before you run around changing everything, tweak the intensity of the lights and see how adjusting the ratio between your light sources might improve the scene.

(a) (b)

Figure 6.10: (a) A single key light on one side of the face with a backlight on the background. (b) A single key light with a fill light to balance out the contrast on the face.

High Key

High-key lighting is lighting that looks very bright over the entire scene. This style is notable for its scarcity of shadows in the overall frame. The simplest way to achieve high-key lighting is to use all soft, diffused light—and a lot of it. Usually, the foreground, middle ground, and background of the shot all have the same lighting. To achieve the high-key look you need to have light and brightness throughout the entire depth of your scene. High-key lighting is not achieved by simply changing the exposure of the shot or slightly overexposing (Figure 6.11). It is a properly exposed shot that is lit with the fill light intensity and brightness nearly matching the key light.

Natural light that is not at midday will often not allow for high-key or strong blacks.

Figure 6.11: The lighting and exposure leave very little that might be underexposed in this scene.

Low Key

Low-key lighting is much moodier than high-key lighting and uses shadows to help create the look. Low-key lighting is predominantly shadows and darker areas, but the bright areas can pop, creating interplay of dark, black, and dim tones with hits of brightness (Figure 6.12). Low-key shots are not underexposed shots but shots that are lit to be low-key. Low-key lighting is achieved most often by using very little fill light or even turning the fill lights off completely. As stated previously, this is simply a changing of the ratios between your lighting sources. Your main light (your key light) can be bright, that is, have a higher ratio of light, and your fill or backlight can be almost nonexistent, that is, have a low ratio of light in comparison to your main key light. Low-key lighting will by its nature have a higher ratio between the light parts and dark parts of your frame.

Photo courtesy of iStockphoto, © Igor Balasanov, Image ##5568507

Figure 6.12: Low-key lighting creates a high contrast from the light parts of the image to the dark (black) areas of the image.

Light Direction and Angle of Light

The next lighting decision that you have control over is *direction*. The physical direction, or the location the light is coming from, determines what part of the subject will have light hitting it. When using natural, available light, you may need to turn the subject or move camera positions to change the direction of light hitting your subject. You can't change the direction of the sun, but you can change your camera position or move your actors around.

You may not be able to change the entire lighting of a public square that you are shooting in, but you can pick the optimal time of day or shift your camera and actors around. You also can alter the sunlight that will light your subjects, or you can help redirect some sunlight to help augment your overall lighting. The direction the light comes from will change the look of your scene.

As you play with the angles, keep in mind even small changes that may occur in the scene. If you are using natural light, then your major source of light will usually be the sun. The sun will change angles as it passes overhead and will also be influenced by the time of year when you are shooting. If you can't control the lighting and you need a certain light angle, you will have to pick a location suitable to the angle of light and the correct time so the location of your light source is where you need it to be.

The direction that the light is coming from will influence dramatically how the scene and subjects look. Flatness, dimensionality, shape, and detail of a subject are all determined in major part by the direction of the light as it hits the subject. This is most obvious when shooting close-ups and people because you can see the changes of light direction and how their face changes from one direction to another.

Generally, light direction on set is referred to in degrees related to the camera and/or simply as back, side, or front in relation to the subject.

Front light is light that is in front of a subject and hitting the subject mostly in the front (Figure 6.13). Front light will flatten a subject or an actor; it takes out most of the potential for shadows and decreases the dimensionality of the subject. Something lit with only front light will look very two-dimensional.

Figure 6.13: Diagram of lighting predominantly with a front light

To show the dimension of the subject or actor you must use back and side lights in addition to front lights. Dimension in a two-dimensional world is created by "shaping" your image with light. Backlight comes from behind a subject and will provide a general shape to the edges of a subject; it is best seen in exaggerated silhouettes or simply hair lights.

Side light emphasizes shape and most importantly the dimension of an object or subject. It creates shadows and contrast across the subject. Often more than one direction of light will be present in a shot or lighting scheme (Figure 6.14).

Figure 6.14: Diagram of lighting positions from the front, back, and side

Increasing the dimensionality and depth in the scene or even just in a close-up of an object is often a key role of lighting. Though the final image will be shown in a two-dimensional system, the visual depth of the scene is vital to give life to the image. The direction and position of the light will create the shape and texture in the scene and subjects. Showing depth is the opposite of flat lighting, but both types of lighting schemes may be useful for the different effects they provide.

"Lighting flat" is not the same as using camera settings to increase the flatness of the image, and the two techniques do not have the same impact on the image.

To increase depth, you can move the lights to the side and back. Try introducing front illumination later, and adjust the position, height, and angle of the lights until they hit the subject and create light and shadows on several sides or planes of the scene. Dimensional lighting is not achieved by direction alone but is also influenced by the angle and height of the light source.

Types of Lights by Position

No matter what brand or set of lights you choose, the individual lights will function in three major roles: key light, backlight, or fill light. The role of a light is based on its physical location oriented to the camera and the action. As you set up your lights or make adjustments, keep in mind how light is functioning or what its role or position is on set. The type of light is less important than the position or role it is playing.

(a)

(b)

Figure 6.15: (a) The actor's face being lit with a far-side key.
(b) The actress is facing the key light, lit with a near-side key.

Key Light

The *key light* is usually the major light source for a shot, and it can be placed anywhere on the set. The position of the key light will be determined by a number of factors. The first thing you should do when you begin lighting is figure out where you want your key light to be. Determine where you want the light to be coming from in the scene and where you want the shadows to fall. Once you have decided that, you will have a good starting position for the key light.

A *far-side key* is a key light that lights the side of the face that is not pointed at the camera. A *near-side key* lights the side of the face that is pointed or angled to the camera. This description assumes that the actor is looking a bit right or a bit left of the camera and not centered looking directly at the camera. Usually actors are positioned at a slight angle to the camera. There is usually more modeling and interplay with contrast with far-key lighting; this is especially true for close-ups (Figure 6.15).

Backlight

A *backlight* is a light source placed behind the subjects or objects that you want to separate visually from the background (Figure 6.16). Backlights are not always used in every lighting setup but can be subtle or pronounced depending on the intensity of the light. If you want separation between the background and foreground objects, you can also choose to light the background instead of using a backlight as separation. This usually works the best when the background has a solid element such as an interesting wall or foliage.

The physical position of the backlight may change how it is referred to on set. Often terms such as *backlight*, *hair light*, or *rim light* will be used to describe a backlight but only the height of the light will be changed. The position in terms of height and at what angle the backlight is set will change the effect of the backlight.

- *Hair lights* are not directly overhead but are still very high. Hair lights are typically placed at a 45-degree angle or higher above the subject and opposite the key light. You will have the proper position when you see the hair suddenly pop into view with a glow about it (Figure 6.17).

Photo courtesy of iStockphoto, © Elkor, Image #2242502

Figure 6.16: The backlight on the fountains can help create a mood or look with only the use of the backlight to silhouette the actor.

Figure 6.17: Actress without and with a hair light

- *Side backlights* that are placed on the side of an actor or object provide dramatic shadows and can be used alone or with combinations of lights for other effects.
- *Rim lights* are backlights that are very high and make what is in the foreground strongly separated from the background.
- A *kicker* is low backlight that is generally placed at a 45-degree angle in the back of the subject you are lighting. A kicker will usually be placed in tandem with a front key placed at a 45-degree angle in front of the subject you are shooting. The backlight kicker should create an edge around the chosen subject, giving dimension to the overall shot (Figure 6.18).

Figure 6.18: Actress without and with a kicker light

Fill Light

A *fill light* is usually positioned opposite the key light to help boost the light ratio between the key side of the face and the darker shadow side of the face opposite the key light. The main function of the fill light is to fill in shadows and unwanted dark areas on the far side of the key light. Fill lights are usually placed almost opposite the key light and to the side of the camera. Depending on the angles of your lighting setup you can sometimes use a light that is placed on the camera itself (Figure 6.19) as a potential fill light. The fill light will not be used in every shot you set up, especially if you need a very dramatic look with dark shadows as a predominant characteristic.

Eyes reflect light marvelously. *Eye light* refers to the light source that your actor's eyes will be lit by in the scene. When you decide what kind of light to use as an eye light, think about the shape (Figure 6.20) that you will see reflected in your actor's eye. Some shapes are more appealing than others; in some cases, strangely shaped eye lights can add an

Figure 6.19: Canon 5D Mark III with a Torch LED Bolt light mounted to light the top of the taxicab

otherworldly effect to the actor. If you're using a lot of fill in front, you may not see the effect of an eye light. You also need to ensure that the eye light is not so bright as to light the entire face, taking out shadows and eliminating desired contrast. For many still photographers, this is known as a *catch light*.

Figure 6.20: *Reflection of lights in the eye: (a) circle light, (b) square light, (c) sky*

Illuminating the Rest of the Set: The Traditional Three-Point Light Setup

A three-point light setup is a very simple way to light a set. It is a good start if you are just getting started with lighting or if you are setting up lighting for the first time. It is also a good starting point even if you are more experienced. Once you place your main three lights, you can work from there to add or change any lighting before you shoot.

There are a few ways to use a three-point light setup. Figure 6.21 shows the lights all equidistant from the subject and radiating in a circle, but remember that when you are setting up the lights on location, the lights will not always be equally spaced. Some of the lights may be farther from or nearer to the camera or subject.

Figure 6.21: A three-light setup

The type of light also depends on the position of the subject or object in the scene. What will be a key light on one actor in the scene may be a backlight or a fill light on the other.

If you know the basic three-point lighting setup, you will be able to consistently light any shot. The three-point lighting setup uses, as you may have guessed, three lights. This setup will separate the subject from the background and will light the subject, thus providing dimension to the subject. Three-point lighting uses a key light, a fill light, and a backlight as the three light sources.

The key light will be the most intense light in the setup to begin. As you experiment with the setup, you can change the intensity to suit your look if you would like, but to start, put your most intense light in the key light position. Assuming you want soft lighting, you will want to use a light source that provides soft lighting or find a way to bounce or diffuse the light. The key light will be placed to the side of the shot (Figure 6.22).

The second light you will set up is the usually the fill light. The fill light will help fill in and/or minimize shadows and pockets of darkness on the far side of the actor from the key light. The degree of fill that you use is based on what is required by the scene and can be adjusted. You can adjust by moving the light backward or forward and/or diffusing the source light directly. This is the perfect light to have on a dimmer, or you can use a light that

is dimmable. The fill is as a general rule a soft light; a soft fill can be used even if the rest of the lighting is hard. If you need just a bit of fill light, you can bounce the light to create fill (Figure 6.23). This small touch is especially useful when adding fill to close-ups of actors.

Figure 6.22: Key light position shown at roughly 45 degrees to the side of the actor

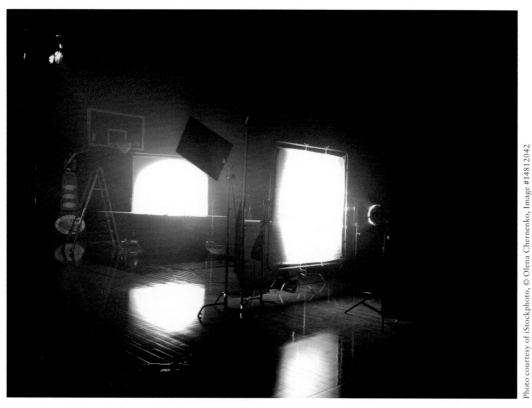

Photo courtesy of iStockphoto, © Olena Chernenko, Image #14812042

Figure 6.23: Fill light bounced to an actor

The last step is to add dimension to the scene with a backlight (Figure 6.24). This light will also sometimes be referred to as a *kicker* or *rim lighting*, as described earlier.

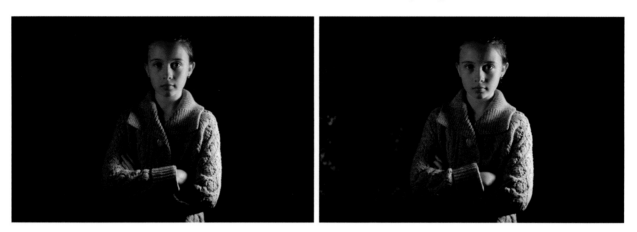

Figure 6.24: The same shot without backlight and with backlight. Notice the subtle light on the background to help separate the background from the actress.

Rembrandt Lighting

Rembrandt lighting is a usually a three-point lighting setup of a key light at 45 degrees, fill light, and backlight at 45 degrees from the subject you are shooting. You can tell immediately whether the lighting is set correctly because there will be a triangular bit of light, usually by the actor's eye, on the side of the face with the most shadow. If you are trying to adjust contrast with this lighting setup, adjust the fill light. If you increase the fill, the contrast will be reduced. Equally, if you decrease the fill light, the contrast will increase. Some of the light for the Rembrandt lighting setup can be reflected light.

Light Sources and Ambient Light

You will need to take into account other lighting that may already be present on the set you are working with for your production. Even if no lighting is set up, there may be factors that prevent your set from being a completely blank slate. For example, if there is ambient light, you will need to determine where it is coming from. Usually light sources that are shown in the scene are accounted for. If the lights in the scene are turned on, they will provide light. This light may influence the lights you are setting up or may ideally work into your lighting scheme. If there are other sources of light that are logical to the script, such as if the scene is supposed to take place in bright sunlight, not only must the actors be lit for bright light, but the entire set should read visually as sunlight.

Lighting for Special Situations

As you move the lights into position, think of light as a physical force that you are directing, altering, and sometimes blocking. The shadows or dark areas created are just as important

as the light areas created. Having contrast within your lighting scheme will be more interesting than having everything evenly lit. Remember that shadows are your friend in most lighting setups.

Shadows

The quality and characteristics of the shadows depend on the light. There is a difference in the shadows depending on the quality and intensity of your light. The hardness or softness of the light will change the effect of the shadows. However, other characteristics of the light affect the shadows as well. Where the light source is positioned or is in relation to the subject will influence the shadows' length, definition, and overall contrast to the rest of the scene (Figure 6.25). The direction of the shadows is determined by the direction of the light. To change the direction of the shadows, change which direction the light is coming from. The size of the shadows will also be determined by the angle of the light to the subject; this includes the position of the sun. Keep in mind what the shadows are supposed to look like according to the time of day of the scene.

(a) (b)

Figure 6.25: (a) Diffused lighting on a wooden fence. (b) Hard lighting on a wooden fence accentuating the grain and the contrast of the wood.

The contrast of the shadows is determined by the intensity of the light and its proximity to the subject. Shadows are not just present as shadowed reflections of objects but also are present when side lighting is used and light is contrasted with shadowed or dark areas in actors' faces or across other planes. If you're using natural sunlight, the shadows will change as the sun changes, so watch them as your shots progress through the day. Sometimes changing your angles can help counter changing shadows.

Light at Night

One of the great advantages of DSLRs is that in many circumstances it's possible to shoot "night for night." Due to the fact that many DSLRs have limited color-correction options, it is often best to shoot night shots at night and capture the scene in camera versus doing it in post. This ability to shoot in very low light is very freeing because in the past this wasn't possible without extensive lighting setups to mimic low light or night settings. Also, available lighting from streetlights, car headlights, and lighted windows can provide sufficient lighting for many of the scenes you wish to capture (Figure 6.26).

Figure 6.26: There is light coming from the café window as well as the square beyond the actors.

At night, creating depth and layering light often produces more pronounced contrast between areas of very dark and very light. Soft light will have a more moderated drop-off in darkness, and hard light will have a more distinct end point. These effects can be interesting to play with as you craft your scene. It is important to remember to not overlight your night scenes. This is especially important if you are lighting from above since the only illumination that people expect from above at night is from streetlights or the moon. Take into account what lights would be present in the scene as you plan your lighting scheme. Even at night, light sources need to feel logical and organic.

> If you have a great moon, remember that it moves just like the sun. Moonlight often must be faked even if shooting at night because it may not be vivid enough for your scene or not present on the evening you are shooting. When creating moonlight, using a bit of cool blue will cue your audience that the light is supposed to be from the moon and not a daylight source.

Exposure for night shots must be very precise. Underexposed shots at night or shots with predominantly dark shadows will look very muddy and noisy. At the same time, even small specks of light will show up against a very dark background, so you can be more creative in what you use to light a scene. What looks like the small glow of a cell phone in real life can light the entire shot on camera. A good plan of action when lighting at night is to keep in mind that lighting should look like it has a logical point of origination in the scene. This is because often at night the only light source that is available in reality is the moon or lighting from streetlights or windows; however, in night shots, you will need to augment the lights. If the scene is supposed to have realistic lighting, augmenting at night requires a

deft hand and paying attention to make sure that the lighting continues from scene to scene. This means that if moonlight is apparent in one shot, you likely will have to keep a visual nod to moonlight in other shots. If it is supposed to be hyper-realistic or not natural at all, then the lighting choices can be more creative in terms of direction, tone, and color.

Fire and Flames

If you have a fire or flame element in your scenes, there are a few things that are good to know. You never want to light the fire or flame directly. Let the flame itself be a light source. However, if that is the only light source in the scene, you will need to augment the lighting throughout the scene. A flame will rarely give off enough light to reach the walls or background of the scene. It is your job to match the lighting of the flame but get that light onto the set pieces, walls, or subjects in the frame so that you don't just have black everywhere that is not near the flame.

At the same time, if you overlight the scene, all of the impact of the flame will be lost (Figure 6.27). Even with a flame as small as a candle, you are in danger of overlighting if you are adding lighting, so if there is a flame, keep in mind that its effect is created by the contrast between the darkness and the flame, not between the flame and the lower light.

(a) (b)

Figure 6.27: (a) Candle on a dinner table as the single source of lighting. (b) Candle on a dinner table with fill lighting, minimizing the effect of the candlelight on the scene.

Mirrors

When using a mirror, start by lighting low so that the wide shot is unobstructed and so that when you pull back there is some space for headroom. You obviously will not be able to shoot these shots head-on, so focus on the angle and tip of the mirror to get the proper lighting reflected inside the mirror (Figure 6.28). When lighting a mirror, angles are especially important; the light's angle and height may have to be adjusted so that it lights the reflected image but does not appear in the shot. This is especially tricky if the camera moves from the reflected image to the real image in the same shot.

Photo courtesy of iStockphoto, © Marco Rosario Venturini Autieri, Image #2368692

Figure 6.28: Aim your light into a broken mirror.

There will be times when the angle of the mirror will produce glare or reflect the light back at the camera. Before worrying about trying to adjust the lighting, first try angling or tipping the mirror slightly to reduce the glare or reflection. This often is a simple and quick solution.

Glare

Glare and unwanted light reflection can screw up many shots. Often just slightly angling or tipping the offending mirror, reflective surface, or picture can take care of the problem. It

can be handy to have furniture felt with adhesive backing or picture putty on hand to put under the edges of a mirror, picture, or reflective surface on the wall to prop objects and change the angle of reflection of their surface. Reflective objects can also be sprayed with dulling spray if necessary to eliminate reflection altogether. If the glare is from an immovable object, angling the camera or the lights can get rid of the glare, or you may have to block off your light source with a flag.

Close-up Lighting, Matching, and Cheating

Have a small emergency light and bounce card handy when shooting so that you can make small adjustments especially to focus points in the shot, such as the actors' faces.

Your lighting will often have to be adjusted for any close-ups of people or objects. When lighting for a wider shot, the lighting may not provide subtle detail on the faces of the actors. This is fine for the wide shot but not always OK for a close-up. When moving in for a close-up, the actor's face and any other small details will appear huge on-screen. Thus the same lighting setup likely will not give you the exact lighting you want on the close-up. This means that the lighting will need adjustment when there is a move, perhaps adding some eye lights, fill light, or shadow detail in the face or on the object. Thinking through all of the shots helps your actors stay with the scene and keeps momentum up by cutting down on the setup and change time between camera moves.

Just as the lighting is restructured, some of the objects or the set may need to be moved. This is one way to cheat or make a change that the audience won't see in order to make the shots look consistent. Keep in mind what the audience would expect to see in the background or in the shot with the close-up. Some slight adjustments may also provide a more pleasing composition or detail.

The lighting changes you make for a close-up should look as if you still have the same light that was present in the wide or master shot. Any cheating or adjustments to light must be made with continuity in mind. Keep the angle, general lighting feel, and major source direction the same unless you are trying for a very off-kilter or disconcerting effect. Once you have established where the light is coming from in the scene, keep the major source direction in the rest of the shots, including the close-up.

Lighting for Green Screen or Chroma Key

When you are capturing a shot that will be used for a composite visual-effects shot and/or a background added in post, certain lighting decisions you make will help you achieve better results. If you are shooting a green screen, the most critical thing is to get consistent light across the entire green screen you are lighting. It is important that from edge to edge the lighting be even and soft. Any bright spots or shadows will adversely affect your ability to remove the green in post. Also note that ideally you need to place the green screen 8–10 feet or more behind your subject. If the green screen is too close, it will reflect the light you are putting on the screen itself back at your subject. This reflected light will have a green hue and cause issues when pulling your key in post.

In these shots, often you'll shoot part of your set or the entire background with a green screen that will later be removed in post (Figure 6.29). Sometimes you'll later add several shots into a single composite shot. The technical aspects of green screen and composite shot manipulation and creation in post are outside the realm of this book. However, you may be in a situation where part of your shot incorporates a green screen, and you will have to light the scene.

Figure 6.29: Green screen light on the set

The first step in setting up and planning your lighting for shots like this is to think about how the final shot is going to look. You need to make sure that the elements you are shooting that will be in the final shot are lit with the end result in mind. Color temperature is an obvious thing to check. Also, look for contrast in the areas you are lighting that will remain in the final product, and consider not just the contrast in the image but how the entire image will fit into the final shot. Each element you light and shoot must in the end look like the main lighting for the wide shot was used. If not, things will look out of place and not blend together properly.

You want the images to match as much as possible, so make sure that what you shoot will not be shot considerably darker or lighter than what will be added in post. For example, if you are going to be shooting actors in the foreground with a green screen that will be matted out in post, make sure that the actors' lighting matches the lighting in mood, logic, and feel of what you want the shot to look like in the final permutation. As you are lighting, think through the image from all angles. If you are shooting two shots that are going to be composited, it is helpful to bring the footage from the first shoot to the set during the second location shoot. Looking at the footage you are trying to match is critical to having a good end product.

Butterfly Lighting

In butterfly lighting, the light is placed in front of the subject with the subject's face toward the light. The light is then raised and adjusted until a butterfly-shaped shadow appears under the subject's nose. For this to work, the subject's nose must be directly facing the light.

The emotion conveyed by butterfly lighting can vary, depending on the overall lighting, especially the choice of harsh vs. soft.

Photo courtesy of iStockphoto, © Peter Zelei, Image #16450270

Look for reflections in any objects that are going to remain in the final image. It is best to eliminate these reflections because they will not match the final image.

The green screen itself has lighting considerations. In post, it will be easier for the team to get a clean, crisp image to work with if the green screen is a uniform, consistently colored image. Essentially what you are trying to do is to keep the same color, tone, and brightness throughout the entire screen. The color of the green screen was designed based on a specific light color, and there are fluorescent lights available specifically designed to light green screens to keep them this color. The screen will be lit from the front with the goal of being uniform color on every area of the screen, from top to bottom and from side to side.

All of the lighting that you do in the foreground or in the area where you are using the image must stay off the green screen. Be especially careful of light spill and reflective color casts. It is helpful to keep some distance between the screen and the lighting. This means you may have to make adjustments to your set or location if you are using a green screen. Many flags, screens, and cards are used to block light from hitting the green screen or prevent the green screen from reflecting light back onto your subjects. Ask your post team how

easy it will be to remove equipment from the shot in post. Often it is better to have visible cards and items in the shot if those items are blocking light than to have the light hit the screen. You need a lot of space to properly set up a green screen, and you need to have a plan or you likely won't be happy with the results.

For a complete discussion of green-screen technique, see *The Green Screen Handbook* by Jeff Foster (Sybex, 2010).

Managing Light

When shooting with DSLRs, a new decision faces you that isn't what lights should be added but rather the opposite: what lights should be dimmed, diffused, or blocked?

This is a new concept in the area of shooting video. In film, you add light to make it look natural and adjust exposure; with DSLRs, you often have to subtract to make sure the lighting looks natural and then adjust your exposure accordingly. Usually with film you light with high intensity, check ratios from there, and stop down; with DSLRs it is effective if you minimize or have low-intensity light and move up.

Three ways to limit light are diffusion, bouncing, and blocking the light.

Diffusion

Light, by its nature, generally radiates in straight parallel or nearly parallel lines. Changing the light rays from parallel lines to rays going in scattered directions is called *diffusing* the light. Diffusion is usually achieved by placing a translucent material in front of the light to interrupt the light waves (Figure 6.30). It can also be done on a grand scale by clouds on an overcast day. When people discuss hard-light vs. soft-light sources, they are referring to non-diffused light as hard light and diffused light as soft light.

Photo courtesy of iStockphoto, © Nathan Jones, Image #9397110

Figure 6.30: A diffuser held by a C-stand in front of the light

Bouncing

Bounced light occurs when light from a light source is reflected or bounced off a light-colored object back at the scene you are shooting. In lighting, the light-colored object is usually a deliberately placed foam core board or card that is turned toward the subject or area where light is desired. The bounced light is less intense than the original light source and can be directed to the exact location by moving or angling the bounce card. Sometimes light bounces off objects on set that you don't want light to be bounced from and in this case will have to be blocked so that it doesn't pollute your scene.

When you bounce light, the material you are bouncing the light off will change the effect of the light (Figure 6.31). If you bounce off a non-reflective surface, you will get less bounce than if you bounce the light off a shiny material. The color of the bounce surface also matters, because if the surface is colored, a color cast may end up in the bounce, which can be pleasing, especially if you want a warmer or cooler tone to the light.

Figure 6.31: Aim your light into a bounce card to create a nice, soft, reflected light for your scene.

Blocking

Blocking part of the light has become common when shooting with DSLR cameras. Because of the extreme light sensitivity of the DSLR sensor, light spill is a common problem. It is very easy for background lights that are far in the distance to overpower a scene if the foreground is not heavily lit with bright lighting. Often on set you will be in the position of needing to block all or part of the light to make sure it doesn't overpower your desired lighting setup. Blocking light can be tricky if you don't have the ability to turn the light off completely or control the light. You can block any unwanted light with a flag, your actor's positioning, or draping. Even when you try to control the light, some light may spill out and still influence your scene, so you have to be very diligent in watching for small amounts of light pollution in your scene. Even if you can correct or remove an unwanted light source in post, you will only be able to take out the light source, and the light spill will still affect your entire shot.

Regardless of how well you can control any unwanted light sources in your frame, paying attention to the blocking of this light is a way to influence your overall lighting scheme. It is useful to have walls of foam core or dark fabric available to block off large sections of your location. Smaller flags, fabric swatches, or similar items can be used to block off smaller individual lights or provide a barrier between the light and an actor's face for a close-up shot. Blocking is an area where it pays to get creative.

Tools for Controlling Light

Whether you come from a motion picture, still, or video background, lighting and controlling the light sources are not new techniques. The same tools you are familiar with will serve you well. Lightboxes, barn doors, scrims, flags, silks, and reflectors are all still very much tools of the trade. The major new change in lighting is the idea of subtractive lighting. Don't confuse this with flagging extra light or controlling the light; rather, it's eliminating existing light from the scene.

Subtractive lighting techniques are employed many times with traditional lighting setup, and understanding how to take away light is just as important as knowing how to add it. For DSLR moviemaking, subtractive lighting techniques are especially useful. Available or natural light sometimes is all you need to alter your shoot in a negative fashion if you don't control the amount or level of light. This is because many types of lighting are simply too intense for the sensitive DSLR sensor, so subtractive philosophies will help shape the lighting. Many times a subtractive and additive lighting scheme will be used where the available light is reduced or altered and some additional lighting like fill or eye lights is added to the scene.

Lightboxes/Softboxes

A softbox or lightbox can be attached directly to the lights and will take a hard light and turn it into a soft light. The most common thing that photographers are accustomed to using is a *lightbox*, which is a large box with black on three sides and a white translucent material on the front (Figure 6.32). It attaches to a light to diffuse and soften the effect of the lighting. A lightbox can change a relatively hard directed light source into a soft large light. Remember that the size of the lightbox will also affect the light. The larger the lightbox, the softer the light and the more the light will wrap around your subject. With a smaller lightbox you will still have soft light but it won't wrap as far around the subject as a larger lightbox of the same diffusion.

Figure 6.32: Standard softbox attachment on a light

Barn Doors and Related Attachments

Barn doors are black flaps or leaves that attach to the side of the light (Figure 6.33). You can adjust the angle of the barn doors to direct the light path or use it to block light off areas you don't want to light. The barn doors can be adjusted to wide open or almost closed with just a small slash of light over the area of the scene you desire.

Figure 6.33: Standard set of barn doors on a light

A *snoot* also can be attached to the light to direct its beam. A snoot is a circular tube that attaches to the light to keep the beam in a highly defined circular pattern. A snoot acts as a focusing mechanism that directs the light instead of letting it spread out across the scene.

Shutters, which look like Venetian blinds, can be used on the light to limit the light or when completely closed block it. They can be useful if a light must be limited during the action, or they can be used to create an actual look for your scene. Imagine very harsh light blasted through shutters, giving you very dramatic shadow lines through your subject's face.

Photo courtesy of iStockphoto, © Petro Teslenko, Image #9505744

Figure 6.34: Notice the bag of scrims that can be inserted on the front of the light. Each scrim blocks more or less light than the others, allowing you to quickly remove or add a small amount of light without changing lights.

Scrims

Scrims look like circular screens that come with different size meshes (Figure 6.34). They are attached to the light to cut the light's intensity. The different mesh disks have varying size screen material that allows more or less light through the scrim. You start with a brighter source light than you need, and you use a scrim to knock down the light to a more appropriate level. This is not needed on newer LED lights because the lights themselves can be dimmed directly on the light fixture.

Flags

Flags are pieces of dark fabric or solid black heavy silk that are mounted on wire frames. They are usually rectangular in shape and are used to block light. Flags come in many different sizes and are made with an end that attaches to a stand or that can be clamped to various surfaces. There are times when an assistant can hold a flag to block light temporarily, but you have to be careful because any movement with the flag will show a change in light through your camera. These types of flags are not attached to the camera itself like French flags (which are placed on the camera or the light). Regular flags are not attached to the camera at all and are used for both blocking and directing light. Flags are placed to block unwanted light or to create a hard light path. If you are trying to get a hard cut or defined shadows, the flag will need to be moved farther from the light and closer to the area where the shot will be composed. The closer the flag is to the light, the softer the shadow edge will be. The farther the flag is from the light, the more defined the shadow edge will be.

Teasers are huge flags used to block light from larger areas or to avoid light spill, especially from bounced light.

Foam core makes a great large-scale flag, bounce card, or temporary bounce wall. It can be cut into many sizes or attached in multiple units to form substantial bounce cards or flags. Usually white and black can be easily procured; to maximize the benefit, try to get the foam core that is white on one side and black on the other. It can also be easily spray-painted if you want an inexpensive gold or silver reflector. Foam core is always useful but will definitely be an asset during natural light shoots where power isn't handy.

Silks

Sometimes you should consider using silks to soften your light. Vertical light, like high sunlight, will often make the entire scene, including the landscape and scenery in the background, look flat or lifeless. In these situations, large silks combined with flags can save the shot and turn harsh or direct light into beautiful soft light. In these cases, the silk must be placed to keep the light from directly hitting the area where the shot is framed (Figure 6.35). Large silks are an effective way of shaping bright sunlight. However, it is often necessary (and especially so in extreme sunlight) to focus primarily on the area where the actors or subject is going to be and not worry about the light in the entire outdoor panorama.

Figure 6.35: Silk placed in front of the light to diffuse the light

> Anything that is blocking, reflecting, or adjusting the light will need to be firmly attached to a stand and/or something that prevents it from moving. If the item influencing the light is moving, it will look like the light itself is moving or waving in an unnatural way.

Silks are exactly what they sound like—pieces of silk fabric that are translucent but not transparent. They let some light through but manage to spread those harsh bright light waves a bit. Silks can be just the silk fabric you hang or find a way to attach or they can be the same as standard flags and be permanently mounted on rectangular grids to be used with a stand. There are silks that can be taken apart for transport. These larger silks can be mounted or held by assistants for a shot and/or be moved along with a moving shot. This size silk is often called a *butterfly*. Very large silks that are closer in size to sails are

put together in pieces and with frames. These silks are mounted and used for areas where a large amount of diffusion is needed or for a moving scene. These silks are often called *overheads* and are mounted on larger stands or high roller stands. These silks will need to be weighed down and set up by a person who has knowledge in gripping because you are essentially setting up a large sail that can catch wind drafts.

> Other types of material can be used on frames or put on stands to diffuse, block, or alter the light. Some of this is essentially a large tarp-like material called Griffolyn, but other fabric and material can be used to suit your needs. If you do not have the budget for professional grip and lighting alteration equipment, you can usually make your own with various cloth material, mirrors, Duvetyne, mesh, muslin, and sheets to rig up several options to use on set.

Reflectors and Bounce Cards

Reflectors are shiny surfaces that are used to reflect light. They can be boards, large rolls, cloth that can be stretched onto grids, pop-up disks, or even mirrors. The reflector is usually attached to a C-stand and placed so that the light hits it and is reflected to the appropriate area of your choosing. Most reflectors have a different surface on each side so you can use each one for more than one purpose. Often one surface will be a hard side that has a high-gloss finish that can reflect a hard beam of light a long distance. The other side is the soft side and is less shiny with a bit of texture. The light quality from the softer side is softer, less beam-like, and less intense.

> If you have to cut down on sunlight or balance it, you will find it hard to get lights that can match the sunlight; it's often difficult to even tell you added a light in direct sunlight. Reflecting light is usually the best choice when trying to add more light to a bright sunlight scene. If you are using the sun, remember that as the sun moves, your reflector position will also have to be adjusted.

When light hits anything that is reflective and not light absorbing, the light waves bounce back. You can take advantage of this property of light with reflectors and other bounce cards. A bounce card is simply a light surface that is placed so that the light can hit it and bounce to the desired place in the shot. Walls or other large surfaces can also provide bounce (just remember that sometimes this is unwanted bounce). Bounce can be done on a grand scale with a large piece of foam core or with a very small white card for close-up portrait-style shots. The bounced light will have a different feel than the direct light, so try it to see how you like your bounce light and what sort of bounce source works best.

Bounce happens any time the light hits a light surface, so the technique and materials for bouncing light are limitless. If you need light in an area, first try bouncing it in; this can quickly fix many shots and provide that extra bit of light the shot needs.

Nets

Nets have the same physical structure as flags, but instead of being an opaque black they are made from netted material. They are used to reduce the light intensity but not block the light altogether. Nets won't cast a shadow when the light passes through them but just

reduce and soften the light passing through. Nets can be used in layers, with the more layers used, the more light is reduced with each layer.

Patterned Light and Adding Texture Artificially

If you need to add patterns or texture to your lighting you can just place items in front of the light. Those can range from blinds, tree branches, or flags with shapes cut out of them.

Traditionally gobos or patterned nets are used, and these items can make your life a lot simpler on set. They attach to the light or in front of the light much like a scrim and then provide the pattern that is needed for your shot. They can also be custom manufactured for a particular pattern if you need one.

Light Quality

Light on set is often described as *hard* or *soft* (Figure 6.36). This is not determined by the direction, angle, or any other general light characteristics. Rather it is more a subjective quality assessment that varies with each person who views the light. The easiest way to understand the distinction is to simply look at the light. The quality of the light is based on the type and size of the light source and also how far away the light is from the subject.

(a) (b)

Figure 6.36: (a) An exposed lightbulb is hard light. (b) Notice how just adding a lamp shade softens the light but also cuts down on the light farther from the source.

Hard light has high contrast and generally has little to no diffusion. One example of hard lighting is high midday light on a sunny day. Even though the atmosphere diffuses the sun, the sun can create hard shadows and a more pinpointed source at midday. Hard light is easily seen when an intense spotlight is beaming on your actor as the sole illumination. Hard light has more contrast, whereas soft light has less contrast. Hard light is often from one pointed direction with the light source coming from a smaller area. Lights that are generally hard are lights that are from very small source points and don't have any diffusion between the bulb or light source and subject.

Soft light is low-contrast light that is either directly or indirectly illuminating the subject. An example of soft light is the light on a completely cloudy day. Soft light comes from light sources that are diffused or bounced. If you want soft light, you need to look for lights with easy diffusion abilities or use Kino Flo Blanket-Lites, egg carton diffusers, or diffusers placed separately in front of the lights (Figure 6.37). The light can also be bounced or the lights physically moved back to change the intensity and give the effect of more diffused light.

Photo courtesy of iStockphoto, © Peter Lora, Image #185141

Figure 6.37: An egg carton is used over a softbox to direct the light.

Light that is produced artificially can also be hard or soft. If you're shooting with available natural light, you may be able to get both in the same location. For example, if you are shooting in a field midday when it's sunny, the area in the field will be very hard light, but if you step under a tree, you can get soft light that is easily bounced (Figure 6.38).

Changing the Quality of the Light

If you have soft light but you need hard light, there is little you can do to change it to a hard light. Hard light can easily be made soft by adding diffusion to the light source (Figure 6.39). Soft light falls off more quickly than hard light, and once you have soft light, it can be difficult or impossible to control. Sometimes light can be so soft that it creates almost no contrast in the image. The choice is not between hard and soft lighting or between bad and good lighting but what works with your visual goals.

Photo courtesy of iStockphoto, © Ilya Bushuev, Image #13897014

Figure 6.38: Notice that the shade of the tree creates a nice, even, soft light over the actress.

Figure 6.39: You can set a flag to keep the hard light off an actor or area of the set, or you could use a silk to diffuse the hard light.

If you are starting with a large light source, it can be a good idea to start with a harder light. You can add your diffusion or bounce of choice to create a soft lighting setup. Think about it like a hose—if you start with a lot of pressure you have options to turn it down later, but if you start with little to no pressure, it is hard if not impossible to increase the pressure down the line. You can also make the light softer with softboxes and similar light additions (Figure 6.40).

Adding softening blankets or diffusers to the light will help you create soft, even light (Figure 6.41). There are specific attachments made for this purpose if you are attaching them directly to a light. You should use the attachments designed for your lights because they have been made to be heat resistant and less flammable depending on the type of lighting fixture you are using.

You can also bounce the light with either small bounce cards or, if necessary, large bounce boards that are set up. If you need to diffuse the light on a large scale, you may need to set up walls made of sheets of a diffusion material such as muslin or specialized silks.

Figure 6.40: A typical softbox light to help create a soft, even light source

As the action occurs and motion happens in the shot, keep your eye on the lighting. Watch how the light quality and quantity change as the camera moves or the actor moves during the scene. What starts out as very soft side light may turn into bright front light by the end of the scene, or vice versa.

Picking Exposure

Exposure directs the eye by choosing which element will be the brightest and which the darkest in the scene. Answer this question: "What part of the scene will you be exposing for?" The answer to this is almost always what the focal point will be in the scene.

Many scenes will have a few different options for exposure, all of which may have certain aspects of the shot in the proper exposure range. Proper exposure means that the scene is given adequate light but not excessive light to provide an image that has appropriate contrast and tonal range.

The scene's *contrast ratio* is the proportion between the brightest parts of the light and the darkest, usually given in the number of f-stops between the darkest and lightest parts of the lighting. So, for example, if you light an actor's face, you can have a 2:1 ratio between the lightest and darkest parts of his face, which means that there is a one f-stop change between those areas. The greater the number of f-stops between these points, the more dramatic the difference in your lighting and at the same time the higher the contrast ratio. If the contrast gets too high, you can actually start to lose

Figure 6.41: The use of a diffusing ring to cut down the midday sun. We additionally used a blackout fabric on top of the diffusion ring to further cut down part of the light passing through to the actor and car.

Photo courtesy of Carrie Vines Photography

detail and will end up not having a good range of tones. This is especially true in the darker areas of the frame; shadows will go to black quickly. If you have too high a ratio, you may need to add fill light in order to be able to expose for the midtones and shadows while keeping the highlights from blowing out. This is all a delicate balance that you, the artist, get to play with.

There are times, especially when shooting in an uncontrolled location, where the exposure choice you make to get your central subject properly exposed may leave part of the scene under- or overexposed. Again, because there is a limited correction range with DSLR footage, you should prioritize getting your actors or central action visual properly exposed. What you expose in the image and what you feel is the most visually pleasing exposure is up to you. Of course, when shooting in a very dark set with only one small light, your exposure choices will be limited if you want to keep lower ISOs and a shutter speed that is functional for video.

The zone system can be a beneficial tool when making lighting decisions relating to exposure on the set. It can even help determine how intense the different lights in the scene are set or what other elements need a lighting adjustment. The zone system (Figure 6.42) in its simplest form breaks the grayscale from black to white into 11 zones. Each zone is twice as bright or twice as dark as the previous one.

Figure 6.42: The zone system

In general, the eye looks at and focuses on any people and therefore skin in the image or lighter areas in the image. Skin falls mainly into zones IV, V, and VI. Zones VII, VIII, and IX are usually the lightest part of any given image.

The zone system helps determine what parts of the image should be in what zone. For example, if you are trying to determine whether you have adequate light to get proper exposure of your actors in a scene, put their skin tones in zone 5 and set the exposure for this zone. Now look at the rest of the image to see how it looks. You will want to see an image with a nice range of zones represented in the shadows and the highlights. If you don't get the range you want or if exposing for the skin to be zone 5 makes other parts of the image improperly exposed, you will need to find a way to adjust your lighting.

The zone system can help in another way as well. When you set up the lighting, put your central visual focus on the zone you want it to be in. As you set the lights and test your shots, you can adjust the lighting to keep your exposure and make sure that the rest of the image has the proper light and dark areas to keep your exposure pleasing.

A quick way to test the zone system is to use a spot meter to test the f-stop of the element you are exposing for. Then you can expose to that point and check to make sure that any of the other parts of the image are in a range to get shadows and highlights in your shot the way you want them to look.

The zone system is not a fixed scale. The values are determined by how you decide to set the lighting in order to get the range you want or how you decide to expose based on into what zones you place visual elements of the shot. Any area can be placed into the zone of your choosing. For instance, if you choose an area that appears very bright on set to the naked eye but you determine that you will expose this to be in zone 6, then the rest of the image will be automatically shuffled into zones. This is because when you pick what zone 6 is and set exposure, the rest of the image will have its exposure and zone placement determined by this decision and settings. If after you do this you don't like how the image looks, you can move elements to new zones by adding or subtracting the light on them or by moving the objects into a light area in the zone that you want them to be in.

When using the zone system, it can be hard to visualize because you are looking at the image in color. You may be able to visualize it more easily by looking at the image through a black-and-white monitor setting. Knowing the science of lighting is important. However, practically speaking, most of the time this is done by eye. Lighting is at its best an art. But you need to know and understand all of the technical knowledge as a baseline so you have the tools to use the art of lighting. You won't be able to decide whether it's the right lighting, whether it's beautiful, or whether it's perfect for your shot because there is no right or wrong. It is up to you to decide, shape, and experiment with to see what you like. Keep the ratios or zones or ISOs in mind as a philosophy and use the concepts to create well-balanced shots, but focus on the overall lighting scheme's look to make your final decisions.

Lighting with Large Balloon Lights

An interesting solution to lighting a large area from above is to use giant balloons filled with helium that have lights mounted inside. These giant balloon lights produce wonderful soft, diffused light. They can also be a particularly large light source. The balloons float overhead tethered to the ground by guy wires. Clearly, they provide an overhead light source, but they also can be backed up from the subject to provide a slightly angled light source.

Balloon lights are great for locations where lights must be provided but can't be hung, such as outdoor sets with no option of grid work or ceiling lights. They are easily hidden because they can simply be moved out of the frame at any time and can be used to add to a kinetic large-scale environment for additional light. They are very movable, and multiple balloons can be used to create a look. If putting lights on cranes is problematic or if you are in a location where you need large overhead light but have limited power, light balloons may be a good option. They do have some disadvantages; most prominently the wind can cause them to move erratically, and for obvious reasons they must not be used if there is danger of lightning.

seven

Sound on Location

"Sound is never noticed unless it's
bad." Recording good sound on location is essential for any filmmaker.
Working with DSLR cameras is totally different than working with
traditional video cameras. They are much more like film cameras. Depending
on your particular situation, your best option may be to record audio on a
separate device and skip recording audio directly into the camera.

The Role of Sound

Sound has come a long way in terms of both technology and workflow since sound was first
added to movies. Yet one thing that has remained constant is the level of difficulty in cap-
turing great audio. It's a tricky process whether you are shooting on a closed set or on loca-
tion. There are always various factors that can't be easily controlled. Getting good audio
starts in pre-production, by understanding what you have to work with before you are actu-
ally on set.

Sound is critical, but often people don't notice how important sound is to understand-
ing the surroundings until they process it in isolation. Try this experiment. Shut your eyes.
Then sit or stand perfectly still for five minutes and do nothing but listen . . . just listen. Try
to critically identify everything you are hearing. And we do mean *everything*. Are you inside
a house? Can you hear people talking, the radio or TV, or a pet? Listen deeper. Can you
hear that clock on the shelf, water running in the sink down the hall, traffic or wind from
outside, or people breathing? OK, now listen very deeply. Can you hear your computer hard
drive or your monitor whine or an air conditioner or furnace fan? Or even the low hum of a
refrigerator motor in the next room?

Astonishing, isn't it? The world is a huge jumble of sound that you take for granted
every second of every day. You need to remind yourself that you must record this world of
sound to give your film the ring of truth and authenticity. Sound imparts realism, drama,
tension, and humor.

Sound is every bit as important as the pictures you see. Still don't think so? If we say Darth Vader, what do you think of? Your answer will probably include the sound of Vader breathing. It is an iconic part of *Star Wars*, and we identify with the audio and sound as much as, if not more than, the image of Darth Vader. If we played you just a sound clip of a light saber duel, how many seconds would it take you to identify it as a Jedi battle? Think of the shark in *Jaws*. We defy you to tell us that you do not hear that "baaadup baadup bump bump bump bump" of the string bass in the orchestra. Hearing the dialogue is essential, but it isn't sufficient; you must also be able to hear the world around your dialogue. You must inhabit the movie universe that you are trying to create with sound. This requires you to think hard about all the aspects of the world you are trying to capture.

This chapter concentrates on managing and capturing sound on set. Chapter 11, "Audio Crash Course," talks about working with sound in post.

Hiring a Professional

Just remember that sound is critical to your project, so if at all possible, hire a professional. If you don't have the means, then make sure to prepare equally hard for capturing sound as you will when picking your camera and lenses. Great sound doesn't just happen. A lot of hard work goes into capturing great audio.

Extras to Bring Whether You Have a Sound Person or Not

Bring the following:

- Two identical sets of headphones (if the headphones fail, you fail).
- Extra XLR-to-XLR cables.
- Adapters to convert to XLR.
- Various audio jacks, inverters, and converters.
- Extra microphone clips and fasteners.
- Two flashlights (one for you and one to share or if yours gets dropped).
- One Leatherman tool (a multitool is invaluable).
- One multimeter.
- One clipboard with paper and extra pens and two copies of the script.
- Extra batteries. Know all the brands and sizes you will be using and get extras.
- Earplugs.
- Hairpiece tape, which is excellent for taping down lavaliere microphones on skin or in hair.
- Twenty zip ties, various sizes.
- Twelve rubber bands.
- Twelve safety pins.
- Six spring-loaded clothespins.
- 2" to 12" strips of Velcro.
- Gaffer's tape.
- Electrical tape.
- Superfine sandpaper.
- WD-40, talc, or baby powder.
- Soldering pen (don't forget the solder).
- Tiny screwdriver set.
- Two old white T-shirts (for when things get sloppy, dirty, or sweaty).
- A few old blankets for muffling stray sounds, blocking wind, and deadening noises.

In DSLR filmmaking, especially when you have a small budget, every member of your crew has to be capable and actually do multiple jobs. Sound is often shortchanged here, so it is important that you not let it be. In addition, many jobs have similar talents that can easily move from job to job. For instance, a camera assistant can easily be a camera operator and in some cases a director of photography. All of the skills are similar and complementary.

Sound, on the other hand, is more or less its own beast. The skills, knowledge, and even equipment don't translate to most of the traditional camera and lighting equipment. This is why it is best to hire a dedicated sound professional.

Hiring a sound professional will usually mean that audio will be recorded on an external system. Consequently, you will be getting audio files from the sound person after you have finished shooting. If you are working with a sound person, make sure you discuss how the files will be given to you and how the audio notes will be taken, and ensure that there is a system for file backup. The sound person will also be able to give you recommendations on gear rental and sound requirements for a set, so be sure that the sound person is included in pre-production planning.

Recording Sound with DSLR Cameras

Each DSLR camera is similar but not identical in its audio specifications. Chances are you don't have an audio background, so making sure you understand your equipment and taking a little extra time to learn or review some basic rules for capturing good audio is recommended.

Let's start by taking a look at how to set up the basics to run audio from a camera. No cameras are identical, but there will be some similarities in their audio setups, so we will use the Canon 5D Mark III (Figure 7.1) as our example model.

First, just look at the specifications on your camera. This will help you get acquainted with some of the basic terminology and things that can be done with your camera in terms of audio.

The 5D's built-in microphone is an electret condenser microphone (Figure 7.2). These microphones used to have the stereotype of low-quality microphones, but now the best models are regularly accepted as professional-grade microphones. The major challenge with audio on DSLR cameras is the audio input and sampling rate.

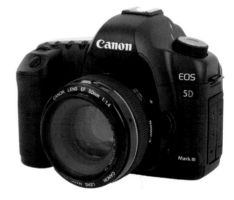

Figure 7.1: Canon 5D Mark III camera

The Canon 5D Mark III records 16-bit 44.1 kHz linear PCM audio in the camera. You have the ability to control the sound recording as Auto, Manual, or Disable.

The Auto setting (Figure 7.3) is a form of automatic gain control (AGC). This auto gain control will amplify many ambient noises or sounds, such as wind, car engines, and so on. This amplification of peripheral noise will distract from the dialogue you are trying to record cleanly. In a movie, it is most important for the dialogue to take auditory precedence because most of the other sound can be added or tweaked in the mix. For filmmaking or narrative pieces,

Figure 7.2: Close-up of 5D Mark III internal mic

any use of auto gain will certainly identify your project as low budget and not professional. AGC works great as a reference audio track to be used during post, but it should not be used for the actual audio capture to be used in a final mix. If you are ever in an emergency situation and must use the on-camera audio, turn off the automatic gain control and manually control as much as possible.

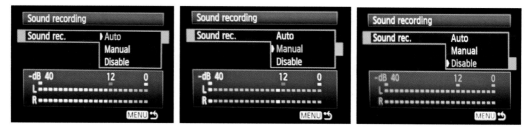

Figure 7.3: Auto, Manual, and Disable audio options

The manual settings are a recently added function of the camera; they allow the operator to manually control the audio levels. When you select Manual in the sound recording menu, you get a Rec. Level adjustment bar to manually control your audio levels.

As with any audio recording, you want to set your audio levels to peak right between –12 dB and 0 dB. If your audio levels exceed 0 dB, then your audio will be *clipped*, or distorted.

Image Stabilization Systems Make Noise

If you are relying on your built-in camera microphone, be aware when you use image stabilization (IS) lenses. An IS lens has a built-in gyroscope. The Canon IS system uses a microcomputer that controls sensors, actuators, and two micro gyros to eliminate vibration—and the IS system is *always* active in Video mode. The IS lens produces a very faint scratchy noise that is almost unnoticeable to the human ear, but it all but takes over the audio track on the camera. If you are using an IS lens, it is imperative that you use an external microphone of some sort to give yourself a good clean reference audio track in the camera.

Peak

Audio levels need to be set or normalized so that all sounds fall within a specified range and can be accurately recorded. As you set audio levels, you will need to be aware of where the upper and lower limits of the audio are set, and all sounds should fall between these limits. Audio will need to be normalized or have the entire signal adjusted so that it fits into the levels or norm. Essentially, you are moving the peaks and valleys, the highs and lows, to a range where they all can fit and be recorded. It is the audio equivalent of making sure that the camera is set to accurately record the whitest and blackest areas of your image.

Other DSLR cameras will operate similarly but with slightly different menus. For example, the Nikon D3S has a built-in monaural microphone, and you can attach a stereo microphone via the hot-shoe mount. You have the ability to set your microphone to High, Medium, Low, or Auto sensitivity or turn it off through the camera menu.

With any DSLR camera, it is important to read the technical specifications for the type of microphone, the input of the camera, and the recording specifications. In general, however, no DSLR camera has audio quality that is good enough to be used as the primary audio recording method for a high-quality project.

Using an External Recording Device

In reality, if you are going to make a movie or other dramatic project, you must use an external recording device and record in a double system. "Recording in a double system" means capturing audio with the camera as well as an external recording device. Think of your project just like a film shoot: record the image in the camera, get your high-quality sound from a separate device, and sync it in post.

Practically speaking, it is best to capture audio externally. It is easier and more efficient to get better audio using a dual recording system where the camera records the image and audio for matching purposes and a separate audio system is used to record audio. These devices allow for a direct digital recording from a microphone and provide a much higher-quality recording.

Bit Depth and Sampling

DSLR cameras have limited audio bit depth and usually top out around 16 bit. External recorders record higher at 20–24 bit depth. This increased range greatly enhances the final audio. External audio recorders also record at high sample rates. The sample rate is the number of times an analog signal is measured (sampled) per second to represent that sound. The more samples taken per second, the more accurate the sound can be. The unit of sample rate is samples per second. This is often expressed in kHz. For example, the current sample rate for CD-quality audio is 44,100 samples per second, or 44.1 kHz. Simply stated: the higher the sample rate, the better.

External audio recorders will provide a higher bit depth and often better sampling.

It can seem intimidating to have a separate system for recording audio, but even if you are doing audio yourself, it is actually easier to have a dedicated audio setup that functions separately from your camera. If you keep them separate, you have the option of getting several more channels for audio, the ability to record performers with multiple microphones, greater ease with post-production mixing because of multiple channels, easier voice-over or dubbing capabilities, freedom from having extra microphones or cords attached to your camera, and the ability to hand over the role of audio to another person (ideally a professional or at worst an ambitious assistant).

Audio for DSLR projects is usually captured externally by using one of a variety of digital audio recorders. These devices have many different features, but the key components that you need to look for are the ability to record high-quality audio with multiple inputs, multiple-channel ability, storage capacity, and ease of use including the ability to label takes.

When capturing audio externally, you may also need to add an audio mixer to the gear list if you have multiple tracks that need to be recorded concurrently or live.

You have a variety of options for external audio recorders. One of the most popular recorders available is the Tascam DR-40 or the Zoom H6 recorder (see Figure 7.4).

The Zoom H6 records on standard SDHC cards. If you get a 32 GB card, at the target rate of 48 kHz 24-bit you can record for about 15½ hours.

If you want to go with a more professional-style audio recording setup, a Sound Device 744T digital audio recorder is a good option (Figure 7.5).

Figure 7.4: Tascam DR-40 external recorder

The 744T is a powerful four-track file-based digital audio recorder. It records to and plays back audio from its internal hard drive, CompactFlash cards, or external FireWire drives. It writes and reads uncompressed PCM audio at 16 or 24 bits with sample rates between 32 kHz and 192 kHz.

Figure 7.5: 744T digital mixer/recorder

If you are not an experienced field audio professional, this system has a low learning curve, and you can set it up and be running in no time. If you add a Sound Device 422 outboard field mixer, you have a truly portable audio station. The removable, rechargeable battery is a standard Sony-compatible Li-ion camcorder cell.

The 744T interconnects with Windows and Mac OS computers for convenient data transfer and backup. Its recording media (hard drive, CompactFlash cards, and external FireWire drives) are reliable, industry-standard, and easily obtainable storage.

If you have time during the workday, you can download your audio for backup, or if your schedule doesn't allow, there is more than enough storage to wait until the end of the day to dump your audio files and back them up.

Capturing Reference Audio

Even if you are recording to an external audio system, it is helpful to use the audio captured with the camera for reference during post. None of the onboard audio will be used in the final project, but reference audio can save time and answer any syncing questions in post. Even if you are just capturing reference audio, it makes sense to try to capture good reference audio, and a little extra work and effort will save you time on the backend.

The first step to getting better in-camera audio is to upgrade the onboard microphone wherever possible. If you are in a quiet, small location or in a location where a large

microphone might draw too much attention, then you may be able to get away with the camera's built-in microphone. With that said, you are risking headaches and extra work in post relying on the built-in microphone even for reference. Adding an accessory shotgun mic for getting the best possible reference audio into the camera will be useful for capturing reference audio.

You can buy a variety of hot shoe–mounted shotgun microphones (Figure 7.6) that you can plug directly into your camera and get a decent reference audio track to use in post. This is essentially boosting what you would get with the built-in camera microphone and making sure the signal strength is good and you don't have things like the noise from an IS lens overpowering your reference audio track.

Figure 7.6: Hot shoe mount

Using these sorts of microphones is a way to create a better audio reference track in the camera that you will use to help sync your audio in post. The audio will still be controlled either by the camera's AGC or by the manual control if your particular camera model allows manual audio adjustments.

If you choose to use an onboard microphone for ambient audio recording outdoors, use an additional windscreen. Any wind will ruin the audio, so a cheap windscreen can save you a ton of headaches in post. Both Rycote and RedHead offer windscreens that will cut out any unwanted wind noise. The H4n also has phantom power if you need to power microphones without batteries or another external power supply. It also has a headphone jack for monitoring, which is a clear advantage because you cannot do this with most DSLR cameras.

Deciding how you are going to record audio is just the beginning of the process. After determining your primary audio recording system and reference audio setup, you will need to plan the audio setup for the shoot. Here is where an audio professional will prove most helpful in deciding what additional gear is required and how to set up a coherent system

to record quality audio throughout the shoot. Remember, moviemakers are responsible for planning all the audio, and you must understand that audio gear as much as possible in order to communicate your wants and needs with the actors and audio technicians. The next step to recording audio on set is planning the microphones, or ears, of the shoot.

Using an XLR Audio Adapter

Two major drawbacks in recording audio on your DSLR camera are the inability to see your audio levels and the fact that there is no audio-monitoring jack so you can listen and adjust your audio while you are recording. An XLR audio adapter can fix one or both of these problems. Any XLR adapter will have a headphone jack that allows you to plug in headphones and monitor the audio live. This allows for quick, small adjustments to the audio during the scene to make sure the audio levels are strong and consistent throughout the scene.

> We don't normally recommend XLR adapters because external audio recording is superior. However, if you must record audio directly into your camera, an XLR adapter will be very helpful.

Some XLR audio adapters also have audio meters on the front that visually show you the audio signal strength. This is just another way you can quickly look and make sure your audio signal is strong without being too strong to clip the audio signal.

Another reason to use XLR audio adapters is the ability to use an XLR audio cable as opposed to a smaller, mini audio plug. The XLR cable is a professional audio cable designed to carry a much stronger and better audio signal than what is possible to transmit through a standard mini plug. With that said, we don't consider the benefits of the XLR cables to be great enough to make them a valid choice.

XLR cables are balanced, which means they have three wires inside the cable itself. One carries the signal, another carries a phase-inverted signal, and the third is a shield/ground wire. When the signal gets to the recorder, any noise that is present on either of the two audio signal wires gets automatically canceled out or rejected by two of the three wires. So, think of it more as one XLR cable carrying one channel of sound on three wires and being auto-noise-rejecting. A normal mini-plug cable carries two channels of sound on three wires. This makes mini plugs much more susceptible to noise because nothing gets canceled internally in the cable itself. This is why XLR cables are so much better than standard stereo mini-plug types or even single-channel 1/8-inch (3.5 mm) audio cables.

There are a few XLR adapters on the market, but the two most prominent are the Beachtek DXA-SLR PRO (Figure 7.7, www.beachtek.com) and the juicedLINK Riggy-Assist (Figure 7.8, www.juicedlink.com).

Figure 7.7: Beachtek DXA-SLR PRO for DSLR cameras

Figure 7.8: juicedLINK Riggy-Assist RA222 phantom power unit

These adapters have XLR inputs, phantom power, and gain control. That is great, but you still must come out of the adapter and plug directly into the camera's 3.5 mm input, thus leaving you with the same 16-bit 44.1 kHz audio you started with. Unless there is some special need for your project, it would be better to just use an external device and not have the extra expense and extra piece of equipment attached to the camera.

Wearing Headphones

Always make sure to use headphones to monitor the sound of the microphone before and during the shoot. The pickup patterns vary, and monitoring the microphone will ensure that you are getting the sound you want. Not monitoring can mean that when you get back to the edit suite, you discover that the entire day of shooting is worthless because your actors sound like they are speaking to you from a cave in the Antarctic.

Get the full ear cup style. They provide a great seal for maximum isolation. Cutting down on outside noise really helps you hear what you are getting.

Do not use the in-ear bud style for monitoring or recording audio. One bad feedback squeal and you can permanently damage your hearing.

Use a Y-Cable Splitter for the Headphones

Use a Y-cable to split the headphone jack. You can take one audio input to plug in your headphones and use the other input to plug directly into your DSLR camera's 3.5 mm input jack. This will be a huge assistance in helping to sync the audio in post. This eliminates any sound differences between the reference audio and the master audio that can from time to time make it difficult to sync.

Also, just because you are bringing your 24-bit 48 kHz audio from your external recorder into the camera, don't think that you can use the audio on the camera. The audio quality is being dropped back down to the camera's audio limitations (16-bit 44.1 kHz audio). You should use the audio recorded in the camera only as reference audio for post.

A side benefit of using a split audio feed is if you play back your takes directly from the camera, you will have your actual audio (reference only) synced with the clip while you play back your dailies. This gives you a pretty good idea of what you have and whether you need to reshoot or are good to move on.

Just note that it is important to double-check your levels if you do use a splitter because every time you split a signal you lose 3 dB of gain. This is just the physics of splitting an audio signal in half and can't be fixed. Just be aware and make sure you are still getting good levels during the audio capture.

Microphones and Key Accessories

All microphones either are designed to pick up audio in varying patterns or are most sensitive to certain sounds. Thus, some microphones are better than others for different situations. If you are unfamiliar with microphones, take a look at the most common ones.

Types of Microphones

Microphones are designed to fit various scenarios, so deciding what is required of your shoot is important. In general, microphones that will be used on set fall into two broad categories:

Condenser Condenser microphones allow for a high-quality sound recording. They require power to work. The power, known as *phantom power*, can come from a battery

in the microphone or can be sent down the microphone cable from a mixer or recorder that has phantom-power capabilities. These microphones tend to be more sensitive.

Dynamic Dynamic microphones are well suited to fieldwork and do not require extra power to function. They can handle loud sounds well, and they are *very* sturdy. Years ago, we had an actor drop a Shure SM 57 microphone out of a third-story window to the asphalt driveway below. We still have that microphone, and it works perfectly.

If you categorize by type, size, construction, and cost, there are hundreds of different kinds of mics. They have different pickup patterns, sensitivity, and accuracy. There is no one correct microphone to use for any given situation. However, you want to try to use the best tool for the job at hand.

These are a few specialty microphone types you might need for particular circumstances:

PZM Microphone PZM stands for "pressure zone microphone"; it is also referred to as a *boundary mic*. These types of microphones actually attach to tables, Plexiglas plates, the floor, or other flat surfaces, and they capture the sounds that reflect off the surfaces to which they are attached. They are great for micing big space sounds like an audience laughing or clapping. If you use them on a table, be aware that every little finger tap will be heard, so make sure this is the right microphone for your scene if you choose to use it.

Lavaliere Microphone A *lavaliere* (see Figure 7.9) ranges in physical size from small to tiny and can be attached to lapels, collars, and hats. Or, it can be hidden inside a shirt or hair. In fact, they can be stuck almost anywhere. They are extremely versatile but are not the easiest microphone to use. You must take great care when placing these little gems, because they can pick up everything. Your sound enemies become clothing noise, breathing, mouth and lip noises, heartbeats, and so on. Put them too close, and they will sound boomy. Put them too far away, and the voices will be overwhelmed by background noise. However, when you find the sweet spot, they can deliver stunningly good sound. The most common type of wireless microphone is lavaliere microphones.

Figure 7.9: Shure FP1/FP5 Wireless lavaliere

Shotgun Microphone Shotgun microphones get their name because the microphone element is placed in a tube that looks like a shotgun barrel. They are most commonly attached to the end of a pole so they can easily be directed at an actor or object that needs to be recorded.

Boom Microphones

A boom microphone is simply a microphone at the end of a long pole (Figure 7.10). The designed use of a boom pole is to place the microphone directly above or directly below an actor's face just outside the camera frame. This allows the microphone to get as close to the source of audio as possible without being seen in the frame. A boom pole is usually operated by a sound person, but if there is no movement by the actors in a given scene, sometimes the boom pole is mounted to a C-stand, so the audio person doesn't have to hold the boom pole for every shot.

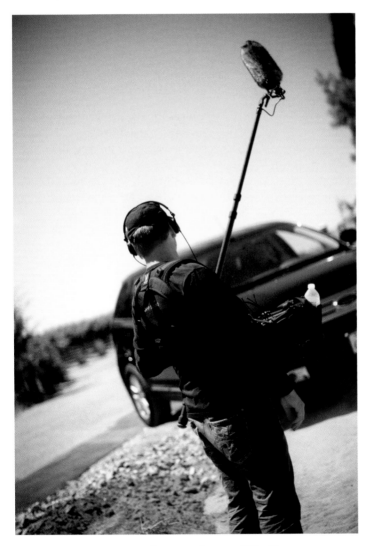

Figure 7.10: Boom microphone on the set of The Shamus

Boom poles are lightweight and usually made of carbon or aluminum. These telescoping rods can be either handheld or attached to a stand to capture your audio. Some models have the microphone cable inside the tube, which not only protects the wiring but also is much easier to carry around. They are more expensive, but this is where you need to be the judge of whether it is worth the extra money.

Technique is very important when using a boom, so whoever is going to be holding it needs to practice using it *before* you start shooting. Start by placing the microphone just out of frame. Work above and a few inches in front of the head, with the microphone pointed toward the actor's mouth and in the general direction of the floor. You can also work from below and point up toward the ceiling if that is what the shot dictates. Pointing up or down eliminates picking up a bunch of background sound because the floor and ceiling don't make noise. Pointing the microphone in other directions can capture sounds behind or around your actor.

Microphone Clips

Figure 7.11: A vampire clip to help reduce the rubbing of clothes against the microphone

Any time you place a wireless lavaliere microphone on an actor, you are open for unwanted sounds to appear. Any sort of rubbing of clothes against the microphone or just a little bump of the microphone by an actor's hand when adjusting his shirt could potentially render a take unusable. Get yourself a cheap insurance device commonly called a *vampire clip* (Figure 7.11). This can be anything from a shielded enclosure that you place your lavaliere microphone inside (like a cage that keeps clothing and unwanted objects from bumping or rubbing against it) to a furry tape that will keep the microphone attached to the actor but not allow for any wind to interfere with the audio being recorded.

Another tool is a suspension-style clip; these are usually made with elastic bands that hold the microphone suspended in a cage or fork. When attached to the pole, the clip isolates the microphone from the noise transmitted through the pole.

Placing Microphones

After looking at the various microphone types, it becomes apparent that where you place the microphone and the type of microphone used are critical to getting great audio. In general, the closer you place your microphone to what you want to capture, the stronger and better the audio signal you will get. Conversely, get too close, and you might get the microphone in the shot or have that audio signal be too strong so that the audio peaks or is crushed when being recorded. Here are a few tips to remember:

- Choose your microphone's audio pattern for what you want to record. If you want to get room tone, choose an omnidirectional microphone to best represent the location's audio characteristics, and if you want to get a line of dialogue, use a good shotgun mic on a boom as close as you can directly above your talent.
- Get the microphone close to your subject. If you are using a wireless microphone, place the microphone as close as you can to the actor's mouth or throat. The farther away from their voice box, the worse your audio will sound.
- When do you actually place the microphones? In general, any microphones being used on your actors are placed as soon as the actors are on set, in costume, and ready to shoot. Boom microphones should be set up and ready as soon as the sound person is on set. Any placement of microphones within the set needs to be coordinated with the grips and art department. In general, the microphones are placed in the set or in props

after the set is decorated and lit. This will depend on what sort of set you are working on and several other factors, but the sound should be ready to be placed as soon as possible so as not to slow down the shoot.

This is also a great time to mention something called *proximity effect*. If you do not know what this is, try this experiment. Move your mouth closer and closer to the mic while talking. Hear how the bass frequencies get exaggerated? That is proximity effect. Don't let the talent get too close to the mic, or everyone will sound like James Earl Jones.

Microphone Pickup Patterns

Pickup pattern refers to the physical dimensions of what, where, and how well the microphone hears depending on where it is pointed. Think of a regular lightbulb. Put it on a simple straight stand with no shade attached and turn it on. A microphone will hear everywhere the lamp shines. The pickup pattern of a microphone changes how much and where the microphone hears.

Microphones are designed to pick up sound in very specific ways and are specialized as to in what areas they pick up sound the best. You need to look at an individual microphone as possessing a specific sound field, or *area of capture*. Knowing and planning for this invisible sound field where the microphone will pick up sound allows you to map your set.

You can choose microphone placement according to where the sounds you want recorded are coming from and the placement of your actors on your set. By knowing your microphone's polar pattern, you can help cut down on sounds you don't want recorded that are present at your location and at the same time plan specific microphones to pick up desirable dialogue or background sounds you want to capture.

There are three basic sensitivity patterns.

Omnidirectional, Cardioid, and Hypercardioid Microphone Polar Patterns

An *omnidirectional* microphone polar pattern is *omni*, or all around (Figure 7.12). This is best used when trying to capture sounds from a large area around you. On the flip side, this is generally not a microphone for getting dialogue.

Cardioid, from the Greek for heart, has a pickup pattern that looks like . . . wait for it . . . a heart (Figure 7.13). With excellent sensitivity to the front and good pickup to the side, one of the strengths of this pattern is its ability to reject sound from the backside of the mic. It is a much more *unidirectional*, or one-direction, microphone so it works great in limiting the amount of room ambience the mic hears.

Pickup patterns are easy to visualize. Think of a 10-inch-tall mushroom. Imagine stuffing the microphone up through the middle of the stem until the head of the microphone is buried at the base of the cap. The mushroom is the pickup pattern for most cardioid microphones.

Hypercardioid is a tighter pickup pattern version of the cardioid but not as extreme as a shotgun microphone (Figure 7.14). These are excellent voice or speech microphones; be aware that the pattern is tighter so you do not want the talent to be far off to either side of the mic.

Shotgun Microphone Polar Pattern

The pickup pattern on these tends to be like a flashlight beam (Figure 7.15). These microphones excel at capturing the noise in the flashlight beam and not hearing sounds to the sides of the tube very well (this is known as *off-axis noise rejection*). These are generally great for dialogue and interviews.

Figure 7.12: Omnidirectional pattern

Figure 7.13: Cardioid pattern

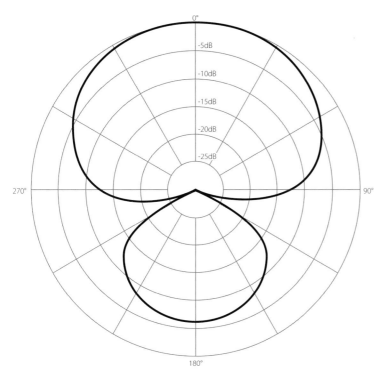

Figure 7.14: Hypercardioid pattern

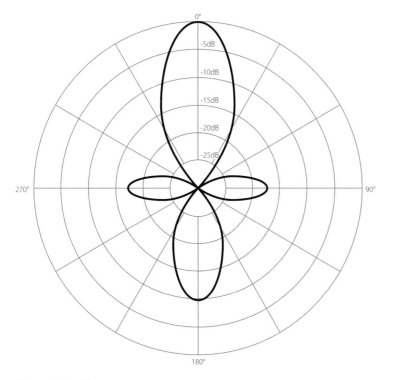

Figure 7.15: Shotgun pattern

Microphone Tips

Feel free to be creative with microphones. *How* you use microphones is almost more impor-
tant than *what* you use. Using two or more microphones at the same time to capture per-
formances gives you tremendous flexibility. A close microphone will give you an intimate
sound, and a farther-away microphone will capture a bigger room sound. Microphones
are best used if you use several and layer them, thinking about where each sound can best
be recorded and designing the type and placement of a microphone for that sound. For
example, several different microphones should ideally be used for the same scene, with each
microphone set to pick up different voices or sounds.

Mixing different levels of those will give you great choices. You can hide microphones.
Think of all the spots the camera cannot see. You can sneak microphones behind props or
actors, on C-stands just off-camera, in clothing or hair, in plants, hanging from the ceil-
ing, or on almost anything that is out of the sight lines. The flexibility of a microphone on
a boom is limitless. The good news is that once you get the microphone off the camera, you
have already taken the biggest step in improving the audio quality of your project.

Sound-Managing Accessories

Also consider these accessories to improve sound quality:

Zeppelins or Windscreens These are cages or fuzzy socks designed to protect the
microphone and help filter out wind and background noise. Unless you are on a very
quiet soundstage, you will want to use them, depending on conditions and ambient noise.

Sound-Deadening Blankets Think of the kind of blankets you get from a moving
company. Having a bunch of these (10–15) on hand or in a trunk can be lifesaving in
difficult situations. You can drape them or tape them to wherever you need to deaden
sound or knock down wind. They also work great as sun shields. You can fold and
stack them to rest cameras or other gear on. You can clip them to C-stands and build
makeshift changing rooms or dark rooms. They can protect gear from rain, snow,
dust, and hail. They work for padding when packing up gear.

Planning, Setting Up, and Recording a Shoot

This sound design time is essential to ending up with a good overall sound signature for
your film. The first thing you have to do is sit down and decide how you want your film to
sound. Will there be voice-over or narration? Will there be sound effects? Will you have to
go into the field and capture or create them? Will there be a music track? Will there be music
in the film?

Whatever you decide for your sound palette, write it all down. Find the spot in the
script where you need a doorbell and write it in. Go to where in the script you need a phone
to ring and write it in. Then, go to the last tab in your notebook and write "Sound Effects."
On that last page, start a list. Describe what you need. Write where in the script it belongs
and add other needed sound criteria. Here are a couple of examples:

"BELL CHIME, DING-DONG STYLE OF DOOR BELL, 3 DING DONGS,"
page 6, scene 1; doorbell sounds from far away down a hall
"OLD-FASHIONED BELL RING, PHONE 5 RINGS," page 8, scene 2; phone is in
the room and on the wall

Do not forget to pay attention to sound placement; sound placement dictates microphone placement. If the phone is on the right side of the screen, pan the sound a little to the right when mixing. Don't overdo this and pan the sound all the way to the right unless you are trying for a weird effect. In the real world, both ears hear the sound; it is just that one ear hears it first and a little louder. Our brains are extremely good at hearing and interpreting those subtle differences. Using this trick when placing your sounds will add great realism to your sound track.

Planning for Dialogue

There are a couple of things to keep in mind when capturing dialogue. The voice of an average adult male speaking usually falls in the fundamental (think notes on a piano) frequency range of 80 Hz to 150 Hz, with 80 Hz representing the lowest frequency of a well-trained bass singer. The average fundamental frequency range of females speaking is from 155 Hz to 265 Hz, although sopranos can sing as high as 1170 Hz.

Knowing where in the frequency range voices fall is critical when recording and mixing. For instance, a lot of very problematical noise comes from frequencies below 60 Hz to 80 Hz, such as heating, ventilating, and air conditioning (HVAC), wind rumble, and trucks, to name just a few. Many microphones come with a bass roll-off or rumble filter built in. When switched on, these filters cut down the microphone's ability to hear those lowest frequencies. Depending on the microphone, these cutoff switches might be at 40 Hz, 80 Hz, 100 Hz, or higher. (Some microphones will give you multiple frequency choices.)

A good rule is to start with the lowest cutoff and see whether that eliminates the problem. The human voice does not go much below 80 Hz, so if the microphone is set to roll off at 60 or 80, you are not going to be missing many of the fundamental frequencies of the voice, but you might be eliminating a lot of low hum, buzz, or rumble. Power is another source of 50/60 Hz hum that can easily be picked up through improperly grounded wires and audio setups.

Two Sample Setups

Go to where you will be shooting. If possible, go at the same time of the day you will be shooting to better match the filming conditions.

We will be using the following scenarios as examples:

- A kitchen with three people, two at a table and one cooking
- A car ride on the freeway with two people, both in the front seat

Go to the kitchen or the set where you will be building a kitchen, sit down, shut your eyes, and, just like in our earlier example, listen carefully. What do you hear? What can you hear that could be a problem? HVAC? Refrigerator compressor? Fluorescent light fixture buzz? Outside traffic? Might there be people walking around upstairs or downstairs? Are there many reflective surfaces that can create funny echoes? Hard floors or carpet? Try to think of everything that can interfere with the quiet recording of sound, and try to eliminate them. Can you unplug the refrigerator, shut off the HVAC, turn off the buzzing lights, or hang blankets to deaden echo? If you have hard floors, consider having the talent and the crew take off their shoes and walk in socks.

For this scenario, if you are shooting mostly close-ups, you could be recording two tracks of audio. You would use one boom microphone to cover the table dialogue and, at the same time, one omni microphone in the air to capture the ambient action. You would try to shoot the entire dialogue that happens between the actors at the table first. Set the boom

between, above, and slightly in front of the actors. Then, all you have to do is simply rotate the microphone back and forth as the actors exchange lines. Only after you have all the interplay between the two actors at the table should you move the boom microphone and film the lines of the actor who is cooking. Remember to match the actor's situation with the voice. Visual close-ups sound right if you are using close micing; is the cooking actor in the background and farther away? Consider using the omni room mic to capture his dialogue. He will look farther away, so you will want it to sound like he is a bit farther from the camera. Is there something cooking on the stove or grill? Consider recording separate tracks of whatever extra sounds the scene calls for: sizzling steak, boiling water, or a toaster popping up at a later time. This keeps your dialogue tracks as quiet as possible.

> You should always have your script in front of you as you are working to help cue when to turn the microphones as the actors speak.

By the way, this blueprint is just a suggestion. There are as many different ways to record a scene as there are recording engineers. For example, let's say you know you are going to be using mostly wide shots that show all three actors and a lot of kitchen. In that case, you would use three lavalieres for the actors and one omnidirectional microphone hidden behind the ceiling light for more ambient-sounding dialogue. Remember, if you are going to go this route, you would need to have equipment capable of recording four separate audio tracks at the same time.

OK, let's look at the car scenario. Automobile scenes are very hard to capture. Cars are really noisy, and it is all the worst kind of noise: low road rumble, traffic, engine sounds, wind . . . yuck. If you have a great budget, get a flat car trailer and shoot the scene while towing the car. That eliminates a ton of problems. If you get a big enough trailer, your camera crew can also be riding the trailer and shooting the scene.

> Remember: safety, safety, safety! You don't want anybody getting hurt.

Pull off the door panels and stuff them full of soundproofing. Hang towels from the windows. Get the car tuned and check the muffler. Car ignitions can wreak havoc with sound and electronics, so check that ahead of time. We like to suspend two lavalieres from the sun visors just out of frame. Hanging them from their wires helps isolate them from car noise.

There are other good options:

- Does the car have to be moving? As we mentioned, if there's no movement, there's *way* less noise.
- Can you green-screen the ride?
- Can the dialogue happen before or after the car moves?

Recording a Shoot

The main thing to remember is that you always want to record sound in the cleanest, quietest, and most natural-sounding way possible. Although there are amazing tools available to fix sound problems, you really don't want to spend your life trying to "fix it in the mix."

- The sounds should be "dry" and without any kind of reverb or effect. If you need to add something to the sound to make it a better fit for your movie, do so while editing in post-production.

- In almost every case, the more tracks you can record, the better. Different microphones and different sound sources give you greater flexibility when editing.
- If you can, record trial dialogue at the location you will be using so you can hear what it is going to sound like. Make adjustments, record it again, and don't be afraid to experiment.

Managing Sound on Set

Record keeping is a big key to success! Plan the system for audio notes, and make sure that each scene number, take number, actors involved, tracks, and audio notes on the quality of the takes are written down. It is often better to rely on handwriting the notes and then transferring them to a digital format because laptops or other devices can get unwieldy on set. The sound notes and files must be cross-referenced with the script and scene numbers, and takes must be easily identifiable with each sound take. Discuss what scenes are planned for the day with the key crew members, especially the script supervisor. At the beginning of each scene, double-check the numbering to make sure everything is matched.

In modern filmmaking, when directors have a good take, they look to the camera operator to make sure that there were no technical issues and then turn to the sound operator to make sure there were no issues with the sound. This is the time to bring up any audio problems that you hear and make adjustments. Take notes about what adjustments were made or problems that will have to be dealt with in post. After the shoot, keep all backups of audio until all the post-production is completed.

Slating Each Take

We talked in Chapter 1, "Fundamentals of DSLR Filmmaking," about the need to slate each take (whether with a clapboard like the one in Figure 7.16 or simply by clapping your hands) and then use the audio peaks to sync the camera/reference audio with the external sound. In Chapter 12, "Color Correction and Grading," we explain how to use the software plug-in PluralEyes to do this syncing.

Recording Room Tone

Whenever you are filming, take three to five minutes to capture the ambient sound of the area you are filming. This audio clip should have no speech or defining sounds. This is known as *room tone*. If you want professional sound, get room tone. This trick will save you hours in editing and tons of frustration. Let's say you have to overdub voices because one of the actors had a head cold and his dialogue sounded like he was stuffed up. You can record those voices later in any quiet environment, put a track of the original site room tone underneath it, and *ta-da*! It sounds like the actors recorded that dialogue on the

Figure 7.16: A digital slate

original site. Having a few minutes of room tone will allow you to do all kinds of sneaky editing tricks that will help make your sound real and seamless and can sometimes save you from disaster. Don't forget; if you go to a different spot to shoot the next scene, you'll need new room tone.

Setting Sound Levels

With your camera and light, too much or not enough can ruin the picture; sound is the same. Too high a level, and the sound will be distorted. Too low a level, and when you have to turn it way up to hear it, you will also be turning up the noise you captured, and all you will hear is hiss.

Look carefully at the four examples in Figure 7.17, Figure 7.18, Figure 7.19, and Figure 7.20. These are exactly the same sound source recorded at different levels. See how the graphic shows dips and spikes? Think soft and loud. The smaller the dips, the softer the sound. See that jump right at the end? This is called an audio peak. It is the loudest part of this clip.

Take notice of the example marked "too high a level" (Figure 7.20). See how the peaks of the sound seem to be chopped off at the top and the bottom of the graphic? This is an example of *clipping*, which is very undesirable. You are losing a critical part of the sound when this occurs. Think of this just like filming with way too much light. The picture is blown out, and a huge amount of detail is lost.

Conversely, when you look at the example marked "too low a level" (Figure 7.17), you can see that while you are capturing the sound, there is definitely room to increase the level and thereby increase the amount of detail you are capturing. Again, think of filming in no or low light. You are seeing the picture, but the detail is hard to make out because it is so dark.

Figure 7.17: Sound wave file with too low a level: low audio signal

Figure 7.18: Sound wave file with a good audio signal

Figure 7.19: Sound wave file with a perfect audio signal

The other two examples show what it should look like when you are capturing good levels. If you are an amateur or working on your own, you should try to match the graphic titled "good audio signal" (Figure 7.18). If you are skilled or have someone who can monitor the levels as you go, you should try to match more closely to the graphic titled "perfect

audio signal" (Figure 7.19). Remember, you do not want to clip the levels. You should always try to get your audio to peak between −12 and −6 dB to make sure you have a strong signal and don't lose data to clipping.

Figure 7.20: Sound wave file with too high a level: clipped audio signal

Avoiding Clipped Audio

If your audio signal is too strong for your capture device, then the high end of the audio you are capturing will simply peak out and essentially be clipped. It is important to monitor your audio to adjust for this and make sure to adjust your signal strength so that your signal is being captured between −12 dB and 0 dB so as not to be clipped.

Conversely, if you don't raise the audio input so the loudest levels are at least −12 dB, your audio might be too faint to hear and leave you with unusable audio. Using this manual audio setting is great to help get clear audio that has the normal high and low range of natural speech that you would hear naturally in a scene—unlike an auto gain where the lows are automatically raised to the high tones and the high tones are lowered toward the low tones. This results in ambient noise bleeding into your dialogue and the range of your audio being compressed.

You can also set your camera to disable the audio recording. This will save you a little in terms of the size of your files but not enough to recommend this option. Unless you are shooting a silent film, it is critical to have a reference audio track to work from.

Magic Lantern

If you are bemoaning the lack of features on your camera, there are unauthorized firmware extensions that you can look into. Obviously, when using an unauthorized firmware extension, you are taking on risks that will not be covered by your manufacturer. However, even if you don't use these hacks, you should be aware of their existence and decide on your comfort level in case someone on set brings up the idea of using one.

One of the most popular firmware extensions is Magic Lantern. Magic Lantern runs on an open framework and is designed to run alongside any firmware that is already in use. This extension adds various features to supported cameras. Some features are on-screen audio meters, zebra stripes, crop marks, and various audio and focus features.

Ultimately, you will need to make your own decisions on using unofficial firmware extensions. To learn more about these firmware extensions, you will need to do some searching. To get started, you can check out the Magic Lantern details here:

```
http://magiclantern.wikia.com/wiki/Magic_Lantern_Firmware_Wiki
```

eight

Organizing and Storing Data in the Field

You are a filmmaker and shouldn't

need to concern yourself with data storage and data management, right? In the current state of production, there is a good chance that those tasks will fall to you, or it will at least be your task to find someone to do that job for you. Don't take this task too lightly. The entire success of your production may depend on it. As productions are shrinking in overall crew size and more and more tasks are falling to fewer and fewer people, it is often easy to miss things because you will be juggling a lot. With a little forethought and planning, you will save tons of time and headaches later in post-production.

Setting Up a File System

File management has become more complicated since we left the world of film and video tapes. In those days, it was easy to refer to the capture medium and find takes or footage. On film you always could refer to the film frame numbers or reel number, and on video tape you could refer to the tape name or the time code value. Unlike the days of shooting tape or film, you cannot just label a tape or a roll of film and set it aside for later. Your capture medium consists of digital files and folders upon folders of these files. If you are not careful, you can lose, overwrite, or erase your footage in an instant.

Now that filmmakers work in the wonderful world of tapeless workflows, it is important to create an organizational system in order to locate footage easily and quickly.

If you are shooting a short film or a smaller project, file management is a lot easier. When working on a feature or long-format project, things are much more complex, and it is easy to get overwhelmed quickly. There will be dozens or hundreds of hours of footage, thousands or tens of thousands of movie files, multiple cameras, and dozens of capture

cards to keep track of. To help track these details, you must have a coherent naming system for all the moving parts in this workflow.

First Things First: Planning Your Project

One step in the planning process that is often overlooked is the digital asset management of files on location. Once shooting is under way, it is hard or even impossible to change your management system without causing a lot of headaches.

Think about the details of the project you are working on, how long the shoot will be, how many cameras and cards you will be using, and what sort of audio files (if any) you will need to pair up with your video files.

Refer to Chapter 10, "Converting and Editing Your Footage," for more information about hard drives.

Labeling Equipment

To implement a coherent naming system for all your files in your workflow, label each camera for the shoot with a number. The easiest way to do this is to put a small piece of tape directly on the camera (Figure 8.1). Shurtape white gaffer's tape is ideal, but masking tape will work just fine. Using tape also allows you to easily and quickly relabel your cards. Just make sure the tape you are using is not thick and is applied flat. If the tape bunches or is too thick, it can get caught when putting the card into the camera.

Figure 8.1: This is camera B from a multiple-camera shoot.

Second, take all the cards you will be using during the shoot and label them with letters, as shown in Figure 8.2. This is key to being able to track what footage came from what camera, and if you have any issues with either a camera or a card, you can easily track down which one is the problem and remove it from the workflow.

Figure 8.2: Label each card you will use on your shoot.

Regardless of what camera system you are using, the end result will be a lot of video files with strange numeric names. Most of the major camera manufacturers add a three-letter prefix and a four-digit number to each file. This is great if you are using a single camera or are shooting fewer than 9,999 shots in your production.

If you are shooting with multiple cameras, there is a good chance you will end up with different files that have the same name. If you are not careful, you might overwrite or delete what you think are duplicate files by mistake.

In the days of shooting 35 mm motion picture film there was a production assistant (PA) dedicated to running exposed film back and forth to the lab. That meant someone was always in charge of making sure there wasn't any missing film. Furthermore, if you were ever shooting in a location with no lab, the PA would hop on a plane and carry the film from the set to the lab. Nothing was left to chance.

I am finding more and more these days that people copy files onto a drive and think they are covered. I caution you not to fall into that trap. Digital files are fragile, and the files themselves and/or the devices that store those files can go bad in an instant.

Think of it as magic—now you see the file and now you don't. I demand on all my sets that footage be backed up to a minimum of two hard drives before any card is cleared. If the media isn't backed up to two drives, then the original capture card does not get cleared until the main storage drive on set is backed up at night back in the hotel room or studio.

If you don't plan accordingly, you may run out of capture media if you follow this rule. I can't tell you how many sets I have been on that spend $100,000–$500,000 on the shoot and rely on one hard drive to keep everything safe. I have given my personal drive to the person backing up footage on some of those sets where I didn't have control and in one case saved the entire production when their drive failed. Had I not backed it up, they would have lost $350,000 in production costs that were not insured.

Even if your budget is small, treat it like you are burning money if you lose footage. Let's assume you own your camera and you aren't paying out any money on a short film you are shooting over the weekend. You have family and friends who will help you, and they aren't charging you a dime. This is great—you can shoot all day Saturday and Sunday and get what you need for free. How do you think they will respond if you didn't handle the footage properly and you have to tell them you need another weekend of their time for free because you lost footage? My guess is they won't be very pleased. Time in many ways is worth more than money. So whether it is time or money or both you are playing with, make sure to guard your footage with your life.

If you want to do some more fancy data management starting in the camera, here are some cheats that will help you get organized from the very start. If the following sections are a bit too much for what you want to do, you can skip ahead to "Transferring Files from Capture Media to Hard Drive" and continue reading from there.

Manually Setting File Numbering

Once you've labeled your cards and cameras, set up the file-numbering system on your camera so that you can stay organized. This differs from labeling your camera and cards because this deals directly with the labeling of the footage on the cards and when you move the files to a hard drive. The following sections explain how to set up file numbering manually within Canon and Nikon cameras.

Canon

Many Canon cameras number their files `MVI_XXXX.mov` for videos and `IMG_XXXX.jpg` or `IMG_XXXX.CR2` for images. In these models there is no way within the cameras to manually set what number you want to start the movie files at. The biggest problem with this is that if you are using multiple cameras, there is a very good chance that you will end up with movie files with identical names that are in fact different takes from different scenes. If your digital media person on set isn't careful, this is where you can lose a ton of your footage really quickly, and it will be lost for good.

Some newer Canon cameras allow you to either name the files as you want or default to different default naming conventions. Don't let a different naming convention throw you off; you can still follow the steps listed here.

There is a workaround for this numbering issue even though it is not perfect. You still may end up with duplicate numbered files, but it will cut down dramatically on potential duplications and help you get organized for post.

Take one of your cameras and a card that you want to use with that camera, and follow these steps to set up a new numbering system for your video files:

1. Insert the card into your camera.
2. Go to Set-Up Menu 1 ➤ File Numbering ➤ Auto Reset, as shown in Figure 8.3. (Set-Up Menu 1 is the first yellow square that looks like a wrench with one small square.)

Figure 8.3: Select Auto Reset in the menu.

3. Take a picture or a quick video on the card, as shown in Figure 8.4, and confirm that it is present on the card.

Figure 8.4: Confirm that you have a picture or video on the card.

4. Remove the card, and insert it into your card reader on the computer.

5. Rename the IMG or MVI file to the number you want to start with for that camera (in other words, **MVI_3000**, as shown in Figure 8.5), and then remove the card. You must adhere to the numbering convention of the DSLR—in this case, a four-digit file number.

Figure 8.5: Rename the photo or video file.

6. Insert the card back into the camera, and take another picture or movie clip.
7. Verify that the new file incremented from the file you had on the card (that is, the new clip would be MVI_3001, as in Figure 8.6).

Figure 8.6: Confirm that the new image or video is incrementing properly.

8. Delete the image or movie test file in the camera or from the computer, and you are set.

The camera will now increment with this number unless you insert another card with a different numbering sequence or you choose to reset the autonumbering from the camera menu.

Go through this for each camera you will use for shooting. If you have numbered each camera, then set the four-digit number to match that camera's number. For example, camera 1 would read `MVI_1000`, camera 2 would read `MVI_2000`, and so on.

Once you have formatted each camera and the card, it will continue to number in sequence unless you reset the numbering in the menu.

Naming Your Files in the Camera

Some cameras such as the Canon 5D Mark III and the Canon 1DC allow you to enter any naming convention for your files. If your camera allows you to add your own prefix or use any naming convention you want, then you can skip the previous steps and just type in your own system.

Nikon

Nikon cameras number their files `DSC_XXXX.avi` for video and `DSC_XXXX.jpg` and `DSC_XXXX.NEF` for images as the default naming/numbering convention. In the menu settings, Nikon allows you to custom set the first three letters of the files but not the numbers. You can choose to set the first three letters either as your scene number or as any letters you assign to your scene. If you choose to set the prefix as your scene number, then you need to make sure to change the numbering to the new scene number when you move to a new scene. The benefits here are that you won't have duplicate file numbers and that you don't need to set up the file numbers on your computer.

Normally it doesn't matter which card goes into which camera, but for this workflow you need to assign cards to a camera. The reason for this is the settings you set up in the camera are written to a card and stored on the card. If you format a card on your camera 1 and insert it into camera 2, the numbering will continue the numbering sequence from camera 1, not from camera 2. Make sure your camera operator and digital media manager on the set know which cards are for which camera so you don't accidentally move the card to another camera before reformatting the card. If you need or want to use the card in camera B after using it in camera A, it just needs to be reformatted in camera B and set to the next number in your numbering sequence for that camera.

Setting Up Separate Folders in the Camera

Having all your movie files numbered in sequence can make it difficult to separate all the video files for a given scene you are shooting. If you don't have the time to copy all the files from your compact flash (CF) card before you move on to a new scene, you can set up a new folder on your card to hold the new video files. This way, you can separate the video files from one scene to another in the camera as opposed to at the end of the day or the shoot when you have more files to deal with.

You set up your card number the same way we talked about on each camera and start shooting your first scene. When you move to the next scene, you need to follow the instructions in the next sections, depending on what kind of camera you have.

Canon

To set up separate folders on your Canon camera, follow these steps:

1. Go to Set-Up Menu 1 (the first yellow square), and choose Select Folder. Press the Set button to select (Figure 8.7).
2. Scroll down to Create Folder. Press the Set button to select (Figure 8.8).

Figure 8.7: Choose Select Folder from the menu.

Figure 8.8: Select Create Folder from the menu.

3. The camera will ask you whether you want to create folder 101. It numbers sequentially, so you have no manual control over the number unless you change the number on the card from your computer. Select OK.

4. Select the folder you want to start capturing your videos to (Figure 8.9), and press Set.

Figure 8.9: Select the newly created folder from the menu.

Nikon

To set up separate folders on your Nikon camera, follow these steps:

1. Go to the menu and select Shooting Menu ➤ Active Folder (Figure 8.10).

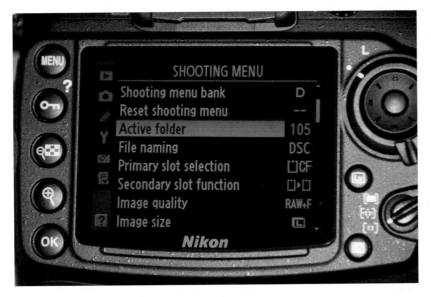

Figure 8.10: Select Active Folder from the menu.

2. Select Active Folder ➤ New Folder Number (Figure 8.11).

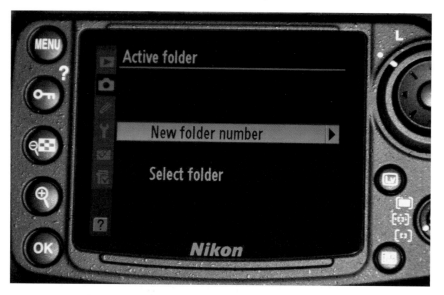

Figure 8.11: Select New Folder Number from the menu.

3. Select the folder number you want (Figure 8.12). Press OK.

Figure 8.12: Select the folder number you want to create.

4. To select one of your folders, go to Shooting Menu ➢ Active Folder ➢ Select Folder.
5. Scroll up or down, select the folder of your choice (Figure 8.13), and click OK.

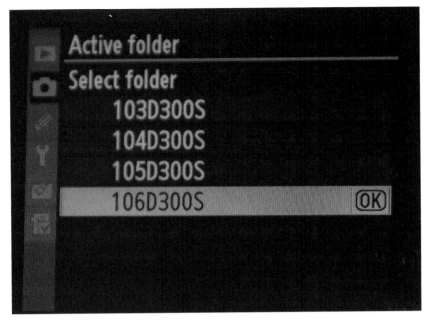

Figure 8.13: Choose your newly created active folder from the menu.

Using the Camera's Clock as a Timestamp

Set the clocks on your camera accurately before you begin shooting. If you make sure to do this, you have another safety net for finding your footage. You can sort for the timestamp on the files and find the footage that was shot from different angles on the same day. You should not do this *instead* of the numbering convention but as an added search function for post.

Understanding Current Types of Capture Media

As the number of cameras you have available to shoot with grows, so does the universe of capture media you have to choose from. Here are the leading ones you need to be aware of and prepare that you will likely be using at some point in the near future if you do not currently use them in your existing workflow.

SD Cards

Many leading cameras either exclusively use or have a slot that allows you to use Secure Digital (SD) cards (Figure 8.14). These have been around since almost the beginning of digital still cameras and many home video HD camcorders. They are the most abundant and most readily available capture media in the world.

Figure 8.14: SanDisk Extreme Pro SD cards

What you need to be aware of as the landscape continues to evolve is the storage capacity of the card as well as the rates at which it can write data to the card.

CF Cards

CF cards (Figure 8.15) are another popular capture media for a variety of cameras. Everything from the Canon 5D Mark II and Mark III to the C300 and others has the ability to capture to CF cards (and/or SD cards at the same time).

Note that you have to pay attention to the read/write speeds of the cards. If you have an older camera and have been using CF cards, your current cards may not be fast enough to use in newer cameras with higher bit rates and faster write speeds. Some people make the mistake of saying "it fits" and think they are OK. Check the speed requirements for your camera and make sure the cards you buy (or have on hand) will work. You can always use newer, faster cards in older cameras but it doesn't work the other way around. If you are shooting stills, the speed of the cards is less important than when you shoot video. It is critical for your cards to have high sustained data-transfer rates when shooting HD video.

Figure 8.15: SanDisk Extreme Pro UDMA 7 CF card

SSD Drives

Many filmmakers may not be familiar with this new capture medium. SSD drives are like mini portable hard drives (Figure 8.16). They are solid-state drives, so they don't have moving parts like a traditional hard drive. What is interesting about the use of an SSD drive is the huge capacity you can achieve. Unlike SD and CF cards, which at the top end usually don't go above 128 GB, you can get SSD drives starting at 250 GB and going to 1 TB or more. You can think of SSD cards as huge memory cards that have the capacity of a hard drive.

Up until this point all capture media have been more or less internal to the camera you are using. One of the more recent developments has come in the use of external recorders. The Atomos devices are my new favorite production tools (Figure 8.17). They can double as an external monitor as well as capture higher-quality footage than if I recorded directly into the camera.

For instance, any camera with a clean HDMI or SDI output can be captured to an external device. Clean output means that your camera can output the signal from your camera without any of the display overlays, so the image you record in the external device is clean from any words, logos, or overlays. You will need to check your camera of choice because it is a mixed bag as to which cameras and which manufacturers allow clean output signals. When you capture internally into your camera, you are limited by the chip speed and the processing power of your camera. That means higher compression and lower data rates can be captured inside the camera.

Figure 8.16: The Blackmagic Cinema Camera has an SSD slot for its capture media.

Figure 8.17: Atomos Ninja 2 external recorder on a Canon 5D Mark III

When I am shooting with my Canon 5D Mark III, I can use the Atomos Ninja Blade to capture high-quality ProRes clips instead of using my H.264 files internally from the camera. All the files are captured to an SSD drive.

Transferring Files from Capture Media to Hard Drive

For your SD and CF cards you need to find a good card reader you can use to transfer the files to your hard drive. Currently a USB 3.0 card reader is probably your best bet.

In a pinch you can connect your camera directly to your computer (Figure 8.18) and transfer files from the camera to your hard drive. I typically don't like to tie up the camera for this amount of time, so I recommend where possible to stick to a good card reader. If you choose to connect your camera to your laptop, make sure you have enough battery life in your camera to finish any transfers.

Transferring your SSD drives is not quite as simple. Outside of investing in SSD drives, you will need a dock or device of some sort to transfer the files to your hard drive for editing. So for many people, working with SSD drives means you must have another set of equipment to make everything work together.

Figure 8.18: Canon 5D Mark III connected directly to the computer via a USB cable

Figure 8.19: You can use an adapter cable to directly connect an SSD drive to your computer.

Figure 8.20: SSD empty enclosure case ready to put your SDD card into

You can use a couple of different methods to transfer files from your SSD drives. First, you can use an adapter cable to connect your SSD drive to the computer (currently USB 3.0), as shown in Figure 8.19. This is a good option because of the small size. It is easy to travel with and have on standby.

Another option is to obtain an external enclosure (Figure 8.20). If you go this route, then you can leave it connected to your computer and just slide the SSD drive into the enclosure when you need it. This is a little cumbersome but it does work.

The best method, in my opinion, is to use a dock connector (Figure 8.21). This allows you to connect SSD drives, 3.5″ external drives, and other devices to your computer. This does stay attached to your computer; you just slip in your SSD drive and you are ready to transfer files. One reason I like this is it that it gives you an option to connect more than one drive into the same device, so it multi-purposes your purchase.

Once you have the labeling and workflow set up in the camera, the second part of field management is transferring your footage from your card to a hard drive. The key is to start with a system that makes sense and will allow you to track and find footage long after you leave the set.

How Much Drive Space Will You Need?

It is hard to estimate exactly how much hard drive space you will need in advance of shooting. The actual file size for each video can vary based on what camera you are using, the resolution you are recording the video at, the frame rate you are using, the picture style settings used, and whether you are shooting for slow motion. Because of the numerous variables and the fact that the camera manufacturers generally don't publish the data rate their video files are recorded at (or it's very difficult to find), there is no chart you can use as reference.

Figure 8.21: Newer Technology dock that allows you to insert both SSD drives and 3.5" hard drives into the same dock

Downloading and Viewing Movie Files from a CF or SD Card

In case you're just beginning to shoot video, here are the steps to download movie files and view them on your computer:

1. Remove the card from the camera and place it into your card reader.
2. Open the card folder on your computer. Navigate to the folder named DCIM and then to the camera folder.

	DCIM	
◀ ▶	⊞ ≣ ▥ ▥▮ ◉ ✿▾ ♻▾	Q
▼ DEVICES	📁 DCIM ▸	📁 103D300S ▸
💾 Barry	📁 MISC ▸	📁 108ND300 ▸
💾 iDisk	▪ NIKON001.DSC	
👁 Barry_Backup ⏏		
💾 NIKON D300 ⏏		
▼ PLACES		
🖥 Desktop		
🏠 barryanderson		
📁 Applications		
📄 Documents		
🔵 Downloads		
🖼 Pictures		
🎬 Movies		
🎵 Music		
📦 Dropbox		
📁 DATA		
▶ SEARCH FOR		
	2 items, 6.23 GB available	

3. Copy this folder to your backup drive.
4. When the card has fully copied to your backup drive, open a few of the video files to make sure they are all working fine.
5. Repeat steps 3 and 4 with a second backup drive.
6. Delete the card.
7. Remove the card and place it in the camera.

With that said, we can help you estimate pretty accurately how much hard drive space you will need. Take the camera you have chosen to shoot your project with and shoot 5 to 10 test shots that are exactly 5 or 10 minutes in length. When you have completed that, copy

those files onto your computer and view the file sizes. You now have all the data you need to estimate your hard drive space requirements. Add together the file sizes of your sample clips and divide by the number of clips. This will give you the average file size for the length of time of your test clips.

Now you can figure out the amount of hard drive space needed for your shoot. Determine the average file size per minute from your test clips. Then estimate the number of minutes you will be shooting per day. Multiply that by the number of cameras you are using and by the total number of days you plan to shoot. This will get you a pretty good estimate of how large a hard drive you will need.

If you are shooting in a studio or near civilization, then you can always run out and get more drives. If you are shooting on location or in a remote area, then you need to be much more careful about having enough hard drive space, because you don't have the option of running down to your local computer store. Buy more drive space than you calculate you need if you will be shooting remotely. If you run out of drive space, it is just like running out of film or tape. Your production will shut down until you get more drive space in set.

How Do You Keep Your Labeling Straight?

You went through the process of labeling your camera and cards and setting up your file numbering. When you copy from your CF card to your hard drive, you want to make sure the labeling carries through to your computer. First, set up folders for the days you will be shooting (for example, *YYMMDD*) so that you can quickly find footage from any particular day of your shoot.

Using the *YYMMDD* naming convention guarantees that you will never have a duplicate date and that your files will always be in order from the oldest footage you shot to the newest.

Next, set up a folder on your hard drive for each camera (for example, C1) and, within that folder, a subfolder for each card that was used or will be used by that camera (for example, C1A, C3B). Then when the camera department sends a card to be copied, you can put the labeled card into the labeled folder from the labeled camera. This may sound a bit confusing, but try doing this while you are testing before you go out on the set. In addition, make sure the system is clear to the camera department and the data manager for the shoot.

Understanding Different Capture Formats

Let's quickly cover the capture formats for the various DSLR cameras currently on the market:

- Nikon's DSLR cameras use Motion JPEG AVI files as the capture format for video.
- Panasonic DSLR cameras use AVCHD as the capture format for video.
- Canon DSLR cameras, on the other hand, have embraced video recording in H.264 movie files.
- Sony cameras record in XAVC or AVCHD formats.

All the major NLE editors can handle any video files coming from any of the leading camera manufacturers. If you buy a brand-new camera two years from now, you might run into an issue, but with the growing impact of DSLR cameras on the market, it is unlikely that you will see issues with capture formats not working with editing programs in the future.

Delivery Format vs. Capture Format

In general, *a capture format* is one you should use when you want the highest-resolution video signal (preferably uncompressed). Then you are starting with the best possible image, and you have more latitude in making color corrections and adjustments to the footage. In general, higher bit rates and high-resolution capture formats are much too large to burn onto a DVD or stream on the Web.

A *delivery format* is a compressed video format that provides for the best preservation of the original footage's quality at the lowest bit rates and file size. This allows for easier streaming and the ability to be burned to DVDs and other storage devices.

Backing Up Your Footage on Set

As soon as a card or SSD drive is removed from the camera and handed to the person handling the media management, it must be treated like exposed film. If it gets damaged or lost, you are out of luck. The card should be backed up no less than two times prior to being cleared. If you have the footage on only one card or one hard drive, you are at major risk for losing your footage and having to reshoot or not finish your project.

Once the footage has been backed up two or more times, you are free to clear the card and send it back to the camera department. If you are low on time and people, you can skip clearing the card on the computer and have the camera department reformat the card in the camera. The only thing to note is that if there is any video or picture on the card when it is first put in the camera, then the camera will continue numbering from that number even if you format the card before you shoot the next scene. To be safe, clear the card before sending it back to the camera department, or have the camera team clear the card and set up the numbering again to make sure it continues in sequence.

The hard drives you are using are obviously essential to data management and must be protected (Figure 8.22). Most of the time, however, hard drives are thrown about with reckless abandon. Clearly you don't want your hard drives to fall or suffer any sort of impact or encounter heat or water damage. This means that on set your hard drives should have a weatherproof carrying case and should be stored in a climate-controlled environment.

Figure 8.22: Real-life example of how not to handle the hard drives that carry your footage

Hard drives can be damaged by pulling the plug or turning off the drive incorrectly. Unplugging a hard drive without properly shutting it down or ejecting it can also lead to data loss, so develop a system that includes a shutdown procedure.

Static electricity can also damage your hard drive. As you swap or touch hard drives, make sure you discharge any electric charge prior to touching the hard drive, and if you are in a static-prone environment, use an antistatic mat.

Organizing Data on Set

Here is what you will need to have on set for your data management and storage:

- Multiple CF cards or SSD drives to make sure you can rotate cards/drives into your system and have enough on hand to be backing up and shooting at the same time without waiting
- An SD/CF card reader or SDD dock so you can transfer the footage onto a hard drive in the field
- Tape and a Sharpie pen for labeling cards, hard drives, and many other unforeseen things
- Notepad and pen/pencil for taking notes and keeping track of footage, drives, cards, takes, script notes, and who knows what else
- Laptop for viewing the footage and using it as the hub for all data transfers and logging
- Minimum of two hard drives so you can always have two backups of all your footage before the capture media get cleared and sent back into production

We'll talk more about backups in Chapter 10.

Managing Files on the Set

Normally when shooting film or tape, you can track and find your footage easily by the roll or tape number, your slate, and your script notes. But DSLR filmmaking is a tapeless work-flow with no time code or standardized numbering system.

While we were shooting *The Shamus*, ideally we would have loved to slate as a reference for every scene and take, not to mention how this would help sync audio in post. But because we were shooting in Italy without permits, we had to keep a low profile. We knew we would be kicked out of many of the areas we were shooting if we tried to slate the takes. For us, the data management of the files was critical because if we messed up, we would more or less have to watch each shot of our thousands of takes to label what scene, take, and location we were at.

We did this by following our system of a folder with the date, a folder with the labeled camera, and a subfolder of the labeled card. This way, we were able to take our shooting schedule and match what footage was in which folder and find it quickly and sync in post without any formal slate or script notes to follow. We are aware that this is not an ideal way to run a shoot, but since many people are using the cameras to shoot in locations they could not before, this is a critical step to master to save you time and stress.

Arranging Your Footage

Now that you have your footage on several drives with dozens or hundreds of folders with thousands or even tens of thousands of clips, you will want to find a way to organize and tag all of the footage.

It's not a matter of *whether* someone will have to copy and back up files on the set but a question of how much time they will have to do the copying and backing up. We recommend having a full-time person on set to do your data management. If you don't have the budget or personnel, then be prepared for some late nights. The better you can organize and label on set, the less work you will have to do prior to getting started editing. Then you will be thankful you were so organized on set or fixed any problems with labeling footage.

The file structure that works really well is setting up a folder for each day of your shoot, as shown in Figure 8.23. Within that folder you can put a folder from each camera you used that day. In each of those folders, you can put folders from each card that each camera used. This way, you have a record of what was shot on what day, and if there is trouble with a camera or a data card, then it is easy to track down what was shot on the troubled camera or the bad card.

Figure 8.23: Example of file structure from a two-camera shoot

You should also have a folder each day for your audio files, as shown in Figure 8.24. This will cut down on searching for audio clips later, and if you have any trouble with automating the syncing of your audio, then you can work day by day and not get lost in what you have done and what still needs to be worked on.

You will be using your script notes, actual shot list, and audio notes to double-check your files, match scene numbers with files, and find any missing or unlabeled files.

Figure 8.24: File structure of the H4n Zoom audio files from The Shamus

nine

Troubleshooting

Having to troubleshoot unexpected

problems is not unique to DSLR cameras, but the specific problems and tips in this chapter are unique to these cameras. Before you go out and shoot, make sure to read this chapter and make a cheat sheet for the known problems with these cameras. Be aware of the limitations so when you create the type of shot you want, you don't create one that the camera cannot capture for you. There are problems and limitations, but they're nothing that you can't work around. Knowledge is power in this sense, and the more you know, the more you can craft the way you shoot your film so you can be successful.

Avoiding Problems: What to Do, What to Take

In this section, we give you a few ways to avoid problems in the first place, by having the right gear along or by planning ahead.

Emergency Items

These are some "make the shot work or die" items for your kit:

Zoom Lens Shooting with prime lenses is the most common choice for most feature films. However, in tight spots with limited time, having a zoom lens that you can snap into framing and hit Record is priceless.

Variable ND Filter If you are shooting outside in a sunlight/shade mixture, then moving back and forth between different ND filters can really slow down the shoot. If you have a variable ND filter (Figure 9.1), you can just dial into the proper ND amount and hit Record.

Figure 9.1: Tiffen variable neutral density filter

Tripod or Camera Support Stand-ins Tripods are an essential part of production. However, since DSLR cameras are small and light, part of the fun is using them in locations not possible with traditional tripods. Get your hands on a GorillaPod (Figure 9.2) or other support system that allows you to stay small but still have some control as to where you point the lens.

Figure 9.2: GorillaPod with a DSLR camera attached to a railing

Sandbag Don't want to buy a GorillaPod or other small support gear? You should have a sandbag (Figure 9.3) on set anyway. Throw the sandbag down and place your camera right on top. The sand is somewhat moldable, so you can finesse your camera into position without costing you a dime.

Pocket Level When you use a sandbag or other unusual support or mounting system, it is easy to end up not having a level shot. A lot of times you are unable to look directly through the camera if you have the camera rigged in a tight or abnormal location. A simple pocket level (Figure 9.4) can help make sure you haven't tilted your camera in a way you didn't want.

Figure 9.3: You can keep an empty sandbag in your travel case and fill it up with something upon arriving on location.

Car, Skateboard, or Cart Depending on your budget (or if you improvise a last-minute shot), you may not have access to a dolly or Steadicam. No worries—be creative and use a car, skateboard, or cart to help you get the moving shot you need.

Batteries Did we mention batteries? They're not just for the camera; you'll need batteries for any portable lights, remote starters, microphones, and so on. Make a list of all the types of batteries your various gear requires and bring extras.

Color-Correction Cards and White-Balance Cards Have a folder with a white card and color card (Figure 9.5) on standby. Whenever you set up at a new location, go ahead and shoot each card before your first take. You never know what might help in post.

Tape, Sharpie, and Plastic Zip Ties for Emergency Follow Focus Office supplies might seem out of place for the production crew, but on set you never know what will come in handy. Make a little kit with tape, Sharpie pens, zip ties, twist ties, clamps, paper clips, and Ziploc bags.

Black Duvetyne/Black Cloth Ambient light on your monitors sometimes can't be totally flagged or blocked. If you have some black Duvetyne, then you can throw it over the camera or monitor and see exactly what you are getting in the shot. Focus, color, and exposure are infinitely easier to achieve when you are not fighting ambient light on your monitors or LCD screen on the back of the camera.

Hardware Store Lights and/or Small Adjustable LED Light Panel Since DSLR cameras are so light sensitive, it never hurts to have some good old-fashioned flashlights, lanterns, and car spotlights in the trunk. You never know when a little splash of light will complete your scene. Battery-powered, portable, and small are key features (Figure 9.6).

Extension Cords That Work in All Weather Don't use old extension cords from around the house or that are frayed or kinked. Borrow, rent, or buy some high-quality, durable cords that are somewhat weather resistant.

Umbrellas and Plastic Bags News flash—meteorologists are not always right. Bring extra umbrellas for both the equipment and the crew. Also, don't just bring the small pocket umbrellas. If you have your camera on a tripod with a long lens, a tiny umbrella is of little use. Have at least one large umbrella for each camera you have on

Figure 9.4: Three-way bubble level you can place on your camera or camera support to check your horizon line

Figure 9.5: Color-correction and white-balance cards

Figure 9.6: Switronix TorchLED Bolt light

set. Size matters. Also, have a supply of garbage bags and rain covers you can drape over set pieces and equipment (Figure 9.7).

Figure 9.7: Petrol Bags rain cover for the C100

Fold-up Reflectors Sometimes all you need is a little bounce. Having a large foam core bounce card is sometimes impractical or unnecessary. Get a set (Figure 9.8) of fold-out reflectors (white, silver, and gold), and in seconds you can have a light, portable, and flexible reflector to help you get the perfect shot.

Black Wrap and Clamps When shooting with cameras that are so light sensitive, sometimes it is more about subtracting light than adding it. Using some black wrap (Figure 9.9) around a light can help you take away some light or light leakage from your scene. It's cheap and easy to use. Make sure it's part of your preproduction checklist.

Figure 9.9: Rosco Cinefoil black wrap—it's like aluminum foil but helps you control light spill.

Figure 9.8: Polaroid reflector/ bounce kit

White and Black Poster Boards Just as fold-out reflectors have their place, so do large white-and-black foam core boards. You can add these to help set up a large, soft bounce source or create a barrier to keep out light.

Dimmers and Low-Wattage Bulbs You would be surprised how bright a table lamp is if it has even a 13w/60w CFL/incandescent bulb in it. If it has a 27w/100w CFL/incandescent bulb, it is even worse. It is nice to have a box of low-wattage bulbs that you can change out in lamps, ceiling lights, and chandeliers to help you get the correct lighting for your scene. If you don't have low-watt bulbs or if your low-watt bulbs are still too bright, then having a cheap $10 dimmer (Figure 9.10) from Home Depot will save you. Have a couple on hand, and you can put all the incidental lights on a dimmer and in minutes have all the lights balanced and matched. Please note that only certain CFL bulbs can be dimmed so test them in advance to make sure.

Extenders and Extension Tubes If you have only a few lenses, then don't forget to get an extender and extension tubes. An extender can take your 100 mm lens and turn it into a 200 mm or 400 mm lens and help you get the long shot you didn't think you could get. Conversely, if you don't have a macro lens and need to get a close-up of someone writing a letter or the cursor on the computer screen, an extension tube will change your focal plane and make any available lens able to focus at a much shorter distance.

Print It Out Print a copy for yourself and a backup copy. Of what? Everything: the script, schedule, crew contact sheets, actor releases, and so on. With everyone having a laptop or portable device, sometimes you forget to have a printed copy you can hand to someone. If you run out of batteries and don't have a printed copy, then you are out of luck. Again, it's just another backup that you will be happy you have at least once during your shoot.

Coffee and Bribe Money Never underestimate the power of a cup of coffee or a few extra dollars in cash (Figure 9.11). You will without a doubt be thanking numerous crew members and people from whom you secured locations, props, or equipment. After a while, you might need a little extra help to finish a shot or ask someone to stay just a little longer. Always make sure to have fresh, good coffee (at all hours of the day) and an envelope with some cash. $20 to $50 might get you the resources you need at the last minute and help you finish your day.

Figure 9.10: Regular table-lamp dimmer from the local hardware store

Figure 9.11: Good old trusty greenbacks

iPhone/iPad Applications for Filmmaking

There are many great applications on your phone or tablet. Here are some super handy ones you might want to get before you start your shoot:

MatchLens This app helps match 5D and 7D with 35 mm motion-picture lens focal lengths.

http://itunes.apple.com/us/app/matchlens/id315223799?mt=8

pCAM This program gives you field of view and depth of field of all formats. It's absolutely essential in figuring out hyper focals as well as field of view for crane shots, long lens shots, and so on.

https://itunes.apple.com/us/app/pcam-film-+-digital-pro/id295456485?mt=8

Aspect Ratio Calc This calculates video aspect ratios and pixel ratios.

www.digitalrebellion.com/

http://itunes.apple.com/us/app/aspect-ratio-calc/id423170814?mt=8

Artemis Director's Viewfinder This app gives you a fast field of view with a live video feed that shows you a box that represents your field of view. Beware, this app has burned us with not being accurate with 7D, 5D, and 1D representations.

http://itunes.apple.com/us/app/artemis-directors-viewfinder/
id324917457?mt=8

The Weather Channel This indicates what weather you may be dealing with.

http://itunes.apple.com/app/the-weather-channel/id295646461?mt=8

Sun Seeker This sun-tracking program gives you the arc of the sun on your iPhone's camera. Very cool.

http://itunes.apple.com/us/app/sun-seeker-3d-augmented-reality/
id330247123?mt=8

Helios This sun-tracking app works very well and gives you the ability to find the location of the sun at any time and at any place on the planet.

http://itunes.apple.com/us/app/helios-sun-position-calculator/
id311648870?mt=8

Weather Bug Elite This app has given us the most accurate weather out on location that we have ever experienced. It keeps us in the loop with forecasts and alerts.

http://itunes.apple.com/us/app/weatherbug-elite/id310647896?mt=8

Pocket LD This is a very informative lighting program that offers photometrics and a wonderful selection of lights to choose from. Pocket LD is a photometric database and calculation tool for theatrical and TV/film lighting professionals.

http://itunes.apple.com/us/app/pocketld/id292911261?mt=8

Flashlight This is an emergency flashlight for on-set use and digging around gear bags.

http://appsfromouterspace.com/flashlight/

http://itunes.apple.com/us/app/flashlight/id285281827?mt=8

PhotoCalc This is a nice, general-purpose app with depth of field, sunrise/sunset, exposure calculations, and so on.

http://itunes.apple.com/us/app/photocalc/id287811118?mt=8

PhotoBuddy This is an easy-to-use and extensive all-purpose calculator for many useful things that relate to DSLR.

http://iphone.ambertation.de/photobuddy/

http://itunes.apple.com/us/app/photobuddy/id290785551?mt=8

Storyboard Composer This is a storyboard app to keep your ideas on track.

http://itunes.apple.com/us/app/storyboard-composer/id325697961?mt=8

http://www.cinemek.com/storyboard/

Power Load Calculator This is a mobile app and web app to keep track of your power load on circuits so you don't blow anything.

www.digitalrebellion.com/webapps/power_calc.html

Video Space Calculator This is a mobile app and web app that gauges how much space a video format will take up on a disc.

http://www.digitalrebellion.com/webapps/video_calc_mobile.html

pCAM Film + Digital Pro This one does it all, quickly and accurately. If you don't want to mess around with any other calculator or app, this is the one to get.

http://search.itunes.apple.com/WebObjects/MZContentLink.woa/wa/link?path=ap
ps%2fpCAMFilmDigitalCalculator

Cut Notes When you actually do get to time codes, you can use this app to take notes.

http://itunes.apple.com/us/app/cut-notes/id395617220?mt=8

www.digitalrebellion.com/cutnotes/

DSLR Slate Bring your slate with you, in your pocket.

http://itunes.apple.com/us/app/dslr-slate/id374241045?mt=8

MovieSlate This is an all-inclusive slate that provides a lot of features, including notes and logging capabilities.

http://itunes.apple.com/us/app/id320315888?mt=8

ProPrompter Use this when memorizing lines is a problem.

`http://itunes.apple.com/us/app/proprompter/id309792203?mt=8`

Producer App This is a way to keep track of your production on your phone or iPad. This app is a work in progress, but having a centralized location for crucial information can save headaches.

`http://itunes.apple.com/us/app/producer/id414136279?mt=8`

Screenplay It always helps to have a backup script along for the ride.

`www.blackmana.com/iphone/products/screenplay`

Celtx Celtx is the mobile scriptwriting app that syncs with the Celtx desktop software and Celtx Studios, making it easy to write your film, AV, theater, comic book, and audio play scripts from any place at any time.

`www.celtx.com/mobile.html`

Scripts Pro This is a screenwriting application for the iPad and iPhone.

`www.scriptsapp.com/`

Planning for Sufficient Power

Many DSLR shoots do not use equipment that has as big a draw on power as regular film or video shoots. This is because they use different lighting setups that require a lot less power. Therefore, it may be easy to overlook power requirements on set. Before you head out on set, make a list of all the equipment that needs power (both battery and traditional AC power); talk to an electrician and make sure you have enough power for your gear on set. A large shoot will still require a large amount of power, and a generator may be required. If you can't calculate the power draw or don't know an electrician who can help you, then at the very least make sure you test the electrical so you won't blow circuits while shooting. Trial and error is still a good way to go.

DSLR sets are often highly dependent on computer or monitor setups for quality control and data management. Battery charging is a crucial part of every shoot, so plan for a charging station area. Make sure that there is a battery backup and power surge protection system in place. As you evaluate these concerns, plan for the moment when the power goes out or surges, and make sure that your equipment is protected.

Have a car charger adapter. If you are on a "run-and-gun" shoot, it is worth the minimal expense for a battery charger adapter to run power off a vehicle.

Shooting Problems

Shooting problems range from equipment issues such as audio limitations, sensor issues, and shutter speed to user issues such as white balance and exposure. Here are some ways to help minimize or eliminate operator-caused or equipment-related issues.

Rolling Shutter Dilemmas and Sensor Problems

When video is being shot with a DSLR camera, a physical or mechanical shutter is technically not used (even if it is used for the still shots); the shutter is an electronic generation of and controlled by the sensor. Currently, DSLRs that shoot video use a CMOS sensor that utilizes a rolling shutter while shooting video. Shutter speeds are identical between mechanical and electronic shutters, but the image geometry may not be. The design of the electronic shutter will create different problems than you would have with a mechanical shutter or even with a different type of sensor.

Here we focus on CMOS sensors and rolling shutters. CMOS sensor-controlled shutters for DSLR video do not allow for the entire image to be fully or globally exposed in the same moment. Instead, the sensor controls which aspects of the image will be exposed and then rolls through the entire sensor, exposing as it passes along line after line of pixels (which is why it has the moniker *rolling shutter*). The entire exposure happens very quickly, usually in a fraction of a second, and is usually not a problem; however, in some situations, it just isn't fast enough.

Correcting Rolling Shutter

Rolling shutter is the likely culprit if any of these items occur:

- The image is described as having a wobble.
- The image is skewed by bending one way or another.
- The top part of an image is not in direct line with the bottom (something highly distracting when the distortion makes it look like a person or major part of the shot is made of Jell-O!).
- Lines are completely curved when they should be straight.
- You have sensor problems like blooming and smearing.

You can't completely avoid rolling shutter problems because they are a result of the design of the camera sensor. The best thing to do is to try to not shoot visuals that are particularly susceptible to noticeable rolling shutter problems. Skew means the lines are curved or slightly off (Figure 9.12). The Jell-O effect looks like an extreme version of skew. Often the entire object is dramatically curved or completely off-kilter. Both of these problems are found in similar situations, mainly in quick-motion scenarios where either the camera or the parts of the shot are moving rapidly.

You can do two things to potentially fix these problems in shots with motion. First, avoid lines that are in focus in the background of your moving shots. These lines can be buildings, tree trunks, walls, brick patterns, or anything that has a repetitive regular geometric sequence, especially vertical straight edges. As you pan, you move the camera, or the shot moves in other ways; these lines will skew and can be visually distracting. If there is no way to avoid having a distracting bending object in the background, the second way to fix this is to have that part of the image out of focus. The rolling shutter will still be there, but because of the blur and softening, it may be less noticeable or, better yet, not discernable at all.

Figure 9.12: Notice the light poles "leaning" to the left of frame as compared to the shorter fence farther from the camera.

One way to fix the problem of skew in a pan is to altogether frame out anything that is skewing in the foreground. Another way is to move the camera farther away from the objects in the foreground. By moving the camera back from the foreground objects, you are making the objects smaller in the frame and therefore minimizing any potential skew effect. If the foreground images are critical for adding movement in the frame—for instance, showing a fence while someone is running that assists in adding a feeling of speed—you can use ND filters, lower your f-stop, and move the object or actor you want the audience to focus on farther from the foreground objects. Then when you focus on the object or actor in your scene, the foreground objects are out of focus and are less noticeable if they have any skewing. If you have the ability to slow down your pan or the action in the scene, thus slowing down the camera movement or action, this will also minimize or eliminate any potential skewing.

You can do several things to disguise the Jell-O effect or skew:

- A moving scene like in a car may respond well to a fish-eye lens. The rolling shutter distortion in the shot can blend into the fish-eye lens effect, thereby masking that there is unwanted skew in the shot.
- Clever framing or cuts in the edit can draw the eye away from the problem.
- Changing the shutter speed of the shot can also help lessen the conspicuousness of rolling shutter Jell-O tendencies. The rolling shutter problem will still be present in the shot, but a slight blurring may mask its appearance and make it less noticeable.

Because rolling shutter problems of skew and the Jell-O effect are the result of the sensor's response combined with movement, shots without movement—especially without quick movement—will not be affected. Make sure that any moving shots that do occur are fluid and smooth by using camera support or Steadicam; this can help keep the shot smooth so any distortion is not added on top of jittery camera work. Cutting shots with quick

movement may make the skewing feel like part of the action. If there must be movement—and let's face it, movement is part of many shot designs—you can play with slowing down the action or maybe even speeding it up until the rolling shutter isn't on the forefront of the audience's mind when they see the shot. As the moviemaker, you are directing your audience's eye with how you set up your shot and action, so direct the eye away from the rolling shutter. This will lessen the effect that visible rolling shutter will have on your overall piece.

Some people bring in an entirely different camera to shoot scenes with rolling shutter problems. This may be a great option if you are a big-budget production, but for many moviemakers, it is the most expensive workaround, and unless your production is set up for a dual-camera shoot, shooting a handful of shots on a different medium may not be the best choice. However, if your key shot is plagued with rolling shutter and you can't get over it, consider the ease of getting that shot on film, or if you are on a lower budget, get a CCD sensor video camera.

Correcting Bloom or Smear

If you are having blooming or smear problems, you may also have to switch out cameras, avoid certain types of shots, try blocking the light sources even a little or diverting them from hitting your sensor, or reframe your shots. *Blooming* occurs when bright, circular, halo-like light appears around your subject and there is little or no information in these areas. *Smear* occurs when bright streaks start showing up, usually in highlights. Both of these appear most often with bright light sources or brightly backlit images. Strangely, both of these effects are more common with CCD sensors, so this is one area where the typical DSLR CMOS sensor is advantageous.

Difficulties Achieving Sharp Focus

DSLR cameras can give everybody the ability to shoot a cinematic movie look. The reason for this is that they have great capabilities for shallow depth of field and low-light shooting. However, when you are shooting in such low light situations there are several issues with focus. The biggest issue is that all of the shallow depth of field in low light is fabulous, but if the actor moves or you are pulling focus in low light, the shots have a high ratio of focus problems. The large sensor gives you the ability to get these amazing shots but also creates situations where pulling focus is nearly impossible. Pulling focus with an f-stop of 1.2 on a full-frame sensor in low light is a recipe for insanity. If you decide to set up shots like this, know that you are going to be in for a long day. If possible, take your gear out and check to make sure you can achieve focus on your planned shots.

Using Viewfinders to Aid in Achieving Focus

A viewfinder is a highly useful addition for consistent accurate focus. Certainly your camera came with a basic viewfinder and an LCD screen on the back. These can be used to set focus; however, while you are shooting, they may not be enough for you to tell whether your shot is in focus. Often the viewfinder on the camera will not be available while you are shooting video or in movie mode. A distinct problem for focus is that DSLR cameras do not allow the eyepiece to be used in live view or movie mode. Additionally, even if you could use the viewfinder on the camera, it was designed for the body position of a still photographer. It is not ideally located to use while shooting and moving the camera for the shot. The operator is often leaning at an odd angle to look into the viewfinder or at the LCD screen, and this can contribute to unsteady camera work.

Actually being able to see the shot is an obvious key in getting proper focus. Light can wipe out the detail on the camera's LCD screen and, even with an articulating screen as you change the angle, can cause problems seeing the LCD screen. Achieving focus is a complete gamble if you can't see what is supposed to be in focus. This means that light hitting the back panel of the camera when you are looking at focus is a major challenge. As the shot progresses, you need to keep checking focus, and the easiest way to do this is to get an eyepiece, loupe, or viewfinder that blocks the light and allows you to put your eye right up to the camera to see the focus more clearly (Figure 9.13). This is probably the one gear item that gives you the biggest bang for your buck.

Figure 9.13: A viewfinder in action with DP John Peters on the set of Memphis Beat

Using External Monitors for Sharp Images

External monitors will also be necessary if you are using some camera support systems like Steadicams, and they are nice if you are using a system with rods, such as shoulder-mounted rigs or other camera support rigs. Attaching your camera feed to monitors that are mounted on your rig gives a larger and more ideally located visual for checking focus (Figure 9.14). Additionally, you can use large external monitors or a computer monitor to double-check your test shots, and you can use them to check every shot on part of a larger shoot. A simple way to aid in comfortable, accurate viewing of your shots on a set is to use a viewing tent or vehicle. If you have a smaller set, this can be done by investing in a few yards of Duvetyne or other black-out fabric and setting up your own viewing tent. Duvetyne is a great, reasonably priced option that you can quickly throw over the camera setup, monitors, or viewing area to minimize light spill on your monitors, screen, or viewfinder.

Figure 9.14: An external monitor setup

Another focus problem for some is that autofocus is often not available while shooting DSLR video. Obviously, there are some notable exceptions like the Nikon D700 and the Canon 70D, but most of the time autofocus is not a given. Videographers usually are accustomed to shooting with autofocus and even relying on color-peaking or pixel-magnification tools. These features ensure that their shots are in focus. Filmmakers expect and usually require manual focus because they are familiar with using focus for artistic purposes. In fact, filmmakers likely will turn off autofocus as soon as possible if it is an option. Why? Movies are told through selective focus. The cinematic look is achieved by picking your focus, whether it is a shallow depth of field, rack focus, or another focus decision.

Autofocus

Even if the camera has autofocus, it likely will be a hindrance for shooting your movie. The autofocus will take time to find focus as the shot moves and may focus on the wrong parts of the image. Autofocus systems work by moving the lens back and forth until the camera calculates where it thinks focus should be. While the camera is searching for focus, the entire image is out of focus or moving in and out of focus. When using autofocus while panning, the camera will constantly adjust the focus. Additionally, if any items in the shot change distance or move, the autofocus may adjust. If you are familiar with autofocus and feel comfortable, start by focusing your camera in still mode and moving it to movie mode while keeping the same focus. This will allow you to practice checking your focus. Selective focus is a major creative decision when you are choosing what to show your audience. Don't let your camera make the creative decisions for you: get over the lack of autofocus problem, and if you do have autofocus, don't use it.

Practices for Getting Consistent Focus on Set

You can do several additional things to help make sure your shot is in focus. Often there is no hard-and-fast rule for achieving focus other than the obvious: double-check your focus all the time. This is because how you plan to make sure your shot is in focus depends on what type of shot it is. If it is a moving shot, you may have to use several methods to make sure the elements of the shot that you need in focus are in focus. If it is a close-up shot of an actor, focus may depend on the physical control of the actor to limit movement. Ultimately, it is useful to have several methods to help with focus and adjust your practices on set as best suited for the shot.

There are also times when perfect focus is necessary for success. If your movie is going to be projected, focus is an even bigger issue than normal. Nothing ruins a scene more than an out-of-focus main actor blown up larger than life. That is why having the eye in focus is a key element for determining critical focus in many scenes. You can measure from the eye of the actor to make sure the eye is the point of critical focus. Also, when you are checking focus with monitors or magnification views on the camera, always look at the eyes of the key players in the scene.

In the end, it is often also best to simply mark out where your focal plane is for the shot. This allows everyone on set to see where focus is and make adjustments. Sometimes the only option may be to change focus capabilities by changing the lighting, the f-stop, the actor position, or the equipment (such as changing lenses or adding ND filters).

Multiple Levels of Magnification

When you are in live view mode, most cameras allow for the operator to have several close-ups on the scenes to make sure that small parts are in focus. If you are having focus problems, use this tool to keep double-checking your focus.

Nonmagnified image

With 5x image magnification

With 10x image magnification

Moving shots are challenging for focus, and they often involve a focus change in mid-shot. Follow-focus units are also a key to maintaining focus for moving shots (Figure 9.15).

Figure 9.15: Manual follow-focus unit in action

Make sure your focus puller and operator have practice time and are able to work in sync. Using a focus whip is great because it allows the person pulling focus to be farther away from the camera and gives the operator a little more space to work. Adding gears to the lens will give a little more focus throw and help you achieve beautiful and smooth focus pulls if you are using still lenses.

You can also get your still lenses adapted to work more like cine lenses, and often the adapted still lens will be easier to use for focus than a still lens with an aftermarket external gear (Figure 9.16). Cine lenses have great gears and are easily adaptable to many follow-focus units, but the DSLR market is flooded with follow-focus options. As you do your test shots, if focus is a problem, a follow-focus unit may be your best solution.

Figure 9.16: Geared lens adapter on a still lens so you can use a follow-focus unit to pull focus

There are additional reasons why a cine lens can help your focus. Cine lenses also are designed for movement and so that the image can be blown up and projected; this means they are designed with extreme sharpness in mind. Your focus problem may be partially helped by a lens switch. Cine lenses are also designed with gears that allow for movement and a wide range of motion for smooth focus changes and focus pulling. Still lenses are built so that the shooter has the easiest access to adjusting focus, but a cine lens is designed so that the focus puller doesn't even have to look at the image to pull focus (Figure 9.17). This is a huge advantage in many situations with tricky focus. If you have complex blocking or a lot of movement, a cine lens by design will allow for easier focus pulling.

Figure 9.17: A Zeiss CP.2 cine-style lens with remote follow-focus unit attached

Artifacting

Artifacting occurs because the camera is sampling parts of the image in order to make a complete frame. This is done by taking the information from only some of the pixels in a quadrant or row at a time and using that information to extrapolate the entire image. Essentially, image capture is a puzzle where the pieces are being created and put together in nearly an instant. This sampling is often referred to as *pixel binning* when referring to the process that DSLR video undergoes as it is being shot.

Pixel binning and line skipping are done to reduce the amount of data that must be read from the sensor in order to get the image. Only part of the information from the sensor is going to be read, or it is going to be combined. This is done to speed things up because the chips that were originally designed for still images and video require that the information be read at much faster speeds.

Often all is well and the aliasing is not a noticeable detractor, but sometimes problems show up in the image. The same process that keeps images sharp and lets the camera "read" the data fast enough for video has a downside. The problem is that any artifacting may appear on your image as an aliasing problem.

Artifacting shows up when something is not recorded, something is distorted in the image, you see shimmering effects such as off water, you see lines that wave when viewed during playback, or an optical illusion is created as a result of the pixel binning that is

occurring. This can appear as aliasing, jagged lines, moiré patterns, details that don't completely line up to the real-life image, or temporal aliasing like the wagon wheel effect where moving images look as though they are moving in the wrong direction. Artifacting is at its worst in the following scenarios:

- Items with small patterns or stripes, which is especially distracting if it appears in the clothing of your actors
- Lines that intersect, such as with brick or fences, especially square images
- Lots of small things in motion such as grass or waves
- Computer monitors or other projected images

Aliasing or other artifacting effects may not show up until there is movement in the shot, which means you have to look through the entire shot to find out whether there is a problem and what is causing it. The bricks may appear fine until it starts raining, but the rain and brick combination may be a moiré nightmare; the shot may look fine until you start the pan, and then you may see all sorts of shimmer. If you see aliasing in your shot, you may need to check the whole thing to see what factor is causing the distraction. Aliasing on the still image may just look like part of the image, but if there is motion, the artifacting can take on a whole new level of craziness.

Moiré is a particular aliasing problem that moving video is particularly prone to. Moiré patterns look like waving grids over parts of your image and can appear as a strobe effect, usually in the parts of the shot that have patterns with similar color tones (Figure 9.18). The pattern can often get worse as the part of the shot with the moiré pattern moves. Moiré will usually affect only part of the shot; primarily, the critical plane of focus is where it will mostly be noticed.

Figure 9.18: Still image from a scene with moiré

If you look at the brick and shutters on the walls in the background, you should notice blue-like lines. This is much easier to see when watching a video than looking at a still image in a book. The reason for this is how some DSLR cameras capture video; they skip every other line when shooting video. This causes a gap of information in the video and the

image cannot be displayed properly when straight and or fine lines are present. This is a limitation that each DSLR camera maker is trying to eliminate with faster camera processors and cameras that don't use line skipping when recording video.

Aliasing is a double-edged sword; without it, the image lacks sharpness, but with it, some highly distracting and unreal effects can occur with your image (Figure 9.19). The foremost goal is to shoot around the potential problem whenever possible and soften when you can't.

Figure 9.19: Still image from a scene with aliasing

Just as with moiré, aliasing is difficult to show as a still image. It acts in much the same way as moiré but appears more as odd-colored pixels in the sweet spot of your focus. This problem is also caused by the way some DSLR cameras capture video but eventually will be eliminated altogether.

If you run into artifacting problems, what you do can depend on what type of problem you are having. Aliasing problems can be addressed by first making sure that sharpness is turned down or any automatic sharpening is turned off. It is often better to try to reframe a shot if aliasing is particularly bad. This is not going to get rid of aliasing, but it will lessen the effect by allowing the slight softness to disguise any harshness.

As you work at eliminating aliasing problems, think about softening. Usually areas of sharpest detail are most prone to aliasing. Changing your focus—for example, by dropping your depth of field or moving your field of focus off any affected areas—can get rid of many noticeable aliasing problems. You can also try softening with a diffusion filter. You can use anti-moiré filters if there is no other option for changing focus.

The best thing to do to reduce moiré is to avoid having shots where it will show up in the first place. Watch for patterns, especially repeating tightly defined patterns that occur anywhere in your potential shot, and test them. If moiré shows up while on set, soften, change focus, or cut out the offending area. If you are seeing moiré in post, check your footage on your final product medium to make sure the moiré isn't being caused by your computer monitor.

Aliasing is always present; the key is to make sure that the aliasing is not distracting. If you end up with a shot where aliasing is present and you can't reshoot, there are a few

post-production options that may help. One option is to apply a light median filter in post. Set it to less than a pixel. This will soften the entire image, but it should be subtle enough to minimize or disguise the moiré. If you have access to a program like After Effects, you can use the Chroma Noise Reduction filter and see whether that clears up the problems at all.

Another option if you have Photoshop (CS6 or newer) is to open the movie file as a smart object and apply the Noise Reduction filter to your clip. This helps reduce or remove color noise from items such as water and human hair, places where moiré is commonly a problem.

Avoiding Color Cast or Mismatched Color Balance

As you shoot, you may notice that your footage has a slight overall color cast to it, or maybe it shows up most visibly in skin tones or white areas of the shot. You can also test for a color cast by shooting a white or gray card before beginning the shoot. Use lighting as close as possible to the lighting setup of your projects with proper white balance while double-checking all settings, and also shoot some test footage. If there appears to be a color cast, then you'll need to adjust the color balance of the camera. This should be adjustable under the white balance area in your menu. You adjust by tweaking the color to the opposite of the color prominent in the color cast. So, you correct a yellow cast by shifting it more toward blue, and you correct a red cast by shifting more toward green. This color adjustment should correct any color cast or sensor color preference and should be adjusted for the remainder of shooting.

If you are using multiple cameras for a shoot, you may find that the footage from the cameras doesn't match exactly. It is important to color match the white balance on all of the cameras. It is helpful to have a properly calibrated monitor to do this matching.

To match multiple cameras, first pick the master camera you want as the standard for the other cameras to be adjusted to and then white balance it. Double-check to make sure you have a proper read on the monitor. Then, while using the same settings on both the master camera and a second camera, focus both cameras on the same object. Put both images on the monitor and adjust the second camera until the images match perfectly. Check any picture-style settings using the same system. It is helpful to focus on an image that looks most like the majority of shots in your project—for example, if you are shooting people, have a person in the shot for white balance and color matching. Skin tones are tricky for color, and making sure that they match is crucial. It is also important to note that different lenses can influence the color of the shot; if you are shooting with a variety of different lenses, check the white balance and color matching on the different lenses.

Adjusting Shutter Speeds and Frame Rates

A motion-picture film camera has a rotating shutter that is often set to a 180-degree angle; in other words, it looks like half of a circle (Figure 9.20). (Some cameras like Panavision are set to 200-degree shutter angles as a default.) This shutter spins around as the film is getting fed through the camera, and it spins fully one time for every frame that is exposed. That is why the shutter speed and the frame rate are linked for exposure; as the shutter is covering the door, the film is being moved and fed into place to be exposed, and the speed of the film controls the frame rate, which affects how much time the film is being exposed for. When the shutter is not in front of the door, the film is being exposed; when the shutter is blocking the door, the film is being moved into place and not being exposed.

Figure 9.20: A 180° motion picture camera shutter as it spins around the film gate

Video cameras generally default by design to the 180-degree angle, so most videographers have never dealt with the interaction between shutter speed and frame rate. In a motion-picture film, the cameras have a variable-degree shutter that you can adjust. On a movie camera, you can crank the film speed up or down, and you can use different combinations. The rule was determined from the standard 180-degree shutters that were in use, and that is why it is called the 180-degree rule. If you follow the 180-degree rule, your footage will turn out looking natural; if you want to break the rule, check the effects by testing first, looking especially at the feel of the movement and light requirements.

Excessive Sharpness or Video-like Sharpness

If your shots are looking like video, you need to check your shutter speed. Video has a very crisp, everything-in-focus look that film doesn't have. Check your shutter speed to make sure you are shooting at 1/50 or 1/60. These shutter speeds will give just a slight bit of smudge or blur to your image, but this will help create video that looks cinematic in terms of what you are accustomed to seeing with a typical movie shot. Many films use different frame rates in combination for special effects shots or visual appeal, but these decisions are best made after you understand how to shoot a typical shot. As you watch the motion shot with 1/50 or 1/60, you can see that it looks smoother than images shot at higher shutter speeds. The shutter speed will control the amount of blur that you get in your shot. If you shoot at higher shutter speeds, that crisp video look may start creeping into your footage.

There is an interaction between shutter speed and frame rates. The formula for picking shutter speed is to double your frame rate. So, if you pick a frame rate of 24 fps, your shutter speed will be 1/48 (on many cameras you must use 1/50 because that is the closest you can select), because you would pick the shutter speed that is the closest to twice 24. This general rule will help you make decisions about shutter speed while on set. If you want to play with the action speed and look, keep this formula in mind and remember to adjust exposure, lighting, and so on accordingly.

The main reason to adjust the shutter speed is to add or limit the amount of motion blur in each "frame" of the video. A faster shutter (that is, a narrower angle) will minimize motion blur, whereas a slower shutter (that is, a wider angle) will increase the amount of blur. If you want a cinematic amount of motion blur, stick with a 180-degree shutter or a shutter speed of 1/50 second.

Flickering Image and Lights

If your image starts flickering or flickering lights appear in your footage, your shutter speed may be the problem. Some lights will flicker slightly at high speeds, and this can show up

on your footage as either a flickering effect or an odd color flicker through your shot if you don't have proper shutter speed. Also, depending on the country where you're shooting, the different electrical schemes can cause flickering. This problem should be immediately apparent as you look through your viewfinder or LCD screen. Often a simple shutter speed adjustment will take care of the problem immediately.

Power Line Frequency

Check the electrical power in the country or location where you intend to shoot. In any country that uses 60 Hz power, you will get a vertical band that slowly crawls down your footage if you are shooting at 1/50 of a second shutter speed. You need to change to 1/60 of a second to eliminate the problem. The opposite is true if you are shooting at 1/60 of second and using power in a country that provides 50 Hz power. It is easy to remember, because you just match the power frequency to your shutter speed, and you are safe.

Noise

Noise is always irritating. Noise can be an issue with DSLR video if you are shooting at certain ISOs in low-light situations (Figure 9.21). Obviously, the best thing to do is to change the light and change the ISO, but that is not always a possibility on a "run-and-gun" shoot. The tricky part with noise is that some higher ISOs may have less noise than lower ISOs. If you are having noise issues, try moving the ISO up one notch to see whether that helps.

(a) (b)

(c) (d)

Figure 9.21: (a) Scene shot at 6400 ISO on a Canon 5D Mark II with lots of noise. (b) Notice the green noise patterns on the actor's face. (c) Same scene with a de-noising processing to clean up the image. (d) Notice how the green noise pattern is all but gone but there is some softening of the image.

If noise is going to be a problem in your shot, try to eliminate or lessen parts that show a single wide swatch of color or shadow. If you break up the color or shadow, you may disguise the visibility of the noise. You also have the option of changing picture-style settings or even adjusting exposure, maybe potentially overexposing slightly or clipping, in order to avoid some visible noise. In general, it is easier to recover some highlights than to get rid of noise in the shadows or recover anything in the darks. Obviously, this is somewhat a matter of experience and opinion, but if you have noise issues, playing around with exposure can be very useful. In shadows, underexposure will create the potential for big noise problems, but always keep the shot and the importance of highlights in the shot in mind. There are times when it is better to underexpose because of the needs of the shot and predominant darks or shadows. You'll need to play around with any of these options on set to see whether they help; this is truly an area for experimentation.

Some people have had the experience of increased noise when the camera heats up. If you notice that the noise is increasing as you shoot, it can't hurt to let things cool down a while. When in doubt, let your camera and card cool down. If you are forced to shoot with more noise than you would like or if the noise is more noticeable in post, you can use software to reduce the noise in post.

Banding, Line Noise, and Posterization

DSLR video is prone to posterization, otherwise called banding. The major reason for this propensity is the shallow depth of 8-bit color that is inherent in DSLR video. Technically, banding is a type of noise, but it has some unique attributes that cause it to operate and show up differently than other noise issues.

This particular type of noise can be more distracting than overall noise. Banding looks like an abrupt change of color that usually appears as a line; it happens when tones or colors meet, and instead of a smooth gradient, there are distinct color lines and abrupt changes in tone or brightness. The reason that this problem is separate from other noise issues is that banding occurs most often in different settings and is fixed in different ways than other noise issues. Banding can occur more often at higher ISOs and underexposed images, but with a DSLR, banding is most common when the subject is brightly backlit (Figure 9.22). Banding is easily seen visually, and the histogram will show large gaps between tones.

If this issue comes up, you can check your exposure and try to reduce it by changing your ISO, ensuring sharpness is turned down (which it likely should be to reduce any other noise issues). Most importantly, change your lighting, especially with backlighting. Banding is not easily fixed by adding overall noise to the image or by adding filters, and even changing the ISO may not fix the problem, but these are worth attempting. Ultimately, you may have to fix any banding issues as best as possible in post.

Figure 9.22: Notice the banding in the light behind the actor's head.

Working on Exposure

Exposure is a major issue if not done correctly but luckily can be solved by tweaking the lighting or adding an ND filter. The reason that DSLR filmmakers run into exposure problems more frequently than other filmmakers is that they're often pushing the limits of light. Shooting in available low light is possible with these cameras. However, having some control over the light will definitely help if you find you aren't getting the exposure that you want in order to use the f-stop you need or you aren't getting the richness of the image that is made possible by lighting the entire shot. You can often control the light in these cases by simply adding some small mobile light sources or even bounce.

Exposure problems with DSLRs may not show up until post if you have not checked to make sure that the image you are using to set exposure looks like the image you are actually getting. For example, using a monitor to check for exposure means you need to check to make sure the monitor's image matches the image you are getting with your footage. You can check this by properly calibrating your monitor and shooting test footage. The good news is with a little practice you will find that often the back-of-the-camera LCD provides very accurate images in terms of exposure. If you are using the LCD screen for exposure checking, make sure you have set the proper brightness on the screen. Often when in the movie or video-capable mode, the camera will automatically adjust the LCD brightness and darkness to compensate for exposure changes. It is also important to look at the screen with a minimum of light spill and to be careful during night shoots that you don't overcompensate for what looks like a very bright image simply because you are completely in the dark while viewing the screen.

When you first get your camera, check to see what metering mode or pattern the camera is using to set exposure when automatic exposure settings are used. The metering mode is usually an evaluative or overall sort of metering pattern when the video functionality is

in use. You may need to override the camera's exposure recommendations depending on the desired look of the image, but checking the automatic exposure settings can give you a basis from which to start your adjustments.

If you are having exposure problems of any kind, double-check the histogram. What is it telling you about exposure? Now consider what elements you can adjust and what elements you are locked into. For example, you may be locked into lighting that is not adjustable; this means all of your tweaking will involve ISO settings, f-stops, or minor tweaks with frame rate. It will be helpful to check your dynamic range and to identify what part of the shot must be in perfect exposure. While shooting on location with no control over lighting, you may decide to reframe the image, move closer to or farther from the action, or just pick part of the image to have perfect exposure.

You must take into account what your overall lighting in frame is as you look at the histogram. For example, when you are on location in a dark evening, if you have decided to expose for the actor's face, you may have a background that crushes to black or a noisier image than is desired, but for the shot, the key visual is the element that the story needs and so some picture quality suffers. Sometimes a moviemaker has to make these types of decisions and provide a best-case scenario instead of a perfect scenario.

Exposure Seems to Magically Change during the Shot?

If you notice that your exposure seems to be shifting during the shot even if the lighting is not changing, the problem may start to drive you crazy because adjusting the lighting or controls won't fix it. Usually this problem is most noticeable when panning, but it may happen in any shot. On Canon cameras, an Auto Lighting Optimizer control may be on; turning it off should help with this exposure change.

There are no hard-and-fast methods to achieve perfect exposure in all situations. Control what you can control, and work around the rest. Find creative framing or use the tools in your arsenal—bounce cards, ND filters, small pocket lights, and lenses with appropriate f-stops or the ability to split f-stops—to help give you options for times where exposure is a problem.

Day-for-Night Solutions

It is always better to plan to shoot night shots at night and day shots during the day; however, sometimes schedules are not accommodating. If you must choose a scenario, shooting day for night is possible, and shooting night for day is a nightmare that involves re-creating the sun. If your day-for-night shots have a dreamlike quality or will undergo color grading, this can be a seamless process. You can throw a day-for-night filter in your kit and have excellent results, and this may be a good emergency item to consider adding to your kit. When shooting day for night, keep in mind that contrast and color temperature are key elements. The dark shadows need to look darker, and the light needs to be explained by the moon, stars, or directional light available in your scene. It is also important to pay close attention to the actors' faces or key visuals; these shots will have the exposure brought down, so make sure you use proper lighting, bounce cards, and so on in order to ensure that the key elements are visible as the shot plays out. It may be helpful to think about bouncing light toward faces rather than over-lighting them; after all, it is supposed to be nighttime.

Also, keep track of shadow length and size. Sun shadows can look distinctly different from any shadow ever seen at night even with a full moon.

If you are going to shoot day for night, then the goal is to darken your image, change the color temperature of your white balance, and keep out any elements that will tell the audience you are not shooting at night, mainly the sky. There are two main ways you can achieve this: you can add a filter to give a bluish hue universally, or you can just adjust the white balance of the camera. You can manually set the white balance and adjust your Kelvin settings, or you can set your white balance with an orange-ish card, which will add a blue tint to your image. Then change the overall brightness by stopping the exposure way down for the entire shoot. This will allow you to adjust while still keeping consistent lighting in the scene. If possible, it is effective to further adjust day-for-night shots in post-production.

> When shooting day for night, avoid shooting the skyline. Never put the sun in any part of your scene. Additionally, you need to show little to none of the sky.

Dealing with Limited Control over Naming Clips

Naming clips with a DSLR can be a nightmare, especially on a multicamera shoot. The shots are automatically given a sequence of letters and numbers, but these are not unique to the shot, simply unique to the particular shot with that particular camera on that particular card (Figure 9.23). There are many ways of tweaking the naming so that you can differentiate between shots taken the same day and with different cameras, but this is often a complicated and time-consuming process (Figure 9.24).

Even if you slate each shot, if shots are accidentally named the same, they can be rewritten; if there is any confusion, you are stuck looking through every shot and cross-referencing with the slate. Also, file numbers on your computer can be complex holders with several hundred or thousands of files all named with these tricky letter/number names. It can take time to go through the files on a logging process to make sure that everything is easily editable and most importantly not in danger of getting missed. In the end, data management is going to be a major job, and making sure that this job is covered by a competent person is key. You don't want to have your entire movie on a myriad of cards that all look the same with unmarked potentially duplicate-numbered files most likely spread throughout the various pockets or bags of your crew members. Take data and file management seriously.

We discussed this in more detail in Chapter 8, "Organizing and Storing Data in the Field."

Figure 9.23: Folder with the native filenames off a Canon 7D

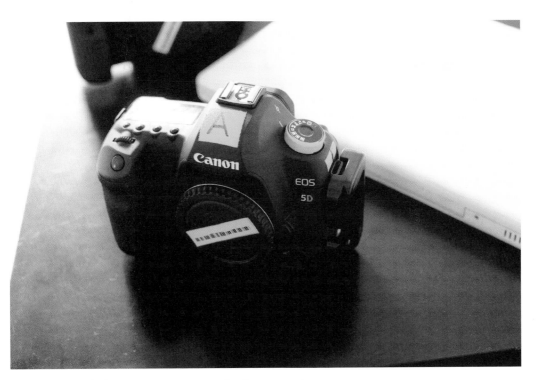

Figure 9.24: Label your cameras on a multiple-camera shoot.

Preparing for Lack of Audio or Time Code

DSLR cameras do not record audio of a high enough quality to be used on most movies or productions. The built-in audio should be viewed more as a reference source than a usable audio track. Also, using external microphones connecting directly to the camera sometimes doesn't yield high-quality audio. A separate audio recording system is necessary. If you simply must use the onboard audio, plan for quiet sets or dubbing and, in the end, audio that may be problematic. Can it be done? Certainly, if there is simply no other option. The cameras do not have extensive abilities to check audio levels and cannot always be hooked up to the external audio system simply because of physical limitations. We covered sound in more detail in Chapter 7, "Sound on Location."

There are also not going to be any time-code capabilities on many cameras. More cameras are now being offered with time-code options but they are not yet universal. There are several software programs you can use to sync sound, but don't get accustomed to the safety of time code being stamped into each shot. Sometimes in "run-and-gun" shoots, using a slate or clapper is also impractical; in these cases, make sure there is a way to match the audio recording in post, and if there isn't an easy option, plan on doing some creative audio matching in post. It may be time-consuming, but it can be done.

Run "rough audio." Run the camera's audio while shooting to make any matching problems easier. You can simplify matching a clip and audio files if you have the camera audio to use as a marker. Take wild audio seriously; make sure you use wind guards if you are in a location where wind may affect your microphones, and check to make sure you are

getting the best possible audio. This audio may not show up on your final project; however, not only will matching be easier, but it is your emergency backup for any voice-over work, and your Foley artists can use it as an auditory inspiration for their work.

Turn off the image stabilization (Canon) or vibration reduction (Nikon) feature for sound. The lens's internal stabilization can cause whirring noises to record on all audio files and can render all audio on the camera useless even for matching purposes.

Hardware Problems

The following are common hardware problems.

Troubleshooting Spots on the Lenses

At some point in the shoot a spot is going to appear in a shot. The first thing to do is to find out where this spot is coming from. First, check your lens since that is the easiest thing to fix. There may be a water spot, hair, or dust on the lens, and a proper cleaning is a simple fix. Make sure that condensation isn't building up anywhere on the lens or camera; water is an electronics killer. If it isn't a lens issue, check to see whether it is a dead or stuck pixel. Now check for sensor dust. If the spot seems to be coming from something on the sensor, the sensor (or technically the filter on the sensor) will need to be cleaned.

The next step is to run a camera-cleaning cycle to see whether that fixes the problem. To examine how your camera runs an automatic cleaning cycle, check the camera manual. Often your camera will run a sensor clean when it shuts off, but there is usually a way to run a longer cleaning cycle manually. The cleaning cycle will use high-frequency vibrations to try to shake debris off the sensor and also may map the dust for later cleanup with the camera software. The cleaning itself will not fix any dead pixels, but it can cause stuck pixels to reset or help the sensor deal with hot pixels. How it helps pixels is a bit of a mystery, but all we can say is that we have found the cleaning cycle can fix many problems when spots show up on an image, so it's a great thing to attempt.

If your camera needs a physical cleaning, you can decide where your comfort level is in cleaning it. Many people have all physical sensor cleaning done professionally, but in a pinch or on a set you may need to clean the sensor yourself. We personally prefer to clean the sensor by blowing off the sensor with a special blower designed for cleaning cameras (Figure 9.25).

Any dust that is blown off the sensor may remain in the camera and end up back on the sensor, the mirror, or the rear lens element, but we have had pretty good luck with this method. On set, we also have static chargeable brushes as well as solvents and cloth for wet cleaning, all in a camera-cleaning kit specially designed for DSLR cameras. Cleaning the sensor is a nerve-racking task for many people and could result in a permanently damaged sensor if you do it incorrectly. This is one area where you need to decide what you are comfortable with and make preparations prior to going on set. If you are in a bind, decide whether the sensor needs cleaning or whether you are willing to do some workarounds in post.

Figure 9.25: Rocket Air Blaster to manually clean the camera sensor

Take care when changing lenses or having the camera open for any reason. The sensor attracts dust, and avoiding dust in the first place is a nice goal.

Bring your camera instruction manual or have it downloaded on a computer so that you know how to make sure that your mirror is locked up and you can access the sensor for cleaning.

Overheating

When you are shooting video for long periods of time or in extreme heat with a DSLR camera, overheating can become a problem even if you aren't aware of it. The camera may give you an overheating icon warning and will likely shut down if it gets overheated. However, even before you get to this point, you may have overheating problems with your footage. The biggest indicator of overheating is that suddenly your image will have increased noise.

To solve overheating, keep your camera out of live view mode as much as possible, give your camera breaks, and if possible have multiple camera bodies on sets with intense shooting times. If there is overheating, sometimes a quick battery or card change can help take the heat off, and potentially using a battery grip or pack can take some of the heat away from the camera. With a little planning, overheating should not be a major issue on your shoot.

(a)

Pixel Problems: Dead, Hot, or Stuck

It's bound to happen to everyone; suddenly a small colored dot in red, green, purple, or blue will appear in every shot of your footage. Hot pixels can happen more frequently when the sensor heats up, but stuck or dead pixels can pretty much happen at any time (Figure 9.26).

- *Dead* pixels are simply pixels that are no longer functioning properly. At some point, the pixel broke.
- A *hot* pixel is a pixel that looks too bright in comparison to the surrounding pixels. Hot pixels have higher electric charges than the surrounding ones, because of manufacturing, breakdown, or increased current leakage on a pixel level at high ISOs or high temperatures.
- *Stuck* pixels are pixels that got stuck in the on position and are just there letting light through but not changing or transferring further information.

(b)

(c)

There usually is no good visual way to find out whether the pixel is stuck or completely dead. Stuck or hot pixels tend to be easier for the camera user to fix, and large amounts of dead pixels mean that your camera may have to be sent back to the manufacturer. The terms are often used interchangeably on set.

Figure 9.26: (a) Notice the red hot pixel in the scene. (b) A hot pixel on a black background. (c) A dead pixel on a black background.

To test for this problem, go to a low-light or black setting and take several shots, ideally with motion, at various ISOs; if you can't get to a dim area, just shoot with the lens cap on. Most likely problems will show up in the higher ISOs. These cameras have huge numbers of pixels, and it can be acceptable to have a few bad pixels; however, if you are seeing a large number of them, it may be time for some camera remapping work with your camera manufacturer. Before you do that, though, try doing a longer-running sensor clean on your camera or a camera remapping option; your camera should have one or both options in one of the menus (Figure 9.27). Also, check to make sure that what you think is a pixel problem is not, in fact, a problem with dust on the lens or sensor. The good news is that this is relatively easy fix in post.

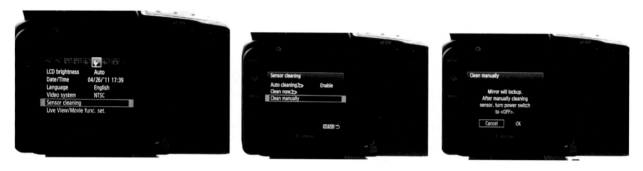

Figure 9.27: Manual cleaning mode on the Canon 5D Mark II

Ensuring Monitor Accuracy

Field monitors are often used for DSLR moviemaking. They allow for easier focus control, playback, and larger screen size for easier shot visualization.

As you set up the shot or watch the footage, the color is a major component to check. Making sure that your field monitor is accurately translating the colors is an important step to ensuring accurate color.

Always make sure that the monitor is warmed up (it's usually a good idea to have it warm up for 20 to 30 minutes before you judge color using the monitor) and that you are calibrating it in proper lighting so that you are able to accurately judge the colors. The best lighting for color calibration is usually in a darkened room with gray or black backgrounds; in a field setting, minimize as much ambient light as possible and make sure to avoid bright lights or glare on the monitor.

Depending on the type of monitor you are using, your monitor may or may not have built-in color bars. If your monitor does, then use the built-in color bars to adjust your color settings accordingly.

Cover the Monitor

If you do not have a tent or area where you can get out of the sun, make sure to have a black cloth (Duvetyne works great) that you can drape over you and the monitor. In a pinch you can use a blanket. Ambient light that hits your monitor has the greatest impact on degrading how you perceive color, contrast, and exposure.

Avoiding HDMI Cable and Converter Box Pitfalls

On some DSLR cameras, when you plug in a HDMI cable or 1/8-inch mini-plug, the following scenario occurs: The camera outputs the image to the external monitor, and the LCD screen on the back of the camera goes black. This is an obvious problem if you are relying on the LCD screen for viewing. Suddenly, if you need to be able to view a monitor onboard the camera as well as send a signal to another monitor, then you are dealing with long cable runs and converter boxes.

> Many newer cameras are offering the ability to send a signal to an external monitor while still maintaining an image on the LCD screen.

294 CHAPTER 9 ■ Troubleshooting

HDMI cable is a consumer cable type not designed for high use and abuse. These cables were designed to plug various electronics into your home theater system and be left alone. When attaching and running extra cables to multiple monitors, the frequency with which the cables are plugged in, removed, rolled up, stepped on, pulled out of the camera, tripped over, and countless other issues that arise on set are magnified. The HDMI cables are prone to breaking and shorting out. The small pins in the cables can break, twist, or get bent. It is vital for you to have multiple cables on hand if you rely on the external monitors to shoot. You don't want one bad cable stopping your shoot. Make sure you have backup cables on your next shoot.

Additionally, if you are working with multiple monitors, you are dealing with HDMI splitters, HDMI extenders, HDMI signal boosters, and in some cases HDMI converter boxes to move you from HDMI to a more reliable cable such as SDI or CAT5. If you use these powered devices or converters, be aware they too were not made to be used and abused in the field. They are normally plugged in behind your home entertainment center or in some air-conditioned production studio where they are never touched. These devices can be fragile and tend to be the first things to break down on set. Again, have backups for each device if it is critical to have multiple monitors running. If not and one breaks down, then drop down to just one monitor, and you can keep shooting. Just be prepared for the worst.

Have extra cables on hand. Cords are often the first thing to go or give you problems; buy and bring extras even though the price may make you shudder. It's worth it.

Running Out of Hard Drive Space

If you are in an emergency situation and running out of space, there are a few things you can do to maximize your space. Don't record any audio files on the camera; even though they don't take up much space, they still take up some. Non-shaky footage or very stable footage takes up less space per take (this happens when you select certain types of compression that analyzes your footage to see what changes from frame to frame), so make your shots more static, lock them down, or use a tripod. You can look into using cloud storage as a last resort, but that can be tricky or highly impractical based on Internet speeds and or file sizes. Find out what you have available for space including extra laptops, thumb drives, and so on. Use your cards for the last shot as the backup, but whatever you do, make sure everything is backed up.

All of these tips are really emergency-only solutions. In general, the best solution is to just buy more hard drive space. It's the one thing that skimping on is only going to cause you to spend more money while trying to find workarounds.

We prefer using G-Tech storage devices and have found them to be very reliable and durable.

Clearing Error Messages

Your camera may suddenly give you an error message. This is a rare occurrence, but having your camera guidebook with you is helpful. At the very least, you can do an Internet search

of what the message may pertain to. If you can't figure it out, make the following changes; they solve the three most common messages:

- If your camera and lens are supposed to be electronically communicating but suddenly aren't, an error message will occur. Turn the camera off and on, press the shutter button down halfway, try taking a still photo, and then turn it off and on again. This is the equivalent of hitting the TV to improve reception; mysteriously it sometimes works. We blame trolls.
- Clean the area where the lens contacts the camera at the base of the lens. Reattach. Try another lens that doesn't have electronic communication with your camera if possible. Make sure your lens connection didn't cause an odd lockup issue with the camera by trying several lenses.
- If you are using extension tubes or other lens-related items, remove them and retry using the camera. Does everything look clean and dust free?
- Try formatting the CF card or using another CF card if possible. Check to make sure that the card isn't full.
- Replace your battery with a fully charged battery. If you are using a battery pack or grip, disconnect it and try using a single battery.
- Redo all of your settings. Try everything on manual with no auto functions.
- Disconnect any cables connected to the camera.
- Turn on the camera before connecting any cables or monitors.
- Change your clock.
- Make sure your camera didn't overheat and turn itself off.
- Before you give up, try turning it off and turning it back on.

Always shoot the last shot as something you can throw away. There have been reports that if a shot gets screwed up on a memory card, it is often just the last shot. Because low-budget productions often have the best shot as the last shot, instead always take a throwaway shot as the last shot.

Ways to Save the Shot

If you are short on time and money, then there is a good chance that at least once on your shoot it will be up to you to save the shot. You will have an actor who needs to leave, a location that shuts down early, lighting that changes too quickly, or any of potentially hundreds or thousands of issues that will force you to shoot in less than ideal conditions. Here are some quick "cheats" to help you get through your rough moment and still be able to tell your story in post:

Change perspective. A change of lens quickly changes your field of view. If you lose an actor, have a major continuity problem, or have only enough light to illuminate a small area, you can move to a long lens and go in tight for coverage. No one has to know that the only thing in the frame is the only thing left on the set at the end of the day.

A long shot can cover problem areas in post. The age-old advice is still good. Get a master shot. If you are not sure how much coverage you can get in the short amount

of time or quickly enough with the sun setting and so on, you are well advised to get a master shot you can use in post if all else fails.

Take a few interesting cutaways, get a b-roll. Without a doubt, you know what you want for a master shot, for close-ups, and for some interesting moving shots to compose your scene. That's all great, but don't forget a b-roll and cutaways. Since you're likely working on a project that doesn't have budget for script supervisors, ADs, and other support staff to watch out for the details in your coverage, you need insurance in post to cut around problem areas. Look around the set and take some b-roll of objects in the scene—glass of water, car, mirror, guy in the background sitting on a bench—anything you might be able to use. Additionally, any movement the actor makes—reaching into his pocket for a phone, brushing her hair back from her face, holding a coat during a discussion—you should get a cutaway of. No matter how prepared or alert you are on set, there will be times where the actors' movements, hand placement, dialogue, or other factors may not match with the coverage you have. Having a b-roll or cutaways will help you cut around these problems and can make your scene work and hide the issues you had to begin with.

Get rid of problematic backgrounds. Moiré can be a problem. Lighting may be a problem. Unattractive sets can be a problem. One quick trick that can potentially solve some of these problems is to decrease your depth of field and let the background drop out of focus. If there is a building behind your subject that has lines and patterns that are causing moiré, then slightly narrowing your depth of field will eliminate the moiré patterns in the background. The same goes for lighting or unattractive sets. If you get stuck improvising a location that is less than ideal, find a cool color or pattern that you can place in the background and have it drop out of focus.

Check Your Dailies

On most shoots, things move fast, and if you do not have enough time or personnel, you might miss a few things. The end of each day is the time you need to watch your dailies and work through a simple checklist of items.

Watch Your Footage on the Largest Possible Monitor The bigger the monitor, the easier it is to check focus. Getting focus is hard, and you might find that a crucial shot you thought was good may not be in focus. Decide whether you need to reshoot the next day or whether you have coverage to work around.

Do You Have a Dead or Hot Pixel? Again, this is something that you may miss on set. You want to catch any possible problem as early as possible and correct it if you can. Ideally swap out to a new camera if you can. If not, then make notes on what camera has the issue (if you are using more than one camera) and on what day and card the problem started (this way you have notes to work with in post if you have to do any pixel mapping or touch-ups).

Dust on Your Sensor From time to time you will get dust or a larger particle that can show up in your footage. If you did not notice it on set, then take the time to clean your sensor. Again, mark which scenes or cards were affected.

Audio Listen to your audio, and make sure all is working and you aren't getting unwanted noises (such as clothes rubbing against the microphone during key dialogue scenes). Depending on how skilled your audio person is, you may need to listen carefully and make sure that nothing needs to be adjusted.

Backing Up We can't stress this enough. Each night (preferably throughout the day), make sure to have at least two backups for each card. Once you have adequate backups, clear all the cards so there is no confusion the next day.

Actors When watching the footage, watch your actors. See whether there are any wardrobe issues that you didn't notice. If an actor takes off a coat or has some change of clothing during a scene, you may be left with a shirt that moirés. If this is case, see whether you need to reshoot or find a way for the actor to put the coat back on to cover the problem shirt.

Color Grading If you have the ability to work with your colorist (if you're not doing color grading yourself), do some tests with your footage. If you discover you need to change or adjust your picture styles, then you have time and can correct it early in the shoot.

Menus With these cameras, it's easy to change a menu setting or bump a menu wheel. Each night double-check all of your settings and make sure nothing got inadvertently changed. If it did, then you can limit the damage done, and you can decide whether reshoots are necessary or whether you are fine to move on. It's better to know and make the decision than to find out weeks later.

Scheduling Are you on schedule? Do you need to adjust anything about the shoot to be able to shoot faster or more efficiently? Each night take the time and look over footage, check the equipment and settings, and reread your script and schedule to see what modifications, if any, are needed.

ten

Converting and Editing Your Footage

After the shoot wraps, you have

officially entered post-production. Hours of footage representing months of preparation and work are all contained in items that can roughly fit in a file box. This phase of post-production is closely related to pre-production because you are setting up all of the technical details that will travel with you until the end of production. Your challenge now is to get from the shoot to the edit with your footage intact, perfectly prepared, and organized in a fashion that works for the post-production team. You need to back up your footage for safety, log your shots, deal with technical specifications for editing and color-correcting programs, organize audio files with corresponding shots, and put everything into a format that you can work with for the rest of post-production.

Setting the Foundation for Post-Production Workflow

As they say with all creative endeavors, sometimes you need some time off. We recommend taking some time away from the project after your shoot. You will need the break; it allows things to settle into your brain and allows you to start thinking of your next steps subconsciously. After your time away, you will most likely be excited and overwhelmed at what is ahead of you. We have yet to meet a fellow filmmaker who isn't surprised at how much work there is to do during post. In this section, we'll break down the steps you need to do or consider before you start editing.

When you are finished with your shoot and back in your office or edit suite, here is what you should have in front of you:

- Hard drives with the raw footage from the field
- Audio files from your recording device unless you ran sound only from your camera
- Audio notes with included scene numbers
- A copy of your shooting script and shooting schedule with your scene numbers
- Script notes indicating which takes you thought were most promising for including in your final project

It is with these building blocks that you will start your post-production process. Depending on what you choose for your field hard drives, how much footage was shot, how much time or help you had on set, and how organized the process was kept, your work in this stage could be grueling or simply mechanical.

Choosing the Right Hard Drives

The hard drive requirements for post-production may be different from the requirements of a drive used during shooting; Figure 10.1 shows a good in-the-field drive. Also, the final file size and plans for post-production may lead you to a faster drive than if you have a smaller and less post-production-heavy edit.

Figure 10.1: G Tech G Drive is a great field drive.

Using drives that do not need to be powered on location is great for an easy field workflow. The problem with using these drives for post-production is that the drives are smaller than traditional hard drives that require power. Your field drives will need to be consolidated to just a single or a few master drives. Take all your raw field footage (and all the separate drives you used) and calculate how big a master drive you need to move it all into one location. You need to buy at least two drives that size or larger and copy all of the footage from your field drives onto your external edit master drives. This way, you can have all your footage on one central drive, and you don't have to manage multiple field drives.

Keep your field drives as one of your master backups and move them somewhere out of your house or office so you have copies of your raw footage in more than one location. This system may seem obvious, and we all have heard the mantra "Back up, back up, back up." However, for some reason, there comes a point late at night when you don't want to spend the time and money on having a second backup. A little voice tells you not to worry ("Nothing will happen to the footage!") and that you should go see the midnight showing of *Blade Runner* instead. We can't repeat this enough: ignore this voice, and make sure your data management person ignores this voice.

> Need to figure out the size of the drive you require? If you convert your raw Canon H.264 files to XDCAM files, your total storage will be less than the total of your field drive space. If you choose to convert to ProRes 4.2.2 HQ, then you should plan on the files being seven to eight times larger than your field drive space. For more information on 4:4:4, 4:2:2, and 4:1:1, please check out Chapter 12, "Color Correction and Grading."

Internal Hard Drives

If you are editing on a desktop computer and it has extra bays for drives, then we strongly recommend using internal drives. Using internal drives keeps the edit suite compact and uncluttered. Internal hard drives can be purchased at any local computer store and can be installed and removed easily and quickly. If you are editing on a laptop or your existing desktop hard drive bays are full, then you need to work with an external hard drive.

External Hard Drives

For video editing, you will need an extra drive for storing the footage. Even if your laptop or desktop has a large hard drive, you shouldn't use the main hard drive with your OS and editing program for storing and rendering the footage. The main types of external drives you will find online or at your favorite local computer store are FireWire 800, USB 3.0, eSATA, and/or Thunderbolt drives. You'll need to check the hard drive to see what connections it can accept before purchasing (see Figure 10.2). We

Figure 10.2: Check the back of your hard drive to see what connections your drive can accept.

recommend not using a drive that is slower than USB 3.0, but anything with a faster sustained data rate is better.

FireWire is Apple's trademark for the type of connector that uses the IEEE 1394 protocol.

FireWire 800 This protocol (Figure 10.3) is sometimes referred to as a *nine-circuit beta connector* and is capable of transfer rates of up to 786 Mbps. FireWire 800 is also full duplex, which means data can go both ways at the same time. Think of it as a two-lane highway where data "cars" can travel each direction without clogging up the road. This is a great choice for a drive to be used for editing.

Figure 10.3: The nine-circuit cable is better known as a FireWire 800 cable.

USB 3.0 This standard can reach data transfer rates of 5120 Mbps (Figure 10.4). One main difference between USB and FireWire is that USB is typically *unsustained* data transfer, whereas FireWire is *sustained*. Sustained means the data transfer speed between the computer and the hard drive remains constant from the moment the data starts its transfer. Unsustained transfers can fluctuate and sometimes be faster and other times slower. You do *not* want to edit video with drives with unsustained data rates, because during the edit, the drive might not be able to play back video in real time, causing pauses in video playback. Do note that USB 3.0 and future updates are getting to the point where most users won't push the drives hard enough to run into the sustained vs. unsustained issues.

Figure 10.4: The upper photo is a standard USB 3.0 cable and the other end is the USB 3.0 Micro-B plug.

Also note that USB 3.1 has been announced and it will boast 10 Gbps speeds that rival Thunderbolt drives. Since they will be backward compatible, that means the USB platform should remain the most widely used interface in the business for years to come.

eSATA SATA is the current standard for the internal bus interface for hard drives. The drives also exist as *external* hard drives using the eSATA designation (Figure 10.5). There are three iterations of eSATA connections.

Figure 10.5: Adapter kit for a laptop without an eSATA connector

eSATA transfer speeds are sustained and are usually about three times that of FireWire 400 and USB 2.0. Unlike FireWire and USB connectors, eSATA drives must be plugged into a power source and cannot be run off the computer via the connector. This makes eSATA drives more at home in the edit bay than on location where power outlets may not be readily available. Additionally, since eSATA technology is more recent, not all laptops or desktops have the proper eSATA port. In this case, you need a PCI adapter card or a new card installed in your desktop unit to be able to plug in your drives.

Another difference in eSATA technology is that, unlike FireWire and USB 2.0, it doesn't have to translate the data between the interface and the computer (Figure 10.6). This improves transfer speeds and saves your computer precious processor resources. eSATA also has its "hot-swappable" feature that allows you to quickly and easily remove and interchange a drive from work to your home or vice versa (the other protocols are generally not hot-swappable). Also, a quick and easy way is to have a backup drive on which you can make your backup and then easily remove it and store it in a different location.

Figure 10.6: A standard eSATA cable

Thunderbolt 1 and 2 This is one of the newest interfaces on the market. This interface combines the PCI express and the DisplayPort alongside a copper wire for power in a single cable. What really matters to filmmakers is the sustained data speeds of 10 Gbps.

Version 2 of the Thunderbolt connection (Figure 10.7) incorporates DisplayPort 1.2, which will allow 4K video streaming to a single 4K monitor.

Figure 10.7: Thunderbolt cable

The name of the drive is from the type of connector that the hard drive uses. A USB 3.0 drive usually has only one USB port on the drive. But other types of drives sometimes support more than one connector. FireWire and eSATA drives typically have multiple ports and can be used with more than one protocol.

Hard Drive Recommendations

Our recommendations for a hard drive break down as follows:

- Use an external FireWire 800 or USB 3.0 drive for locations where you lack power. We recommend LaCie Rugged drives.
- Use Thunderbolt drives in your editing suite (where you have plenty of power).
- Use a cheaper USB 3.0 drive for your master backup drives that you store away in case of an emergency.

When One Drive Isn't Enough

If you are editing a feature film or a longer-format project, chances are you won't be able to fit everything onto one external drive. You can buy multiple drives and connect them to your computer. Most laptops usually only have one FireWire port, if they have a FireWire port at all. There are usually two USB 3.0 ports (assuming you have a newer laptop) and possibly a Thunderbolt port.

Many hard drives will also have dual ports so you can chain the drives together and have your computer read multiple drives at the same time. This isn't wrong, but if you need to pull a drive, depending on how large and where the drive is placed in your chain, you may have to eject all the drives and manually rechain the drives back together.

RAID Drives

Redundant array of independent disks (RAID) is now used as a generic or catchall for any computer storage device that divides and replicates data across multiple hard drives. Most RAID systems combine two or more drives into one unit (Figure 10.8). It is possible to set up a RAID with drives that are identical but don't have the same storage capacity. With that said, it is best to have all the drives with the same capacity for maximum performance. In a RAID, the drives will work in concert. This can be done via software or hardware solutions. By combining the drives into one virtual unit, you allow the computer to divide and use the drives faster and most efficiently.

RAID arrays also provide more security for drive failure. If you are using only one stand-alone drive and the drive starts to fail or becomes corrupt, your drive may crash. You may have no warning and lose whatever work you had done between that moment and the last time you backed up. Any RAID array beyond a RAID 0 will have a redundancy of data. RAID arrays ameliorate this risk with the multiple redundancies. This allows for potential problems to be detected and in many cases repaired prior to a massive drive crash. This safety net is often called *fault tolerance*. RAID systems are very dependable and are

Figure 10.8: A dual external RAID drive

a great option. RAID drive enclosures are more expensive than stand-alone external drives. However, using dedicated RAID enclosures saves desktop space, cuts down on the number of power cords, and is a more secure environment for your data.

Mirror RAIDs write identical data from one drive to another drive, basically giving you a backup in real time. If, however, the mirror RAID is writing to the same disk array, then it is not considered a true backup. If any part of the drive were to fail, you could still lose all the data from the entire drive. True backups need to be on totally separate drives to protect you.

Drive Speed and Cache

Regardless of what type of drive you choose, you should know they come in several different disk speeds, measured in rotations per minute. The most common are 5400 rpm, 7200 rpm, and 10,000 rpm. The faster the rotation, the quicker the platter runs under the head that reads the data. So, the faster the speed of the drive, the faster data can be accessed from the drive and communicated to your computer.

It is widely considered that the minimum drive speed for editing video is 7200 rpm. In the past, we have edited on a 5400 rpm drive, but that was a very small project, and a 5400 rpm drive isn't suitable for most projects. 5400 rpm drives can be used as backup or storage drives as long as you don't edit with them as your source drives. 7200 rpm drives are one of the more common drives available and will work fine for editing. A 10,000 rpm drive will be faster and is best used with larger video files. If you are working with a ton of footage that is mostly uncompressed files, you might want to invest in the 10,000 rpm drives.

Cache on hard drives is similar to the cache in your web browser. It stores information and data that can be accessed more quickly. Most drives today have an 8 MB cache, but there are many with 16 MB capacity if you want to give yourself maximum speed at every connection. Also, computer bus speeds come into play (Figure 10.9). This is the bottleneck for most data transfers. If you are connected to your computer through a regular PCI card with either USB 2.0 or a FireWire 400 connector and are experiencing slowdown in your playback or editing, you may want to switch to an eSATA external drive and see whether that fixes your problems.

Figure 10.9: You can check your computer to see the internal bus speed.

Solid State Drives

The previous disk speeds are for drives that have moving parts in them. Now there are solid state drives that don't have moving parts but rather are solid state memory drives that can access the data similarly to the RAM on your computer. These drives are currently more expensive per GB of data and they are not as widely available. With that said, they are quickly becoming the drives of choice due to their unbelievable speed when compared to traditional hard drives.

Backing Up Data

Once you have all your footage in one central location (following the guidelines we gave at the end of Chapter 8, "Organizing and Storing Data in the Field"), you should actually perform the backup. You want two (we prefer three) backups of the *original* footage prior to

the start of editing. Make sure you have your original footage totally untouched and stored away so you can always go back to what you originally shot in case anything goes wrong in post.

You can back up your footage in different ways in case you are like most of us and don't back up your computer often enough. There are three main ways you can back up your footage:

Copying the Drive Take your master drive and an empty drive (of equal or greater capacity) and just copy the footage from your master drive to your new backup drive. This essentially makes an exact duplicate of your master drive.

Incremental Backup The first time you back up, an *incremental* backup makes a master backup of your main drive. Then at scheduled time intervals (hourly, daily, monthly, and so on), it makes backups of all files that have been created or modified since the last backup. Think of it as a file cabinet that you place all of your files into and fill up when you first buy it. Then each time you get mail or documents, you copy them and stuff them into the file cabinet. You didn't touch the original files; you just added a few new files each time you needed to. Probably the most popular backup software of this type is Apple's Time Machine (Figure 10.10).

Figure 10.10: Time Machine while backing up

Recursive (or Complete) Backup This type of backup uses software to make a complete backup of your drive. Each time you back up, it again takes your entire main drive and backs it up and stores it on your new backup drive. You can imagine this type of backup as a self-contained container of your main drive. If your main drive were to fail, you would use this image to restore your files and footage. We use EMC's Retrospect (and this works on both Mac and Windows) for this type of backup.

All of these various backup methods work fine. We recommend either copying your drive or using Retrospect to back up your original raw footage (the drives you won't touch again unless there is a drive failure) and using an incremental backup on the drive you are

using with your converted footage for the edit. That way, each day you work on your edit, files will be changed or created or modified, and the incremental backup will back them up each day.

You have to remember to back up and back up *often*. Drives are relatively cheap these days, and no matter your excuse for not having multiple backups, you will kick yourself if you lose any of your footage. Don't tempt fate. Buy backup drives and back up now.

Choosing and Using an Editing Codec

The key to video delivery has always been size and speed. Generally, the higher the quality of video you have, the larger the file/data is. This makes it hard to store on DVDs or Blu-ray or to stream on the Internet. Mathematical geniuses created *codecs* (short for "compressor/decompressor") to help shrink and store the data so it could be more easily transmitted or stored. Each codec is a different mathematical algorithm to compress and store your video data. The codec you choose will impact the size of your converted video files, the quality of the image, and where the video can be played.

Early codecs often focused on certain areas of the video data, and many codecs produced lousy video that was mostly unwatchable. As the technology progressed, more and more codecs entered the market, and today hundreds of codecs are available. Some newer codecs result in footage that cannot be played on all computers or devices without having the codec present to decode the video.

Video compression is the relationship between the video quality, the storage (disk) space, and the hardware (cost) required to decompress the video (quickly). Compression decides what data (from your original footage) is necessary for achieving the best visual quality. During the compression process, much of the data in your footage is discarded, and if done poorly, this creates visual artifacts in your footage. This potential risk is why choosing the right codec and compression for your footage is critical.

In simple terms, there are two main categories of codecs. First you have an intermediate codec, which is simply a codec that is to be used during the video-editing process. An intermediate codec retains more data from the raw video footage but requires less hard drive space than uncompressed video would need. Second, you have a delivery codec. A delivery codec compresses (throws out some of your video data) and makes a smaller video file that can be easily streamed or viewed for an end user. Currently, the most popular delivery codec is H.264.

"Format" Is Not "Codec"

Nikon's DSLR cameras use Motion JPEG AVI files as the container format for video. Panasonic DSLR cameras use AVCHD as the container format for video. Canon DSLR cameras have embraced using a MOV container with the H.264 codec to compress the original movie files. The type of video file—.avi, .mov, and so on—is just a container and *not* an actual codec. It is an easy mistake to make to think that the type of video file is the same as the codec. A MOV file can hold video that ranges from H.264 to XDCAM to ProRes, and many more. Don't make the mistake of thinking the container is the codec; they are not one and the same.

Delivery Codec vs. Capture Codec

In general, the best *capture* codec is the one with the highest resolution video signal (preferably uncompressed). Then you are starting with the best possible image, and you have more latitude in making color corrections and adjustments to the footage. In general, higher bit rates and high-resolution capture codecs are much too large to burn onto a DVD or stream on the Web.

A *delivery* codec is a compressed video format that provides for the best preservation of the original footage's quality at the lowest bit rates and file size. This allows for easier streaming and the ability to be burned to DVDs and other storage devices.

What Are Bit Rates?

Bit rates are simply the number of bits that are visible or processed per unit of time. In video terms, think of the amount of detail that is stored per unit of time—here, megabits per second. As a reference, the Canon 5D Mark III records around 100 Mbps when capturing All-I footage, and the standard for Blu-ray is 40 Mbps. In hard drive terms, here are the theoretical speeds in Mbps:

- USB 2.0: 480 Mbps
- FireWire 800: 800 Mbps
- USB 3.0: 5 Gbps
- Thunderbolt: 10 Gbps
- Thunderbolt 2: 20 Gbps

A bit is a smaller portion of a byte. Just note that a byte is made up of 8 bits. So this is just a way of measuring units in digital form.

To Convert or Not to Convert

You might be asking yourself, "Do I need to convert my footage before I start editing? Why would I want to?" In years past, many editing programs couldn't handle the files coming from DSLR cameras because the files were encoded as delivery codecs (Figure 10.11). Since then, all editors have updated their software, and you can now edit files coming from the leading camera manufacturers in any NLE.

These are the main reasons you would want to convert your files now:

- Post-production–friendly codec that allows more latitude in post
- Downsampling 4K footage to a lower-res version to save time and storage during post

Figure 10.11: The information dialog box showing the codecs of the .mov *file from the camera*

Post-Production–Friendly Codec

You might want to convert your footage to a much more post-production–friendly codec that allows for more latitude during post for color corrections and adjustments to your video. Since most DSLR cameras capture footage in 8-bit color space, if you leave them in their current form you are stuck in 8-bit color space. If you convert to a post-production–friendly codec such as ProRes, you move into a 10-bit color space. Let me be clear that by doing this you haven't increased your color space from the original footage, but you are allowing the tools you will use in post a wider latitude as well as any effects you might add. Additionally, if you are not doing the editing yourself, then converting to a format your editor or post-production house uses all the time will help increase the speed of your edit and post.

4K to 1080p

Another reason you might want to convert your footage before you start your edit is because of file size. If you are shooting 4K video, you might want to convert your footage to a different codec and/or a smaller resolution, which will help speed your edit. Smaller file sizes mean less storage and less stress on your computer's resources. You can make a rough edit and then go back and use your original footage for your final output and deal with the higher-quality footage only at the end. Just note that currently there is little demand for a final 4K file, so likely the original 4K video files will remain archive files and the lower-res 1080 footage (or 720 if you are mastering at that resolution) will be your final output.

Another thing you need to decide a plan of action for is knowing whether you plan an online or offline edit.

Online vs. Offline Editing

There are various factors for choosing an online vs. offline edit for your film. Online more or less means you are editing with the original, unprocessed, or converted files at the highest quality so you can export the final project as is.

If you choose to do an offline edit, then you are using a compressed version of the footage for your edit. This means after you have completed your edit, you need to *replace* the compressed footage with the original unprocessed or ProRes version of the footage to create the highest-quality output available.

The best reasons for doing an offline edit are speed and data storage. You can convert/compress the original movie files to ones that are half the size or less. This frees you up to work with smaller, more portable drives if you need to be more mobile while you edit. Additionally, if you are not working on the latest machine that has the fastest processors, video cards, or RAM, you can use the converted/compressed video without taxing your current computer too much.

If you choose to do an offline edit, it is critical that you keep great notes on the structure of your original footage and try to match it exactly with any converted footage. Since there is no timecode with these cameras, you will be matching the footage with the filenames. If you don't keep the original filenames (for instance, you may want to change them to the scene number/take/date instead of `MVI_2304.mov`), you will need to be able to match those to the converted footage names.

If you decide to change the filenames from the camera, do it before you start your edit or it will be difficult to go back and match the renamed footage from your edit to the master full-res files with the original names from the camera.

If you do not keep track of your naming conventions, you could end up having a hard time moving from your offline edit to your online edit, and you'll create more work for yourself.

Choosing to do an online edit is great: as soon as you lock your picture, you can export and have a high-resolution file with no extra steps. This is a very effective workflow and can be easily achieved even without the fastest laptop or tower at your disposal. The big thing is organization and keeping track of where your footage is located and the naming convention you decide to follow for the edit. Once you make your decision, you can't change, or you will have to go back and rework what you have already done. This is especially key for working with 4K footage.

Codecs for Online and Offline Editing

Various manufacturers develop their own intermediate codecs. Apple develops ProRes 4:2:2, Microsoft develops Windows Media Video (WMV), RealNetworks develops RealVideo, and there are many, many others (Figure 10.12). You will see a master list of codecs in your editing software, and you might wonder, "How do I choose the right codec?" In reality, there is no "right" codec. Codecs are based on many different algorithms and were engineered for a variety of reasons. There are codecs that match capture formats (like DVCPro) that make it easy when choosing, and there are broader codecs like H.264. Covering codecs could easily fill a book or volume of books on its own. So, for simplicity and so you can get busy finishing your project, we are outlining a couple of codecs that should work great for your post-production workflow.

Let's start with the offline edit. H.264 video files are small, and we prefer to keep them that way. Unless you shot 4K footage and need to downres them to 1080 or 720, you should be OK. Many desktop and mid-to-higher-end laptops will handle 1080 footage directly from your DSLR camera of choice with few to no issues.

> If you finish your offline edit and you are happy the way it looks, you don't need to convert your footage to another codec.

```
✓ Apple Motion JPEG A
  Apple Motion JPEG B
  Apple MPEG4 Compressor
  Apple MPEG IMX 525/60 (30 Mb/s)
  Apple MPEG IMX 625/50 (30 Mb/s)
  Apple MPEG IMX 525/60 (40 Mb/s)
  Apple MPEG IMX 625/50 (40 Mb/s)
  Apple MPEG IMX 525/60 (50 Mb/s)
  Apple MPEG IMX 625/50 (50 Mb/s)
  Apple PNG
  Apple Pixlet Video
  Apple Animation
  Apple Video
  Apple Graphics
  Apple TGA
  Apple TIFF
  Apple FCP Uncompressed 10-bit 4:2:2
  Apple XDCAM HD422 720p60 (50 Mb/s CBR)
  Apple XDCAM HD422 720p50 (50 Mb/s CBR)
  Apple XDCAM HD422 1080i60 (50 Mb/s CBR)
  Apple XDCAM HD422 1080i50 (50 Mb/s CBR)
  Apple XDCAM HD422 1080p24 (50 Mb/s CBR)
  Apple XDCAM HD422 1080p25 (50 Mb/s CBR)
  Apple XDCAM HD422 1080p30 (50 Mb/s CBR)
  Apple XDCAM EX 720p30 (35 Mb/s VBR)
  Apple XDCAM HD 1080i60 (35 Mb/s VBR)
  Apple XDCAM HD 1080i50 (35 Mb/s VBR)
  Apple XDCAM EX 720p24 (35 Mb/s VBR)
  Apple XDCAM EX 720p25 (35 Mb/s VBR)
  Apple XDCAM HD 1080p24 (35 Mb/s VBR)
  Apple XDCAM HD 1080p25 (35 Mb/s VBR)
  Apple XDCAM HD 1080p30 (35 Mb/s VBR)
  Apple XDCAM EX 720p60 (35 Mb/s VBR)
  Apple XDCAM EX 720p50 (35 Mb/s VBR)
  Apple XDCAM EX 1080i60 (35 Mb/s VBR)
  Apple XDCAM EX 1080i50 (35 Mb/s VBR)
  Apple XDCAM EX 1080p24 (35 Mb/s VBR)
  Apple XDCAM EX 1080p25 (35 Mb/s VBR)
  Apple XDCAM EX 1080p30 (35 Mb/s VBR)
  Apple Component Video - YUV422
  No Video
```

Figure 10.12: The codecs within Final Cut Pro

For your online edit, take the footage you used in your offline and convert it to Apple ProRes 4:2:2. H.264 files when converted to ProRes files will jump seven to eight times the original size, so you need to make sure you have enough hard drive space before you start. It is during the online edit that you are going to do any sort of video adjustments—darkening, lighting, color correction, and adding of motion graphics to your footage. The Apple ProRes codec gives you the most latitude to work with your video footage and is why this is the best choice for your online codec. Just be aware that you need a lot of hard drive space, a fast computer, and lots of computer memory. The large files will really drain your computer resources, so make sure your system can handle the amount of strain you will put it through.

Behind the Scenes: Converting from Start to Finish

On our recent feature film, we used several different cameras, and most of the footage was in need of conversion before we could move forward with post-production. We wanted to make sure we ended up with every file in the same format for the edit. We used Streamclip for the conversion process. This step-by-step exercise shows the entire process of converting several files at a time, including the codec used and how the files were navigated between.

1. Open MPEG Streamclip.
2. Select File ➢ Batch List. The Batch List window will open.
3. Click the Add Files button. The Open Files window will open. From here, navigate to your master hard drive and to your original source files. Select the files you want to convert. Once you have selected the files you want to convert, click the To Batch button.
4. A dialog box will open asking you to choose a task. Leave it as the default Export To QuickTime, and click OK.

MPEG Streamclip – Movie Exporter

Compression: Apple XDCAM EX 1080p30 (35 Mb/s VB ▲▼) (Options...)
Quality: ☐ 2–Pass
100 % ☐ B–Frames

☐ Limit Data Rate: [] Kbps ▲▼

Sound: (Uncompressed ▲▼) (Stereo ▲▼) (Auto ▲▼) (256 kbps ▲▼)

Frame Size: No scaling will be performed Frame Rate: []
○ 444 × 333 (4:3) ☐ Frame Blending
○ 592 × 333 (16:9) ☐ Better Downscaling
◉ 393 × 333 (unscaled)
○ 720 × 576 (DV–PAL) Deselect for progressive movies:
○ 720 × 480 (DV–NTSC) ☐ Interlaced Scaling
○ 1280 × 720 (HDTV 720p) ☑ Reinterlace Chroma
○ 1920 × 1080 (HDTV 1080i) ☐ Deinterlace Video
○ Other: 320 ▼ × 240 ▼

Field Dominance: (Upper Field First ▲▼) Use "Upper Field First" for all codecs except DV

Rotation: (No ▲▼)

Zoom: 100 ▼ % X/Y 1 ▼ Center 0 , 0

☐ Cropping: Top 0 Left 0 Bottom 0 Right 0 (Destinat... ▲▼)

(Presets...) (Reset All) (Adjustments...)

(Preview) ☐ Fast Start (Cancel) (To Batch)

5. Now you can select a destination folder to have the converted files saved to. If you want, you can add multiple folders and convert directly to subfolders. Click OK.
6. The Movie Exporter dialog will appear (as shown here). There will be a drop-down menu next to Compression. From here choose the codec you want to use. For our rough edit, we chose the Apple XDCAM EX 1080p30 (35 Mb/s VBR) codec.
7. Next, move the Quality slider from the default 50% to 100%.
8. Uncheck the Interlaced Scaling check box. You can leave everything else as it is.
9. Click the To Batch button to start the conversion process.

Now that you have your footage converted and organized, it is time to bring all your footage into your editing program. Let's move on to the edit.

Converting Your Footage

How do you actually convert the footage? There are several different software products you can use to convert the footage. Apple's Compressor, CineForm's NeoScene, MPEG Streamclip, and Adobe Media Encoder are great tools for converting footage. You need to own Final Cut Studio in order to get Compressor, and you need to have Premiere Pro to have Adobe Media Encoder.

MPEG Streamclip is a great little product that you can use to batch convert your footage, and it comes for the very low cost of free. We have been editing in Final Cut Pro, and the testing we did had MPEG Streamclip conversions finishing before the Compressor conversions. Streamclip works on both Mac and Windows computers, and did we mention it is free?

Now you are ready to move to the creative and stylistic parts of post-production. Go through this checklist:

1. Back up raw field footage to at least two drives, and store them in different locations.
2. Organize and label the folders for all your raw footage and audio files.
3. Find out whether you need or want to convert your footage before you start your edit.
4. Convert your footage.
5. Back up your *converted* footage (on two drives), and move one drive to a different physical location.

You are now ready to import the files to the editing program of your choosing.

Editing Your Footage

The age-old saying is that you make your film three times. First you write your movie, then you shoot the movie, but it is in the editing room where you make your movie. We won't cover the entire editing process, nor will we cover any particular editing program as a step-by-step process. We will hit some of the key points you will want to be aware of when starting the editing process.

Choosing a Nonlinear Editor

There are many nonlinear editors (NLEs) to choose from. (No one uses a linear editor anymore; all editing software is NLE.) The big three are Apple's Final Cut Pro, Avid's Media Composer, and Adobe's Premiere Pro. There are some other editing programs or light versions of the big three, but if you are looking to edit your film, you need to buy, rent, or borrow a computer with one of the big three editing programs on it.

The main reason for using Final Cut Pro, Media Composer, or Premiere Pro is they are designed for large projects. On a film, you will have thousands of clips that cover dozens or possibly more than 100 hours of footage (Figure 10.13). You need an editing program that can handle everything you will throw at it.

Choosing your NLE is more difficult than it was in the past. Final Cut Pro has been the standard for the better part of a decade, so it was easy to steer people in that direction. However, with the major changes in Final Cut X, many people are unhappy with the new way of editing in the program. Final Cut X is a wonderful editing tool, but if you decide to go that route, just note there will be a learning curve to adjust.

Figure 10.13: All the footage from a feature film in Premiere Pro

Adobe Premiere Pro is a great tool and is now included in the Adobe Creative Cloud. So if you subscribe to the Adobe Creative Cloud, then you don't have to buy another program. Just note that Premiere is not a QuickTime-based editor, so you might run into some issues later in your edit if you don't know what you are doing. Premiere accepts all formats, sizes, and frame rates on the timeline, so users find it easy to get started editing. In other programs, you would be forced to conform and make everything play well from the start. Premiere saves those issues until later, so it is just something to be aware of. Again, I use Premiere Pro and love it, so this is another solid choice.

Avid Media Composer recently became affordable to the masses. When I started 15+ years ago, this was the industry standard, and it cost as much as a new car to buy. What is wonderful about Media Composer is it was designed to handle large projects like feature films. Its file-management features, rendering abilities, and other tools that allow you to do more on the timeline without going to other software products are second to none.

In the end, it really comes down to personal choice and what you are familiar with. There is no current industry standard, so find what works for you, and don't let that stop you from shooting.

Organizing Your Footage in Your NLE

As we have discussed, you will have a ton of footage, and organizing it within your NLE is crucial to your film (Figure 10.14). There are far too many audio and movie files to just dump all the footage into the project window.

Since there is a good chance you will have duplicate filenames, sorting through all your video files to find the shots you want would be a mini-disaster.

If you follow the same setup for organizing the footage in the editing program as you used in organizing the footage from the set, you will be in much better shape. Start by setting up bins in your project (Figure 10.15).

Figure 10.14: All of your footage placed into the project with no bins or organizational structure

Figure 10.15: Create bins that you can import your footage into.

Figure 10.16: Footage imported and arranged in bins according to scene numbers

It's best to set up bins according to your scene numbers and place all the audio and video files into that bin. If you go through and do that for the entire script, you have the start of your edit well under way. This will save you countless hours of searching through clips looking for certain clips or trying to find that one shot you are sure you filmed. If you are careful at this step to sort your footage properly, you can dig right in and start editing scene by scene in bite-size chunks that will allow you to keep your sanity (Figure 10.16).

After you have created the bins and have organized your footage, you will begin to sync your footage, as we will cover in greater detail in Chapter 11, "Audio Crash Course." As you go through this process, we suggest you become familiar with color labeling your bins. When you work with this amount of data, it is very easy to forget where you are at and what tasks you have done to what bin.

Whatever color-coding system you want to use is totally up to you (Figure 10.17). Just make a note of how you are labeling the bins/footage so you can stay consistent all the way through.

Figure 10.17: If you use labels and color code as you progress during your edit, you can visually see what stage each bin is at.

Capturing Stills during Editing

Many times on a low-budget shoot you don't have the money for a dedicated still photographer. This means you will miss out on some great production stills that you will need later. No worries, because there is a trick to pull some production stills directly from your footage. This is not the best option because you will have far less latitude in the images and they will be of much lower resolution that might limit some of the uses for the images. With that said, you will still need some additional shots, and here is how to do it:

1. Find the frame from the footage you want to use.
2. Make sure you are viewing the footage at its actual size.
3. Take a screenshot of the image.

This will need some cleanup in Photoshop. Screenshots are limited to 72 dpi, which is terrible if you want to print the image. If you have a bigger screen, try displaying your footage at full screen before taking a screenshot to get more information in the image to work with (but check the image quality of the resulting capture).

If you still need to print the image larger than you can with the limitations of screen captures, there is one last trick: display the frame onscreen and then *photograph* the screen. Take the image into Photoshop, crop out everything but the screen, and clean up the image.

Again, this is a *last-ditch effort*, but if you didn't get stills taken on set and you must provide stills for a film festival or investor packet, this may be an option you are forced to use. Obviously, taking great stills on set is the ideal, but if you didn't have the time or budget to get stills on set and you need a production still, then this is an option for you to use as a last resort.

eleven

Audio Crash Course

You have made it through your

shoot, and you have drives with extra backups lying around. It is time to start assembling your workflow for post-production.

Whether you have converted your footage or are working in an editing program that lets you edit native files, now is the time to sync up your footage. This is a critical and potentially time-consuming process. You have to do it right from the start, or there is a good chance you will have to redo it later.

Syncing Your Audio and Video

One way to sync your audio and video files is manually syncing them. This time-honored tradition stretches back to the invention of sound for movies. This is a pretty simple yet time-consuming way to sync your footage. You just find the start of each scene where you used a clapboard (or your hands), find the frame where the clapboard first closes, and find the audio spike on your audio waveform. Line them up, and you are finished (Figure 11.1). Considering you will have hundreds if not thousands of shots, you can see how this may not be the most efficient way to work.

Figure 11.1: Working in Premiere Pro and syncing audio with video clips

Before you start syncing your audio, you must first make sure your timeline or project file is set up properly so you don't have issues later down the road. If you have your settings for your project/sequence wrong from the start, then you may end up having drift audio issues where the audio slowly loses sync with the video. Also, if you try to sync your audio after a rough edit, it is infinitely more difficult and time consuming than doing it from the get-go.

Setting Up Your Editing Timelines Properly

The most likely explanation for audio sync issues is that your project has not been set up properly or that your audio recorder wasn't set up properly from the beginning. More specifically, if you shoot with NTSC frame rates (like 23.98 or 29.97) and have your project set up with non-NTSC frame rates (like 25 or 30), then you will have troubles with your audio drifting out of sync over the course of longer clips.

Changing the Speed of the Audio Clips

You have the option of changing the speed of your audio clips, which in theory will help you correct for the difference between 30 fps and 29.97 fps. The best reason to not do this is you would be resampling your audio twice. This would cause a quality drop right up front and can cause more issues as you move through post. Just because you can speed up or slow down clips from 99.9 percent or 100.1 percent and sync them doesn't mean you should. The best practice always is to set things up right to begin with and deal with issues only at the last few steps of post, not up front.

Setting Up Your NLE Properly

In a nonlinear editor (NLE), do these two key things to avoid sync problems:

- Never mix NTSC and non-NTSC footage in one sequence. Use Twixtor or Compressor to conform your clips to a common frame rate.
- Utilize an Easy Setup—an option in Final Cut Pro—that automatically matches your properties and frame rate.

To use an Easy Setup in Final Cut Pro, *before* you start importing your clips and setting up your projects and sequences, take the following steps. This will reduce troubles and prevent having to re-create a lot of your work at a later point.

1. Close all open projects.
2. From the Final Cut Pro menu, choose an Easy Setup that matches the frame rate of your video clips. If you can't find an exact match, pick one with the same NTSC properties as your video. For example, if you are working with 30.00 fps material from a Canon 5D, then choose an Easy Setup with a 25 fps frame rate.
3. Close Final Cut and restart.
4. Create a new project and import your footage.
5. Add your clips to the timeline (do this first so that Final Cut will autoconform the sequence if the settings are different from your clip).

Just like most things in filmmaking, it is best to check and double-check before you start. It is much harder to correct and change course after you have started down the path in one direction. Test your audio and make sure it is working before you jump in and start syncing hundreds or thousands of clips only to have to redo them later.

Syncing Footage Directly in Your NLE

You should begin by syncing your footage in your nonlinear editor of choice. We will look at both FCPX and Premiere Pro CC and how you can quickly sync your audio and video in those programs.

Final Cut Pro X

Follow these steps to sync your footage in Final Cut Pro X:

1. Make sure you have your audio and video clips in a bin (Figure 11.2).

Figure 11.2: Make sure you have all your video and audio clips imported into Final Cut.

2. Select the video file and the audio file by right-clicking both files (Figure 11.3).

Figure 11.3: Select the audio and video files you want to synchronize.

3. Choose Clip ➤ Synchronize Clips (Figure 11.4).
 You will get a dialog box asking you to name the clip you are creating (Figure 11.5).

Figure 11.4: Choose Synchronize Clips to start the process.

Figure 11.5: Name the new file you are creating anything you want.

Your new synchronized clip will appear in your clip window with all your other source clips (Figure 11.6).

Figure 11.6: The synchronized clip will be added to your project bin.

4. You can then open the clip in the timeline and listen to the synced clip (Figure 11.7).

Figure 11.7: Add the clip to your timeline and you can begin your edit.

Premiere Pro CC

Follow these steps to sync your footage in Premiere Pro CC:

1. Import your audio and video files into your project (Figure 11.8).

Figure 11.8: Your imported clips will be in your project bin.

2. Click both the audio and video files so both are selected (Figure 11.9).

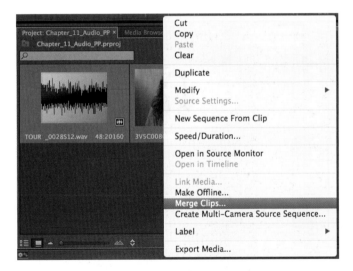

Figure 11.9: Make sure both clips are selected/highlighted.

3. Right-click (Control+click on the Mac) and select Merge Clips from the drop-down menu (Figure 11.10).

Figure 11.10: Select Merge Clips from the menu.

4. A dialog box will appear with options for you to merge the clips (Figure 11.11).
5. Under Synchronize Point, select Audio to sync the clips via the audio track (Figure 11.12).

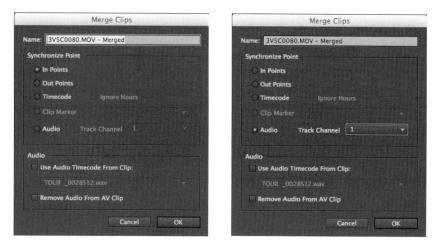

Figure 11.11: You can see the dialog box with all your options for merging the clips.

Figure 11.12: If you are merging the clips based on the audio tracks, make sure to select the Audio button in the Synchronize Point area.

6. If you want to remove the rough audio from your original video file, you can select Remove Audio From AV Clip and the resulting file will have only the newly synced audio from your external recorder (Figure 11.13).
 A new merged clip will appear in your project bin (Figure 11.14).

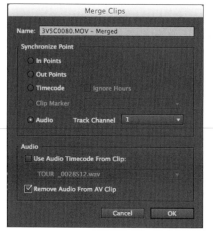

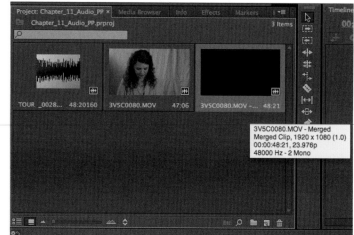

Figure 11.13: If you don't want both the new and old audio attached to the video file, you can click Remove Audio From AV Clip.

Figure 11.14: The merged clip will appear in the project bin.

7. You can then right-click (Control+click on the Mac) the new merged clip and select New Sequence From Clip (Figure 11.15).

Figure 11.15: Select New Sequence From Clip to add the new merged clip to the timeline.

You will now have the merged audio and video clip on the timeline ready for you to edit (Figure 11.16).

Figure 11.16: You are ready to edit.

Syncing Automatically with PluralEyes

Another way to sync audio is to let a software program automate the syncing process. The most popular today is a plug-in called PluralEyes made by Red Giant Software (www.redgiant.com). This plug-in sells for $199 full retail, $79 to upgrade from a previous version, or $99 for an academic license. PluralEyes works with Final Cut Pro, Premiere Pro, and Avid.

PluralEyes works by reading the audio files in the video files from the camera and compares them to the audio files off your external recorder. It matches up the waveforms and syncs them automatically. This is why it is critical if you choose a dual-audio system to get a good, strong audio signal into your camera. If you are shooting a scene with two cameras and one is close to the actors and the other is much farther away, this could cause problems. If the audio signal is too weak, PluralEyes can't match the waveforms, and you will be stuck doing all these takes manually. Trust us; it is much easier to make sure to get a strong audio feed into the camera than to touch a lot of your scenes manually in post.

To sync your audio from your external device to your video clips, follow these steps:

1. Open PluralEyes.
2. Import your audio and video files into PluralEyes (Figure 11.17).

Figure 11.17: Version 3 of PluralEyes is a stand-alone program and works outside your NLE of choice.

3. Once the files have been processed, you will see the audio and video files on the time-line (Figure 11.18).

Figure 11.18: All the audio and video files will be aligned to the start but they are not yet synced.

4. You can click the Synchronize button above the video preview window or you can select an option from the Sync drop-down menu to begin the syncing process (Figure 11.19).

Figure 11.19: Click Sync and let PluralEyes do all the work for you.

If the syncing works, you will see the files line up and colored green (Figure 11.20). This process can take a long time depending on the number of files you are trying to sync and how strong your reference audio is on your raw movie files.

Figure 11.20: Anything labeled in green is good and ready to edit.

Unsynced Files?

When you have finished running PluralEyes, there may be some files that can't be synced for a number of reasons. This can be because you placed movie files where there was no reference audio or because the reference audio was too bad for the waveforms to be matched up. Any non-synced files will appear red and not green (Figure 11.21).

Figure 11.21: Clips labeled in red are not synced and not ready to edit.

Look through the red files and determine whether they were supposed to sync or whether you had extra files in your sequence. Sometimes you will find you had extra video clips for a scene they weren't supposed to be in or MOS video clips that you shot without audio. Just make sure at this point that all video clips that need to have synced sound are synced, and categorize MOS clips that need to be moved to another project/bin.

If you shot with multiple cameras, no worries because PluralEyes can sync your audio and multiple camera sources all at the same time. You would follow the previous steps but you would need to create a separate video track for each camera.

Troubleshooting Out-of-Sync Sound

Sometimes your synced audio/video clip starts out matching, but the longer you watch, the more it drifts out of sync. This is not a new problem, nor is it unique to DSLR filmmaking. However, more and more people who shoot on DSLR cameras are doing more of the post

work themselves, and a lack of knowledge of what is going on behind the scenes can needlessly create headaches such as this.

Dropped Frames When using traditional video tape or codecs such as AVCHD, when you log in your footage, you actually capture the video instead of transferring it. At times during this process you can have dropped frames. Losing several frames of your video changes where the frames that follow line up with the audio track. Dropping frames in more than one place during capture compounds the audio drift. This is not the case with DSLR cameras, and we have yet to hear of a camera dropping frames while recording; however, you can never rule things out completely. If you are an adventuresome type who will install hardware hacks and push the cameras, you may come across this.

Recording Device Not Accurate As you have read in this book, the Zoom H4n is the recommended audio capture device for the dual system if you cannot hire a professional audio person or rent a 744T digital recording device. With that said, there are many other audio recorders on the market. There is a predecessor to the Zoom H4n called the H4; it is not as accurate as the H4n and is more prone to syncing problems in post. Other devices, such as the M-Audio Microtrack, are not as reliable either. Most of these audio-capture devices have an internal clock that helps them keep track of time and sync. Some models are not as accurate as you need for syncing people speaking.

It is best to do your research and make sure the audio device you are going to record with is accurate for syncing sound and can be changed to support the actual frame rate that you are shooting in the camera.

Frame Rates Many of the current DSLR cameras can shoot in a variety of frame rates, including 30, 29.97, 25, 24, 23.976, 60/50, and 59.97 fps. When so many different frame rates are available and you have two different recording systems, it is very easy to run into trouble.

The funny thing is that rarely is it the video or audio files that are the cause of most of the problems. Most problems arise from how you set up your editing program.

Automated Dialogue Replacement and Sound Effects

On any film there is no way to avoid at least one automated dialogue replacement (ADR) scene. Here are some quick tips and a step-by-step guide to ADRing a bad audio scene.

In the field, you need to make sure to capture or have your audio engineer capture room tone. This is a two- to three-minute audio recording of the ambient noise of your location. This is the foundation for all ADR work in post. If you don't get this on location, you can expect many extra hours or days of post work to get close to matching but may never match the audio that surrounds the new ADR scene.

1. Open your project with the scene you need to ADR (Figure 11.22).

Figure 11.22: Open the project and sequence you want to do your ADR work on.

2. Open your sequence and delete the original audio from the timeline (Figure 11.23). You may need to unlink your video and audio files before you can delete just the audio files. If you didn't record with any audio (meaning you turned off the audio recording function on your camera), you can skip this step.

Figure 11.23: You may need to unlink your video and audio files before you can delete just the audio files.

3. Select your room tone audio file that you recorded in that location (Figure 11.24).
4. Lay down the room tone audio in the timeline to fit the exact amount of time you need to fill (Figure 11.25). (If you need longer than the two to three minutes, you can just duplicate the clip over and over until you fill the total time you need filled. The reason you record three minutes of audio is that humans can detect audio looping if the loops are too short. If you have two to three minutes, you can just keep copying the file, and you are good to go.)

Figure 11.24: In this bin, the room tone is labeled AMBIENCET03.WAV.

Figure 11.25: Lay down the room tone track as your baseline.

5. Add additional audio tracks (Figure 11.26) for the number of items you will be using to rebuild the audio.

Figure 11.26: In Final Cut Pro on the Mac, you can simply Control+click under the audio files to add more tracks.

6. Lay your voice audio files to the video on their own audio track (Figure 11.27). Add each ADR track on its own track to keep each audio level separate and allow for maximum control during the edit.

Figure 11.27: Add your voice-over tracks under the ADR audio tracks.

7. Lay down your sound effects in their own track, if you need any (Figure 11.28).

Figure 11.28: Add the sound effects to their own track under the room tone and ADR tracks.

8. Lay down your music track (Figure 11.29).

Figure 11.29: Continue adding the score to its own track(s) under the other audio tracks.

This will help you rebuild any scene where you recorded bad audio or if some external noise pollution wrecked the perfect take. Just a little time and planning can make for a very smooth and successful ADR session.

Now that you have your field audio synced and your ADR done, you want to place in any sound effects for your film.

Finding Music

Let's not forget about one of the most important parts about any video—the music! In many cases this will be the reason your film or video is loved and shared or not. Bad music will kill all the other hard work you have done. Great music can transform what you have done to something you only dreamed of.

There are a few ways you can go about getting great music. Here are some resources:

- Premiumbeat.com
- TheMusicBed.com
- Pond5.com
- AudioJungle.com

You can find many other royalty-free music sites on the Web, so take a look around. The big thing with royalty-free music is the amount of time it takes you to comb through their libraries. Some sites have so many tracks you could search as your full-time job. Please note that "royalty-free" does not mean they are free, but rather they don't have copyright issues associated with them so you can pay to use them in your videos. You may be able to find some royalty-free music that is indeed free, but please don't get confused by the term.

Also available are services where you provide a song or a piece of music you like and they will try to pull tracks that are close. Sometimes websites offer this service, but other times they are part of a music licensing company that works with other companies that buy a yearly subscription to their libraries, and they help them find the best music for projects throughout the year.

My favorite way to get great music is to work with a composer and have them score the film for me. In general, this is a risky way to go because it tends to be expensive or the quality you get back for your cost may be low. The way I have had success is to find music from major motion pictures that I like and give me the feel I want. Then I find a composer whose work I like and play that for them. If they feel the same thing I do, I go ahead and work out a price and hire them. For the most part I have been blown away at the quality of work I have gotten back, and I get compliments all the time on the music from my projects. It takes more work and requires a longer post-production schedule, so this is definitely not for everyone.

twelve

Color Correction and Grading

Color has always been an obsession

in movies. Before movies could be shot with color film, colorists hand-tinted, dyed, and stenciled film in order to satisfy the filmmaker's vision. The advent of movies filmed in full color was met with enthusiasm and awe. Finally the film world reflected the colors of life and, most important, the colors of our imaginations. Color continues to be an obsession for filmmakers today because we now have the ability to not only shoot in color but also digitally manipulate any image to any color range our minds can imagine.

The topic of color encompasses not just creating the look of the movie but also correcting color problems and creating a series of seamless images that cut together into a final piece that looks like it was all shot together. DSLR filmmaking has some unique challenges in both capturing color images and refining the color process in post.

Color Theory and the Eye

As you work with the coloring of your project, your eyes (Figure 12.1) are the most important part of the process. In the end, there are technical changes that you can make and certain rules that you must follow in order for the film to be broadcast ready, but most of the decisions ultimately will depend on whether you think the image is pleasing to your eye.

Figure 12.1: The human eye can see anywhere from 2.5 to 10 million colors, depending on who you ask.

Color is a serious business. Did you know that there is an international organization devoted to many aspects of color including color standards and measurement?

The eye contains rods and cones named according to their general shape. The eye has greater numbers of rods than cones, and each serves a distinctive function. Rods are sensitive to levels of brightness or darkness, black, and white. There are three types of cones (Figure 12.2), and each type is sensitive to either red, green, or blue. Often, the red and green cones outnumber the blue-sensitive cones.

Figure 12.2: The human eye has three types of cones, which are sensitive to red, green, or blue.

These three colors, combined with the rod's ability to determine brightness or darkness, allow the eye to see not just red, green, or blue but the visual spectrum of colors (Figure 12.3).

Light rays reflected from objects are what make the color you see. Also note that light can work additively when emitted rather than being reflected.

When light reaches your eyes, whether direct or reflected, it will determine the colors you see. Light can reach your eyes through direct paths or from reflecting off objects. There is no intrinsic "color" property embedded in the material that is reflecting the light aside from what wavelengths of light it reflects.

Figure 12.4 shows color as an additive color system. Color is represented as a mixture of red, green, and/or blue. The choice of red, green, or blue is linked directly to the way the human visual system processes color. The RGB (red, green, blue) system is an additive color system that is crucial to color correction. Red, green, and blue are the primary colors. In between the primary colors are the secondary colors: yellow, cyan, and magenta. The secondary colors are created by mixing the primary colors in equal proportion, and in general the more color that is added, the lighter the color. In the middle of the color wheel is white.

Figure 12.3: The red, green, and blue cones together can see the total visible spectrum of colors.

Yes, the technical meaning of *primary color* used in color theory differs from the everyday meaning. Most people use *primary* to mean red, *yellow*, and blue.

The color system can also be thought of as representing light. Additive color systems are important in moviemaking; the various types of light going through the lens and hitting the sensor add to each other, and this is especially evident when using a filter. Additionally, projection equipment and many software programs use additive color language or theory in their design structure.

There is another color system known as the *subtractive* color system (Figure 12.5), which is best demonstrated when mixing paint or ink. When red and green are added together in an additive system, the result is yellow. In a subtractive system, it's more of a dull brown. It is also the method by which we see color in objects. An orange, for example, absorbs all other colors except orange, giving us the color it has.

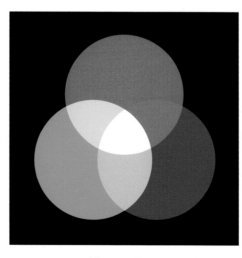

Figure 12.4: Additive color (notice how the center is white)

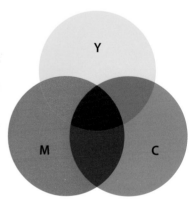

Figure 12.5: Subtractive color (notice how it is black in the center)

Subjective Properties of Color

Colorimetry, or *chromatics*—the technical term for the scientific measurement and description of color—is important for color correction and movie color design because some of its tools and terms are also used by filmmakers. While a filmmaker doesn't sit in a lab measuring color properties, the actual color properties will be involved in many areas of production. On-set color temperature is a critical concern, as are what filters to use, the relative quantity of light or the colorimetry standards used to broadcast, how to ensure that the desired color is able to be achieved with the video-recording system being used, and so on.

Colorimetry encompasses the two categories of the properties of color: *subjective* properties and *objective* properties. Color properties are a major component of color correction and grading. Understanding these properties as distinct characteristics is necessary for making and discussing color adjustment. The subjective properties for color are the value, hue, and saturation of a color. A subjective color system judges and categorizes colors based on these properties:

Value How light or dark is the color? The brightness of a light source or the lightness of an opaque object is measured on a scale ranging from dim to bright for a source or from black to white for an opaque object (or from black to colorless for a transparent object).

Hue What is the actual color? Hues are the color names you learned as a child, and what is called a color in regular conversation is normally referring to hue. A hue is red, green-blue, orange, and so on. For the purposes of depiction on a color spectrum or color wheel, hue is the direction the color is oriented toward.

Saturation How intense is the color? Saturation is the richness or brightness of a hue. Anything without saturation is depicted in grayscale. When you add black and white (gray) to any color, you reduce the saturation.

Many color correction programs or systems for examining color rely on color wheels. A color wheel (Figure 12.6) simplifies complex color information and relationships in a simple visual.

Understanding the color wheel is essential for making grading decisions. Primary colors are equidistant from each other on the color wheel and split the wheel into thirds. Secondary colors or complementary colors are equidistant from each other on the color wheel and also split the wheel into thirds. The perimeter of the color wheel measures hue; saturation is measured by the distance from the center of the wheel, with less saturation closer to the center and more as you move closer to the perimeter.

The perception of color is relative. Color's property of darkness or lightness is affected by the colors, darkness, or lightness surrounding it. A color interacts with what is around it on the screen. This relative value of aspects of the image can be helpful when creating a look for the final image.

The three subjective properties of color can be relative when viewed by the human eye when the final image is watched.

Relative Value A color will appear dark if it is surrounded by lighter colors, and the same color can appear light if it is surrounded by darker

Figure 12.6: Simple color wheel showing Hue, Saturation, Value (HSV) relationships

colors (Figure 12.7). The value of a color is defined in relation to the values of the colors around it. This linked definition forms a relationship between the colors in your image that can be manipulated based on what you want the viewer to notice the most in your shot.

Figure 12.7: Actual vs. perceived lightness/darkness value of an image

Relative Hue White seems like a pretty simple color to recognize until you walk into any paint store with the objective of picking out white paint. It is soon clear that "white" is a relative term. You can pick anything from a pure white that would stand out as white in nearly any setting to a white with creamier tones that would still appear white against walls painted chocolate brown. The relative nature of hue is present when discussing terms like *warm* and *cool* because these aspects of hue are dealing with psychological issues with color and perception (Figure 12.8).

Relative Saturation The saturation of a color can be relative if the saturation levels around it are diminished. A color will pop if it is surrounded by parts of the image that are muted or less intense (Figure 12.9). Saturation as a rule is perceived as more intense when it takes up more of the image. To make an image pop, put a saturated color on parts of the image that are less intense.

Figure 12.8: Notice how the center square is the same color, but your perception of it changes based on the surrounding hues.

Figure 12.9: Notice that the saturation levels may appear different depending on what is surrounding the color.

This relative nature of color is crucial for color correcting and grading purposes because eventually the end product will be viewed by a human eye that will perceive the colors and the image as a whole. This relative nature means that the colorist can guide the eye toward a particular part of the image or maybe trick the viewer by first leading them with color in one direction and then letting the action surprise them.

Objective Properties of Color

The subjective properties of color can make color feel fluid and somewhat arbitrary. However, the objective system of color is anything but arbitrary. In an objective system for color, the color properties are dominant wavelength, purity, and luminance.

The dominant wavelength is the measured wavelength of light that is combined with a reference standard light and matches the given color sample. Essentially, it is a measurement ensuring the colors match. Color and light are directly linked, and a measurement of light can indicate color.

Light itself is a measurable thing. The *electromagnetic spectrum* is composed of many different types of radiation, or energy that is moving. Visible light is part of this spectrum, as shown in Figure 12.10. Light is emitted at different wavelengths, and each wavelength corresponds to a specific color.

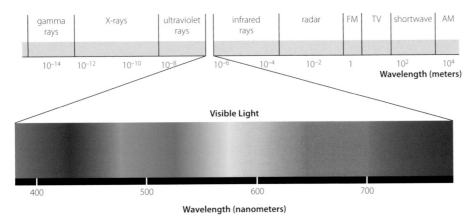

Figure 12.10: Visible light spectrum

The visible portion of the electromagnetic spectrum begins at wavelengths measured at about 380 nanometers, which is the measurement of a color perceived as violet. The range of the visible spectrum continues to wavelengths of about 700 nanometers, which is red. These different wavelengths hit the human eye light receptors (rods and cones) and are translated as different colors.

Purity is the degree to which a color is devoid of gray, white, or black. This is often linked with the definition of chroma. A color with high purity, or high *chroma*, will appear very strongly as that distinct color and not have the impression of being diluted.

Luminance is the term most crucial for DSLR color correction. Luminance is technically a measure of the intensity of the light through complex wavelength measurements of

reflected light in specific areas when the light is traveling in a set direction. In colloquial terms, luminance is often described as the brightness of the light.

Luma Luma is the brightness of a captured image. Luma is the black and white parts of the image and is represented by Y prime.

Luminance Luminance is the measurement of light being reflected off a surface.

Chroma Chroma, or chrominance, is the color part of the image. Chroma consists of two parts: hue and saturation. Chroma is represented by CbCr in digital component video.

One last color concept that is crucial is contrast. Many stylistic decisions will involve color directly; however, contrast is equal to color in importance.

Contrast is the relationship between light and dark areas in the image. When contrast is described in terms of value, low-contrast images have a low value difference, and high-contrast images have a high value difference.

Adjusting the contrast will direct the eye of the audience. Our eyes are highly adapted to contrast variations. People are generally attracted to the highest point of contrast and are more interested in images with a high contrast ratio. To increase the visual power of contrast, a scene with large objects and high contrast can be very compelling. Parts of the scene with low contrast will keep those aspects in the background, and they will not draw as much attention.

As you make decisions regarding coloring for the project, remember that the whole point is to add dimension to your image, tell the story through color, and create a look that fits the project's style and dramatic tenor. Through symbolic uses of color and controlled color planning, you can tell the story through image alone. Color decisions will show the audience where to look and how to feel and can ultimately shape their entire experience.

Color Correction on Set: Outside the Camera

The final look of your project and the coloring for your piece start with on-set choices. It is a good idea to take still images of your basic setups and locations, play with the potential lighting, and plan the overall color scheme prior to the shoot. You should make choices about color at every stage of production, even in pre-production as well as on set. Pre-production is the time to test footage to make sure that the final outcome matches the vision. On-set decisions ranging from wardrobe to light temperature will guide the look of the final piece.

Multiple Light Sources and Color Temperature

One of the biggest decisions will be the type of lighting used for the shoot. The color temperature is a defining characteristic of the overall color look of the final product.

Every light source will have a specific color temperature. These various color temperatures are useful when trying to design color to simulate realistic light on a set. For example, knowing the color temperature of fire in a fireplace will help when setting up a close-up of an actor who is being lit by that fireplace light, and knowing how certain light temperatures influence mood may help you determine the ideal color temperature.

Color temperature is a literal term; color is measured in degrees Kelvin. This temperature and corresponding hue can be charted (Table 12.1) to give the moviemaker an idea of

what color temperature is going to result. Color temperature is actually opposite the cultural view of color, which states that warmer colors are redder and cooler colors are bluer. On a color temperature scale, higher numbers indicate bluer tones, and lower numbers indicate redder tones.

Table 12.1: Temperatures for some common light sources

Light source	Temperature (Kelvin)
Match flame	1700K
Candle flame	1850K
Incandescent light bulb	2800–3300K
Sunrise, sunset	3350K
Midday sun, electronic flash	5000K
Sun through cloudy sky	5500–6000K
Cloud cover, shade	7000K
Blue sky	9300K

On-Set Changes in Light

Although digital technology allows for all sorts of adjustments in post-production, it is always better to get the shot as close as possible to the desired look in the camera and then make more subtle adjustments later. Here are some reasons to consider monitoring and, if necessary, changing lighting on set.

Scene Consistency As a commonsense precaution, make sure that your lighting (including contrast) matches the takes that will be cut together to form the same scene. As the shot changes, the lens may change, the camera position may change, the lighting setup may change, and so on. This is essentially your process of color correction/balancing on set.

Shot Consistency Watch the entire shot play out to make sure the lighting is what is envisioned. Make sure your lighting works for all of the movement within the shot. If there is camera or actor movement, double-check that all of the aspects of the scene are properly lit and the color temperature for each light is what you envisioned. If there is an undesired color temperature change midway through a shot, it will be difficult to remove or drastically change it in post.

Available Light and Sun Consistency If you are shooting an exterior day shot and using the sun as your light source, you need to realize that your light source is constantly changing. As the sun moves across the sky, the angle, the intensity of its light, and the color temperature of the light will change throughout the day. These changes can even be noticed within the scene if the take is long enough or if you are cutting together clips taken over a couple of hours. Note that the changes are subtle and almost imperceptible to your eyes, but in the final footage you will clearly see the changes over time. So you will need to make an effort to keep the lighting consistent.

Remember that the actual color of the sunlight changes as the day progresses (Figure 12.11). The color can range from pure white to shades of orange, red, and yellow.

Figure 12.11: The Helios Sun Position Calculator for the iPhone and iPad helps you predict where and at what angle sunlight will be shining on the day of your shoot.

Proportion of Light, Keeping Contrast, Keeping Brights Bright It is necessary to think about lighting ratios on set. Lighting ratios are the difference in the light on your subject, most often between the key and fill sides of your subject. It also pertains to the differences between the highlights (bright spots of your scene) and the shadows (darker parts of your scene.) This is especially true when the final image will be a high-contrast look. It's important to keep track of the proper lighting ratio with light intensity, angle, and distance to ensure that if the contrast is tweaked in post, the high-contrast look can be achieved without the blacks becoming noisy or the highlights blowing out.

Gels and Filters

One way to change your color is to add color filters directly to your lens. This will affect the entire image and does not allow you to locally affect subtle changes in the frame. This change in color temperature can help create an even image or correct color casts when using different types of lights in a single shot. This ability to blend several kinds of light sources into a single visual look can be useful if you have little to no control over how many types of lights are in a scene. You can also use filters if the color temperature or overall color needs to be changed for an effect. An ND filter can be useful to lower the overall intensity of a light source while retaining the desired color temperature.

Filters use a slightly different method of indicating color temperature, known as MIRED. When using gels to change the color temperature of a light source, you use MIRED values to calculate how much the temperature will change with a particular gel or how much change is needed on a particular light source. You can think of MIRED as a *relative* value for color vs. degrees Kelvin, which is an *absolute* one.

A gel, which mounts on the light instead of on your lens, can be used to affect the color temperature or brightness of a single light source. Gels are easily movable and adjustable to allow for many variations on a set. Color temperature decisions are a primary concern and influence the entire visual image and tone. It can be useful to adjust the some of the lighting's color temperature by using gels or use a second color temperature to provide

a visual effect. If the lighting setup is complicated or many different color temperatures or color hues are desired, gels will allow the lights to be easily altered and adjusted to fit the vision.

Sometimes the Camera Sees Things You Don't

Occasionally a situation may arise where light doesn't respond the way your eyes perceive it, or a "phantom" light may show up on the image that wasn't seen on set. Being aware of this potential and double-checking the image will help eliminate unwelcome surprises in post. The following are a few circumstances where the lighting can be altered unexpectedly.

The color of lights that are visible on set or location may not show up on the final image if the light is too bright. The DSLR camera sensor is very sensitive to light, but one trade-off is that if a light is too bright, the actual color of the light may be blown out and appear simply as a white-toned light. So, if there are bright lights that you desire to have colored in the final image, they may need to be dimmed to the point where the color will be picked up by the camera's sensor.

The white balance that your eye sees can be different from the white balance that will be in the final image because of the chromatic adaptation of the human eye. The human eye makes white balance adjustments constantly in the overall area or when moving from one white balance to another. The adjustments your brain and eyes make allow you to see color contrasts in many color temperature settings. This means that on set you may not see what white balance will show up or how dramatic the light temperature changes in the scene may be as the actor moves from one area to another. Your eyes and brain are constantly adjusting the white balance to give you coherent vision, but the camera has only eyes.

The color of the area surrounding the shot may influence the color that appears in the image. If very prominent and strong colors are near the shot, these colors can be reflected into the shot itself and/or create a color cast over part or all of the shot. In short, the shot is influenced by all nearby light and reflected light.

Color Correction Card

For extra insurance or when the lighting is tricky, shooting a color correction card before taking the shot will help the color correction process. The color correction card is a simple card with preset colors in squares (Figure 12.12). The card is a guide on set for the proper exposure of colors. Later, the card image allows the color correctionist to match to the colors and apply those corrections to the entire piece of footage.

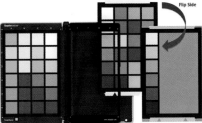

Single Camera Shoot vs. Multiple Cameras

Many productions whether large budget or micro budget now shoot with multiple cameras. Multiple cameras have some advantages that apply to color correction. When multiple cameras are used for a shot, the lighting, setup, and balance will stay the same for each camera, and the footage can be cut together with little variation in the color of each camera. This assumes that the white balance of each camera is the same, which can be a challenge because the color settings for cameras from different manufacturers can be slightly different.

Figure 12.12: You can use something like the Datacolor SpyderCHECKR 48-color test chart and reversible neutral gray cards to help you get the correct colors from your footage in post.

When shooting with a single camera, lighting usually has to be reset between shots, and the angles can change, creating more room for error in lighting continuity. This means that the colorist will likely have to do some balancing to ensure that the scene can cut together with continuity of color. Because DSLR footage has limited latitude for change, it is important to make sure that the look of the shot stays consistent as camera setups change.

It may be useful to take test shots of the basic lighting and setup and have a colorist correct test shots to ensure that the final project is attainable based on technical decisions and budget.

When testing footage, the test will be far better if the level of detail in the test shot is as close to the real thing as possible, even things like the skin tone of the actors and the time of day you plan to shoot. This is especially important if you are using sets that are influenced by outside light. Even small details like wardrobe choice can influence the project. It is important to test the colors of the wardrobe and sets to ensure that as color is adjusted, the look stays consistent and that the colors complement the project. Take note of anything that may reflect color on the scene or any large portions of the image, thereby creating odd color tints or color casts. Take every detail of the project and examine it with the same strict eye that has just been given to wardrobe color; the test footage will help you make sure that your on-set color choices are informed.

Checking the shot with a properly calibrated monitor and on the camera screen will help make sure that the footage has the proper color. You should also check the footage after it is shot so you can make adjustments if necessary. Adjusting color on the set is usually better than waiting until post to color correct. DSLR color correction in post is most effective when the footage was shot as close to the ideal as possible.

Color Correction on Set: Inside the Camera

To capture video with correct color, it is important to set up your camera properly. First, you need to set the white balance of your camera. By setting the proper white balance, you are able to tell the camera what white is and have all other colors fall into the correct range. Second, and a bit more confusing, is the picture-style settings or custom image styles of the camera. You can modify these picture styles to help change contrast, saturation, sharpness, and more. All of these not only can help you get the proper color set but also can assist you in achieving the best results in post in terms of final color correction of your footage.

White Balance: Setting It in the Camera and Changing for Effect

The white-balance control of the camera adjusts colors so that white objects are actually recorded as white in various lighting conditions. The point of this is to get the whites in the shot to match true white as best the camera can. If you stand under an incandescent bulb holding a white sheet of paper, it will appear white to you because your eyes have adjusted to the color of the bulb. However, a camera will record it as orange. The goal is to record what you would perceive in that situation rather than the actual lighting conditions.

The DSLR camera that you are using will likely have automatic white balance settings. You can use automatic white balance settings on the camera if you like, but auto settings often are not as accurate as manual methods (Figure 12.13) when shooting video. Also, if you are going to do any post color correction, manually setting the white balance on the camera will ensure that the post process starts with footage that is less in need of

correction. Accuracy with desired white balance is the first step for color correction that you can do with your camera.

You can also achieve this by using the camera's white balance presets. These presets are designed to give proper white balance under various lighting conditions across several color temperatures. You can also use these presets artistically to add various tints to your image. The presets can also be used for a simple "day for night" effect by using the tungsten setting and altering the exposure. This makes for a somewhat convincing bright moonlit night.

To increase the flexibility of the white balance settings, you may be able to fine-tune the white balance preset. You can often tweak the automatic white balance settings by adjusting the warmth or coolness of the setting.

Manually adjusting the white balance allows customized settings for each shot. Before shooting, point the camera at an area

Figure 12.13: You can always select the automatic white balance setting on your camera in a pinch.

in the scene that should be white or a target card that is neutral gray, and take an image (Figure 12.14). Then set the camera to make this the custom white balance for the shot. For more precision, you can use this same process, but instead of shooting part of the scene, you can fill the frame with a card. There are specially designed cards with calibrated colors that are the proper neutral gray shade for white balance settings of the camera. Once again, you take an image of the card and set the white balance to that image. You can often save these white balance settings to provide a quick custom white balance for a location.

Figure 12.14: In addition to using color cards, you can use white or gray cards to help you achieve the proper white balance for your footage.

The presets for white balance in a camera may not be exactly what are desired. Some cameras may have a bent toward a slight tone in one color, or you may need a specific color bent. You can alter the white balance by using the white balance shift options (Figure 12.15). The white balance shift selection allows for adding or subtracting color tones and essentially allows for color correction to happen in the camera.

Figure 12.15: In the Canon 5D Mark II, you can manually shift your white balance to compensate for color pollution from your sensor in your footage.

If multiple cameras are being used for a shoot, it is helpful to have them all set to the same white balance. The white balance of different camera brands, and even different cameras within the same line, often has subtle differences. With DSLR video, it is important to maximize color space because digital video is much less flexible than film. Keeping the white balance perfectly matched maximizes the color space because if you are shooting the whites as close to the white tone you desire and using the overall color temperature, the post team will have more room to play with the look and won't spend the color latitude merely color matching.

To adjust several cameras to the same white balance, pick the master white balance camera and set its white balance to your approval. Put the footage of the master white balance camera and that of the other camera side by side on screen or on two identical and calibrated monitors. At this point, it's a matter of tweaking the white balance shift options until the look of the white balance matches (Figure 12.16).

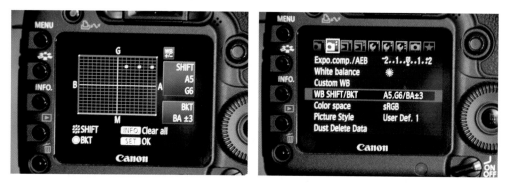

Figure 12.16: The settings on this 5D Mark II show the white balance being shifted toward the green and red spectrum.

When you are testing the white balance, bracket your test shots. White balance bracketing works like exposure bracketing to give you several images: the original, one brighter, and one darker (Figure 12.17). This is useful if you have a shot and a white balance selected but aren't sure exactly how much of a color shift you want. The bracketed shots will give you test images to allow you to pick your final white balance custom setting.

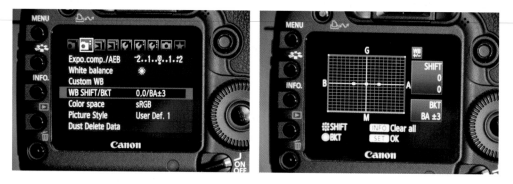

Figure 12.17: You can set the 5D Mark II to bracket up to three times so you can better pick your final white balance setting.

Picture-Style Settings

DSLR cameras are consumer cameras and were not designed to be professional cameras in that they are set at the factory to provide a standard image that consumers find pleasing to the eye. This causes a problem for filmmakers who want to control the image.

In general, the camera's settings have sharpening, saturation, and contrast set too high. All of these functions are best done in post-production rather than in the camera. Once these have been applied to your image, they are very difficult to remove.

Shooting Flat or Not? Sharpening or Not?

You may have heard the phrase "shooting flat." This means setting your camera to shoot an image that is not sharpened, has a low contrast ratio, and has the color saturation turned down. If you compare a flat image with an image that is shot with the factory presets, you will find the footage shot with the factory settings much more appealing. Don't let that fool you as you look at the flat footage. In post you will clean up the image, and the result will be better than the factory settings. If you aren't familiar with working with flattened footage, this takes some time to get used to.

In short, it's best to set your camera to the most neutral setting for color saturation, sharpening, and contrast. The details will vary with each camera, but in short, turn off sharpening, turn off any enhancements the camera may be adding, and set any brightness and contrast settings to off or neutral.

Shooting When There Aren't Going to Be Any Post-Production Changes

The best practice with DSLR cameras is to shoot flat and correct in post, but there may be times where you don't have the resources or tools to do much correction in post. If you are just starting your career and want to focus more on techniques on set than in post, you can set your camera to split the difference. Turn down the sharpening, contrast, and saturation, but just don't go as far as to turn them off. Any editing program can make minor adjustments, but if you leave your footage as it is right out of the camera, you should still be good to go.

Remember, the look of your film is your vision. Shoot some tests and try adjusting all of the settings. You may find the right combination of settings that gives you a unique look that doesn't require much or any post-production color. The camera is flexible, and test footage, unlike in the film days, is essentially free. Test, test, test, and test some more.

What Is This Camera Shooting Anyway and Why Do I Care?

The first thing that is important to know is what kind of color space and color information your DSLR camera is capturing. All of the current DSLR cameras will capture the video in a codec that will compress the color. Most DSLR cameras will produce 8-bit video with a 4:2:0 color space, but some now are recording 4:2:2, and in some cases you can capture output from the camera in 10-bit color. The importance of these technical specifications becomes clear when post-production color correction is necessary for your production.

When planning for color correction, you need to consider the available color space. A color space is an agreed-upon way of defining colors, usually involving the mathematics of color. Knowing what color space is available will help in determining what colors will

be available for color correction and what range of color can be captured by the video. You don't get to pick what color space you want to work with when dealing with a DSLR camera. It is predetermined by the camera itself or in some cases the external output of the camera, and only color variations that are capable of being produced by the camera are available both in capturing the image and in post color correction.

Video color space is *device-dependent* color space, meaning that it's color space that is determined by a device—in this case the camera system that reproduces the color in a predetermined color gamut.

A *gamut* consists of the actual colors or variations of the colors that appear in a color space. The phrase "run the gamut" works as a reminder; the gamut is the entire subsection of colors available or that can be accurately reproduced in a given color space.

Color Spaces in Video and Encoding

Color space is independent of any particular device or method of capturing the colors. Another way to think of this is as an absolute reference to a particular color. If I describe a car as red, how do you know which red I'm referring to? A color space is a universal, accurate, and consistent way of referencing color. However, the point of the movie process is to actually get these colors onto the recording device, in this case a DSLR camera, which has a system for encoding the color information.

A *color encoding model* or *color mapping system* is a method whereby the image can be reproduced or generated to another device. Color mapping specifically refers to encoding that is necessary when one color space and gamut are mapped into another color space.

In the post-production color process, the color space and gamut determined by the camera must also be reproduced by monitors. The monitor is not reproducing the actual color space (because that was already determined when the image was shot) but must be able to reproduce the captured color space.

DSLR video deals with color by encoding it in the signal. During encoding, the brightness/luminance of the video is given higher priority than color. This is because the human eye is more sensitive to luminance than it is to chroma. Luminance is given a dedicated channel, the Y channel.

The color information is then split into two channels, a blue channel and a red channel. These channels have several different names; they are often named Cb and Cr for "blue-difference chroma" and "red-difference chroma," or in some models they're named U and V. Many types of video are broken down or encoded in this fashion. These channels have a range of values between 0 and 255. Most major video formats use some flavor of the YUV color space (see Figure 12.18).

Figure 12.18: A YUV color space visual example. Top to bottom: composite image, luminance channel, blue-luminance channel, and red-luminance channel

Here are the several different ways of naming the component video:

- Y, R-Y, B-Y; Y = luminance, R = red, B = blue
- Y, Cb, Cr; commonly written as YCbCr or YC_BC_R
- YPbPr
- YUV

The crucial point to remember is that this method of encoding the RGB color space provides for three channels: one channel that essentially is a grayscale image that is focused

on luminance and two channels with color information. This means that when color correcting, most programs such as Apple Color allow for separate manipulations of luma and chroma. Because the luma and chroma are separate, it is possible to manipulate hue and saturation without making color lighter or darker, and vice versa.

Bit Depth and Color Depth

Bit depth indicates the number of bits that are used to represent color in a pixel.

A bit is not the same as a byte. A *bit* is the smallest data amount. It can be 1 or 0, black or white, on or off. An ordered group of 8 bits is a *byte*.

When light hits the sensor, it is converted to numeric data. Every pixel has a set of numbers available for assigning colors. Typically zero represents black, and the highest available value represents white. The maximum value in each bit depth represents the same signal; however, lower bit depths simply have fewer numbers to work with over that same range, and this results in fewer color values and more distance between the colors. Think of a box of 64 crayons vs. a box of 8. Having fewer color choices also means that it is harder to get a smooth flow from one color hue or tone to the next; colors can be moved only in whole numbers. For example, if the 129 red looks too dark, you have to move to 130 red, but you can't move to 129.5 red. Full steps are the only available option. In this instance, having more red numbers or steps to pick from, like in higher bit depths, would enable the color changes to have greater flexibility and smoothness. In 8-bit, even a single step in color can be significant in comparison to a one-step increase in a higher bit depth system.

The more bits per pixel dedicated to color, the higher the bit depth and broader the range of color that's available. The bit depth will indicate the range of color that is available in a given color model. Many color models are 8-bit or 16-bit, but they can be much higher. There is a good reason why smaller bit depth is chosen: as bit depth increases, the requirements for space, processing speed, and storage also grow.

Most current DSLR video is 8-bit, which means that the bit depth offers considerably fewer colors and less adjustment latitude than film or higher-bit-depth color models in the post process. Obviously, 10-, 12-, or 16-bit color would provide much more latitude for color correction, but take heart; 8-bit color is not new in the video world, and amazing amounts of color correction work can still effectively be done in post.

The bit *rate* (or bitrate) should not be confused with bit *depth*. Bit rate refers to the rate at which data is being transferred over a unit of time.

RGB 8-Bit

Looking at 8-bit color helps you see where the limitations are in using this color mode. In 8-bit there are 256 (that is, 2^8) tonal values. Those shades of gray are then multiplied over three color channels (256 red values × 256 green values × 256 blue values) to show how many theoretical colors you can describe in that color space. The result is that there are more than 16 million possible color combinations, which sounds like it would be plenty (and in many ways, it is). The challenge comes when those colors are shifted during the

color correction process. What once seemed like a vast array of colors gets compressed quickly and reveals issues like posterization and color banding.

8-Bit and YUV or Other Encoding

Another factor contributing to this challenge is that DSLR video isn't technically 8-bit RGB; it is 8-bit YCrCb or other similar encoding. The colors for YUV and YCrCb or similar encoding work a bit like RGB. The luminance channel starts at 0 for black and has the white at a maximum number, which for 8-bit is 255. The two color channels consist of positive and negative numbers because the color channels are covering more than one color tone. For example, the negative numbers or steps in the blue channel will produce a yellow color, and the color will be set based on a mix of the two colors at the ends of each channel.

Posterization and Color Banding

Posterization occurs when there is the breakdown of a smooth color gradation into a grainier appearance. This is most often seen in a blue sky. Color *banding* occurs between color levels. Color banding is distinct and abrupt color changes consisting of small color lines or bands appearing on the image where the color is supposed to be shifting shades more gradually. This happens most often in low-color bit-depth systems like 8-bit when the tonal range is being stretched past the scope of bit depth in the image.

Working in 16-Bit When Dealing with 8-Bit Reality

Even when capturing 8-bit color, sometimes the post color correction will be working with 16-bit color. This doesn't mean that colors are magically added to the final image; rather, the available color values are allowed the latitude to work within a wider range. As the modifications are applied, the full range of color is available, and the results may be smoother even when going back to 8-bit. In the end, there may be some value in working in a 16-bit environment even with an 8-bit project.

Compression, Subsampling, and Color

Video shot with current DSLR cameras is highly *compressed*. Compressed video reduces the file sizes, which makes the files more manageable, extending memory card storage, and makes them faster to move and easier to store. It also allows for lower-speed memory cards because the data rate is lower. Compression is perceptual, which means that the method uses visually similar colors and shapes to represent those areas with less detail. Obviously,

there are compromises with compression, specifically a functional decrease in quality and lack of information in comparison to uncompressed images even if the results aren't readily visible.

See Chapter 14, "Fixing It in Post," for a complete discussion of compression.

Chroma subsampling or *color sampling* is similar to compression in that it results in smaller file sizes, but the process is very different. Subsampling reduces the color information by simply discarding it. This reduction in color information captures less data and produces video files that are smaller.

To understand how the pixels are recording color information through subsampling, keep in mind that the human eye is more sensitive to changes in brightness than to changes in color. This rule comes in handy because each pixel has a unique luminance/brightness value that indicates how light or dark that pixel is—this is the Y value. However, individual pixels aren't given color information as a distinct number. Instead, color information from several adjoining pixels is averaged into a single value. In short, while each pixel has its own brightness value, two or more pixels may share a single color value.

To see how subsampling affects color, it helps to examine uncompressed color on an individual pixel level. Uncompressed color is portrayed as 4:4:4. The first digit indicates how many pixels out of four have a unique luma (Y) value. The next two digits indicate how many pixels out of four have a unique color number for the two color information spaces (Cb and Cr). In YCbCr, 4:4:4 color space, each pixel would have its own Y value, Cb value, and Cr value. Every pixel is providing both color and luminance values, and nothing is being lost or discarded.

This is easier to see when looking at the actual pixels. Figure 12.19 shows how brightness values are per pixel but color values are averaged across two or more.

Now compare Figure 12.19 to the example of 4:2:2 subsampling shown in Figure 12.20. This type of subsampling is commonly seen in DigiBeta video content. Here, the first digit indicates that four pixels each have unique luma values. The second digit indicates that pixels 1 and 2 share color information averaged together into a single-color information space. The final digit indicates that pixels 3 and 4 also have colors averaged together into one color information space. Essentially, color is being sampled at half the rate of luma. This decrease isn't visually significant for many formats, and it greatly reduces file size.

4:1:1 subsampling (Figure 12.21), which is used in DV video, has four pixels with unique luma values, but all four pixels share a single color value averaged across all four pixels. Hence, the color is being sampled at only one-quarter the rate of luma.

Many leading DSLR video cameras use 4:2:0 subsampling (Figure 12.22). Here all four pixels have a unique luma value, and the color information is sampled in a different way. The color information is sampled on every other line. It gives a greater depth of color information or resolution on each line for one particular color or channel but at the loss of half the original color information.

Figure 12.19: A visual representation of 4:4:4 uncompressed color

Figure 12.20: A visual representation of 4:2:2 color subsampling

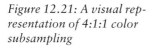

Figure 12.21: A visual representation of 4:1:1 color subsampling

Figure 12.22: A visual representation of 4:2:0 color subsampling

There are several different ways in which 4:2:0 subsamples the chroma information. Essentially it reads a combination of pixels in various formations for the chroma information, but the concept is the same. There are luma values for each pixel, but the chroma information is sampled from every other pixel for every other line.

This subsampling has an effect on color post-processing methods and planning. For color post-processing, the more color information that you have, the better, but DSLR video is literally lacking some color information. This means that certain problems, such as color artifacting and color smearing, can occur more easily, making it crucial that the footage look better on set than to rely on major post color correction changes.

Post-Production Color Correction and Grading

Color correction is divided into fluid categories. In general, *color correction* refers to changes made in order to get the image to look correct—in other words, actions to fix things. *Grading* generally refers to changes made to create a look or a specific change made to footage for overall effect. However, these terms are often used interchangeably and can overlap.

A simpler way of breaking down post-production color is into primary correction and secondary correction and grading:

Primary corrections are usually done first in the process, and they are corrections that apply to the entire image or shot. These corrections include removing color casts, changing contrast, fixing exposure problems, correcting white balance, fixing color balance, tweaking saturation, and checking to make sure the footage is constrained to broadcast legality parameters. A goal of the color correctionist is to provide continuity in color across each scene, and corrections will be made so that the shots flow smoothly.

Secondary corrections and color grading are usually tackled after primary corrections are done. Secondary corrections refer to changes that are done to just part of the image or one aspect.

Color grading is done to give the footage a stylized look and is where creative vision really kicks in. Creating a look is the driving force behind many high-end color production software packages, and color grading is likely the part of color most commented on

when watching the final project. The look is not just a technical aspect of the project but rather how the story is told through color and how mood is conveyed visually.

Evaluating Footage

It helps to plan the processing and color correction of the footage before all the footage shows up on your computer or with your color correctionist. Even if you aren't personally going to be color correcting, understanding certain terms and tools is helpful in discussing the process. This section will not show you how to use a specific color correction program or give you detailed steps for the color correction process. Instead, it is an introduction to the terminology and techniques and will provide a jumping-off point either for a specific program or for overseeing a color correction process. It is critical that you know and understand this information before you start playing around in software that allows you to manipulate color.

The first step is to evaluate the footage. The primary tools that you are going to use in the process of determining what needs to be adjusted are scopes and histograms, but in the end your eyes will be your ultimate tool. Color correction is a science and has a technical aspect, but even the greatest color corrector still goes back to "what looks right," and the look of a movie is created by the moviemaker's aesthetic choices.

When preparing for color correction, the following are some initial questions that need to be addressed:

- Is there an exposure problem?
- What parts of the image should be white? Are they actually white? What parts of the image should be black? Are they actually black?
- Should the image be warmer or cooler?
- Are the skin tones the proper color?
- Is the footage too dark or too light?
- Is it too flat? Does it have too much contrast? Where should contrast be added? Does a certain aspect need to pop more?
- Is there a color cast?
- Is there too much saturation? Should some colors have saturation increased?
- How should this image be altered to achieve the desired look?
- Are there specific isolated problems?

Scopes and How to Read Them

Scopes are the tools used to measure video signal. When properly configured, scopes will give the most accurate view of what is happening color-wise with the footage. A scope provides a visual graph of information about video and color levels in all sections of the footage.

There are different types of scopes, hardware, rasterizers, software, and scopes used in dedicated software. Most people shooting DSLR video will rely on scopes built into the editing package or compositing tool (Figure 12.23).

Rasterization is a process in which a picture based on vectors or equations is converted into an image that is made of pixels or pattern of dots, usually so it can be outputted to a monitor, television, or film negative.

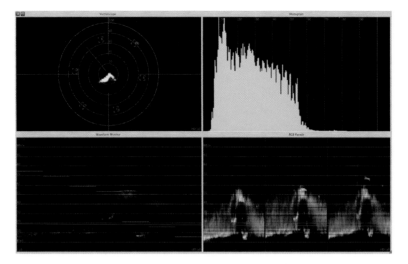

Figure 12.23: In your NLE, you will have access to a vectorscope, histogram, waveform monitor, and RGB parade.

Software scopes are present in color correction software. The scopes will help you evaluate the footage once it is imported into the software. They are simple to use and often have adjustable elements that allow the footage to be viewed and adjusted in a minimum of steps. There are also stand-alone software scopes, but these tend to be very high end and outside the needs of most DSLR shooters.

Let's look at the various settings available on your scopes.

Histogram A histogram is a graph that charts every pixel based on luminance value and shows a breakdown of pixels through the entire tonal range. The histogram shows the quantity of darker pixels on the left and lighter pixels on the right. Every shade of gray in the image is represented in the space between the ends. The relative quantity of pixels at each luminance level is represented vertically (Figure 12.24), so the higher the peak, the greater the quantity of a particular light or dark value. When set to RGB, the histogram also can show each color channel graphed individually.

Figure 12.24: The lines in your histogram are a representation of the luminance of the overall image.

Waveform Scope or Monitor The *trace* (the dots or lines representing the data) on the waveform scope is a mirror of the image on the footage. The left side of the scope corresponds to the left side of the image, and the right side of the scope corresponds to the right side of the image. The trace mirrors the image completely but doesn't show the picture. The trace shows the white and black levels with the entire grayscale. The trace is positioned on a scale; the bottom represents the black, dark pixels, and the top represents the white, light pixels. The middle is the area for the gray pixels. The trace is positioned to match where those pixels appear on the image (Figure 12.25).

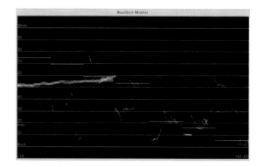

Figure 12.25: The same image viewed through the waveform monitor

RGB Parade and YCbCr Parade The luminance information is broken up into red, green, and blue channels and displayed separately in a row. Each color has its own section, called a *cell*, and the information about the amount of the color is repeated for each color. Occasionally there will be a fourth section or cell for luma displayed. The YCbCr parade works exactly the same way, but the first section is for luma, and the next two are for the color channels. When you are using color correction software, the RGB parade scope will be used because the color correction software techniques are based on RGB additive color theory, but the YCbCr parade is a nod to the fact that the video footage was encoded in YCbCr or a similar encoding (Figure 12.26).

Figure 12.26: When the same image is viewed through the RGB parade, you can see the red, green, and blue values in your image.

Vectorscope Knowledge of the color wheel is key to understanding how the vectorscope works. The scope follows the color organization on a color wheel and follows all of the color wheel precepts. The angle around the scope is for hue, and the distance from the center indicates saturation. The vectorscope trace mirrors the colors displayed on the footage in terms of hue and saturation. The vectorscope has information about each color and displays a trace about what colors are in the scene. Nothing is shown about black and white; gray is just a single dot in the center (Figure 12.27).

Figure 12.27: The same image when viewed through the vectorscope

You may run across tools such as an Info palette, RGB readouts, or an eyedropper within color correction programs. These tools will allow you to take RGB readings from a set of pixels of your choice. The readings will allow for color information evaluations for just certain parts of the image. Numerical values for each color will be provided. These tools can provide useful shorthand ways of adjusting the color of the footage.

Contrast Ratio and Tonal Range

When you see these terms used in color correction, they refer to the relationship and distance between the darkest and lightest portions of the clip.

Tonal range describes all the various shades of gray between white and black and the size of the field between the white and black. The term *tonal range* applies to many concepts such as contrast, contrast ratio, and lightness; often these terms are used when describing the same thing.

Contrast ratio is related to tonal range and is often used interchangeably. Contrast ratio is the difference between the lightest and darkest parts of the footage. A wide tonal range will have dark and light areas of gray between white and black, and a narrow tonal range will have less of a difference between whites and blacks. The tonal range and where these different values of gray, black, and white appear define the contrast of the image.

Primary Corrections

Primary color corrections begin after you have analyzed the footage. They are wide-reaching corrections that apply to the entire image and all (or most) of the footage. Balance and matching are key concepts for this phase of color correction. The primary goal is to match the color and contrast between scenes, between takes, and between shots to provide a consistent visual flow throughout the piece. You began by analyzing the footage; now is the time to start making the changes.

Evaluating Contrast and Tonal Range with Scopes

You can evaluate the contrast of the image by waveform and histogram scopes set to luma.

Waveform Set to Luma or to Y Waveform At this setting, the waveform shows only the luminance information. The bottom represents the darker parts (the blacks) of the tonal range, and the top represents the lighter parts of the tonal range (the highlights). If the footage is overexposed, there will be a concentration of trace toward the top of the scope at 100 percent IRE or even above. If the footage is overexposed, there won't be much if any trace at the bottom of the scope. Having a lack of trace at the bottom indicates that there isn't any black. When more trace is around 0, the footage will be darker. To plan for adjustments, look at the footage, and note what parts need to be white or lighter and what parts need to be black or darker. The waveform scope set to luma will indicate when these changes have been made (Figure 12.28).

IRE Numbers

There are units of measurement for waveform monitors. The units of measurement are set in IRE units. The numbers range into the negatives and go above 100. Practically speaking, to achieve broadcast-safe color and proper black and white settings, the blacks should go as close as possible to 0 IRE, and the whites should go as close to 100 IRE as possible without exceeding it.

Figure 12.28: In Apple Color you can view your footage in the waveform monitor set to luma.

Histogram Scope Set to Luma The histogram on luma can help you evaluate contrast. The spokes represent the different concentrations of pixels in the footage at that part of the tonal range. With the luma setting, the contrast between lights and darks with the range of gray in between will be apparent when looking at how the pixels are arranged among the darker part of the image or the shadows, the grays or midtones, and the lighter parts of the image or highlights (Figure 12.29).

Figure 12.29: Same image as Figure 12.28: looking at your footage through the histogram can help you evaluate the contrast.

Contrast Corrections

If part of the footage is under- or overexposed or the blacks and highlights just aren't popping as they should, you need to adjust the contrast. Contrast corrections can adjust lightness or darkness in images, correct exposure problems, or adjust the contrast ratio by expanding or reducing it. In general, you'll need to increase contrast because it is what gives the audience a place to focus. These corrections are most often done prior to corrections that involve the color.

So, how do you go about actually doing these corrections? That's where knowing your program comes into play. Often you are looking for Levels controls with slider buttons or Curves, basic Master Levels controls, Primary In Room controls, or equivalents.

Setting Blacks and Whites

A critical step for all contrast adjustments and footage is making sure that the whites and blacks are set properly. To check this, you can use the waveform set to luma or the Y waveform. Setting the whites (highlights) and blacks is crucial because many further adjustments will take this into account. Dirty highlights or muddy blacks not only look horrible but also can throw off the whole luma palette of the image.

The procedure for adjusting blacks and whites is often simple. Keeping in mind that the overall goal is to expand tonal range—that is, distance from black to white—look at the image to see where the whites and blacks are, and adjust accordingly by bringing up the whites and bringing down the blacks. Keep adjusting until the whites are as close to the top and the blacks as close to the bottom as possible. "As close as possible" is usually determined by how much you can move the levels and still keep detail in the darkest and lightest parts of the image. If thin lines start to appear at the bottom or top of the waveform scope, it is a sign that detail is being lost and the image is being clipped or crushed.

> When some detail is lost because it was brighter than the range that could be captured, it is called *blown out* or *clipped*. When the lost detail is too dark for the available capture range, it's said to be *crushed*.

When setting for black and highlights, you can easily see whether the tonal range is wide, whether the blacks and highlights are at the proper settings, and if the blacks are close to or at 0 IRE and the highlights are close to but still under 100 IRE. In general, you are trying to stretch the range between black and white as far as it can go.

Clipping is indicated by a thin line of trace at the very top of a waveform monitor (Figure 12.30). When setting whites, clipping is an important consideration because white levels should be raised only to the point where clipping does not occur and should stay in the correct range. If clipping begins to occur, you shouldn't raise the white levels further.

Crushing is indicated by a thin line of trace at the bottom of the waveform monitor (Figure 12.31). When setting black levels, making the footage darker or darkening shadows, crushing happens if the levels are lowered too far.

Increasing or Spreading the Tonal Range with Highlights, Shadows, and Gamma/Midtones

The tonal range is typically split into three sections: shadows, midtones, and highlights. Setting the whites and blacks is the first step in expanding the tonal range, but you still need to address the gray area and midtones in between. The midtones are tied to black and white, and as gamma is altered, the black and white relationship—specifically, the transition between them—is changed. The gamma is the area where the full detail of the footage and the contrast can be fully realized.

Evaluating Color

Evaluating color is essential at all stages ranging from capture to post-production. There are many tools and terms that are critical to be aware of when evaluating color in your footage.

Figure 12.30: As you can see in the image, the light is so bright it blows out all detail. When you look at the waveform monitor, you can see the flat line that represents the clipping.

Figure 12.31: In the same shot you can see the dark areas where there was no data crush along the bottom of the waveform.

Vectorscope or Waveform

When evaluating color and deciding where alterations should occur, you use the vectorscope to evaluate hue and saturation. The vectorscope mimics the color wheel with targets for primary and secondary colors. Trace appears where the color is both for hue and for saturation, and angle around the vectorscope and the distance from the center are crucial. The distribution of the trace shows where the color in the footage is in terms of both hue and saturation.

Another way to evaluate color is with the waveform scope set to parade. This makes it easy to see the relative color balance between all color channels. When one color channel has a trace that is much higher on the scale than the others, it is an indication that there is a color cast and it makes apparent in what color channel the cast is happening.

Fixing Color Casts

Often a color cast appears prominently when the whites are not white or blacks are not totally black but appear to have a slight tint (Figure 12.32). When the color cast is gone, the whites and blacks should appear normal. You can neutralize a color cast by adding color from the opposite side of the color wheel. The tools to fix color casts are usually the color balance controls or curves.

Figure 12.32: In the first image, you can see that the white balance setting was off; the second shows the color adjustment to correct for the reddish-orange hue that was originally in the footage.

Color Balance and Contrast

The waveform and vectorscope can give good color information to help with color balance issues. However, you can also use the histogram to evaluate color balance when set to RGB. This graph is important if you are trying to figure out whether a specific color channel has problems in shadows or blacks, midtones, and highlights or whites. Color balance controls allow for mixing RGB in shadows, midtones, and highlights.

Color balance is an attempt to match the hue and saturation of two shots. The color targets of the vectorscope likely match the colors of the color balance controls, and this can be a useful checkpoint to see how far off the footage is from matching. Some of the theory in adjusting color balance is working with color opposites. You can adjust one color that may lighten the overall channel and then work with the opposite to balance. Saturation can also be adjusted to influence the overall intensity of the color or with certain color channels.

Increasing contrast between colors will shift the eye to the part of the image the moviemaker wants to be of primary focus. To do this, you may have to increase the contrast between two colors or adjust the saturation of one color.

Noise

A little noise in the overall image can be a great addition to a movie. This is because moviegoers are accustomed to seeing film grain, and noise can emulate this look. Noise evenly spread throughout the entire image can enhance the look and color of the piece, but high ISO settings can have distracting noise problems.

One problem with noise vs. grain is that noise mostly occurs in certain parts of the image. The highlights and lighter parts of the image are usually free of noise; however, the shadows and darker parts of the image will have noise, especially if the image is underexposed.

Linear Light Images

A digital camera sensor converts linear light to linear numbers, but film converts linear light to logarithmic densities. Film responds to light the way your eyes do. Film noise or grain is evenly distributed because film's noise is proportional to its logarithmic response to the light. Digital sensors have noise evenly distributed across the sensor's response to light; however, if the sensor simply did not have a response to light or didn't have a number, then the noise would appear in that area only. For example, on a DSLR sensor, the shadows or underexposed images simply will not have linear numbers, and noise will appear in this area. When increasing contrast or moving darks, you may reveal noise in the process.

The first step to noise reduction is to be careful on set that the image is exposed properly. For post-production, be careful when adjusting contrast. If noise becomes a problem, the solution may involve noise-reduction filters, plug-ins, or software to remove it from the footage.

Secondary Corrections

Secondary corrections are targeted corrections concerned only with part of the footage or even just a portion of the image. Secondary corrections can be very subtle such as a vignette to focus interest visually, or they can be extreme color changes. Secondary corrections are generally done after the primary corrections are completed but are occasionally done before. For example, a blemish on skin may need to be fixed first, and then the primary corrections will ensure that this fixed part fits in with the rest of the footage.

Vignettes, Spot Color Corrections, and Masks

Localized corrections allow an effect to apply only to the selected area within a mask or shape. You can layer these to add complexity and a near infinite variety of possibilities for adjustment. You can blend the edges of the masks or shapes into the rest of the image and, through keyframing, apply them throughout moving shots. These localized corrections allow you to adjust the lighting of the footage by lightening or darkening specific areas or adding a vignette to increase the visual focus.

Sometimes one particular color will need adjustment throughout the image. The best example of this is changing the color of various objects on the screen while leaving the background the same. To do this correction, you'll need to define the particular color and make the change to that color.

Colorista Color Correction Software

It's easy to do vignettes, face lights, or any correction for exposure with Colorista's Power Mask, shown here. But it has a few other advantages compared to the color correction tools in Final Cut Pro, Premiere Pro, and After Effects.

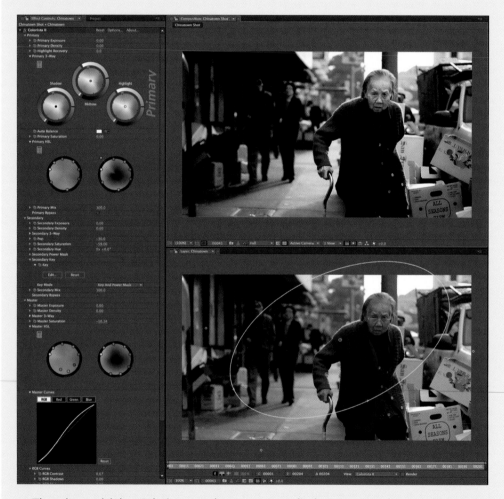

The color model that Colorista uses does not try to split the image into three masked areas based on luma ranges. Instead, it uses a standard Lift, Gamma, Gain model like that proposed for the ASC Color Decision List (CDL) standard. The most important part is that the Lift controls offer more visually pleasing results for shadow adjustments, letting you pollute the shadows with a blue or red tone without causing a shift in the blacks of the image. Final Cut Pro and Premiere Pro both use an offset model for shadow adjustments, which causes a shift in the color tones—flashing the blacks with the target color that just looks wrong.

All the video editors that Colorista supports do not have a way to create a masked area with the color correction. Both Premiere Pro and Final Cut Pro offer secondaries with a color selection, but often these tools fail because of issues like noise in the source, and it is very hard to constrain a correction to just a small area in the frame with just a color selection tool. Additionally, Colorista supports the GPU chip in most video cards. Because Colorista utilizes the GPU, it can offer the highest-quality results with constant processing in 32-bit/channel floating-point color. *Quality* means that you can apply multiple instances for different types of treatments and never worry about posterization or banding. Another huge benefit of GPU support is that Colorista is fast. Colorista can be up to five times faster than the built-in color correction tools with masks enabled.

Skin Tones

When creating looks and changing colors, the skin tones of the actors should still look like skin and shouldn't take on a color cast. You can examine skin tones using the vectorscope, because all skin tones sit in a narrow range on the vectorscope. In fact, there is a target line that identifies skin tones between yellow and red. The saturation and brightness will vary, but every flesh tone will appear along this line.

The trick is to maintain skin tones while doing corrections. In general, it is better to have warm skin tones than to make the tone cooler, unless, of course, a cooler effect is what you are going for.

Broadcast-Safe Color

The FCC set guidelines for video that make it possible for the video to be broadcast properly, and depending on whether your project will be broadcast, it may be necessary to take these guidelines into account during color correction. Following them ensures that your footage is "broadcast safe," meaning that it can be broadcast without color smearing, distortion, or loss. Often color correction software will have filters or built-in steps to ensure that the footage stays within the guidelines.

Scopes offer the only true method of adhering to a broadcast signal, making sure that luminance levels are within broadcast-safe ranges. The vectorscope makes sure that colors are broadcast safe if shown on a TV set.

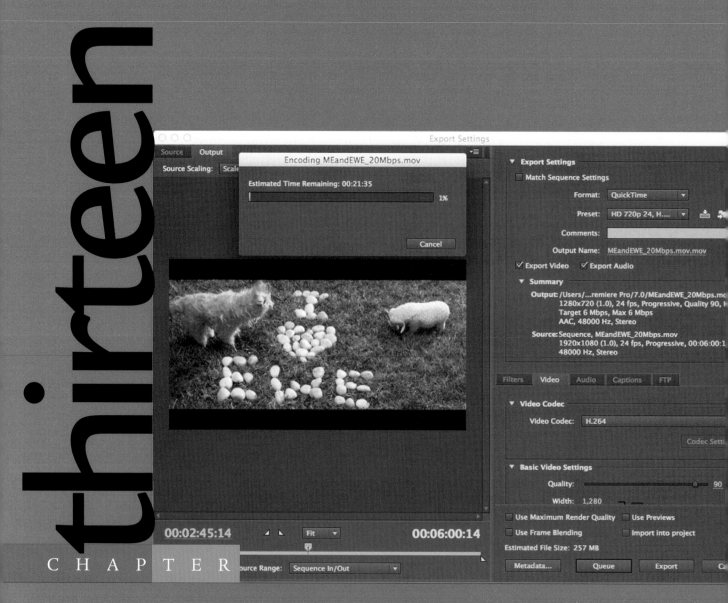

thirteen

Compressing Your Film

At this point, you have spent days,

weeks, or even months carefully planning and executing your shots. You have spent countless hours editing and making sure your scenes work just right, not to mention the hours perfecting the color grading and the look of your film. Now what? Just send it out so everyone can see your masterpiece? If you do an uncompressed output from your nonlinear editor (NLE), then the file will be far too large to stream or share with just about everyone. So, the real question is, how do you compress your film so that it looks as close to the uncompressed version you edited and can be viewed in the best compressed quality possible no matter where you show it?

Understanding Compression

In simple terms, *video compression* is taking the full-resolution video and squeezing it down to a smaller file size. During compression, each frame is compared to the frames right before and after it to determine whether any information in common can be discarded.

Most video compression is *lossy* compression, which means it might reduce quality in the video in order to achieve a smaller file size. This contrasts with *lossless* compression, which saves less on file size because it does not give up any quality.

When doing any video compression, you are balancing image compression and motion compensation.

Spatial Compression This means that in any given frame you can discard data without too dramatically affecting the visual perception of the image. If you remember from Chapter 12, "Color Correction and Grading," the human eye can easily distinguish a change in brightness but cannot easily detect subtle changes in color. So, image compression is more or less the dropping of data throughout the frame to lower the size of the overall file.

Temporal Compression This refers to any change of motion between frames. In many shots, there is little to no movement within the frame, and data can be compressed more aggressively to take advantage of the lack of motion change. During this process, consecutive frames where there is a lot of motion get rewritten, whereas areas that have little to no motion more or less get referenced to the previous frame. This shortcut allows a ton of data to be referenced as opposed to individually being stored in your final compressed video. This means a much smaller file size. If you have a shot that has more motion—a car chase, someone running, and so on—then you need to adjust your compression settings accordingly.

For almost all compression, you will be using spatial compression and not temporal compression. Temporal compression works best if there is very little change from frame to frame. For instance, if you have a person standing in front of a building and the only thing that moves is the actor, then temporal compression could work great. This would allow you to have a much higher bit rate and still maintain a small file size. The reason you will be using spatial compression most of the time is that almost no projects are made mostly of images with very little change from frame to frame. Even if that is true for one scene, it is not likely to be the case for the whole project.

When using spatial compression, you need to see how much you can lower the bit rate or frame size until you feel you are losing the quality you want to maintain. Remember, any compression means you are losing data and therefore lowering the overall quality of your footage. How much you can get away with depends on what type of footage you have, where the end project is being shown, and your personal taste and tolerance for image loss.

Two-Pass or Multipass Compression/Encoding

Compression or encoding takes a long time. The longer your edited piece or the larger the files, the longer this process takes. Most people are in a hurry and select a single-pass encode to quickly compress their video.

Unless the file you are compressing is just a sample or proof, always select a multipass encode when compressing a final output. The first pass through basically analyzes the video and makes a game plan for how to compress. This allows for a more strategic compression process that best uses each frame and maximizes your end result.

As you move down the rabbit hole of video compression, keep asking yourself this simple question: "How much information can I throw away without affecting the visual perception of the footage?" You are simply trying to find the right mix of factors based on the type of footage you have to work with.

With all of the previous stated, you won't see these terms in any software that you will be using to compress your video. The "big three" you will find and need to know are *bit rate* (data rate), *frame rate*, and *frame size*. You will mix and match these three settings to find the best compression settings for your final output.

Bit Rate or Data Rate This is simply the number of bits that are processed per unit of time. When talking about video, bit rate is the number of bits used per second of playback time. When you set your encoding rate for your compression, you are taking the size of your video file in bytes divided by the total time of the clip (calculated in seconds). Basically, this comes down to the higher the bit rate (data rate), the more information per second you are adding to the compressed file. This makes for a much higher-quality video image but also raises the total size of the compressed video, which may be too large depending on your final output.

Frame Rate This is the number of frames per second in your clip. This setting is determined when you select the number of frames per second the original footage is captured with. There are some limited uses for which you may want to change your frame rate from your original capture source, but for most people it will be 24, 25, or 30 fps.

Frame Size This is the actual size of the video clip (Figure 13.1). On your DSLR, it will be either 1920×1280 or 720×480 (and in many cases now 4096×3072, aka 4K video). The larger the frame size, the larger the final compressed video will be. When you are ready to output your final compressed video, check out what the largest frame size that can be handled is and set your compression settings to that. If you make it any larger, you are wasting data that you could use in upping your bit/data rate.

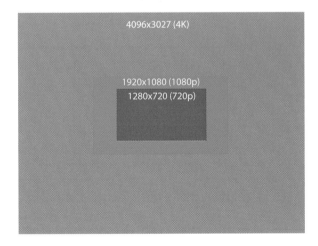

Figure 13.1: Frame size differences among 4K, 1080, and 720 video

You most likely won't be changing your frame rate after you have completed shooting, except in cases where you are mixing footage from cameras that don't have matching frame rates. With that said, you most likely will not change the frame rates to save on the size of the final output of the video files. So, for the discussion of compression, leave that off your checklist to deal with here.

Bit rate or data rate is definitely something you will be adjusting to get the optimum output quality for your finished project. As we already stated, in general, the higher the bit rate/data rate, the higher the resolution of the final video and therefore the larger the final video size.

Frame size is another way you can cut down on file size for your final output. Just because your camera shoots in 1920×1280 doesn't mean your final project should be 1920×1280. A standard DVD is only 720×480, and for most applications this is more than high enough resolution.

There is no one size fits all for all applications, so this process is like a giant trial-and-error exercise. With that said, Table 13.1 shows some good guidelines you can use as a starting point.

Table 13.1: Recommended settings for various outputs

Destination	Frame size	Bit rate
YouTube	Will automatically convert for you	~4500
Vimeo	Will automatically convert for you	~4500
Facebook	Will automatically convert for you	~4500
Personal website	1920×1080	6500
DVD	720×480	4500
Blu-ray	1920×1080	6500

YouTube, Vimeo, Facebook, and other video-sharing sites are set up to take whatever files you upload and convert them for you. In these cases, you are not in control of the final compression as you would be if you uploaded your file to your own personal website. In these cases, it is best to upload as high-quality a file as you can, staying within the file size limits of the website, and let the site do the conversion. This way, you don't compress your video and then let, say, YouTube recompress your compressed file.

Later in this chapter, we will walk you through setting up your export settings and outputting a final video, so don't worry if your head already hurts. Compression is a very complex and almost never-ending maze of new codecs and video specs. We are trying to set you up with a good foundation and some step-by-step processes for common output formats.

There are several in-depth books you can read if you want to dive deeper into understanding what is happening during video compression. We recommend Andy Beach's *Real World Video Compression* (Peachpit, 2008) as a great resource.

Outputting Your Video

If you have never been through this process, you might think that you can just export your video and you are finished. However, in today's world, there are many platforms where you can show or distribute your film. Your options include YouTube, Google, Apple TV, DVD,

Blu-ray, full 1920×1280 HD, and now 4K video. To get the best quality from all the possible platforms, you can't create a one-size-fits-all output. You will have to decide whether you are just going to be outputting for the Web, making a DVD or Blu-ray disc, outputting for broadcast television, or creating a 4K digital-ready print for digital distribution.

Creating a Self-Contained Master Digital File

Before you create all the various movie files, you should create a single master file. From this master file you'll create all of your other movies. The reason you create a self-contained master file is to get away from exporting from your editing program. Just like when editing film, you make your edits on a work print and conform to a master print. From that print, you make all of your other optical prints and send them to theaters.

Conforming can mean one of two things in the world of video editing. The first is if you are doing an offline edit and working with low-resolution video. When you finish your edit or lock your edit, you need to go back and re-create the edit with the higher-resolution footage. This is one instance of conforming during your post-production process. The other is when you are dealing with footage that varies in frame rate, resolution, size, and so on. You cannot have various frame rates, sizes, and resolutions and export them and have it work. You must pick the final standards you want and adjust the footage to match. For instance, if you want your frame rate to be 29.97, you would conform any footage shot in 30 or 24 to conform to 29.97 before you start your edit.

In Final Cut Pro 7, to create your master video file, you should do the following:

1. In Final Cut Pro, choose File ➤ Export ➤ QuickTime Movie (on the Mac, you can use the keyboard shortcut Command+M).
2. Name your movie (Figure 13.2) and select your destination folder.

Figure 13.2: Setting up a QuickTime export

3. Set the Setting option to Current Settings, and set Include to Audio And Video.

4. Unless you set markers specifically for your master file, set Markers to None (Figure 13.3).

Figure 13.3: Choose None if you have no markers set.

5. Make sure to click Make Movie Self-Contained. If you don't click this, it will create a reference movie that will look for original clips on your desktop and won't work to upload and share on the Web.

6. Click Save to create the movie.

Be aware that your current settings are the settings from the timeline in your project file. If you are editing your movie with lower-resolution files and not at the highest-quality settings, then you need to set up a new project with the highest resolution possible and reconform the project. If you don't, you are making your master file at less than the highest possible resolution. If you are using the native H.264 movie files in Adobe Premiere Pro CS5, then you have the highest resolution possible; if you are working in Final Cut Pro, we recommend Apple ProRes 4444 or the CineForm codec. Either will give you the maximum resolution for your converted files.

In Premiere Pro CC, you should follow these instructions to create a high-resolution master file:

1. In Premiere Pro CC, choose File ➤ Export ➤ Media (on the Mac, you can use the keyboard shortcut Command+M).

2. Name your movie (Figure 13.4) and select your destination folder. Click Save.

3. In the upper-left corner of the Export Settings dialog, check the Match Sequence Settings box (Figure 13.5).

Figure 13.4: *Changing the name of your final output file*

Figure 13.5: *Make sure you have Match Sequence Settings checked.*

4. Click the Export button and save your movie.

After you create your master file, you will have one master digital file at the highest resolution that can be repurposed for all your other formats you will need. In the future, when another new media platform comes along, you can quickly and easily create any new format you may need directly from this master file without returning to your edit project file.

Creating a DVD or Blu-ray Disc

You can't get by without making a DVD of your movie. Almost everyone has a DVD player, computer, or gaming console that will play a DVD. It makes your film a little more real to people to have a physical copy of your hard work. The major drawback, however, is that DVDs are standard definition and, as such, don't take advantage of the full quality that your DSLR camera captured.

Blu-ray is not as widely available, and there are far fewer machines that can play a Blu-ray disc. On the flip side, Blu-ray is 1920×1280—the same resolution as your DSLR camera. If you want to show the very best version of your film and need a physical copy to present, make a Blu-ray version.

Unless you have a major distribution deal and will be making thousands of discs, you will be making the DVD and/or Blu-ray discs yourself. This is a two-step process.

In step 1 you compress or convert your movie into a DVD-compatible format. A standard DVD's video file format is MPEG-2, which is a super-compressed, standard-definition video format. If you want to create a standard DVD, you must author in MPEG-2.

There is limited space on a standard DVD. If you are including special features, extras, or any high-quality graphics and animations for your menus, you may want to pay attention to how big your files will be. A neat trick is to author your audio in AC-3, also known as Dolby Digital files. Besides supporting surround sound, AC-3 files are much smaller than AIFF or WAV files that many people use when mastering a DVD.

When mastering a Blu-ray disc, you will use the H.264 format. Don't let the H.264 *format* confuse you, because it is slightly different from the H.264 *compression* that is used in DSLR cameras. However, you can see how closely the resolution and format match your raw files, and you will be able to show your work in true HD and at the full quality at which you shot your footage in the first place.

In step 2 you actually author the disc. This process involves creating the menus and any interactive features you will be including on the disc. This is what allows users to navigate and play your DVD or Blu-ray disc.

Compressing Your Footage

There are many different software tools to convert your footage into the appropriate file format. As we discussed earlier, when converting your raw footage, you could use a program such as MPEG Streamclip. You can set up and automate the process and let it run in the background.

Other programs to consider are Apple's Compressor, Adobe Media Encoder, QuickTime Pro, and your editing software (if you didn't create a master). If you are working on a Mac, all of these programs are an option; if you are working in Windows, then all of them are available to you except for Apple Compressor. Use what you are comfortable using or have available and start compressing your files.

Authoring Your DVD/Blu-ray Disc

Now that you have your files converted and encoded, you are ready to actually author your disc. The process of authoring again starts with designing your menus, interactive features, and special features. When someone inserts a DVD, after the previews, they normally come to a menu where they can play the movie, select language preferences, or watch special features. These are all created in the authoring process.

The great news is that many software programs don't involve much, if any, actual coding. They are designed for users to be able to choose from templates or create limited custom designs.

DVD Studio Pro (Mac) This is Apple's professional DVD-authoring software. You can choose from a myriad of templates or custom create your own interface.

Adobe Encore (Mac and PC) This is Adobe's professional DVD and Blu-ray authoring tool. With Adobe Encore CS6, there are a ton of new features from 24p to AVCHD to Blu-ray output, so this is a great option for your DVD authoring needs. Just note that Adobe did not update Encore for the Creative Cloud because Adobe is focusing on streaming video and moving away from physical disc production in its software.

Roxio Toast 12 Titanium (Mac) Mac users might better know Roxio Toast as CD- and DVD-burning software. The latest Pro version allows you to master Blu-ray and HD discs.

Roxio Creator NXT 2 (PC) This is Roxio's option for Windows users. Creator 2011 allows you to author your DVD, Blu-ray, and even 3D discs.

If you want to be far more original and complex in your designs, you will have some more complex steps and may be dealing with other software.

In addition to DVD/Blu-ray versions of your film, you will need to create several different versions for the Web; these could include online dailies, low-resolution rough cuts, teaser videos, and even full HD versions.

Publishing to the Web

Think of the DSLR revolution as the Wild West, where the rules are always changing and where it seems every day new technologies change what and how things work together. The Web, on the other hand, is the ultimate permanent Wild West. There are so many competing video formats and video players that there is no one right way to output for the Web. Your choice is totally dependent on where you will be publishing your work and what video formats those locations support or require.

Adobe Flash Flash Video is the dominant video format on the Web. You come across it in almost every major website from YouTube to Facebook. Additionally, video-sharing sites from Vimeo to SmugMug use Flash.

Apple QuickTime QuickTime video is also very broadly used on the Web. QuickTime, however, is not totally accurate as a video codec because it actually supports many codecs ranging from .mov to .mp4 files (think iTunes).

Windows Media Video Windows Media Video (WMV files) has the advantage of being able to be played on all Windows computers. Any PC with Windows comes preloaded with Windows Media Player and doesn't require any additional players.

H.264 This is becoming the standard because it creates a high-quality image in a small video file size. H.264 files are used in DSLR cameras, in Blu-ray machines, and now with a variety of other video players (such as the new HTML5 video players). The best argument for H.264 files is they can be full HD, are small, and can be streamed on the Web.

YouTube

Currently YouTube accepts high-definition video formats, up to 2 GB in size and less than 15 minutes. There is a new feature called Advanced Video Upload that allows the user to upload clips up to 128 GB. Note that YouTube also has begun accepting 4K videos, so the outlets for high-resolution videos are on the rise (note that the 2 GB file size still applies to 4K videos.) Raw 4K video is approximately 2 GB per minute of footage.

To upload with this option, users need to have Java version 1.5 or newer. Because YouTube accepts a wide variety of formats, you can go ahead and upload your final output.

As with most online services, YouTube will compress your video file with its own proprietary compression settings before it can be viewed online. If you are unhappy with the results, try creating a new movie with a different codec and re-upload it. This sort of testing will allow you to get the settings you are happy with for people to view your video clips.

1. You need to start by creating, or signing into, your Google account in order to upload videos to YouTube (Figure 13.6). Then click the Upload button at the top of the page.

Figure 13.6: Sign in and then click Upload.

2. Click the Upload Video button in the center of the page (Figure 13.7).

Figure 13.7: Click the Upload Video button.

3. Navigate to the file you want to upload. Click Open, and the file will automatically start to upload (Figure 13.8).

Figure 13.8: You can add details and options about your video as it uploads.

Increase Your Limit for Videos Longer Than 15 Minutes

You now have the ability to increase the limit of the length of your videos to more than 15 minutes. On the Video Upload page you will see an Increase Your Limit link (Figure 13.9). When you click this link, you will have to verify your account via your mobile number and enter a code (Figure 13.10).

Upload videos longer than 15 minutes

By default, you can upload videos that are 15 minutes long. To upload longer videos, follow these steps:

1. Visit the upload page at www.youtube.com/my_videos_upload ⤴
2. Click **Increase your limit** at the bottom of the page, or visit https://www.youtube.com/verify
3. Follow the steps to verify your account with a mobile phone. Currently we aren't able to offer other ways to verify your account.

Want to upload videos longer than 15 minutes? Increase your limit.

You must own the copyright or have the necessary rights for any content you upload. Learn more

Once you've increased your limit, make sure you're using an up-to-date version of your browser so you can upload files greater than 20GB. The maximum file size you'll be able to upload to YouTube is 128GB and the maximum duration is 11hours.

Figure 13.9: You can actually upload more than the 15-minute limit.

Increase Your Upload Limit

Account Verification (Step 1 of 2)

To enable long uploads for your account we require you to verify your identity. Please enter your mobile number, and we'll send you a text message containing a verification code.

Select your country
[United States ▾]

Enter your mobile number (no dashes or other symbols, please)
[]

(Submit)

Figure 13.10: Verify your account via your mobile number and enter a code.

So, if you want to upload a video that is more than 15 minutes in length, either you can break it up into parts that are less than 15 minutes in total length or you can use the Advanced Video Upload feature and verify your account.

Facebook

You are not going to create and upload your entire movie to Facebook, but you are going to upload video clips for sure. As your production moves along, you can upload some sample shots to tease fans about the film as it is in production. You can do the same through the post-production process, by uploading short snippets of edited scenes. Regardless of what you are uploading, you need to follow some rules.

Facebook supports all major video formats but converts any video you upload to Adobe Flash. Because the video you are uploading is not the one that will actually be seen, you need to upload the highest-quality video to start with. Facebook does another conversion that will lower the quality of the video.

1. From your Facebook home page, at the top, click Add Photos/Video (Figure 13.11). This will allow you to either record a video from your webcam or upload a video you have created.
2. When you click Upload Photos/Video, you can browse to the file on your hard drive and select your compressed video you want to share with your friends and family. The video file needs to be smaller than 1,024 MB and less than 20 minutes in total length.
3. If you want, you can add a note or title of the video and hit Share. It will take a few minutes to upload, and you are finished.

Figure 13.11: When you click Add Photos/Video you can choose Upload Photos/Video, Use Webcam, or Create Photo Album.

Websites such as Facebook, Vimeo, and other video-sharing sites convert your video after you upload. For these sites, we recommend you upload a higher-resolution H.264 file so you get the best possible video quality after they convert your file.

Vimeo, SmugMug, and Other Video-Sharing Sites

Several video-sharing websites, such as Vimeo and SmugMug (Figure 13.12), are geared to more professional users. Whereas YouTube and Facebook videos are mostly made up of cell phone or home camcorder videos, these sites cater to people using higher-quality cameras and high-definition footage. Again, most of these sites will do some sort of compression on their end, but the results are often some of the best on the Web.

Figure 13.12: You can also distribute your video through Vimeo or SmugMug.

Post-Production Looks

Once upon a time, filmmakers

avoided common camera artifacts such as lens flares and vignettes at all costs, but now we seek out lenses that give us beautiful artifacts—or even resort to creating those artifacts in post-production. Embracing the imperfect is a great way to break free from the bonds of digital sterility, so consider this chapter a recipe book for eliminating or dealing with some of the most common problems or even crafting a few new ones of your own.

This chapter on fixing in post was graciously contributed by Michael Heagle.

Primary Color Correction

We take the recorded image for granted, because when it comes to exposure and color, our own eyes are adaptive. We close down our irises when the light is too bright, and a white piece of paper looks equally white to us whether we're indoors or out. No special filters are required for this trick; the human eye has "auto white balance" and "auto exposure" as standard features. But a DSLR camera is only as smart as its operator.

If you're hoping to do a lot of overall exposure correction for broken shots, we warned you before: in a video environment, there's not much you can do to recover clipped blacks and blown highlights. They are gone, gone, gone, in the same way that a person standing on the side of the freeway didn't record the license plate of every car that drove by because you didn't tell him to. That's data, and it's no longer available to decode and display.

If you try to lower the values of a shot to resurrect missing information from the over-exposed top end, a dull gray is introduced where the white used to be. All you're doing is lowering white, not retrieving information. Likewise for the underexposed blacks: when you raise them, very little new picture information is introduced, and what you see may

be made up mostly of unsightly noise or grain. That being said, begin by working with the midtones of a shot, and you may find that the ensuing contrast change takes some of the heat off the problem. It's amazing to find what is lurking just around the corner, waiting to be coaxed out of a shot with gentle color correction. If you need a bad shot to cut with other properly exposed shots in the same sequence, however, the challenge increases.

If you overlooked color temperature settings, fear not: color correction tools are great, and all will do corrective fixes like these quite easily.

Primary fixes happen in three places: shadows, midtones, and highlights. Luckily, most good color correctors are called "three-way" because they offer independent control over these discrete but overlapping areas of a picture (Figure 14.1). These discrete regions don't own an equal amount of picture real estate, and the borders of where one ends and the next begins are vague. What's more, as you change one area, you're likely to undo another.

Professional color correction homes in on the black and white levels of a shot first. One great way to make shots match in these areas is to look at a grayscale version of the footage, keeping color out of the equation completely until you're ready to deal with it. Find the blackest black in the incorrect shot, and make sure it is the same value as the blacks in the target or destination shot by dialing the shadow levels up and down. Then repeat for the whitest white in the shot. A shot with good dynamic range will have some of each in the frame, but not all shots are created equal here, and some guesswork is inevitable.

Lastly, you can tune color in the same way. Some people are born with an innate ability to see color problems and fix them by eye, and a good understanding of traditional color theory goes a long way here. Just remember that this isn't your art-class, paint-mixing, subtractive-color space; it's RGB additive color land.

If you are one of the regular people who lack this natural ability and need to make two shots look the same, try analyzing the problem one color channel at a time—red, green, and blue individually—and treat each picture like a grayscale shot where you are trying to match overall exposure. Look at the green channel on the good shot, and compare it to the green channel on the bad shot. Is the bad shot brighter? If so, darken it by adjusting the levels of the green channel until it matches the target shot. Then repeat for the other channels and see what you end up with. If you've set your black and white points, leave them where they're at and work only the midtones until the two pictures look like they're the same. Switch it back to full color to see whether you were right. This trick works like magic most of the time.

Micromanaging with Regional Color Corrections

Most regional color corrections can be accomplished via simple masks. The trick is to make sure the masks don't move independently of the footage and don't have obvious borders. In a shot like the one in Figure 14.2 where the actor stepped into an unsightly shadow, you can fix it in post with the "power windows" method. This trick gets its name from the first digital color-correction suites, whose

Figure 14.1: In some applications, such as The Foundry's Nuke, the discrete areas of color correction are more accurately depicted as overlapping curves.

masks were limited to geometric shapes like rectangles and ovals. What sounds like a gross limitation is actually a benefit: there are few problems that can't be solved with one or two of these simple shapes, provided you soften the mask edge to hide your tracks. This means no extensive frame-by-frame rotoscoping, which is a huge time-saver.

Figure 14.2: Though he walked through the valley of shadow, he can be saved through regional color correction.

Rotoscoping gets its name from its similarity to the old hand-animation techniques pioneered by Max Fleischer in the early 20th century.

Some editing software and all compositing software should have this capability. We'll use Adobe After Effects for its added ability to use 2D tracking to affix masks to a moving subject, but a lockdown shot wouldn't need much animation and could be manually animated to change over time. In classical movie F/X parlance, this was called a *traveling matte*. Nowadays we call this *rotoscoping*, and the simpler the mask, the quicker the task.

In off-the-shelf software, the trick is accomplished by having two layers stacked on top of one another, one for each version of the color correction. In this scene, we will use two copies of the footage: the original, shadowed copy below and a brightened copy above. The top layer is masked to include only the problem areas, and it is softened or "feathered" liberally to hide the mask's edges.

1. Import the shot. Make a new composition from it.
2. Select the layer in the comp and duplicate it by pressing Cmd+D (Mac)/Ctrl+D (Windows).
3. On the topmost layer, start masking the areas of the shot that need to be brightened. We opted for two elliptical masks, rotating them to better fit the shape of the problem area (Figure 14.3). (A useful shortcut for this is to create the mask and then immediately hit Cmd+T/Ctrl+T to transform the mask. You can then move it as a whole or scale and rotate it from the corners.)

Figure 14.3: Elliptical masks are all you need for subtle color corrections. The mask on the right is being rotated via Cmd+T/Ctrl+T.

4. Feather the masks substantially by twirling down the Mask properties on the layer and increasing the Mask Feather value. Depending on the size of the mask and the resolution of your footage, these can be big numbers—in our case we feathered it to a value of 40 (the distance of the soft edge in pixels). This makes for a really soft mask and tapers off the effect of color correction just as actual photographed light would fall off.

5. All that remains is to color correct the top layer, bringing it up to the level of the unshadowed side of the face. We did this with a simple Levels effect, raising the Gamma by dragging the middle gray triangle to the left until the images matched satisfactorily (Figure 14.4).

Figure 14.4: A simple Gamma adjustment leaves the black and the white values of the shot intact and usually fixes the problem.

Figure 14.5 shows the before and after versions.

Figure 14.5: Before and after the regional color correction

If the character moves only a little, animating these masks is probably unnecessary and may in fact be more distracting. But if the camera or subject moves substantially, consider using the software's 2D tracking tools to stick the mask to the footage. In 2D tracking, software looks at a point on the footage (usually one selected by the user that is unique and high contrast) and then follows that feature through the shot on a frame-by-frame basis. The information it gleans from this analysis is then applied, either to the shot itself to remove the camera movement (stabilizing) or to another layer to parent it to the original footage (match moving).

There are some great resources out there for how to do more complicated tricks like this in After Effects. A popular one is Andrew Kramer's Video Copilot (`www.videocopilot.net`), which features After Effects tutorials for virtually every function in the software.

When it comes time to manually mask a moving subject, remember the following rules:

- Use as few keyframes as possible. Keyframes, those increments of animation necessary to change the mask's shape over time, are generated first when you click a property's stopwatch icon in After Effects and then every time you move the mask thereafter. Remember that you need to advance the current time indicator to a new spot in the timeline, chosen based on the change or movement that has occurred, in order for animation to take place. Without differing keyframes in differing spots in the timeline, there is no movement.
- Keep your shape as simple as possible.
- Move the shape as a unit, not the individual keypoints. Keypoints are created every time you click the mouse during the mask-drawing process. Select them all by drawing a marquee over them, or select one point and press Cmd+A/Ctrl+A to select all the keypoints on the shape.
- Think like an animator and use key poses to drive your keyframes. Extremes of motion (foot rises, foot falls) are key poses and are natural spots of movement to base the animation around.
- Break the object into manageable pieces instead of outlining the whole object.

Secondary Color Correction

Filmmaking in the 21st century no longer takes the latent image for granted. Many filmmakers are satisfied with the technically correct image, but some aspects of color correction go beyond mere black-and-white point management and into full creative expression.

As digital effects rose in prominence in the 1990s, the need to scan images into the computer increased and became commonplace. When the storage size of that image was no longer a deal breaker, entire movies could be stored at high resolution. Enter the digital intermediate, which replaces the old photochemical method of placing colored filters in front of an optical printer to correct the image. In the digital arena, new looks could be auditioned quickly and inexpensively.

Filmmakers saw the potential here for a new level of expression, no longer bound by what was captured on set or even by reality itself. Whether it was the cold machine world of *The Matrix* or the Dust Bowl sepia of *O Brother, Where Art Thou?*, the age of the color grade had arrived. Since then, cinematic looks have trickled down to the desktop in the shape of easy-to-use plug-ins like Magic Bullet Looks (from www.redgiantsoftware.com), designed to give the budget-conscious filmmaker Plug and Play access to cinematic styles that mimic everything from *Saving Private Ryan* (itself a photochemical look, not a digital one, ironically enough) to *Amélie*. But third-party plug-ins like this are merely brilliantly conceived time-savers, and the stock tools in most good editing and all good compositing software can get you there at no additional charge for those artists willing to do the legwork.

Creating a Hard-Hitting Action Movie Look

Color and contrast are a huge part of what makes modern movies look the way they do, and missing out on this post-production opportunity can be the tipping point between making your movie look incomplete and finished. What follows is a recipe for a dramatic, hard-hitting "action movie" look, but if you carefully analyze some images from a film, you should be able to reverse engineer what's going on and replicate a favorite style. We begin by breaking the "action movie" problem into component parts: we want to make the footage "contrasty" but not crush the blacks beyond recognition or lose the skin values, we want to grain it up, and we'll favor a blue color palette.

The method for adding realistic grain is outlined later in this chapter, so let's work on secondary color correction with an emphasis on color and contrast here.

Saturation

The saturation of your footage is one of the prime mood-generating devices available to the filmmaker. Look no further than 1939's *The Wizard of Oz* to see how desaturation (black-and-white Kansas) and super-saturation (three-strip Technicolor Oz) establish mood and locale and can even work in concert. In the old days, the photochemical process was the closest thing to alchemy, and experienced lab technicians mixed dyes and solutions to produce a specific effect, often resorting to trial and error. You have it easy; in every software program there are controls to get virtually any effect.

Thinking as an art director, you have probably already decided what the primary color palette for your movie looks like. Maybe it's warm and nostalgic or cold and oppressive. The principle behind a lot of these post looks is the systematic desaturation of anything

that doesn't fit in the color scheme. A cool scheme has the warms dropped down and vice versa. So if you want a police-procedural, cold, urban look here, you should remove reds and yellows. Think of movies like the *Underworld* series, where everything exists in a tight color palette of black and blue—colors of death. It's likely that you would have costumed your characters to fit this scheme from the beginning, but there is some recourse for the post-production artist to remove unwanted hues from the footage (Figure 14.6), especially in locations where you don't have complete control over the art direction.

Figure 14.6: Unmodified raw footage before any color adjustments

1. In After Effects, with the shot in a new composition, choose Effect ➢ Color Correction ➢ Hue/Saturation.
2. Underneath the Channel Control drop-down, you will find options for something other than the Master saturation. If you decided to leave the blues and kill the warms, you would start with desaturation of the reds and yellows. The Channel Range slider shows exactly what portion of the color spectrum will be affected, and this range can be expanded. The innermost squares indicate full selection, and the triangles on either side show the slow falloff of this effect. On this one, there's only a little bit of red in the taillights, and it disappears quickly; set this to taste depending on how far you're pushing the look.
3. Now you can add a contrast change to make the scene more severe. Instead of the obvious Brightness & Contrast, you can do the same with Effect ➢ Color Correction ➢ Levels.
4. The "mountain range" that you see is the Histogram display, a very useful image-analysis tool if you know how to read it (Figure 14.7). On the left side of the mountains are the black values, the midtones are in the center of the display, and everything to the right is highlights. There are 255 discrete spikes on this display; the height of those spikes indicates how much of a particular value is present in the shot. According to this, we have a properly exposed shot with not a lot of pure black but a good

midrange and a moderate number of highlights. That certainly agrees with what the image looks like to the eye, and we now know where to begin.

5. The first triangle beneath the histogram is the Input Black level. If you raise this (dragging it to the right), you cause values that were formerly almost black to become totally black. This is also referred to as *crushing the blacks* and is something you want to do only with caution. Some information will be lost in these areas, and although it is limited to grain, there may be shadow detail that can be flattened in the process. To keep this data, don't push the slider past the start of the "foothills" at the left of the histogram.

Figure 14.7: "There's gold in them thar hills!" The histogram in Adobe After Effects.

6. When the triangle is aligned with the beginning of those mountains, a value of about 8.0 appears in the Input Black option. Anything more than that on this shot and you are losing data. On the top (right side), you also don't want to risk losing detail in the highlights. On this clip, you have nowhere to go without washing out something in the top end. What to do? If you are willing to lose some detail, you can push it, but raising contrast is about lowering the range of values, and you haven't touched the midrange yet.

7. Gamma describes the middle of the video value and is represented by the gray triangle in the middle of the histogram. Move the Gamma slider to the right, and the contrast increases. The closer together the gray and white sliders are, the more contrast there is. If this has changed your exposure and you want to push the effect further, grab the right triangle (Input White) now and drag it in toward the gray. The gray keeps its distance, and the shot gets brighter and crunchier still (at the cost of some detail) (Figure 14.8).

Figure 14.8: The crunchy version of the shot, stripped of warm colors...

You could finish this off with a tint (Figure 14.9) and really cool off the shot, making it more stylized yet.

Figure 14.9: ...and tinted a cold steel blue

Faux Lens Effects

The wise DSLR shooter has been warned about keeping a flat picture profile to expand creative options in post. (This means you, because you read Chapter 3, "Testing and Custom Settings," where we recommended this.) Besides mimicking the traditional film process, this expands your creative options. Nowhere is this more evident than when you try to replicate the types of attenuation that cinematographers have traditionally stuck in front of their lens.

Diffusing Your Footage

Placing diffusion filters in front of the lens is a time-honored technique to soften the image, bloom the highlights, and otherwise impart an otherworldly or heavenly character to the shot. Check out the classic *Star Trek* TV series to see how it was conventionally used to soften the close-ups, especially on the female crew members. Hollywood myth suggests that some actresses even required it in their contracts, and numerous films from the 1970s and 1980s relied on Pro-Mist and Fog filters to create their low-contrast look. With the DSLR look firmly entrenched in today's digital films, some shooters may be looking for a way to distance themselves from their off-the-shelf colleagues. Diffusion can quickly take your image out of that thick-blacks/high-contrast HD look and into a more retro filmic space.

Digital compositing has made it possible to save this trick until post-production, where it can be fine-tuned infinitely. If you shoot with diffusion on the lens, you are married to it—this effect is not reversible. Creating a mist or fog filter style with software is a simple and infinitely adjustable effect but can be very render intensive and will take time to produce.

The principle is the same in all software: take a second, blurred copy of the footage and layer it atop the original. From here, the opacity of the soft copy is attenuated, either with a dip in transparency or by using a compositing mode or "transfer mode" that best replicates the filter experience. Since the effect of fog filters was seen most clearly in the highlights of the picture, this means using a "screen" or "add" compositing mode on the top layer. The power of the effect is controlled by the amount of blur or the opacity of the top layer. The brightness of the effect is determined by the compositing mode—"screen" is less overpowering than "add."

1. Regardless of software platform, the principle here is the same. Import your footage and place it in a composition.
2. Duplicate the layer (Cmd+D in After Effects) and set the compositing mode to Screen (Figure 14.10). At this point, the luminance of the image increases, because the color values of the top layer are being added to those of the bottom layer.

Figure 14.10: Two layers are better than one when replicating a diffusion filter.

3. To the top layer, add a Gaussian blur (Effect ➤ Blur & Sharpen ➤ Gaussian Blur). Depending on the resolution of your footage and the level of diffusion you want, you can crank the Blurriness value fairly high. In Figure 14.11, a value of 20 creates a classic gauzy filter look; you can see the luminance jump in the before and after comparison (Figure 14.12).
4. If you don't want this trick forcing your exposure up, experiment with color correction before the blur operation on the top layer; this is a way to control what part of the image blooms. A Levels adjustment like the one illustrated shows a way to clamp the effect and get it out of the dark parts of the image by raising the Input Black and lowering the Input White on the diffusion layer. This version lacks the great equalizing effect on the midtones, particularly on skin, but gets your exposure back in the intended ballpark (Figure 14.13).

Figure 14.11: Hazy, fuzzy goodness is a click away.

Figure 14.12: Before and after, you can see the luminance leap, thanks to the "screen" compositing mode.

Figure 14.13: Crushing the blacks on the top layer is legal, because you're using only the brightness information from that layer.

Applying Color, Filters, or Tints

Another piece of photographic attenuation that can be simulated in the post process is color filters. If you are shooting as raw and as flat as you can in production, it is likely you didn't put one of these between you and your subject. No matter, because with the digital realm, you instantly have every color of filter imaginable, at a fraction of the cost, each with infinite control.

The shot of the actor in the field in Figure 14.14 could go a number of ways. Let's say for story purposes that this is dawn, which the soft light suggests. You can use color to up the romance factor in a shot like this, when nature fails to deliver on a spectacular sunrise, for example.

Figure 14.14: The original misty morning plate

1. Start with a tint and add color correction to enhance it. In After Effects, selecting Effect ➤ Color Correction ➤ Tint is similar to most programs, in that you have a color swatch and some value sliders to indicate the percentage of dial back between original (no tint) and 100 percent (totally tinted). Typically, the white value is changed to a color, which can be oversaturated and brighter than you might need, and then the percentage is dialed back. Using the Hue picker in the ensuing prompt allows you to audition new looks quickly; just move the slider up and down through the options until you see something you like (Figure 14.15).

2. Dialing the percentage back to 20 percent on this shot makes the pre-dawn color more believable.

3. Finally, a gentle midtone adjustment with a Curves effect tunes the exposure to something more appealing (Figure 14.16). Try some other color variations here for a different effect, or home in on the ones that are typically used in cinema.

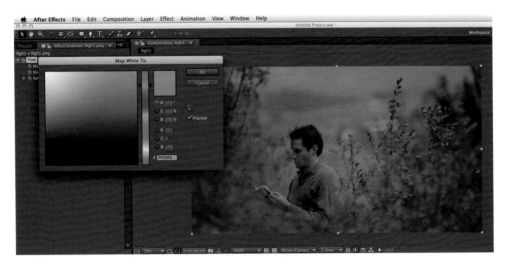

Figure 14.15: The Color Picker in After Effects. It's like owning every single color filter they make!

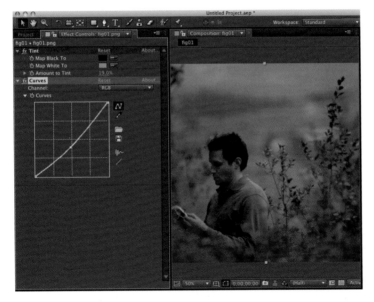

Figure 14.16: A dip in the Gamma via a Curves effect. Just click the line to add more controls; one or two is all it takes.

Need a graduated filter, such as for a sky? Apply the tint on an adjustment layer, and mask the layer with a heavily feathered mask at the top of the shot (Figure 14.17). Bam, instant Michael Bay!

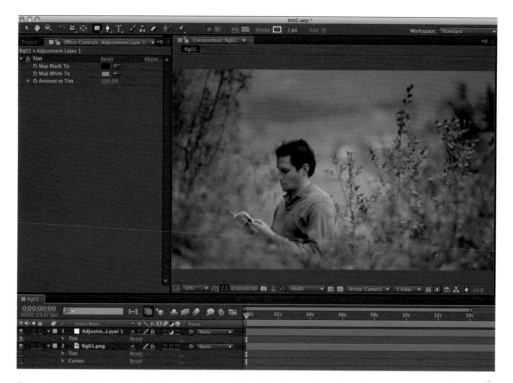

Figure 14.17: Miami Vice? Duran Duran video? Adding a feathered mask to a Tint filter.

Behind-the-Lens Fakery

In addition to the traditional filters in front of the lens, you can also replicate the artifacts that happen in or behind the lens.

Adding Vignettes

Let's add some additional photographic artifacts to the existing shot. Since a vignette occurs at the edge of the frame, it can be overlooked by most people. The traditional and compelling reason to use one is that it helps push the eye into the shot. As with most of our tricks, you can attenuate the amount of the effect to taste, unlike the real thing.

1. For this, use a solid layer set to a suitable dark color, such as a dark gray (Figure 14.18). Vignettes occur in real life when elements of the lens shadow the image plane, so this should be black or dark gray, but you can introduce color here for artistic purposes to, say, warm it up.
2. Switch the compositing mode to Multiply.
3. Create a new mask by using the Rounded Rectangle mask tool (click and hold the mask icon to see other shape options). Click and drag a mask slightly smaller than the frame, but before you release the mouse button, use the up/down arrow buttons to increase/decrease the roundness of the corners (Figure 14.19). A big round corner here is good.

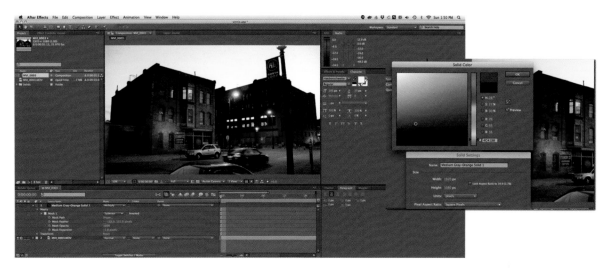

Figure 14.18: Original shot without any effect applied (top). A warm gray solid layer is chosen to complement the shot (bottom).

Figure 14.19: By default, the mask defines what is kept. The Rounded Rectangle mask is used to describe the vignette's shape.

4. The default for masks is to add, meaning the selection is kept and the outside is thrown away, so you need to switch the mask mode to Subtract, which will create a gray border in the shot (Figure 14.20).

5. Now feather that mask to taste. If the effect is too strong, you can either dial down the opacity of the layer or use the Mask Expansion parameter to dial it away from the edge, which should appear as though you are scaling the vignette (Figure 14.21). Useful hint: hit the M key twice to reveal all the properties of the mask.

Figure 14.20: Invert the selection by choosing Subtract in the mask parameters. Note the use of Multiply as the compositing mode.

Figure 14.21: The Mask Feather and Expansion controls now give you a perfectly adjustable vignette.

Understanding Grain

We are in the age of high-fidelity moviemaking. Our picture is bigger and clearer, and our sound is bigger and clearer. The rise of high-resolution digital acquisition and distribution on Blu-ray and HDTV has made picture clarity and sharpness a priority. Technically, the DSLR user is on the bottom end of the high end in terms of resolution, but we've already come to grips with that. What we haven't faced yet is the threat of grain and noise.

If you're shooting film, that minute hairy, fuzzy, sandy particle stuff in every frame is called *grain*, and it's a by-product of the photochemical process. Film grain varies in size and shape and is substantially different on each color layer of the celluloid. In the DSLR image sensor the equivalent is noise, which is most noticeable on high ISO footage but present everywhere. Noise varies in amplitude based on subtle variations in the image-generating device. Noise is assumed to be 1 pixel in size, although you can get noise of similar values in adjacent pixels, which gives the illusion of bigger blocks of noise.

Some high-end digital formats are so devoid of grain that filmmakers were initially unprepared to deal with it. The 2008 film *Speed Racer* was shot on a system (the Sony F23 camera) whose spotless image had to be specially treated when it was discovered that skin complexion problems normally hidden by the film grain were undesirably amplified.

For the DSLR user in post, grain is an opportunity to make their digital movie look more like a celluloid film. In an age of super clarity, a grainy movie can stand out or provide a gritty texture for a subject matter that benefits from it. Want to really get out of the commonplace DSLR look fast? Imagine a black-and-white picture grained to the gills like Darren Aronofsky's *Pi*. Film grain effects often ship with software or are available as a third-party plug-in, and many of these even faithfully replicate the look of specific commercial 35 mm film stock by Kodak or Fuji. While these are great, here's a recipe that renders faster and looks just as good because it's made from the real thing.

Making Genuine Film-Grained Footage

For this ultrarealistic film grain recipe, you need a large still image of film grain. The best type is scanned from real film, at which point you will see truly organic variation in size and amplitude. The bigger it is, the easier it will be to vary the effect from frame to frame, because you're going to be rapidly moving it in front of your footage (Figure 14.22). Search *film grain* or *scanned film grain* on the Web, and you might find some good high-resolution examples. The important thing is that the average luminance value is 50 percent gray or thereabouts. Anything darker or lighter will not have the same effect. If you need to alter the characteristics of the grain, you can do so in Photoshop prior to compositing with a simple Levels or Curves adjustment.

Figure 14.22: Example of scanned film grain, 2X enlarged

Can't find a real film grain plate? Here's a decent facsimile that can be produced in Adobe Photoshop. Create a new document that is 4096 pixels by 2294 pixels. Fill the background with 50 percent gray. Apply a noise filter (Filter ➤ Noise ➤ Add Noise). Set the Amount to 7 percent and the Distribution to Gaussian. Be sure to hit the Monochromatic button at the bottom of the prompt and hit OK. This is close enough to the real thing to fool most people, but because it is procedurally generated by the computer, it lacks the organic flaws of the real thing.

1. Import your video and grain plate into After Effects.
2. Create a new composition based exactly on the video footage settings by dragging it to the Create A New Composition button located at the bottom of the Project window.
3. Put the grain layer on top of the video in the timeline. The grain should cover and obscure the picture beneath entirely; in the example shown (Figure 14.23), the grain plate is 4K in size, so there is a lot of room to wiggle it in front of the picture.

Figure 14.23: This grain plate is about twice the size of the original HD picture, and that's good.

4. At the bottom of the timeline, click the Toggle Switches/Modes button, which will reveal the layer's mode of compositing. By default it is set to Normal. We will use Soft Light for a natural, realistic film grain (Figure 14.24). Feel free to experiment with other looks, such as Overlay for a slightly crunchier grain.

Figure 14.24: The Soft Light blending mode composites the grain over the footage in a subtle and realistic way.

5. Twirl the down arrow to reveal the grain plate's Position parameter.

6. We will use a simple expression to drive an infinite amount of animation in After Effects. Expressions are very powerful formulas that can make life easier in After Effects, but they come with a learning curve that is steep for many. To enable expressions on any parameter (Figure 14.25), simply Alt-click the stopwatch normally reserved for animation. Upon doing so, the parameter's values turn red and the default expression "transform.position" appears just to the right in the Expression field of the timeline. Single-click the words to open the field, and type **wiggle(24,1000)**. With expressions, the spacing and case are essential. Lowercase letters and no spaces are correct here. The first number tells the software how often to move the grain plate per second, in this case once per frame of our 24 frames per second. The second number tells us how many pixels it's going to move it on both the X (horizontal) and Y (vertical) axes. Hit the Enter key, not the Return key, to accept the value. Experiment with the values if needed to make the plate fit the shot; remember that it needs to cover the whole image to work.

Figure 14.25: A wiggle expression makes short work of random animation in After Effects.

7. If you scrub through the timeline, you can see the grain plate bouncing rapidly from position to position. As you can see here, this has a good random scatter going on (Figure 14.26). Preview the grain by itself by soloing the layer and see whether it looks like random noise or a picture being shaken wildly. If you can see it reposition, you need a higher value in your expression.

Figure 14.26: The wiggled grain: infinite, random animation at a fraction of the cost of hand animation

8. Compare the before and after pictures. You'll love what this does to skin tones and motion-blurred footage, and though the results will be subtle down the road (compression and distribution media will seem to eat this stuff up), if you're taking care of your data, this will lend a timeless analog look to your footage (Figure 14.27).

Figure 14.27: Subtly filmic, without the lab costs

Removing Banding

Let's say you've discovered that the incredible shot of the character emerging from the morning mist, which looked so brilliant in person and on the monitor, now looks like something from a low-resolution video game. Guess what, you got dithered!

When a highly compressed 8-bit system like DSLR meets a smooth gradient, it must make a choice about the fidelity, and it always chooses to emphasize luminance and detail over large, slowly attenuated patches of color. And that's great, because most of your image is fine detail. But you can run into this *banding* in any gradient, everything from a soft shadow on a wall to a clear blue sky. The fix is simple but requires that you be working in a color space higher than the conventional 8-bit.

Check your software's documentation about working in 10-bit or 16-bit color before proceeding. Banding can be eliminated by up-converting your shot to 16-bit and then adding a small amount of grain to the shot. The grain keeps the fine detail but breaks up the borders of the offensive banding, restoring a semblance of the original fidelity.

Remember that almost every post-production trick takes your footage out of the first generation and requires that it be re-rendered. Re-rendering already-compressed footage can have deleterious effects that may be detected by seasoned professionals and obsessive-compulsive people (and in most cases these are the same folks). But the benefit of changing something that is plain wrong always outweighs a few compression artifacts that the average moviegoer is unaware of.

fifteen

CHAPTER

Workshops

We thought it might be fun to cover

a few specialty areas before you head out and start shooting. In case you want to shoot a scene in a pool or in the ocean, you will need some knowledge of underwater photography and video. Additionally, you might need to know how to rig cameras to a car and shoot coverage in a moving car (or fake the movement when you aren't able to shoot it on the road). Lastly, we will recap changing camera speeds, switching shutter angles, and creating the cinematic look with your DSLR cameras.

A Brief Guide to Underwater Cinematography

This section on underwater photography/cinematography was graciously contributed by Daniel Brown.

I can't think of too many situations less conducive to photography than being underwater (perhaps being on the surface of the moon or inside an active volcano). Yet thousands of people do this as a hobby. The subtle but distinct addition of water affects every aspect of the photographic process, from the lenses to the photographer. Conveniences you take for granted on land are suddenly yanked away. Even if you've mastered photography on the surface, you have a whole new set of challenges awaiting you underwater.

I am referring mainly to scuba diving rather than snorkeling. Although snorkeling is a great way to get your feet wet (so to speak) in underwater photography, the best stuff is farther down. In fact, most critters stay clear of the surface. I'm also assuming that your camera allows for at least basic controls over settings such as ISO. Even modest point-and-shoot models usually allow for changing at least this setting, while others allow changes to shutter speed and aperture and have some subtle differences when the flash is fired. (I'm not going to talk about a disposable underwater film camera—for so many reasons.)

Before we kick off the official tips, one of the main questions I'm asked by people not familiar with underwater photography is whether we use a special camera. Most of the time, it is not special. It wouldn't be cost-effective for any major camera manufacturer to make an underwater-specific camera. A few consumer cameras are "waterproof," but that proof usually wears off at about 15 feet and so is mainly targeted at snorkelers and people with pools.

Most underwater rigs are simply standard cameras enclosed in a watertight housing made of acrylic or aluminum (Figure 15.1). The housing is a strong defense against salt water getting in your camera, but it must be sealed with care. As the old saying goes, "Water finds a way."

Figure 15.1: A Canon 40D inside a Sea & Sea housing with a wide-angle (dome) port, two Inon Z-40 strobes, and Ultralight strobe arms

Remember Where You Are

At the risk of stating the obvious, no photographic opportunity is worth gambling with your life or even a sliver of your health. I know several people who have done stupid things underwater (one of whom is extremely lucky to be alive) because they either ignored fundamental diving lessons or briefly forgot their priorities underwater. I'm not talking about accidents or equipment failure; I'm talking about people who knew that their ability to surface safely was in jeopardy and chose to stay down anyway and get "that shot." For that choice, a few got to spend time in a decompression chamber—a tedious, embarrassing, and astoundingly expensive affair (one for which few insurance companies are willing to pay). In short, make safety your first priority for yourself as well as those around you.

I also hear time and time again rookie divers say something to the effect of "The water is so warm; I don't even bother with a wetsuit." Meanwhile, they're surrounded by seasoned divers wearing at the very least a dive skin but more commonly a 3 mm wetsuit. Here's why.

Your body doesn't respond well to even a 4-degree drop in temperature. In fact, a 4-degree drop is where the classifications of hypothermia start. Even in the warmest water on Earth, a 3 mm wetsuit is a good idea. While I've rarely been too warm underwater, it does happen. In those rare instances, I can force water down into my wetsuit to cool off. (There are other reasons to do this that I won't mention. Let's just say the market for used wetsuits is really small.) It's like wearing a sweater; you can always take it off if you have it, but if you don't have it, you can't put it on.

The other reason seasoned divers wear a wetsuit in warm water is that plenty of things in the ocean can sting you, and a few even bite (look up *trigger fish*). Some of the stinging ones are hard to see and are discovered only when you accidentally brush against them; jellyfish and the aptly named fire coral (because that's what it feels like when you touch it) are just a few.

Want an Example?

There is a statue just off the coast of Key Largo, Florida, of Jesus Christ in about 20 feet of water, a gift from the Cressi family of Genoa, Italy, for all of the preservation efforts being undertaken in Florida (Figure 15.2). Plenty of rookie divers come to Key Largo every year, armed with point-and-shoot cameras. It's natural that they would want to take a picture of each other with the statue, but a few go so far as sitting on Christ's shoulders. Because the water is so warm, they go diving in just shorts and T-shirts and, unfortunately, don't realize that his shoulders and neck are *covered* in fire coral. As you can imagine, they have a long, painful, and awkward two days to two weeks ahead of them.

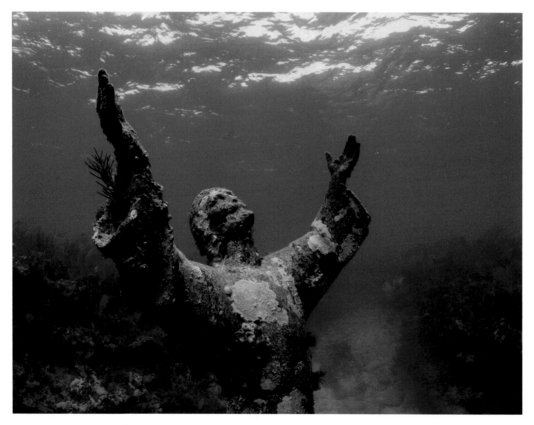

Figure 15.2: Statue of Jesus Christ off the coast of Key Largo

With the precautions about safety out of the way, it's time for some general tips about photography. This is my take on the top tips anyone who shoots underwater pictures needs to know regardless of the camera being used.

Get Closer

If you don't read anything else in this chapter and remember only one piece of advice about underwater photography, this is it. It's the one tip you'll hear over and over again in every single underwater photography class by every speaker on the topic. Its impact is immediate and downright magical in effectiveness. It remedies so many photographic ailments at once, and it's comically simple. Ready?

Get closer.

That's it. Those two words. If you do that one thing, every aspect of your photography will improve, period. Get closer. When you think you're ready to take a picture of a subject, go for it. Then get closer and take another shot, and compare the results later.

Got it? OK. Then, just when you think you're close enough:

Get closer.

"How close?" you ask. Ridiculously close. Ludicrously close. In most cases, you should be able to reach out and touch whatever you're photographing (though generally, you shouldn't). Whether it's a critter the size of a grain of rice or the side of the U.S.S. *Sunkenlongago*, get close to it. You obviously can't touch an entire wreck at the same time, but you should be able to touch the point closest to you.

Why So Close? Where Do I Begin?

With photography on land, it's easy to take distances for granted. During the day, you can just whip out your camera and snap a photo of something directly in front of you or several hundred feet away.

Underwater, especially below about 15 feet, the need to get close to your subject becomes absolutely critical. I'll list most of the reasons in a moment, but for now just remember to get closer than you think you need to and, with some subjects (sharks, for example), closer than you might feel comfortable with.

Proximity to your subject helps with a large number of issues:

- Water is 800 times denser than air. While light still travels through water, it has a tougher time.
- There is a lot of "stuff" in sea water including a host of tiny critters and particles from various sources (some of which you don't want to know about). The technical term for this is *backscatter*, referring to any particulate matter between your lens and the subject. And, of course, there's salt.
- You lose roughly one stop for every foot you are from your subject. Don't expect to be 10 feet away and just crank up your strobes. It doesn't work that way (I'll talk about strobes in just a minute).

Getting closer simply reduces the amount of water between you and your subject and transforms your images in a way that's hard to fully quantify. Your photos will be astoundingly better when you learn to get closer.

Figure 15.3 is three photographs taken seconds apart. All have the same settings; the only real difference is my distance from the subject. So, get closer. Trust me.

Figure 15.3: Photos of the same fish taken three different times just seconds apart. The only difference between the images is the distance I was from the subject.

Bring a Flash, Ideally Two

A flash (a better name is *strobe*) provides an abundant, white light source regardless of the depth. Ambient light might still be there for you in the background, but only white light can help show the profound color palette normally hidden in the ocean. Ambient light also doesn't do much when your subject is under a ledge or wreck.

I mentioned bringing two strobes, and the temptation is to think this is simply for "horsepower"; double the strobes means double the amount of light being cast on your subject, right? In fact, the role of the second strobe is usually a fill light to fill in where ambient light might not be available.

When positioning strobes, remember that you are most accustomed to seeing light from above. The sun is a prime example; it rarely shines "up" unless you're standing on a mirror, and most indoor lighting is also from above. Hence, the most common lighting approach is to have the main strobe (usually the one set to the higher output level) aimed down on your subject and the other strobe (usually set to a lower level than the main strobe) aimed from the side to fill the areas that would be left in shadow by the main strobe.

One last tidbit about strobes is diffusion. For larger subjects (the side of a wreck, for example), you want those strobes punching out as much light as they can as far as they can without blowing out your main subject. For macro photography, a softer light source is generally better. Most underwater strobes include at least one diffuser, sometimes two. With each level of diffusion, you also sacrifice a bit of light (diffusers often have the value etched

on them: 1 stop, 1.5 stops, and so on), but when you're 4 inches from your subject, the softer light is worth the sacrifice.

How Light Behaves Underwater—Ambient Light vs. Strobe

We've discussed the passage of light horizontally through water; now I'll talk about its passage vertically.

Ambient light is basically another term for sunlight (since few other light sources can light up the ocean). Near the surface, you can snap shots of just about anything without having to think too much.

However, descending to just 15 feet changes the lighting conditions; everything is now slightly more blue-green than it was at the surface. At 30 feet, there may be enough light to take photos, but all that water above you is filtering out more light, particularly red light. Ocean water acts like a giant cyan filter (*cyan* is a fancy term for sky-blue), and by about 60 feet, most of the red light has been absorbed, even on a bright, sunny day with the sun directly overhead.

With this in mind, something I said a moment ago is technically incorrect. There isn't more blue-green light; there's less red light, which makes red subjects difficult to see. In fact, if you were to photograph a red apple and a black eight-ball at this depth, you'd be hard-pressed to see a difference in color.

Apart from the loss of color, you're also losing light overall. A good rule of thumb is that you lose one f-stop of sunlight for every 10 feet you descend. In other words, for every 10 feet, you lose half your light. Here's an example for those of you savvy with f-stops and shutter speeds (if not, you'll want to be).

Let's say you're using what is known as the sunny 16 rule, which says that if you set your camera to f/16, your shutter speed for a photo on a bright, sunny day will be the reciprocal of your ISO setting. If ISO is currently set to 100 and you're at f/16, set your shutter to 1/100 of a second, and you'll get a good exposure (more or less). If your ISO was 200, you'd set shutter speed to 1/200, and so on.

OK, your camera is set to f/16, 1/100 of a second shutter speed, and ISO 100.

Now you hop in the water. You can take a picture of anything near the surface being lit by sunlight. However, if you drop 10 feet, your settings are now wrong.

In practical terms, you'll be exposing for one f-stop more light than you now have. You need to change one of those variables to expose correctly for your new depth. If you drop your aperture to f/11, you'll have twice the amount of light coming in the lens, and you'll (essentially) be back to where you were at the surface. (I'm ignoring depth of field for the moment.)

Output Power

Although strobes have about twice the output underwater of a normal strobe, they are still subject to the same physics as your camera. Water is still 800 times denser than air, and all the stuff in the water that affects what your camera sees also affects what your strobes illuminate.

Remember that "get close" tip from earlier? It comes into play again here.

Light from your strobe actually needs to travel twice the distance you are from your subject. If you're 4 feet away, light from your strobe needs to travel through 4 feet of water from strobe to subject and then 4 feet again back to your camera. For every inch you get closer, light from your strobes is traveling 2 inches less.

So, get close.

Speed

There's another fundamental reason to use a flash that has less to do with the amount of light it produces and more to do with how quickly it produces it.

A strobe can freeze motion much better than your shutter. While your shutter speed will be from, say, 1/30 of a second to 1/250 of a second, a strobe fires in the neighborhood of 1/6000 of a second. It takes a pretty fast critter to outrun a strobe. It may be hustling to get away from you, but it'll look frozen in the resulting picture.

The Two Flavors of Light

I've discussed ambient light (that provided by the sun) and artificial light (the strobes you brought with you). Now I will discuss how you control each of them.

The following factors affect ambient light:

- Time of day
- Surface conditions of the water
- Amount and type of particulate matter in the water
- Whether the weather is sunny or cloudy

I like to think of ambient light as a faucet that runs at a constant rate. For any given shooting condition, you can't do a whole lot about the amount of ambient light available to you; you can't "adjust the tap," so to speak. However, you can control how large the opening is to the container you're filling (aperture setting) and how long you leave the top of the container open (the shutter speed). ISO, in this case, behaves a lot like the aperture setting.

On your camera, your ISO setting, aperture setting, and shutter speed control how much ambient light hits your sensor.

The following factors affect artificial light:

- Strobe power
- Strobe to subject distance
- Aperture
- ISO setting

Notice that shutter speed has fallen off the list. Why? If a strobe fires at 1/6000 of a second, it really doesn't matter whether your shutter was set to 1/30 of a second or 1/250 of a second; all the light that will come from your strobe has already happened.

To use the faucet analogy, a strobe is like a flash flood with a specific amount of water behind it. You can't control how much is delivered, but you can control how much you catch.

At first glance, it seems like it would be tough to control ambient vs. strobe light:

Ambient Controlled by aperture, ISO, shutter speed

Strobe Controlled by strobe power, distance, ISO, aperture

Actually, you can control strobe and ambient light separately; it just takes a bit of planning.

In Figure 15.4, there's a pretty good balance between artificial light and ambient light, but if I wanted the water to be lighter, I'd simply decrease the shutter speed.

If I wanted a little less light to retain detail in the tank, I could do one of the following:

- Decrease strobe power.
- Close the aperture *and* decrease the shutter speed.

Wait, what? Let's break that down.

Figure 15.4: "One fish, two fish": 1/180, f/6.7, ISO 200

Aperture controls both ambient and strobe light, while shutter speed controls only ambient light. Closing the aperture one stop halves the amount of light entering the camera. Decreasing (slowing) the shutter speed doubles it again, so the net result is the same—half the amount of ambient light for twice the amount of time. However, the aperture is smaller,

so there is less light coming in from the strobes. Since the strobes fire so fast, they're not affected by the change in shutter speed, so the foreground simply gets darker while the water in the background remains basically the same.

If you understood that after reading it only once, you're ahead of me.

Shoot Up

Here is another simple but amazingly effective tip for better shots: shoot up. Rather, get as low as or lower than your subject and aim the camera up at it. I'm not really sure why this makes such a profound difference with underwater photographs, but it does. Having water behind an animal helps emphasize where it is and tells the story a bit better than a fish hovering in front of a reef.

This angle can be tricky for a flounder or stingray that likes to sit on the bottom. In that case, get down on its level and shoot horizontally. The beauty of their camouflage is highlighted nicely when all you see is a bulging pair of eyes from the sand.

This photo of a scorpion fish would never make a good gallery wall image, but it's a good example of what happens when you shoot across at something resting on the bottom (Figure 15.5). From above, it's pretty well camouflaged and far less interesting as a subject (Figure 15.6).

In short, don't take the picture a human would; take the picture another fish would.

Figure 15.5: Scorpion fish from below

Figure 15.6: Scorpion fish from above

Buoyancy

A camera changes your buoyancy in the water. Nearly all cameras are negatively buoyant, which, if you're a certified diver, you should know means it will try to sink if you let go of it. You might think that a camera that is slightly positive would be better (should you let go of it, you'd want your investment to rise to the surface rather than sinking), but a positively buoyant camera is very difficult to handle.

Bringing a full camera rig is like having an extra two pounds of weight in your buoyancy control (BC) vest or weight belt, and unfortunately, it's in your hands rather than around your waist. This makes for some awkward moments when the upper half of your body sinks and your fins are sticking straight up in the air like a prawn in a cocktail dish. The remedy here is to simply become an experienced diver and really dial in your buoyancy before bothering with a camera.

However, I'd argue that a camera can help you become a better diver.

I remember first learning to dive and watching our dive master swim effortlessly with her arms folded against her body. Meanwhile, I was flailing around, kicking with my feet and frantically paddling with my hands, looking like someone trying to escape a car they'd just driven into a lake. I improved a bit over time as experience kicked in, but something magical happened when I started holding a camera: I couldn't use my hands anymore and began to rely almost entirely on my legs. It was a great lesson.

You Need Two Lenses Only If You Have the Option of Changing Them Out

You can leave your telephoto lens on the boat. You won't be photographing (successfully anyway) a subject 100 feet from you. Oh, I know it's your first time diving with a whale and you want to capture the moment, but for all the earlier reasons, zooming just doesn't work.

You'll mostly shoot two kinds of subjects:

- Wide-angle when there's a relatively large subject and you need to be close to it
- Macro when there's a small subject and you need to be even closer to it

I've seen people do quite well with a 60 mm macro lens and a 10 mm–17 mm wide-angle fish-eye lens (an ironic name since it's very difficult to actually shoot a fish eye with one).

Here's the trick: everything is about one-third closer underwater. Rather, everything *appears* to be about one-third closer underwater. Hold your hand out in front of you underwater, and it looks like your arm shrank. A pencil in a glass of water looks distorted for the same reason (Figure 15.7).

Figure 15.8 shows another example: a ruler half submerged in water. Note the closer appearance of the underwater portion.

This is good news and bad news.

The good news is that 60 mm macro lens I mentioned earlier is now more like a 90 mm lens underwater; you get an extra 30 mm closer for free.

The bad news is that a super-wide-angle lens is now essentially cropped by one-third because of that same refraction. Instead of seeing a wreck from end to end, you now see only the middle two-thirds.

To compensate for this, most higher-end camera enclosures offer something called a *dome port*, which is a curved piece of either glass (expensive) or polycarbonate (cheaper) that sits in front of the lens and forms the front window of the camera housing (Figure 15.9). By curving the water in this way, the refraction properties are undone, essentially subtracting the distortion. Everything underwater now looks to be the same distance away as it does on land.

Figure 15.7: When viewing a pencil partially in the water, it can look disconnected or distorted.

Figure 15.8: Look at the ruler below the water, and notice how it appears closer than the part of the ruler still out of the water.

Figure 15.9: Notice how the dome port corrects the part of the ruler under the water so it more or less appears the same as the part out of the water.

It's the same subject, but the dome port undoes the distortion exhibited with the flat port.

The other little tidbit here is that dome ports allow for these over/under shots (also called *splits*) where the lower half of the photograph is underwater and the other half is out of the water. A dome port helps this in two distinct ways:

- It does away with that annoying distortion so that someone standing in the water has their torso and legs the same distance away from the camera.
- The larger surface area of the port makes it easier to hold the camera in such a way that half of the port is out of the water and half is in the water. Hence, smaller waves don't overwhelm the shot. You get a much greater margin for error, but these are still tricky shots to get.

Focus. Not the Camera, *You.*

Most people want a series of quick shots from their dive—a chronicle of the event much like going to the zoo. That's a fine goal, but simply documenting the creatures you encounter isn't nearly as rewarding as taking a truly great photograph of them. There are "bonus points" if you can manage to photograph them exhibiting some sort of behavior—a fish tending to her eggs or stopping at a "cleaning station," for example.

Figure 15.10 is a good example of a behavior shot. Although it looks like the butterfly fish on the right is about to be devoured, the truth is that the blue stripe grunt is opening its mouth to be cleaned by the butterfly fish. I waited for about 20 minutes to get this shot.

Figure 15.10: The butterfly fish appears to be moments away from being eaten by the blue stripe grunt.

Some animals are plentiful and will hold still for (almost) as long as you want them to. Others just take off and don't come back, or they retreat into their hiding places and wait until they think it's safe to come back out. Those critters take some patience and, in a few cases, a bit of cunning to become gallery material.

The lesson here is to focus. Pick a subject—one subject—on a particular dive, and take the best picture you can of that subject. Stick with it, and experiment for as long as the critter will let you. Change your position and see how it affects the photograph. Can you incorporate layers into the shot (in other words, something in the foreground, your subject, something behind it, and some water surface ripples)? Is there a better way to frame the animal? Certainly, any time two animals are interacting is worth working for a while. Got a great shot? Wonderful! Go get a better one.

As you approach a subject, keep shooting. Take the first shot you think you'd be proud of; then keep getting closer and take another shot. Keep getting closer and shooting. I'll bet your best shot is the one just before it runs away.

The Manual Method

This comes as a shock to most people, but cameras weren't specifically designed to shoot underwater. With that comes some bad news; the auto functions on your camera aren't likely to work. To successfully shoot underwater, you'll need to use . . . (dramatic music here) manual mode!

I can hear the shrieks and cries now, but hear me out.

I became a much better photographer after shooting underwater. I was forced to understand nearly every function my camera had to offer. The lure, frankly, was the photographs that other people were taking who *did* understand all those functions. Being surrounded by other people who are getting great results is a very strong form of peer pressure.

Learning to shoot in manual mode was almost as frustrating as learning to play golf, but I kept at it. Gradually, the concepts became clear.

Autofocus

Unlike manual mode, autofocus is your friend depending on your camera. Your odds of being able to determine whether a subject is in focus are pretty small given the timeframes involved and your ability to see the back of your camera. This is one case where technology has a distinct advantage over humans.

The default focus mode is fine when you're just getting started. The default is for the camera to focus on whatever is in the center of the frame. As you become more familiar with your camera (and if your camera supports it), you can change where the camera will "look" for focus. Generally speaking, you want the eye of the animal to be in focus.

Obviously, this requires some preparation before shooting. Which reminds me

Preparation before Shooting

The idea here is to be prepared to shoot anything in the situation you're in. Unsure of your settings? Take a picture, look at that histogram, make adjustments, and then take another one. It costs you nothing to be prepared, which is yet another brilliant aspect of digital cameras.

Shooting under or inside a wreck? Adjust accordingly. Take a few snapshots of something that doesn't move, and you'll be ready for something that does.

However, there is beauty in such shots of unpreparedness.

In 2002, I was on a small island in the Caribbean called Bonaire (which is among the "ABC" islands; Aruba and Curacao are the more prominent islands). I was still logging my first 20 dives or so and was armed with a very modest digital camera by today's standards.

For whatever reason, I turned away from the gently sloping wall and gazed out into the open ocean behind me. Not 10 feet away from me, swimming from right to left, was a small manta ray, probably 4 to 5 feet in diameter. I was both speechless and frantic to get a picture of it. I snapped two or three images (it was, of course, *well* out of range of the built-in flash, so the pictures won't be going on my wall), but the memory was recorded. I'd seen my first manta.

Later, in the dive shop, I mentioned the encounter to the man working behind the counter, which he laughed off as impossible. In a thick Dutch accent, he noted, "I've been here thirty-five years, and I've never seen one. I don't know what you saw, but it wasn't a manta." Recalling that I was still holding the camera that contained the evidence, I said, "Oh yeah? Then what is . . . *this?*" There, on the back of my camera, was proof that I'd witnessed what I said I had and something he hadn't. No one could quite figure out what the manta was doing so far from home, but his disbelief fell away in an instant and turned to sheer envy.

Pre-Dive Prep

Other kinds of prep involve what to do before you even get in the water. Electronics don't like to get wet, and this is especially true with salt water. Few substances can so quickly, thoroughly, and permanently ruin your equipment like salt water.

You should be warned that every now and then camera housings fail. This is most often because of user error (though equipment occasionally fails on its own). Most of the time, a "flood" happens because something interfered with the seal keeping water out. In one case, a *very* expensive camera I was using was ruined because the O-ring that forms the seal was partly sticking out the bottom of the housing. Water went in so fast, the camera never had a chance. The good news is that it wasn't my camera; the better news is that the owner is the one who sealed the housing. It's a bit like the mentality of packing your own parachute. If something goes wrong, you can't blame anyone else.

Follow the advice of the company or person who sold you the housing. Clean and lubricate O-rings every time you open the housing. Seal the housing in a clean environment where you can clearly see any piece of lint, hair, sand, and so on that might sit along that O-ring.

Then, before climbing in the water, take one last step; dunk your camera in a fresh water tank. If you see a small, steady stream of bubbles, lift the housing quickly but calmly out of the water and keep it upright. Have someone else open the back of the housing and get the water out.

Be aware that rinse tanks on dive boats and on the docks are usually also rinsed with dive masks, and the antifog agent that's so great on your mask does bad things to O-rings in a camera housing. The larger tanks for rinsing gear are slightly safer just because of dilution, but it's best to stick with fresh water that's free of antifog agents.

Histograms

One of the greatest features of digital cameras over film is that they allow you to do the following:

- See the current scene on the screen on the back of the camera
- See the previous photograph on the screen on the back of the camera

That's awesome . . . on land.

But here you are, 60 feet down surrounded by blue-green water. The screen on the back of your camera is under a clear plastic panel, both of which are reflecting ambient light back at you. Then there's the 7 to 12 inches of salt water between you and the back of the camera housing and the piece of glass that comprises the mask you're wearing. As it turns out, not one of these things improves viewing conditions.

Whenever you view a photograph underwater, it always looks red. Why? Because your eyes cleverly adjust to the blue-green ambient light that surrounds you. After a while, the green environment seems normal. Hence, anything lit with normal lighting now looks too red by comparison. With that in mind, how can you possibly use the back of your camera as an accurate indicator of what you actually photographed?

Well, in terms of cropping, you can, but as for exposure, there's no chance. Some cameras can show you areas that are blown out (too bright for the camera to capture) or underexposed (too dark for the camera to capture). This is another instance where a single tool transformed my photography as much as getting closer: I turned on the histogram preview function in my camera.

For those who aren't familiar with histograms, think of them as a census of your image. How many bright pixels do you have, and how many of them are so bright that the information in them may get blown out? Likewise, how many dark pixels are there, and how close to being too dark are they? Dark subjects on dark backgrounds will have a large number of dark pixels. Light subjects on light backgrounds will have a large number of light pixels. A histogram will tell you when pixels of either type are in jeopardy of losing detail.

Most digital photography books talk about an ideal (if rare) histogram with the bulk of the information near the center and the rest evenly distributed on either side, sloping elegantly to zero as they reach pure black and pure white.

The reality is that some perfectly exposed photographs will have odd, or even seemingly incorrect, histograms. A black cat sitting on a black car, for example, will have a largely dark histogram. Likewise, a snowman in the middle of a snowy field will have a mostly white histogram. What does a good histogram look like?

Well, *it depends*. (Don't you hate that phrase?)

Underwater, it's difficult to know whether an image was exposed correctly if you can't see the histogram. Likewise, it's tough to know whether a histogram is appropriate if you can't see the image from which it was measured. In short? Turn on the histogram function so you can see both the image and its histogram. You can thank me later.

So, there you have it. Those are some modest, if hopefully helpful, tips from someone who spent seven years taking bad photos underwater. OK, I still take bad photos, but at least now I can say *why* they are bad.

Daniel Brown

Daniel Brown discovered Adobe Photoshop in 1990, long before he really discovered a camera. He performed high-end retouching projects for Apple, Adobe, Sun Microsystems, and Revo Sunglasses. In 1997, he discovered photography and began to manipulate his own photographs; shortly after that he joined Adobe Systems and taught classes, seminars, and workshops on Photoshop and digital imaging. In 2000, Daniel was invited to speak at The Digital Shootout in Monterey, the first photo competition for underwater photographers using digital cameras, and he took up underwater photography in 2006. He has cotaught weeklong seminars with Stephen Frink and has given classes at Digital Shootout competitions and at the Backscatter Underwater Photography store on Cannery Row in Monterey.

Rigging a Car

Shooting scenes with a car or in a car can be exciting, painful, dangerous, or rewarding—or probably all of these. When you are driving a car, your attention (or, more accurately, the actor's attention) should be solely focused on driving the vehicle. All other elements—acting, making eye contact, using props, or anything else your actors or crew members are doing—make driving a car more dangerous.

Safety First

There are many ways to be able to shoot in a car or to shoot a chase scene and get great results without endangering any of your cast or crew. But at all times, make sure safety is the first priority.

Two terms that are good to be aware of are *picture car* and *camera car*. A picture car is any car that will appear on screen. These are usually the nicest car you own, a car someone in your family or group of friends owns, or one that you can rent. Camera cars are any vehicles that the camera and crew are in that never appear on screen but are needed to get the coverage you need for your scene.

Interior Dialogue Scenes

Most movies have at least one scene that takes place inside a car. This can range from a simple dialogue scene between two characters to a single actor driving late at night. The key is knowing the best ways to get the coverage you need and to make the scene as real and interesting as possible.

Angles for Shooting Actors in a Car

There are only so many ways you can shoot actors who are inside a car. There are limitations as to where the actors can be placed and how far they can move or be moved.

Shooting through the Front Windshield

Let's start with the standard: shooting directly through the front windshield. This requires the camera to be mounted to the hood of the car and have the lens pointed directly at the actors in the car. You will immediately notice that the windshield itself acts as a giant reflector. The brighter the sun, the more reflection you will see, and the harder it will be to see the actors inside the car.

One option you have is to shoot the car in the shade. When there is little to no sun, then you don't have much, if any, reflection off the windshield. If the car is moving, it may be hard to find a road that is totally shaded, so find a road with a lot of mature trees that provide dappled lighting on the street. This is a mixture of shade and sunlight that gives you reduced but still present reflection; it allows the audience to see through the window, but the reflection helps enhance the feeling of the moving car. Another option is to shoot with a polarizing filter. This can help reduce the reflection or glare but doesn't always eliminate the reflection altogether.

The first option for shooting through the front windshield is to directly mount the camera to the hood of the car. You will have a variety of options ranging from suction

cups (Figure 15.11) to a hood dolly mount to attach your camera to get your coverage (Figure 15.12). You can simply mount the camera in a fixed position and let the camera catch the action inside the car. If you use a dolly mount or have the car loaded onto a trailer bed, you can actually have an operator control and get movement into the shot instead of it simply being static.

Figure 15.11: Camera mounted on a single suction cup mount on the front of the car

Figure 15.12: Camera mounted on a secure dolly mount on the front of the vehicle

Another option is to shoot from a lead car toward the front of the picture car. You can mount the camera in a fixed position on the back of the vehicle, you can have the camera-person operate the camera handheld, or you can mount a tripod in the back of a truck/van and operate off a good tripod (Figure 15.13). A simple and cheap option is using a beanbag. This can be any sort of small beanbag or beanbag-like object that is soft and somewhat moldable. Make a little depression and rest your camera right on top (Figure 15.14). Then you can go ahead and fasten the beanbag and camera directly to the hood, and you have a cheap and fast way to set up your camera.

Figure 15.13: Tripod weighted down with sandbags in the back of a pickup truck to shoot the picture car from the front

Figure 15.14: Camera resting in a beanbag ready to be strapped down for the shot

Shooting through the Side Window

You have two options when shooting through the side window. You can choose to frame the car door so the audience sees the outside of the car, or you can frame only your actor to give the audience a more intimate view of your actor. Both need to be done from the outside of the car so you have enough distance to actually keep your actor in the frame. Another choice you have is whether to have the windows up or down. Again, you could be dealing with reflections if you are shooting through a side window, especially if you are in direct sunlight. So you can view your choice as mostly an aesthetic one and what makes it easiest to get the shot you want. If you shoot with the windows open and are driving down the freeway, it may be impossible for you to get usable audio of the actors live and you'll force yourself into an ADR situation.

When you chose to shoot through the side window, you limit the number of choices you have to mount your camera. You can mount the camera to the side of the car pointing in the side window (Figure 15.15), you can shoot out of the side of a minivan or another camera vehicle, or you can shoot from a tripod with the car parked while you are using rear-screen projection to simulate that the car is driving.

Shooting from the Passenger Seat

If you have an actor driving the car with no passengers, you can shoot the actor from the passenger seat. This will allow you to set the camera more or less where the passenger would be sitting and allows the audience to feel like they are riding in the car with the driver. You can accomplish this either by using a longer lens on a camera mounted on the exterior of the car or by rigging the camera inside the car.

Figure 15.15: Camera mounted to the driver's window that will capture the profile of the lead actor while driving

You have three main options when shooting from the passenger seat from a car. First, you can have your cameraperson handhold the camera and shoot in the direction of the driver. Second, you can mount the camera on the exterior of the car and shoot an over-the-shoulder or two-shot of the main two actors in the front seat. Finally, you can mount your camera to the dashboard of the car, space permitting, of course.

Shooting from the Driver's Seat

You have two ways to achieve this type of shot. The first may be too expensive and not available for many low-budget productions. It calls for a trailer to actually physically carry the picture car. This means any actors in the car do not need to drive the vehicle but at the same time the background will be moving as if the car is being driven since the tow car is moving the picture car on the trailer. If you have access to this sort of setup, that is great, and you can mount the camera directly in the driver's seat. If you don't have a trailer to carry the car, then you will be forced to mount the camera on the exterior of the driver's car door. If you need to frame out the driver and show only the passenger, then use a long lens and make sure the angle on the camera is such that the driver isn't in the shot.

Shooting from the driver's seat can be a bit trickier. If you are shooting on a low-budget and you have to get coverage while your actors are physically driving the car, then you really have only two options. You can rig the camera to the outside door of the driver's side, or you can rig the camera to the dashboard.

Shooting from the Backseat

Whether or not you have an actor in the backseat, you can mount a camera in the rear of the car for a variety of angles. You can choose to frame both the driver and passenger seats in

the same shot, shoot the driver or just the passenger, or shoot the eyes in the rearview mirror. How much room you have, what angle you are trying to frame, or other practical issues will determine how you rig your camera.

There are a few different ways you can rig a camera to shoot into the front seat. First, you can handhold the camera, with some sort of support rig, and manually operate the camera. This allows you to control where the camera is pointing and to adjust for the actors' movements during the scene. This can be tricky because it is easy for this to end up looking overly shaky and more like you shot it from the side of a boat if the road is rough or if the car is turning a lot. Test shooting this way to make sure you can achieve the look you want with your camera setup.

Second, you can rig the camera with some grip equipment to the back of the headrests of the car. Then you can angle your camera and get a profile of the actor in the driver's seat or the passenger seat.

Lastly, you can go with the old tried-and-true tripod (Figure 15.16). If you have enough room to put a tripod, go ahead and set it up. Use sandbags or something to help add weight to the bottom and keep the tripod from tipping during the turns while driving (Figure 15.17).

Figure 15.17: Add weight to the bottom of your tripod to help keep it from tipping. A couple of sandbags will be perfect.

Figure 15.16: Tripod positioned in the back of a pickup truck

Movement out the Window

One of the main reasons for shooting in a car is for the added movement of the background outside the car. Without the movement outside the window, the car appears not to be moving or moving very slowly. You should be aware of a few tricks. The first is if you shoot with wider lenses, then your background won't move as fast. This can help make it look like the car is moving slower. If you are driving slowly and need it to appear like the car is going faster, then you can use a long lens or find a road with objects such as hedges that are closer to the car to help add the perception of speed in the background.

If you are shooting at night and so you can't see out of the window, you can shoot when the car is either parked or moving. However, if you choose to shoot the car as if it were driving at night, you will need to add some lights that will periodically move through the shot. For instance, if you really are driving at night, you will from time to time drive under a street lamp. A small spotlight can be rotated so the intensity starts soft, grows, and disappears, and the audience will be tricked into thinking the car is moving and not that you just moved the light.

Another trick is if you can frame your shot so on one side of the car you see only the skyline (this works only if you have a clear blue sky) and you can't see out of the back window. Then if you shoot through the front window and only from one side of the car, you can have the car parked and make it seem as if it is moving. Open the windows and put a fan on the actors to simulate the wind in their hair. Since the audience cannot see anything that would move in the background, the simple wind blowing through their hair will be all you need to sell the movement of the car. Just find an establishing shot where you can shoot the car driving with your actors and show the blue sky in the background (this can be shot on a tripod) that can be cut in.

In the good old days of Hollywood, they used to use a system called *rear projection* where they would simply project a moving background onto a screen and let the actors play their scene in a parked car. You might wonder why you would resort to this when it is so easy to mount a DSLR camera today. Well, there are a few reasons why this may be a good choice for your production. First, just as in the old days, your actors won't be driving while acting, so it is a safe way to get your scene. Second, you can film, or get stock footage, of a location that is far more cinematic than the streets where you live. Lastly, perhaps you borrowed your uncle's classic car, and the only rule he gave you is you can't drive it on the road.

There are two great ways you might be able to get the rear projection to work for you. First, get a large projector screen that allows for rear-screen projection and an LCD or DLP video projector. Get one large enough to fill the background of your scene and turn it on: instant background motion. Second, if you have a large-screen TV, you can use that as your rear-screen projector. Hook up your DVD or connect your video camera directly to the TV. Position the TV outside the car window you want and *presto*; your car now appears to be moving.

Rules are made to be broken. If you can find a new way to tell your story inside a car, then don't be held down by these angles. Rent Alfonso Cuarón's *Children of Men* and watch the special features. They modified the interior of a car, and the camera operator sat in the middle of the car and had four actors: two in the front and two in the back. Then in a complete 360-degree turn, the operator spun the camera around so each actor had their moment during the pan. This was done with a film camera and not a small compact DSLR camera. Each actor then had to duck as the camera swung around and had only a short time to sit up and get ready before the camera got back around to them. Use the camera's size and flexibility to find new ways to help you tell your story.

Car Chase

If you are just capturing dialogue in a car, then most of your camera coverage will take place inside the car. For a car chase scene, though, you will have equal or more coverage with the camera outside the car.

Lead Car This is also referred to as the *picture car* and is the car that will appear on screen. For our purposes, this is the car that has no camera equipment rigged on it while getting coverage for your scene.

Chase Car For our purposes, we will call any car that is accompanying the picture car for coverage the *chase car*. This is the car that will *not* be seen in the movie but will be the vehicle that you rig in order to follow the cars shown on screen and get coverage while they are moving. In some cases, this car can be seen on screen if you have only two cars and have to switch the rigging from one car to the other if you don't have a third vehicle. If that is your situation, just think of the chase car as the car that isn't seen during the filming of that take.

Coverage of the Chase Vehicle

In any good car-chase sequence, you will have one or more cars chasing your picture car. Usually there is some coverage of the people driving those cars, but mostly there is coverage of the vehicles in hot pursuit. It is key that you get the point of view of the pursuit vehicle from the lead picture car. First, you can shoot through the rearview or side mirrors to see the pursuit car. Additionally, you can simply rig the camera in the backseat facing out the back of the car (Figure 15.18). Then, you can get the perspective of how far the pursuit vehicles are behind the lead car and help add the sense of speed if you catch some action such as the chase vehicle coming around a turn or avoiding an obstacle in the road (Figure 15.19).

Figure 15.18: Setting up the tripod and camera to shoot directly out the back window of the car

Figure 15.19: You can see the how close the chase van is getting to the lead vehicle.

Chasing the Lead Picture Vehicle

If you are a fan of action movies, you have seen many chase scenes, and most if not all have the pursuit vehicle closing in on the lead picture vehicle. This is accomplished by rigging a camera on the front of the pursuit car (or on a chase vehicle that won't appear in the movie) and pointing the camera directly at the lead picture car (Figure 15.20). This allows the pursuit (or chase) car to speed up and get close to the lead picture car and slow down and drift away from the lead car. By mixing this sort of action, you can cut between the pursuit car gaining ground and losing ground throughout the scene.

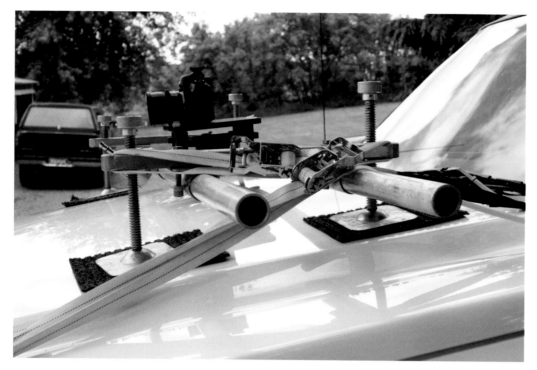

Figure 15.20: Camera mounted and strapped down on the front of the pursuit vehicle

Coverage from the Sidewalk

In any car chase scene you need to have some static shots that help establish where you are and how fast you are going. Cameras placed on the sidewalk, in a store window, or in any other area along your chase route will help tell your story. Choose strategic places to place your camera that are visually compelling and catch the car either at its top speed or during some movement such as turning or swerving to avoid an object on the road. Just getting shots of cars driving down the street creates no sense of speed or urgency. During the slower parts of the action where there is no movement or obstacle, get coverage of the actors inside the car and close-up shots of the car driving. Then if you use a faster editing pace, you can help keep the speed of the scene nice and fast without having to race down every road you shoot.

Alongside the Vehicle

Another way to get great action shots of both the lead and chase vehicles is to get a van or minivan with sliding side doors. This allows you shoot out the side of a vehicle in relative safety and get close coverage of the cars. Ideally, you should borrow or rent a minivan that has sliding doors on both sides. This allows you to get coverage from both sides and doesn't limit your shot selection to just one side of the cars.

Looking in the Rearview Mirror

A lot of times it is desirable to get coverage of your driver looking in the rearview mirror (Figure 15.21). You can accomplish this by either having a cameraperson seated in the backseat handholding the camera or having the tripod weighted down with sandbags in the backseat (Figure 15.22).

Figure 15.21: From the backseat, not only can you see the actor's eyes in the rearview mirror, but you can also see the moving action out the front windshield.

Figure 15.22: Without the actor in place, you can see the placement of the camera in the backseat on the tripod.

Turns and Low Angle of the Wheels Turning

Another great angle is seeing the wheels spinning and turning while driving. You can accomplish this by mounting a sled mount (Figure 15.23) or by using suction cup mounts and anchoring them to the car. Preferably mount the camera as low to the ground as you can without risking it getting damaged. This can really help you capture the speed and motion of the car during the chase. Point the camera at the front wheel (Figure 15.24), and notice how you can clearly see the tire; if you do this on the chase vehicle, you can see the lead car directly out the front (Figure 15.25).

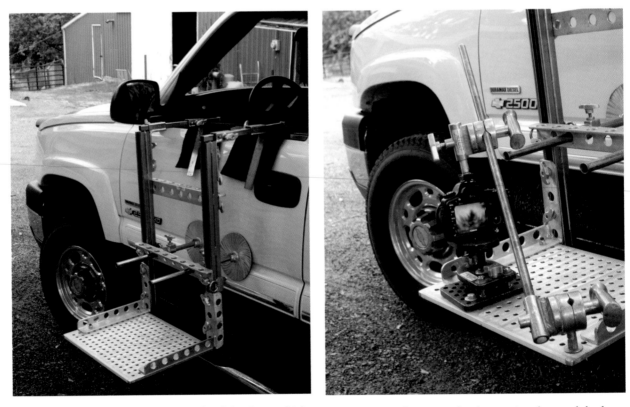

Figure 15.23: Sled mounted on the side of the chase vehicle

Figure 15.24: The camera has been pointed toward the front tire of the vehicle so the movement of the wheel and what the car is chasing can be seen from the road's-eye view.

Figure 15.25: The tire as seen through the camera lens while the car is parked

Achieving That Cinematic Look: Ramping and Changing Frames per Second

When Canon first announced the 5D Mark II, the only frame rate available to shoot video was 30 frames per second (fps). For filmmakers, 24 fps is the standard for the film look or cinema feel of the moving image. People shooting with DSLR cameras that had only 30 fps as an option had to look at some sort of post-processing technique to get their footage to look more cinematic. The only way to achieve this was to use a conversion process that took the 30 frames in the original footage and mathematically turned those into 24 fps that would play back as if it were shot in 24 fps originally. A software program called Twixtor by RE:Vision (Figure 15.26) allows the editor to speed up or slow down your footage.

Twixtor works with all major editing programs and most of the motion-graphics tools on the market today. This is the top product if you want to convert footage to a new frame rate from what you originally captured it at. Just be cautioned that this process of converting is very time intensive. Plan on a ratio of one hour of conversion processing time for every one minute of footage. Twixtor works great for creating slow motion (when you did not shoot for slow motion), for converting from your source frame rate to a new frame rate (30p to 24p, and so on), and for speeding up your footage.

RE:Vision Plug-ins	▶	Twixtor FxPlug
Sharpen	▶	Twixtor Pro FxPlug
Stylize	▶	
Tiling	▶	
Time	▶	
Video	▶	

Figure 15.26: After you install Twixtor, you can find it in the menu under Effects ➤ Video Filters ➤ RE: Vision Plug-ins.

Shooting in Slow Motion

Several DSLR cameras now shoot slow motion, with the most common slowest option being 60 fps. This means you can slow down your footage to almost one-third of 24 fps footage and to half-speed at 30 fps footage.

If you shoot slow motion on film, you would choose a frame rate in the range of 48 fps to 120 fps. When shooting at these speeds, the camera requires a faster shutter speed in order to capture sharp enough images to not look blurry. For instance, if you were shooting at 96 fps, you would set your shutter speed to around 1/200 of a second in order to get a sharp, smooth slow-motion shot. If on your DSLR camera you shot at either 24 fps or 30 fps, you would have your shutter most likely set to around 1/50 or 1/60 of a second. At these speeds, faster motion causes blurring, which looks natural when viewed at the recorded speed.

If you want super slow motion (more than is available with the current DSLR cameras), then you should know a trick to improve this problem in post. If you plan on shooting 24 fps and slowing it down to 96 fps in post, then you should artificially set your shutter speed to a higher rate. If you were to use a program such as Twixtor or After Effects in post to create a 96 fps (4× slow motion) sequence, you would want to shoot with a shutter speed of 1/200.

The basic theory here is that you shoot at a normal frame rate, and then in post you slow down the footage by adding more frames—thereby increasing your overall fps for your clip. To compensate for adding the frames, you need to increase your shutter speed in the original footage so that you have as sharp as possible frames so the post-production software has as much detail as possible to create the extra frames. This will give you the best possible final image.

Whatever frame rate you want to slow your footage down to, make sure to double the number and set that as your shutter speed when capturing the footage. For instance, 4× slow motion is 96 fps, and the camera should be set to 1/200 shutter speed. If you want 6× slow motion at 144 fps, then you want to set the camera to 1/300 shutter speed.

The reason for this is that you in essence get the same amount of blurring as a 24 fps sequence. This is because any post-processing that changes normal-speed footage into slow motion is creating new frames and is replicating each pixel when creating the added frames. If you shoot the original-speed footage with a higher shutter speed, you will be better set up for the conversion in post. The converted slow-motion video will result in a nice slow-motion scene, but it will look like the images in the scene smear or blur as if they were shot at regular speed. If you don't shoot with a higher shutter speed, it is possible that your footage will have too much motion blur, and when you slow down the images in post, the scene will look out of focus or will smear as it plays.

"Rubber Arms" (or the Bending of Images That Shouldn't Bend That Way)

If you have fast-moving items in your scene, then you need to be aware of the limitations of any post-processing and how certain movements can make it impossible to change the speed of the footage in post. Most programs such as After Effects and Twixtor work by mathematically anticipating where the pixels will be moving to and from in a scene. In a normal scene where someone is walking, Twixtor can handle estimating how far each leg will travel, where it will stop, and so on.

For instance, if you have a girl running through your frame and she abruptly stops and runs back in the direction she came from, you will have problems with this technology slowing down the footage and having it look normal.

What happens is that the programs are estimating where the objects in the scene are moving based on previous frames. Any abnormal or abrupt change of action of an image in the frame can look strange to downright bad. In the case of the girl running, as she enters the frame, she is moving in a normal path that is predictable. However, that changes when she stops and does an about-face. During the stop and about-face, the programs adjust the algorithm to track where she is going. It may take a few frames for the programs to be able to calculate what happened to make the corrections. The problem is that during these few frames the girl stretches or bends unnaturally before returning to a normal pattern as she runs off screen.

If you are planning on shooting normal-speed footage and slowing it down in post, it is a good idea to make sure there is no movement or objects that may not turn out looking natural and force you to be unable to use the footage as planned.

The 180° Rule

When shooting motion-picture film, there was (and is) a physical shutter. This shutter is circular and is most commonly set as a half circle. The shutter spins around and allows light to hit the film, and then when the half of the shutter blocks the light, the camera moves the next frame of film into the gate, and the shutter opens up and exposes the next frame. This process happens 24 times each second, and the 180° shutter is the default shutter angle for most films.

With this said, the physical shutter can be changed to other angles. For instance, you can shoot at a 90° shutter instead of the 180°. By decreasing the angle of the shutter, you need more light to expose your image, and the image is captured with less motion blur. This can be described as a sort of strobing effect. It's commonly done now in war movies where it helps to freeze the dirt and debris flying through the air and makes the viewing experience feel more intense. So, you can accentuate this hyper-realism or strobing by further decreasing your shutter angle.

DSLR cameras do not have a traditional 180° film shutter but rather a curtain shutter that acts differently from a film shutter, but you can set the shutter "speed," which is in effect your shutter angle. For instance, if you are shooting at 24 fps, you would want a 180° shutter, which translates into a 1/48 shutter speed. You need to find the closest shutter speed, which in this case would be 1/50. If you wanted to shoot with a 90° shutter, you would need to double your shutter speed from 1/48 to 1/96. Again, on most DSLR cameras, you would set the camera to 1/100.

Each halving of the shutter angle will decrease your f-stop by one full stop. For instance, moving from 1/50 to 1/100, you lose a full stop, and from 1/50 to 1/200, you lose approximately two full stops. So, keep in mind that if you want to shoot at a different shutter angle, you will need to have more light or be willing to increase your ISO to maintain a good exposure for your scene (Table 15.1).

Table 15.1: Converting film shutter angle to DSLR shutter speed

Motion-picture film shutter angle	Shutter speed when shooting at 24 fps	Shutter speed setting on your DSLR	Amount of light loss from a standard 180° shutter
180°	1/48	1/50	None
90°	1/96	1/100	1 full stop
45°	1/192	1/200	~ 2 full stops

Index

blockbuster budget packages, **61**
camera motion, **147–153**, *148–153*
chase scenes, 428–429, *428*, *430*
emergency items, 264
fluid head and a nonfluid head, 50, **152–153**, *153*
head plates, 155, *155*
independent budget packages, **60–61**
low budget packages, **60**
side window shots, 424
windshield shots, 423, *423*, *426*
troubleshooting, **263**
emergency items, **264–267**
hardware problems. *See* hardware problems
iPhone/iPad applications for, **268–270**
shooting-related problems. *See* shooting-related problems
syncing, **329–330**
trucking, 144
true ISOs, **68**
turning wheels in chase scenes, **430**, *430–431*
24 fps rate, 8, 25–26
25 fps rate, 8, 26
29.97 fps rate, 8, 26
Twixtor program, 319, 431–432, *431*
two-pass compression, **371**

U

U channel, 352
Ultralight strobe arms, *406*
ultraviolet filters, 37
umbrellas, 265
underwater cinematography, **405–406**, *406*
autofocus, **418**
buoyancy, **414–415**
distance, 408, *409*
example, **407–408**
flash, **409–413**, *412*
histograms, **419–420**
lenses, **415–417**, *415–416*
manual methods, **418**
preparation, **418–419**
risks, **406–407**
shoot up, 413, *413–414*
subjects, **417–418**, *417*

Underworld series, 389
unidirectional pickup patterns, 231
unique movement and support, **171**, *171*
unsustained data transfer, 302
unsynced files, **329–330**
USB 3.0 standard, **302–304**, *302*

V

V channel, 352
VA monitors, 43
value of color, 340, *340*
vampire clips, 230, *230*
variable-aperture zoom lenses, 14
variable-focal-length lenses, 135
variable ND filters, 36
emergency items, 264, *264*
testing, **76–77**, *76*
vectorscopes, **359**, *359*, **364**
versatile lens kits, **31**
vibration reduction, **128**, *128*
video
audio syncing. *See* syncing sound and video
color spaces, **352–353**, *352*
compression. *See* compression
focus, **84–85**
output. *See* output
Video Copilot, 387
video-like sharpness, **283**
video-sharing sites, 380, *381*
Video Space Calculator app, 269
view features, 39
LCD screens, **39–41**, *40*
monitors, **41–44**, *42–43*
viewfinders, **40–41**, *40–41*
for focus, **273–274**, *274*
gear packages, 61
testing, **77–78**, *79*
viewing movie files, **257**, *257*
vignettes, 76, *76*, **365–366**, **396–397**, *397–398*
Vimeo video-sharing site, 380, *381*
visible light, 343, *343*
VistaVision size, 5, *5*
visual priority in lighting, **185**
visualization benefits of camera stabilization, 158